C000091922

TALKING
MAPS

Jerry Brotton • Nick Millea

with a contribution by Benjamin Hennig

TALKING
MAPS

Bodleian Library
UNIVERSITY OF OXFORD

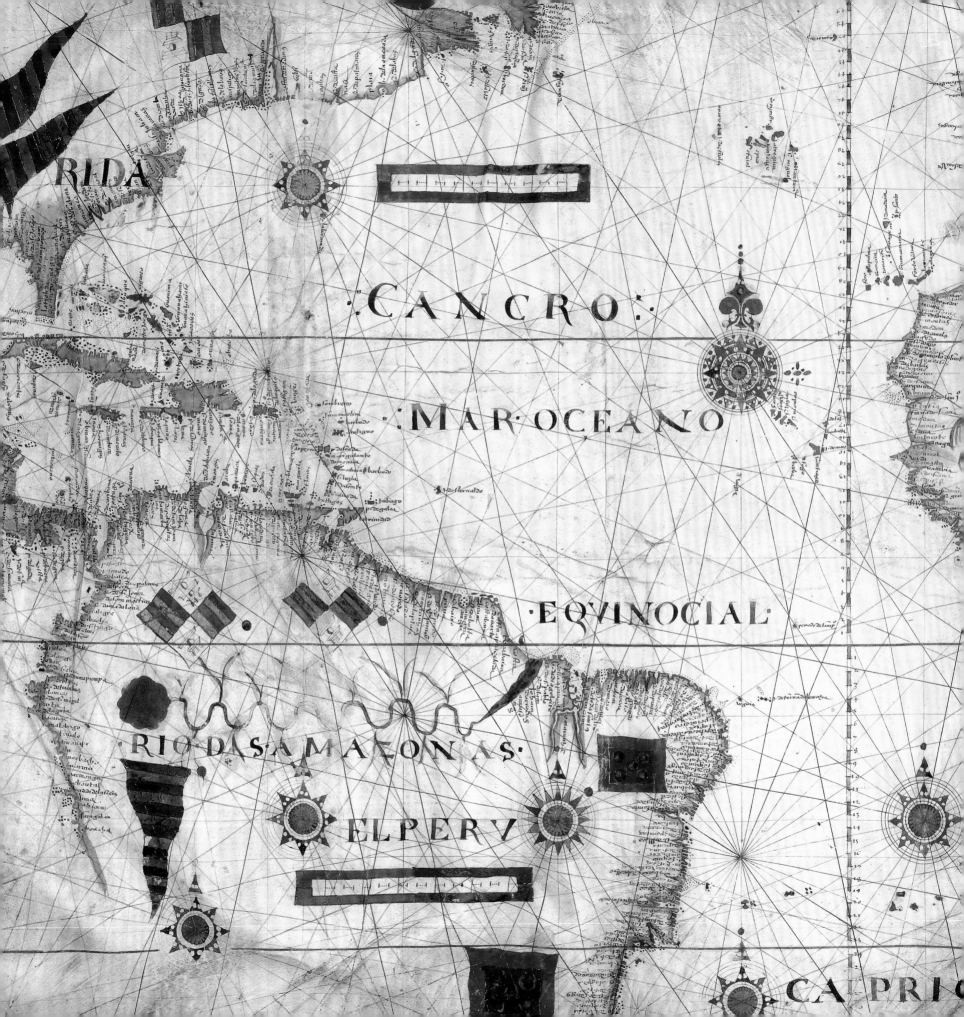

RIDA

CANCRO

MAR·OCEANO

EQVINOCIAL

RIO·DAS·AMAZONAS

EL·PERV

CA·PRI

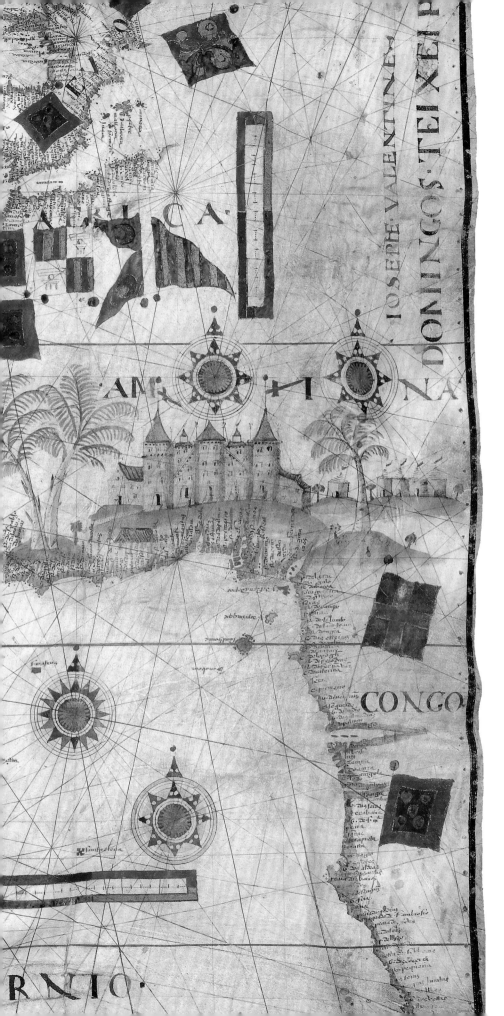

Contents

Domingos Teixeira, Portuguese portolan chart of the Atlantic showing Africa and Brazil 1570. MS. K1 (110).

Foreword

Every map has been created through many individuals and their stories: the map-maker, the traveller, the surveyor, the armchair geographer, the writer and the artist. Maps are full of tales, of the places they survey, the travellers whose reports they absorb and the changes their use bring to people's lives, places and spaces, as their application begins the cycle of mapping, discovery and change all over again. Maps and stories have always gone together; they even share the same root in English. A 'plot' can be a piece of land, the main events in a story and a map, all of which are taken from the same Middle English root, 'platen', to fold or entwine. This book, together with the exhibition at the Bodleian's Weston Library which it accompanies, is a celebration of maps, the stories they tell, the places they depict and the people that make and use them. It shows how maps are neither transparent objects of scientific communication nor baleful tools of ideology, but rather proposals about the world, seductive arguments helping people to understand who they are by describing where they are. A map begins a conversation with a community, and this volume elicits a series of dialogues with history, science, the arts, students at every level of education, and the general public.

Drawing on the unparalleled historical richness and cultural diversity of the Bodleian Libraries' map collection, this book brings together an extraordinary collection of ancient, pre-modern and contemporary maps in a range of media. The approach has been to use a key map (or in some cases a series of maps) to tell a specific story of events and individuals.

This approach highlights the various social lives of maps, and enables us to understand them in a variety of exciting and surprising ways, as: scientific objects that get us from one place to another; windows into alternative worlds; ways of reaching the afterlife; tools to manage land, nations and empires; images of environmental change; and visions of the future. This range of maps enables us to pursue the aim of educating, engaging, entertaining and enriching readers' experiences. At one level, the book provides a concise history and definition of map-making, drawing on the Libraries' collection ranging from the medieval period to today. At another level it offers a new perspective on the enduring power of maps by showing a range of 'imaginary' maps (C.S. Lewis's Narnia maps, J.R.R. Tolkien's cosmology of Middle-earth, and Grayson Perry's contemporary art maps). It also shows how we can understand the past through maps and confront the present by using them to interpret our contemporary urban landscape and the pressing global challenges of rapid environmental change.

I would like to thank our Curators for this exhibition, and the authors of this book, Professor Jerry Brotton, of Queen Mary University of London, and Nick Millea, Map Librarian in the Bodleian, for bringing together such a compelling collection of historic maps and for telling their stories in such an engaging and thought-provoking manner. With over 1.5 million maps in our collection – which grows daily – we encourage researchers from all disciplines and at all levels to come and enjoy the tales that this collection has to tell. I would especially like to thank Daniel Crouch Rare Books LLP, John and Margaret Leighfield, David and Abby Rumsey and all our other generous contributors. Without their help this exhibition would not have been possible.

Richard Ovenden, Bodley's Librarian

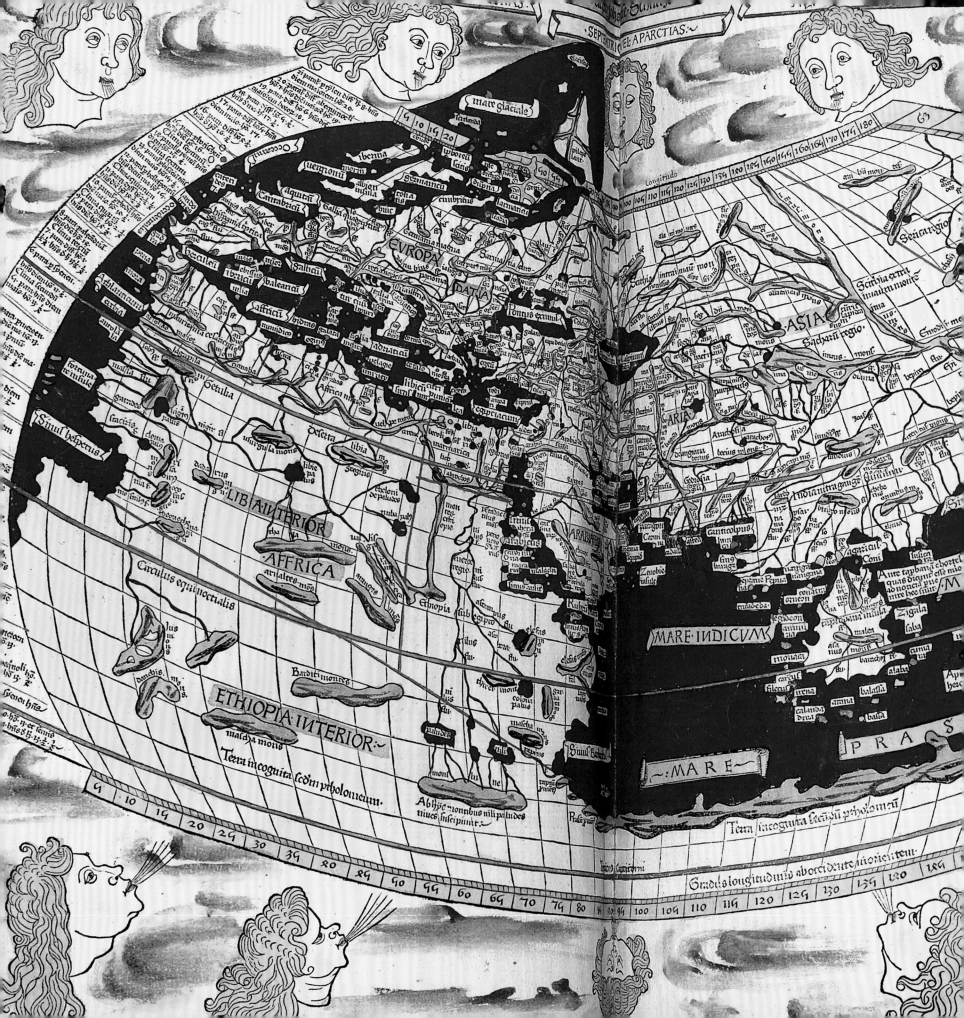

Introduction

Stories make maps. Throughout history and across different cultures, oral and written stories have been recounted to map-makers by travellers and sailors, surveyors and artists, even writers and theologians. As map-makers assimilate these narratives, they in turn create their own graphic stories about the places they represent. Stories generate more stories told by those who use maps to navigate across the land or the sea, or even through their imagination. As the spaces being mapped change over time, so do their narratives, and the cycle of mapping starts all over again. Maps are repositories of personal and collective knowledge, beliefs and memories, brought together by their unique ability to combine science with art, space with time, the visual and the written.

Talking Maps is a celebration of these multifaceted dimensions and the layers of stories, conversations and discussions that surround the creation and use of maps. It shows that any map is a communicative act between its maker and user that requires people to discuss and agree on how to use it. A map is a site and an occasion around which the stories of its users and makers coalesce in agreeing how the world around them looks. Such consensus can only be reached through debate and dialogue – in other words, by talking about and metaphorically 'listening' to maps. In what follows we question the relatively recent assumption – predominant in the modern Western world – that maps are exclusively visual, objective, scientific objects that offer a transparent spatial graphic of the worlds they represent. Instead, throughout the course of this book we tell a somewhat different story: over time and in different communities, maps have been shaped by oral and written narratives and testimonies; they are subjective reflections of their makers' beliefs and prejudices; all maps are to some extent artistic artefacts that offer multidimensional and often contradictory representations of space and place.

As its title suggests, *Talking Maps* proposes a series of conversations and discussions with and about maps. This approach revises recent critical approaches to the history of map-making. Cartography – or the science of map-making – only entered the European languages in the early nineteenth century, from which point map-making was given a scientific and objective veneer of authority, claiming there was a 'correct' and 'truthful' method of mapping the world, that saw it become a key tool in politics, commerce, empire and warfare. In the late twentieth century geographers and historians reacted to this development by criticizing how maps had become instruments of ideology in the service of states and governments. Maps such as those produced by European nations and colonies 'spoke' the graphic language of power and authority. These were not 'talking' maps that proposed a conversation or discussion about what they depicted, but univocal maps expressing command and demanding acquiescence.

This approach proved a powerful corrective to the prevailing assumption that maps were a transparent representation of the world, and it is part of the story we tell in *Talking Maps*. However, such a belief also went too far in assuming that such maps – and their makers – were baleful conspirators in implementing political ideologies. It also failed to take into account how communities received, responded to and acted on maps. Any map's message can be misunderstood or appropriated and used in support of a contrary or alternative belief. Later nineteenth-century thematic maps could show the distribution of poverty in Victorian London in an attempt to disprove its increase, yet ended up inspiring policy reform on social benefits. In contrast, maps commissioned by liberal reformers depicting the presence of Jewish communities in the city's East End were appropriated by right-wing political groups to justify

Fig. 1 World map in Claudius Ptolemy, *Geographia*, woodcut, 1486. Arch. B b.19, fol. Map 1.

their anti-Semitic beliefs. These competing stories – some arguably positive, others negative – suggest that maps are invariably proposals about the world they depict. They offer a graphic story about what they represent, but it is up to those who see and use the map to give it credence by agreeing to accept what it shows. It is these cartographic proposals and stories that concern us in *Talking Maps*.

The stories we tell throughout the course of a book that gives equal weight to words and images are *graphic* in the strict sense of the word's origins. The Greek *graphē* is defined as both drawing *and* writing, and many (though by no means all) maps are of course a compound of word and image. In depicting how events occur across space and time, a map can function very much like a story. Many of its synonyms in European languages reflect this close connection between maps and stories. A 'chart' takes its name from the Greek *khártēs*, to inscribe, while a 'plot' is also common to both fiction and cartography. A plot is the plan or main events in a literary work, yet archaic usages also define it as a ground plan, nautical chart or map. Like fiction, maps entwine descriptions of spaces that are transformed into *places* imbued with meanings, memories, plans, journeys and *stories*.

Over time cultures have taken different views on the role of stories within their maps. A strand of European map-making has always regarded oral testimony with suspicion, an attitude that can be traced back to its Greco-Roman foundations. The most influential text of all from the classical period was Claudius Ptolemy's *Geography* (*c.*150 CE). The *Geography* (fig. 1) was a geographical gazetteer listing over 8,000 places in the Hellenic world and describing two map projections for representing the globe on a plane surface based on Euclidean geometry. Working in what remained of the fabled ancient Library of Alexandria, Ptolemy summarized a millennium of Greco-Roman science, philosophy, astronomy, travellers' tales and mythological stories to create the most comprehensive account of map-making known to the late classical world.

In his quest for absolute geographical knowledge, Ptolemy viewed with suspicion the noisy 'chatter' of travellers' reports required to compile his data. In his introduction he pointed out that 'it is necessary to follow in general the latest reports that we possess, while being on guard for what is and is not plausible'.[1] His book drew on innumerable earlier geographical treatises, Roman *itinerarium* (road maps) and *periplois* (lists of ports and coastlines). But Ptolemy was clearly conscious of the dangers of *akoē* – 'something that is heard', a rumour or hearsay – what we might today call a traveller's 'tall tales', exaggerating their experiences of far-flung places and people. The maps drawn over the next millennium based on his treatise were primarily geometrical, throwing a graticule (a network of meridians and parallels) across the earth. There are no mythical places or monsters on Ptolemy's maps, just a silent, mathematical precision that preferred abstract geometry to the rich but unreliable 'noise' of travellers' conversations. The irony here is that when Ptolemy's text was adopted by Renaissance scholars in the fifteenth century it generated yet more stories. Ptolemy had underestimated the earth's circumference by 18%, or 10,000 kilometres. The voyages of Christopher Columbus (1492–1502) and Ferdinand Magellan (1519–22) involved sailing westwards in search of Asia based on Ptolemy's inaccurate calculations, a decision that generated its own momentous stories of exploration and discovery.

Much of the subsequent history of cartography has exemplified the paradox in Ptolemy's *Geography*, oscillating between the exactitude of geometry and the noisy exuberance of the stories that provide its raw material. Yet ensuing cartographic traditions turned their back on mathematics and embraced narrative. Theological maps invariably privilege stories and places over geometry and space. Medieval Christian maps – *mappae mundi* – teem with biblical stories to such an extent that they can be 'read' vertically as a temporal graphic, with Creation at their apex and Christ's crucifixion in Jerusalem at the centre. As we will see, Muslim, Buddhist and Jain maps of their cosmologies all offer similar graphic stories on their own spiritual terms. Writers have been

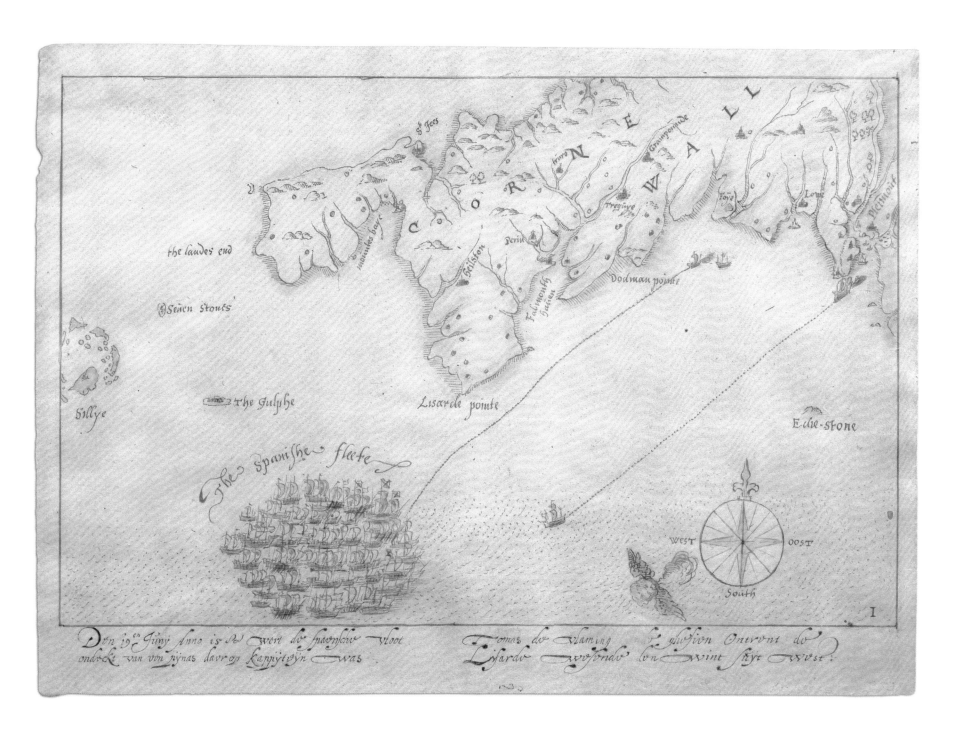

Fig. 2 The sighting of the Spanish Armada off the Lizard, 29 July 1588. The Astor Armada Drawings, ink on watercolour, late 16th–early 17th century.

inevitably drawn to maps as plots enabling them to give shape and definition to their fictional worlds, as both chart the unfolding of temporal events through space. Similarly, artists have shadowed map-making for its ability to create a realistic representation of the world, and to offer graphic visualizations of imagined spaces like heaven, hell, paradise and utopia.

Statesmen, soldiers and sailors have also found maps crucial to telling stories in the form of news about land and sea battles, whether celebrating a victory or downplaying defeat. A series of drawings, engravings and tapestries of the defeat of the Spanish Armada in July–August 1588 are a stunning case in point of the messages maps can convey so much quicker and more powerfully than written documents. Immediately after the English victory a series of charts was commissioned to disseminate news across England and Europe. They show the progress of the Spanish Armada in its dramatic defeat by the English fleet between 29 July and 8 August 1588 (figs 2 and 3). They begin with the first sighting of the Armada off Lizard Point in Cornwall on 29 July, then recount each skirmish and battle with the English fleet up the English Channel over the following eleven days, culminating in the English fireship attack off Calais on 7 August and the battle of Gravelines the next day which finally scattered the remains of the Spanish navy.

Each chart is drawn with painstaking attention to fleet size and battle formation, with coasts and orientation only relevant to the movement of the fleet and their encounters, which are told sequentially like a cartoon. Everything down to individual vessels, cannon fire, flotsam and sinking ships generated by each naval engagement is chronicled in painstaking detail. They recount a cartographic story from beginning to end, one designed to circulate news of the victory across England and Europe. These are vivid, immediate, 'of the moment' artefacts. They were disseminated as engravings, manuscripts and even woven tapestry. The story they tell in such powerful graphic form is the victory of plucky little England against the imperial might of Spain. They represent the Elizabethan authorities getting their story out about the survival of the

English nation and one of its greatest naval victories at a critical moment in its history.

The Armada maps were clearly never intended for navigational purposes and as such are not technically sea charts. Should they even be described as maps? Our ability to embrace such diverse visual materials and mapping traditions alongside the stories they tell is partly due to changes in the way we define and understand a map. Most cartographic historians now accept the definition of a map provided in the multi-volume *History of Cartography*, first published under the editorship of J.B. Harley and David Woodward, who argued in 1987 that 'maps are graphic representations that facilitate a spatial understanding of things, concepts, conditions, processes, or events in the human world'.[2] This definition has enabled scholars to categorize graphic artefacts like the Armada Drawings that were previously unclassifiable as maps, and in the process tell new stories about their content and meaning.

One such example is an object attributed to the semi-nomadic Chukchi people living on the Asiatic side of Siberia's Bering Strait, dated to the late 1860s or 1870s (fig. 4). Painted on a bleached sealskin (*mandarka*), this artefact has been variously described as a painting, a drawing and a pictograph. Based on Harley and Woodward's definition, we can now see it as a map, albeit one that stands outside the modern, Western cartographic tradition. The Chukchi lived by fishing, hunting and trading the skins of Arctic animals such as whales, seals and walruses, and by the late nineteenth century were engaged in trade with Western whaling companies, one of which acquired this map, which subsequently entered the Pitt Rivers Museum's collection in Oxford.

Although it lacks a prime orientation, the map teems with sacred and profane graphic stories of Chukchi beliefs and everyday life, as well as their encounter with the outside world. It appears to be cosmological and calendrical in the images at its centre. The black disc in the middle represents night, the one to the right day, suggesting the map may depict

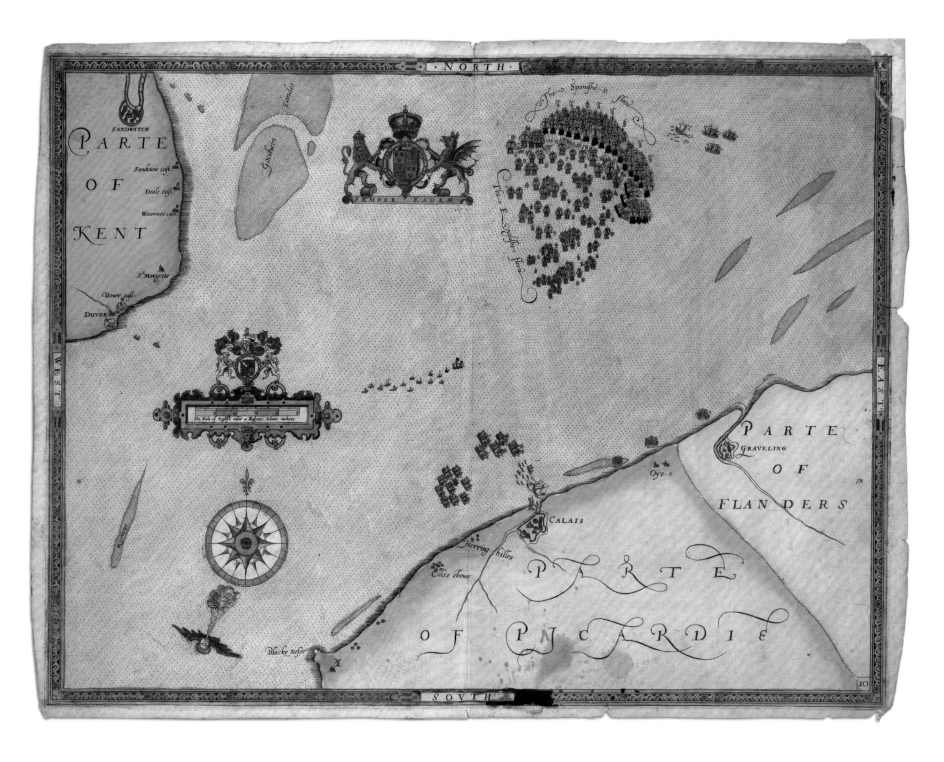

Fig. 3 Robert Adams, 'The Battle of Gravelines, 8 August 1588', engraving
in *Expeditionis Hispanorum in Angliam vera descriptio* (London, 1590).
Library of Congress, Washington, DC.

a year in the everyday life of the Chukchi. To the right of the black sun a rectangle contains two figures with outspread hands, suggesting some form of shamanistic ritual. As we move further outwards the map represents more quotidian scenes of the Chukchi's dwellings, tent-like structures known as *yaranga* shown at centre left, their *kaiaks* and *umiaks* (or skin boats), two of which are drawn to the right of centre, herds of reindeer on the far right, and various graphic scenes of whale, bear and seal hunting (with each weapon and kind of animal precisely differentiated).[3]

As well as its cosmological and cultural preoccupations, the map depicts the coastline of Chukchi territory, although, in keeping with a peninsula that is ever-changing because of its environmental extreme, the cartographic line between land and sea is extremely porous. The lobe of land jutting out at bottom left is St Lawrence Bay, below it Mechigmensky Bay, with the adjoining settlement at the map's very bottom of Unaziq on Cape Chaplin. Bottom right is Plover Bay, with a three-masted European whaler riding at anchor as Chukchi dog teams and merchants approach it to trade (presumably in furs and the kind of skin from which the map is made).[4] At top right is Port Clarence, with the Seaward Peninsula at the top and Kotzebue Sound top left. The map is a graphic embodiment of Chukchi life, embracing its apparently timeless rhythms of hunting, fishing and settlement, as well as how this society was beginning to change in its encounters and exchanges with the Western world.

Many of the stories embedded within the Chukchi map may remain lost to a wider audience, especially as the influence of Russia has gradually eroded its people's language, rituals and beliefs. But perhaps in highlighting the role that maps play in talking about their cultures' stories, we can generate further research into cartography both within and beyond Western cultures and societies. The stories we tell in what follows are trans-historical and global: they range from Tibetan and Jain charts of the cosmos to Mesoamerican maps of ideal cities. Based on our own specialisms and the Bodleian's collection, our focus is often European, even English, as we tell the stories of how countries, cities and the land have been mapped, administered and fought over throughout time. Yet we also offer a more global narrative of how the sea has been mapped in the act of connecting different cultures, why mapping sacred topographies helped various religions understand themselves, how the cartographic methods adopted by writers often define their stories, and the ways in which orientation has acted as a basis from which many societies narrate their very existence. We conclude with perhaps the biggest story in the recent evolution of maps. The digital online revolution has rebranded maps as 'geospatial applications', ubiquitous tools used by virtually everyone with online access. The world is always moving and changing, and with this change come new maps that will always transcend their medium – be it rock, paper or computerized screens – and which will always offer us different arguments and proposals about the world in which we live. With the recent advent of GPS Voice Navigation, maps really can talk to us. The conversation is only just beginning.

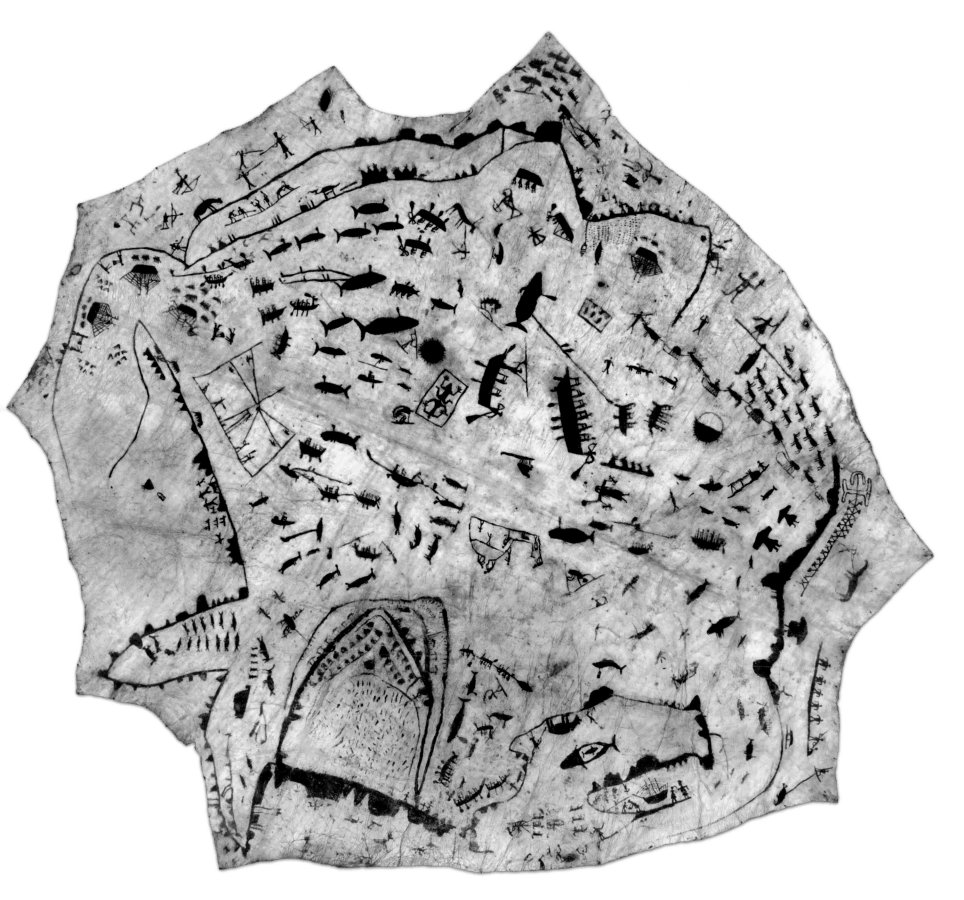

Fig. 4 Chukchi sealskin map, c.1860. Pitt Rivers Museum 1966.19.1.

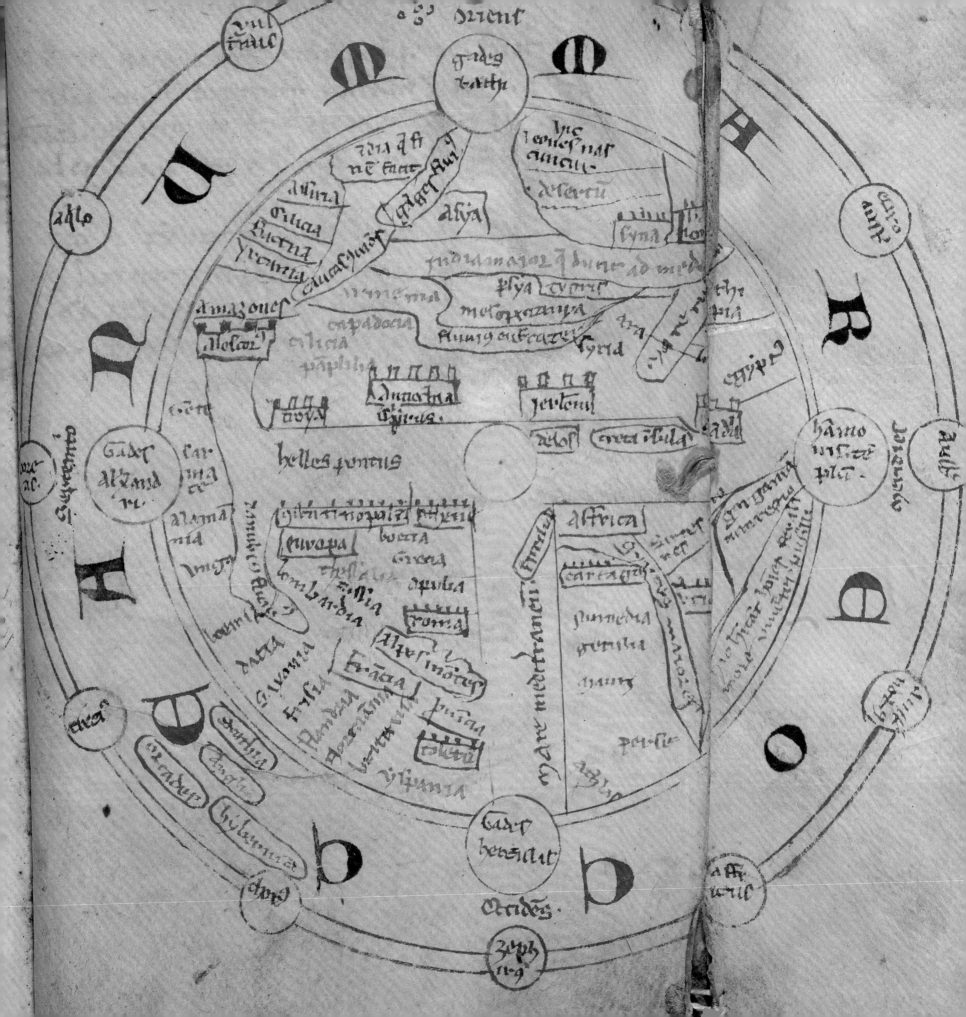

1

Orientation

Where would we be without a map? The obvious answer is that we would be lost and 'disoriented'. What most of us require from a map is *orientation*, the position or direction of a place or thing, usually relative to the four cardinal compass points of north, south, east and west. This allows us to see where we are on a map, and as a consequence to get from one point to another across its surface. This for many of us is the primary function of a modern map. Yet its chosen orientation is never neutral. The map-maker's choice to orient the map with one of the cardinal directions at the top is never an objective decision. It is always influenced by social and cultural factors that will in turn affect the beliefs and prejudices of its users.

The verb 'to orient' is derived from the Latin root *oriens*, referring to the direction of the rising sun, or the east, when observed from Europe and the Mediterranean. Many pre-modern cultures oriented themselves by observing the rising (eastern) and setting (western) sun. But over time in the modern Anglo-American world the terms 'orient' and 'east' took on more loaded social significance and were ascribed negative connotations in contrast to the 'occident' and the 'west'. In the 'Western' intellectual tradition the East has often been characterized as 'barbaric' and 'irrational', in direct opposition to the 'civilized' and 'humane' values of the West.[1] The north and south have also been associated with certain social and political assumptions, depending on where you live. In southern England, 'the north' can conjure up stereotypes of blunt, dour and poor people living in a bleak industrial wasteland, while in contrast the 'southern' states of the United States might be associated with uneducated,

conservative and insular communities. Internationally the political and economic language of development speaks of the 'global north–south divide', with the 'developed' global north represented by the United States, Canada, Europe, parts of Asia, Australia and New Zealand, and the 'developing' south composed of Africa, Latin America and the rest of Asia.

How did these apparently innocent cardinal directions come to exert such a powerful hold over people's political imaginations? To answer the question this chapter concentrates in particular on the medieval and early modern periods, when changes in cardinal directions on maps were at their most pronounced and various. We also have to begin by going back to prehistoric times, and the stories of distinctions between north and south and especially east and west that can still be discerned through the help of academic fields beyond cartographic history, such as archaeology and anthropology. Humanity has always made some attempt to understand itself in relation to a wider world in maps of its surroundings, in a practice that psychologists refer to as 'cognitive mapping'.

From Classical to Christian

Archaeologists have found evidence of rudimentary cartographic petroglyphs (rock carvings) from the Upper Paleolithic period (40,000–10,000 BCE), demarcating small areas for hunting, gathering and primitive settlement. As these communities began to create urban centres and sacred systems of belief, the cardinal directions defined by the rising (eastern) and setting (western) position of the

Fig. 5 World map in Honorius Augustodunensis, *Imago mundi*, 14th century. MS. E Mus. 223, fol. 185r.

sun took on symbolic as well as geographical associations. Although hardly any world maps survive prior to the Greco-Roman world, the sacred texts of early polytheistic societies tell a story of how various cultures regarded each direction. Many revered the east as the direction from which life came, in contrast to the west which was associated with death and the setting sun; indeed hardly any communities privilege the west as a prime direction (hence the expression 'go west', meaning to die, as a figurative expression of the end of light and life). North was also celebrated by ancient Mesopotamian societies as the source of light based on the Pole Star. Chinese cosmology also revered the north but for very different reasons: 'north' is synonymous with 'back', and this is the direction the ancient emperors faced during imperial audiences, looking southwards. His subjects therefore looked 'up', or northwards, hence the orientation of most early Chinese maps with north at the top.[2]

Early Judeo-Christian belief inherited the east as the sacred direction of monotheistic prayer. In the Old Testament Ezekiel announced that 'the glory of the God of Israel came from the way of the east: and his voice was like a noise of many waters: and the earth shined with his glory' (Ezekiel 43: 2). As in Chinese, the etymological link with prime direction is telling: the Hebrew for 'east' means 'front', while 'west' means 'back'. As Jerusalem became the cardinal point of orientation in early Christianity, so the north took on unfavourable pagan associations, as described in Ezekiel: 'the spirit lifted me up between the earth and the heaven, and brought me in the visions of God to Jerusalem, to the door of the inner gate that looketh toward the north; where was the seat of the image of jealousy' (Ezekiel 8: 3).

Despite the rich variety of written traditions privileging one direction over another, very few come with surviving cartographic examples. Even maps that survive from the Greco-Roman world give little tangible evidence of views on their preferred cardinal direction. However, one map that has survived from the fourteenth century and is held in the Bodleian tells a fascinating story of the shift from classical to Christian orientation (fig. 5). It can be found in the pages of a book by Honorius Augustodunensis called *Imago mundi*, a popular medieval encyclopedia describing cosmology, theology and world history. On fol. 185 of the book is an exquisitely drawn manuscript map of the world measuring just 150 millimetres in diameter. It shows the world encircled by an ocean, 'MARE OCEANUM', oriented with east at the top, 'EUROPA' bottom left and 'AFFRICA' bottom right. The Mediterranean is shown running vertically down the middle of the map. The 'T' shape this creates reproduces a classical cartographic model of what is known as a 'T-O' map. In these maps the world is usually oriented with east at the top and divided by three waterways making up the 'T': the Russian river Don to the left dividing Europe and Asia, and the Nile to the right dividing Europe and Africa.

An earlier twelfth-century map from the Bodleian collection illustrating the Roman historian Sallust (86–34 BCE) shows the simplest T-O outline, featuring classical cities like Rome and Carthage (fig. 6). The map in the *Imago mundi* elaborates on this classical outline, showing similar classical locations as well as Christian sites like Jerusalem. Its most fascinating feature is that the Christian map-maker has used a compass-drawn circle to mark the middle of the map as the Cyclades, with Delos at its dead centre. Delos was one of the most revered sites in Greek mythology, with a sanctuary commemorating it as the birthplace of Apollo. Its position on the map shows how early Christian map-makers deferred to the classical past while trying to reorient their maps to accommodate a more biblical perspective. In line with this move, subsequent Christian world maps would shift their centre to Jerusalem and often place the Earthly Paradise explicitly at the top of the map, with the world embodied as Christ (see for example fig. 60). The story they told in the space of their maps was a temporal biblical one, starting with the Creation at the top of the map and, moving down it, depicting the stories of the Old then the New Testament, all centred on Jerusalem as the site of Christ's crucifixion. Yet what remained relatively constant in all these maps was east as a cardinal direction.

Fig. 6 Basic T-O map in Sallust, *Jugurtha*.
MS. Rawl. G. 43, fol. 56v.

roma

europa

cartago

ca ra bath mon

numidia

africa

ciron

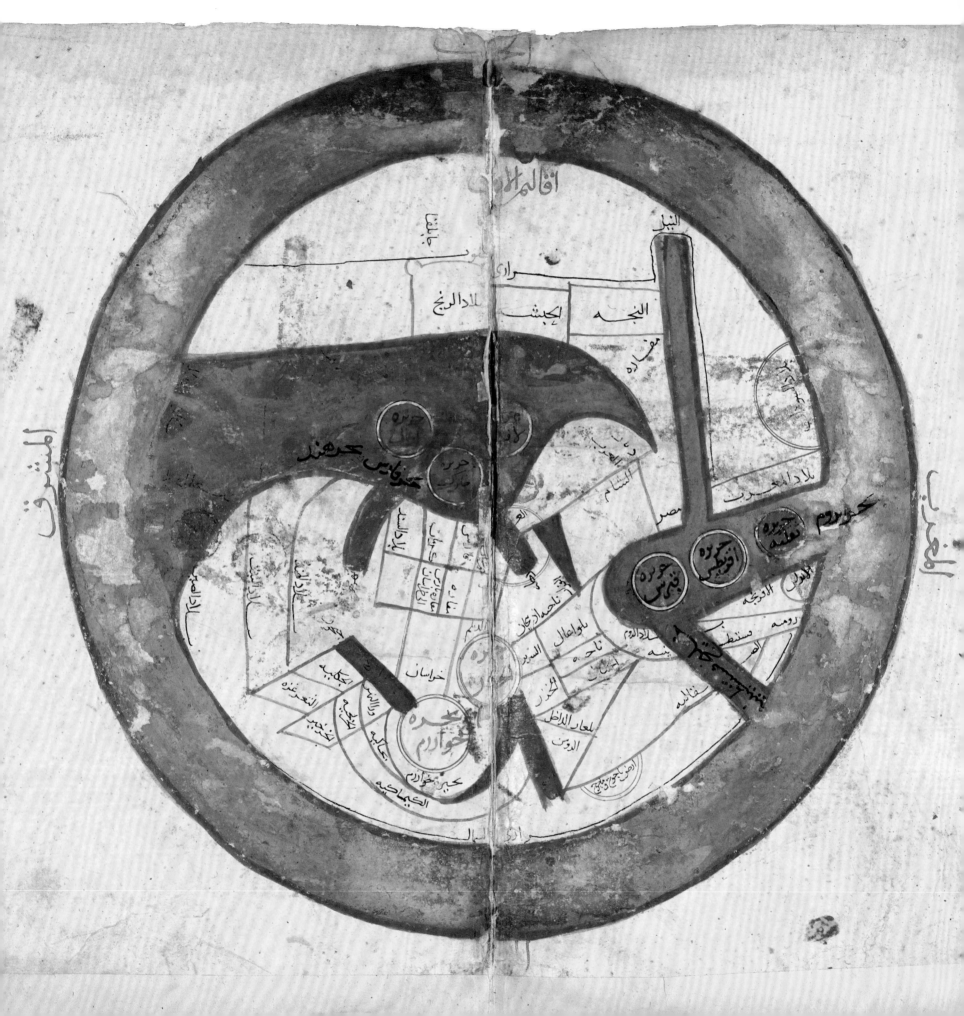

Islamic Maps

While medieval Christian map-makers were establishing east as their prime orientation, Muslim geographers pursued a very different direction.[3] By the tenth century Islamic map-making flourished under the Abbasid caliphate centred on Baghdad. Map-makers across the empire worked in two main cartographic genres. The first were books often entitled *Kitāb ṣurat al-arḍ* ('Picture of the Earth'), which were more theoretical reflections on world mapping that drew on the Greek tradition (whose scientific texts were widely translated in Baghdad at this time). The other was the more practical *Kitāb al-masālik wa-al-mamālik* ('Book of Routes and Provinces'), concerned with trade, pilgrimage and the administration of the rapidly expanding Islamic empire. This second tradition is represented by a relatively unknown map-maker, Muhammad al-Iṣṭakhrī, active in the late tenth century. The Bodleian owns a beautiful Persian copy of al-Iṣṭakhrī's world map dated 1297, painted with gouache and ink on paper (fig. 7). Like the *Imago mundi* map, al-Iṣṭakhrī's is surrounded by an encircling ocean, but the landmass in the central circle is oriented with south at the top. Africa is shown as a large claw extending deep into the Indian Ocean at top left. The vertical bar running from top right downwards is the Nile, flowing into the Mediterranean in which float three red circular islands: Cyprus, Crete and Sicily. The triangle below them represents Europe, with Muslim Spain (*al-Andalus*) labelled at its apex. The map's richest detail lies at the heart of the Muslim empire, whose various administrative districts are neatly demarcated in red. The Indian Ocean contains three red islands, Awal, Harak and Lafit, and towards the bottom (north) of the map the Caspian and Aral seas are shown as two uncoloured circles.

As with their medieval Christian counterparts, Muslim maps like the copy of al-Iṣṭakhrī's are primarily defined by theology: Arabia sits at the heart of the map with the holy sites of Mecca and Medina. But whereas Christian maps are shaped for specific theological reasons with east at the top, many surviving Islamic world maps have south at the top.

None of the accompanying texts explain why this should be, although two reasons seem to have influenced the decision. The first is that most early Muslim imperial conquests lay directly north of Mecca, in areas populated by Zoroastrians, among whom south was revered as the cardinal direction. Thus, both the assimilation of Zoroastrian belief and an understanding of the direction of prayer, or *qibla*, led Muslim map-makers to place Mecca to the south, or top, of the map (in many Muslim lands *qibla* is synonymous with south).

The Bodleian holds at least two other remarkable medieval maps which tell a similar story of how south was established as the cardinal direction in Islamic belief. The first is an anonymous cosmographical treatise originally compiled under the Fatimid dynasty in Egypt between 1020 and 1050, and which survives in this late twelfth- or early thirteenth-century copy. It is entitled *The Book of Curiosities of the Sciences and Marvels for the Eyes*.[4] This manuscript and its seventeen maps is discussed in more detail in chapter 5, but for the purposes of this chapter it is sufficient to illustrate its circular world map, also oriented with south at the top and the Arabian Peninsula at its centre (fig. 8). However, the increase in geographical detail in contrast to the rigid geometry of al-Iṣṭakhrī's map is striking. Africa is massively extended, including an elaborate depiction of the 'Mountains of the Moon', or source of the Nile, looking like a jellyfish in the upper right-hand corner. Asia and the Mediterranean islands are given far more geographical definition, as is Europe, with even England ('Inqiltirrah') being labelled. Such extensive detail suggests that the Egyptian author of the book was drawing on the scientific treatises available to al-Iṣṭakhrī, but supplementing them with maritime knowledge of the Mediterranean, North Africa and Europe from his vantage point in Egypt, a commercial hub for the movement of goods (as well as ideas) from east to west.

The Bodleian holds another book of medieval maps drawn by a Muslim geographer working in a very different part of the Mediterranean, this one dated to the mid-twelfth century (fig. 9). Al-Sharīf al-Idrīsī's geographical

Fig. 7 Copy of al-Iṣṭakhrī, world map, 1297.
MS. Ouseley 373, fols 3b–4a.

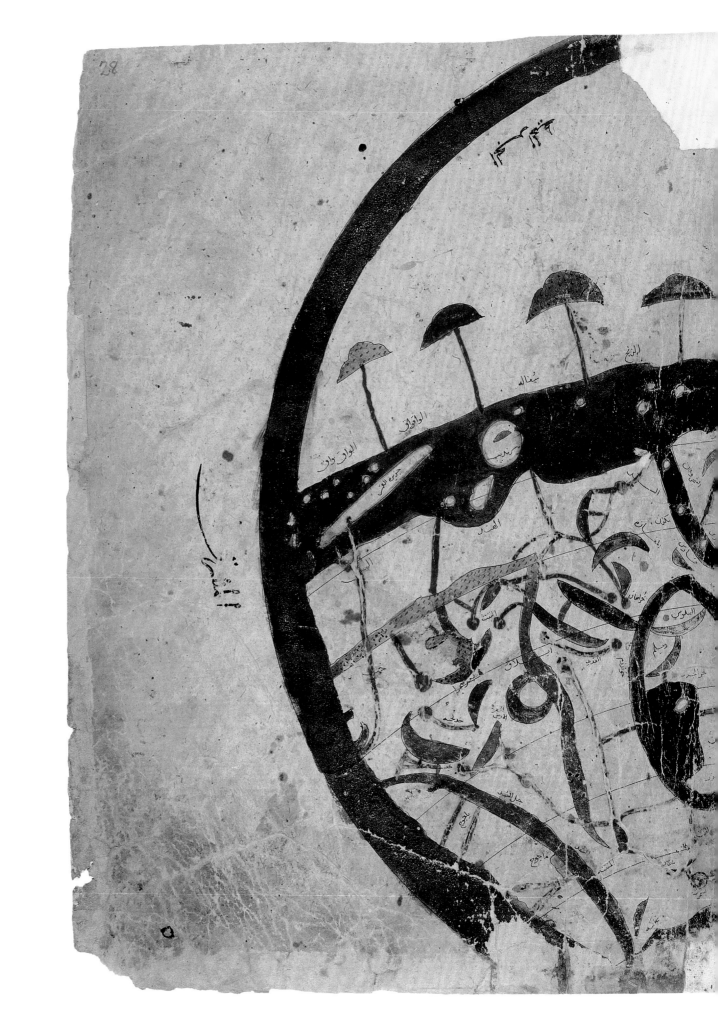

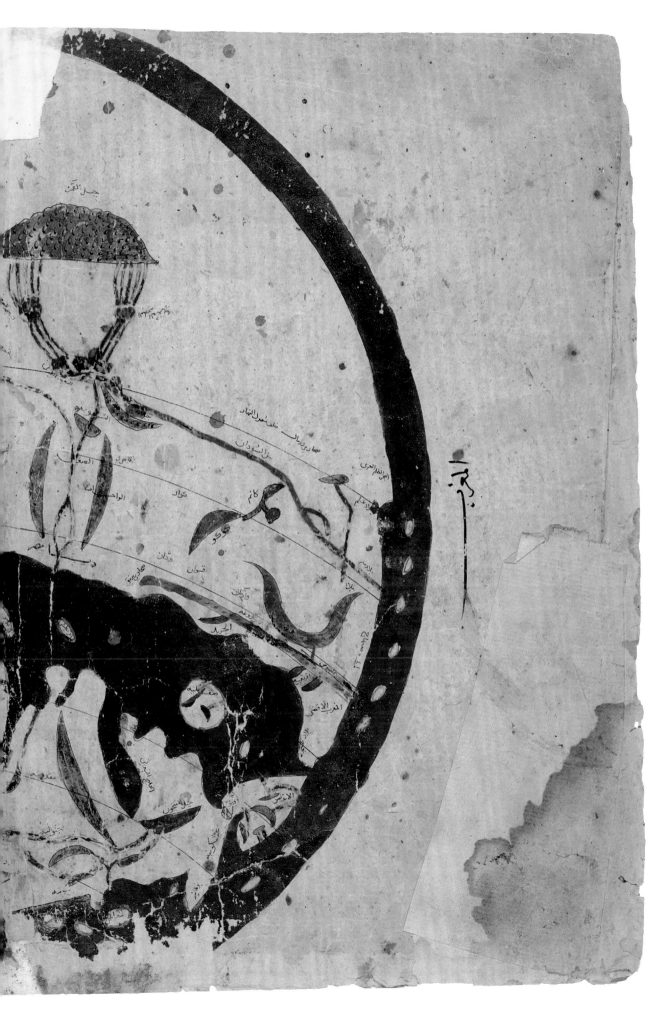

Fig. 8 Circular world map from the *Book of Curiosities*, late 12th–early 13th century. MS. Arab. c. 90, fols 27b–28a.

compendium entitled the *Entertainment for He who Longs to Travel the World* was completed in 1154 on the island of Sicily for its Norman ruler, King Roger II. The book and its maps tell a very different story from the traditional one of antagonism or incomprehension between Muslims and Christians. It is the creation of a Muslim map-maker working for a northern European Christian patron, ruling over a Mediterranean kingdom poised at the confluence of a range of competing cultural and theological traditions. This allowed al-Idrīsī to draw for his inspiration on Greek, Christian and Islamic geographical sources to produce one of the great works of medieval geography, and arguably the most comprehensive to be written since classical times.

The Bodleian holds two surviving manuscripts of the *Entertainment*, one copied in Cairo in 1456 (presumably from the lost original) and the other undated but believed to have been made in the late sixteenth century. The earlier, complete manuscript runs to 352 pages with sixty-nine regional maps (one is missing) plus a world map. The text provides a comprehensive account of the known world from the equator in the south to Scandinavia in the north, and the western Atlantic to the west and South-East Asia in the east. Interspersed among the text are the sixty-nine regional maps arranged according to seven climatic zones (a geographical concept inherited from the Greek *klimata*, meaning 'slope' or 'incline'). In his preface to the book al-Idrīsī explained the reason for this division and how he believed the accompanying maps enhanced geographical understanding:

> And we have entered in each division what belonged to it of towns, districts, and regions so that he who looked at it could observe what would normally be hidden from his eyes or would not normally reach his understanding or would not be able to reach himself because of the impossible nature of the route and the differing nature of the peoples. Thus, he can correct this information by looking at it. So the total number of these sectional maps is seventy, not

> counting the two extreme limits in two directions, one being the southern limit of human habitation caused by the excessive heat and lack of water and the other the northern limit of human habitation caused by excessive cold.[5]

Al-Idrīsī's seven longitudinal climates ran from east to west, starting in equatorial Africa and running all the way to modern-day Korea. The seventh and final one ran from Scandinavia to Siberia.

The book's seventy maps accompanying al-Idrīsī's regional descriptions are all oriented with south at the top, just like the book's world map, which as with the Islamic examples discussed so far is centred on the Arabian Peninsula with south as the cardinal direction. The seventy regional maps were never meant to be united in al-Idrīsī's time, but the Bodleian Library recently commissioned Factum Arte, a digital arts workshop based in Madrid, to produce high-resolution scans of each map and digitally stitch them together to create a huge world map. Like the smaller accompanying world map, this composite map is oriented with south at the top, but its level of detail is quite astonishing. It tells a remarkable story of the extent of geographical knowledge in the twelfth-century Mediterranean, drawing on a Muslim tradition of orienting the world southwards, the Greek conception of the Mediterranean and the Christian understanding of Europe. What is also noticeable about this map is that it is almost completely free of religious influences. Although it is centred on the Arabian Peninsula, Muslim and Christian holy sites are simply marked but given no theological significance. Quite how it was used or even how it circulated in copies (if at all) remains unknown. All we know from the preface to al-Idrīsī's *Entertainment* is that Roger II commissioned the map because he:

> wished that he should accurately know the details of his land and master them with a definite knowledge, and that he should know the boundaries and the

Fig. 9 Al-Sharīf al-Idrīsī, circular world map, mid-12th century. MS. Pococke 375, fols 3b–4a.

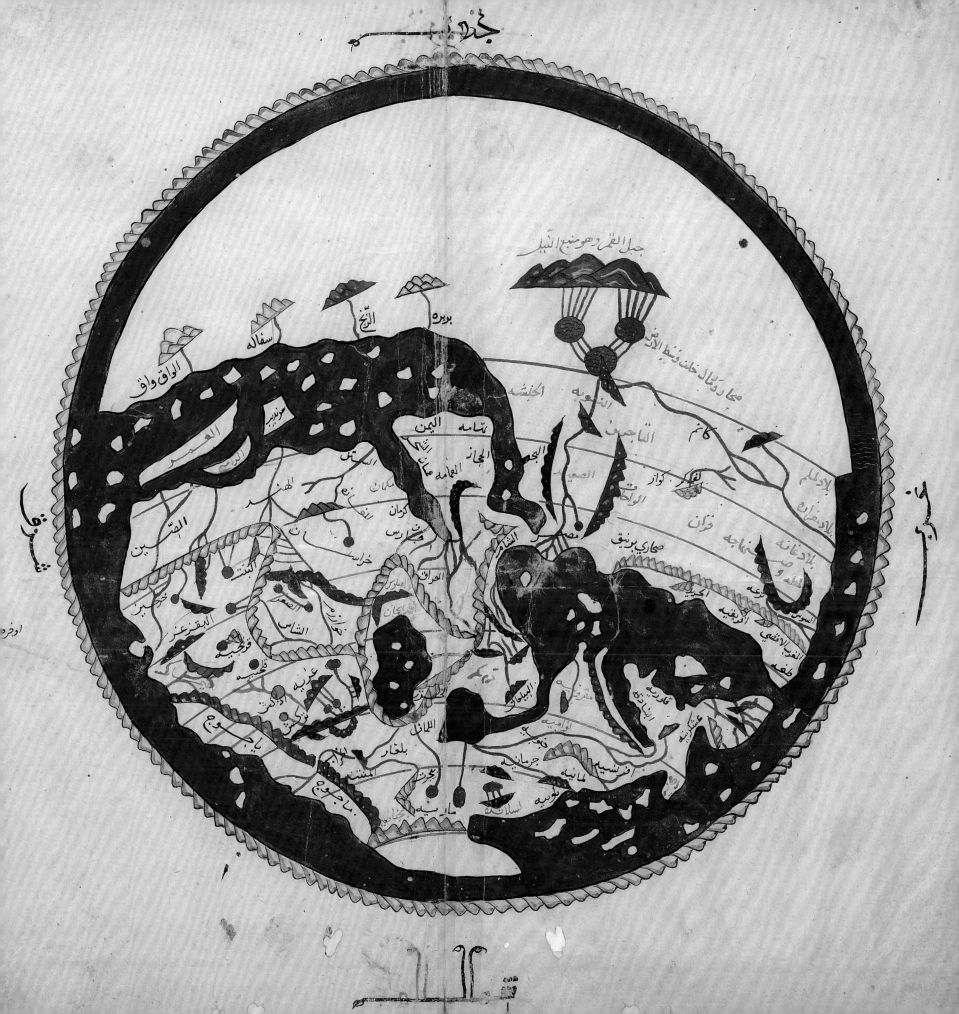

مالطة

عودش

بمريسه

كنكب

كنه

عوص

جنبره

كنبياده

كركمه

الشاقه

نادر

سكنه

نوطس

باقي

سرقوسه

لنتني

بح

طرس

جبل النار

حرت صقليه

فاروينه

بلعدوي

موسه

مادكوا

ماص

بطس

مببصر

جبل النار

كشنه

ديو

من قلورية

براص

انتربكه

بخيطس

اسركله

منزه

دندمه

فليطمه

الرهب

اليابسه

كوني

بوطين

قبره

القيطيه

مشتبيله

سردانيه

مالميره

هولانس

برشلونه

ابونه

من ارض عشكوبينه

قمرقشونه

جزيره

دمشكونه

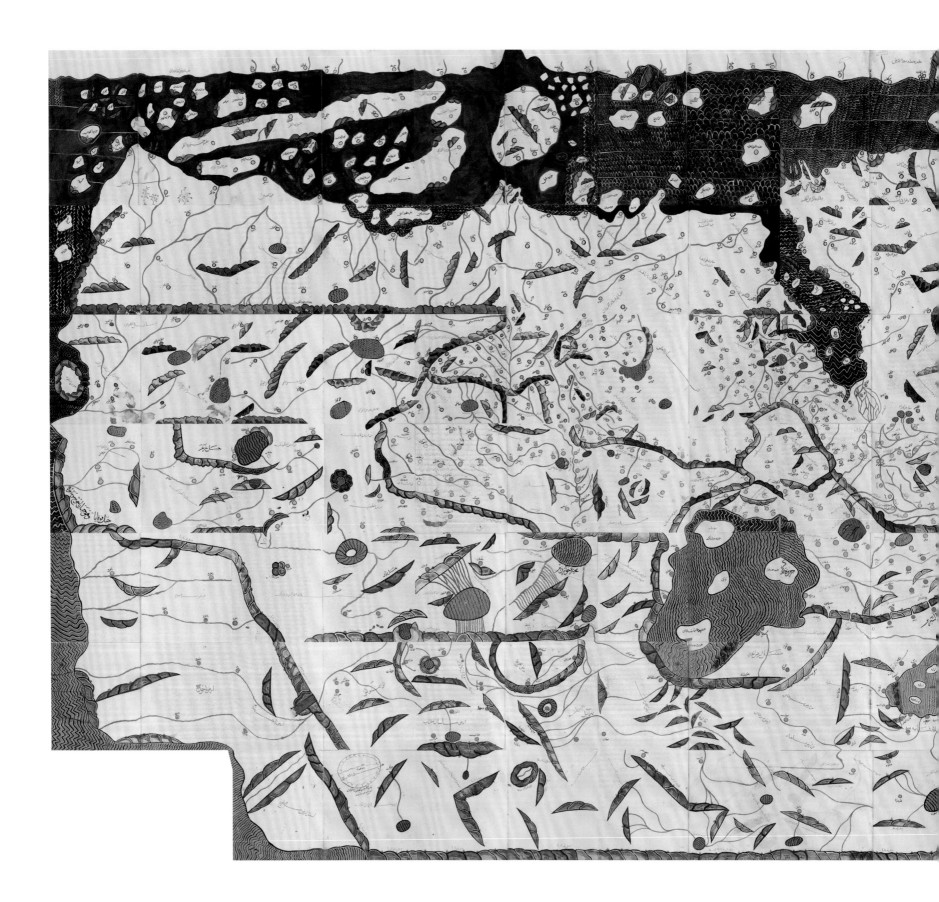

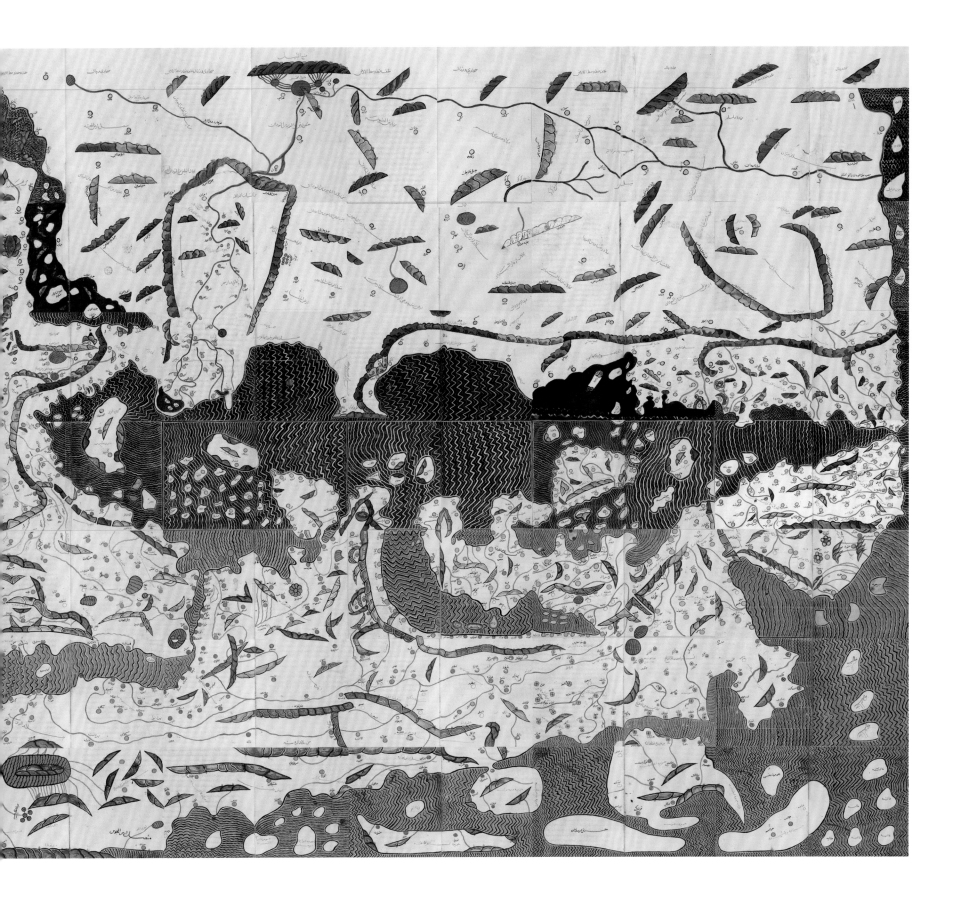

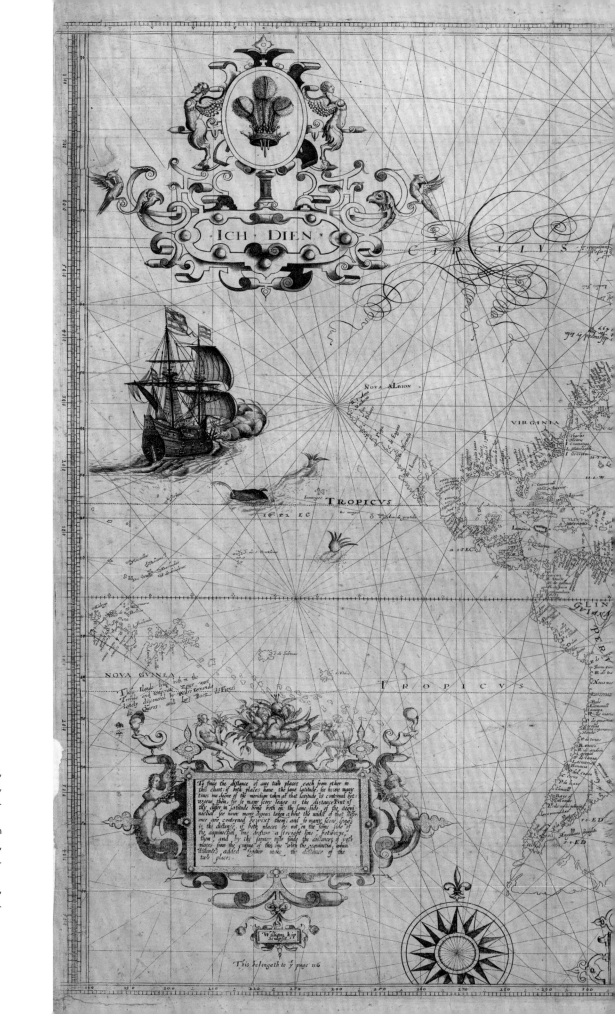

pp. 26–27 Fig. 10 Map of Sicily, from Al-Sharīf al-Idrīsī, *Entertainment for He who Longs to Travel the World*, mid-12th century. MS. Pococke 375, fols 187b–188a.

pp. 28–29 Fig. 11 The seventy regional maps from Al-Sharīf al-Idrīsī, *Entertainment*, Factum Arte composite digital scan.

right Fig. 12 Edward Wright, chart of the world, 1599. (E) B1 (1047).

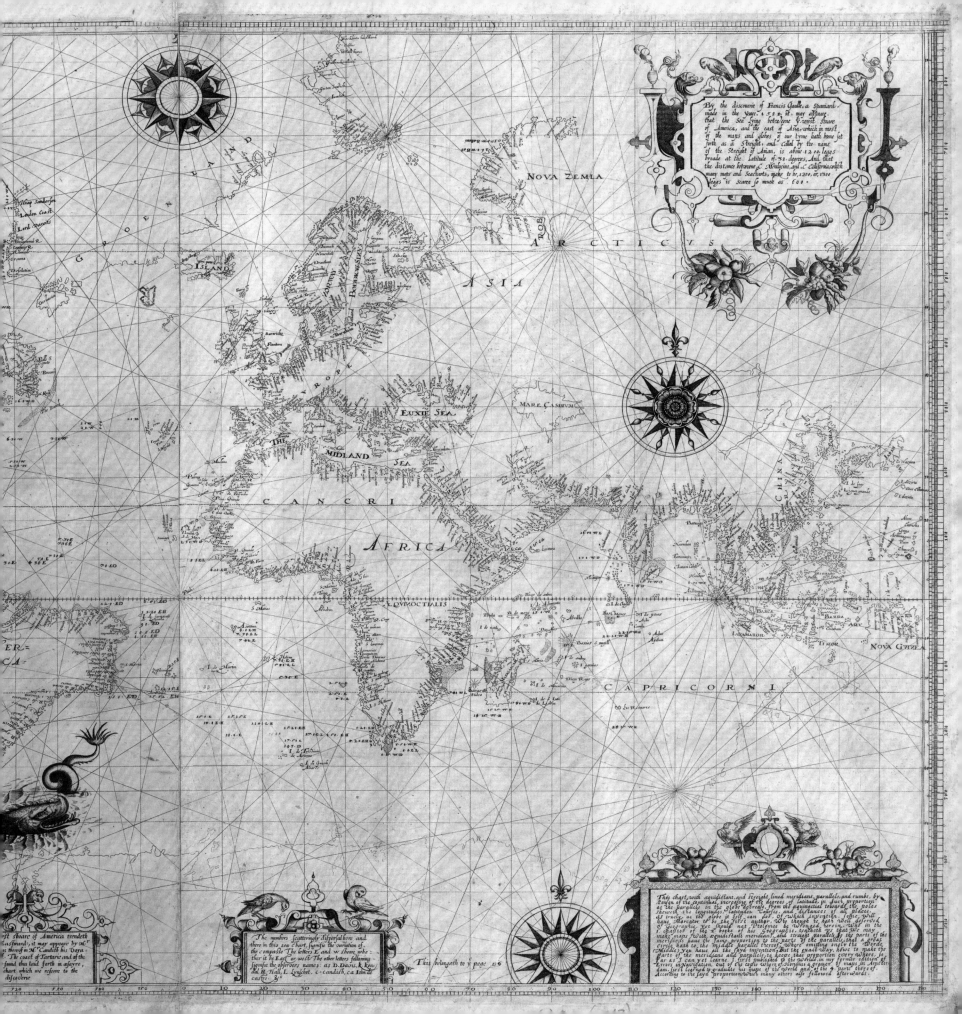

NOVA ZEMLA

ARCTICVS

ASIA

NOVA ZEMLA

ISLAND

EVXIE SEA

MARE CASPIVM

THE MIDLAND SEA

CANCRI

AFRICA

CHINA

A QVINOCTIALIS

CAPRICORNI

NOVA GVINEA

TIMOR

GROENLAND

By the discouerie of Francis Gualle, a Spaniard,
made in the yeare 1584, it may appeare,
that the Sea lying betweene Cauest Fouare
of America, and the east of Asia (which in most
of the mapps and globes, of our tyme hath bene set
forth as a Streight, and called by the name
of the Streight of Anian, is aboue 1200. leags
broade at the latitude of 38. degrees, And that
the distance betweene C. Mendocino, and C. California, which
many mapps and Seacharts, make to be 1200, or, 1300
leags is scarce so much as 600.

This chart, with aequidistant, and streight lined meridians, parallels, and rumbs, by
Design of the continuall increasing of the degrees of latitud in such proportion
as the parallels in the globe decreast, from the aequinoctiall toward the poles
sheweth the longitudes, latitudes Course, and distances of all places
as truly, as the globe it self can do. of which invention, some, will
haue, Mercator to be the first author. Why though he hath well described
it Geographice, yet should not Ptolemee be wronged, therefore in the
1 chapter of the 1 booke of his geographice, teacheth vs that we may
make mapps with, aequidistant meridians, and streight parallels by the parts of the
meridians haue the fame proportion to the parts of the parallels, that in great
circles, hath to the middle parallel thereof, where emitting only the worde
(Middle) You haue all the said invention, But the exact way, how to make the
parts of the meridians and parallels, to keepe that proportion every where, so
far, as I can yet learne, I first publised to the worlde, in my former edition of
Errors in Navigation, out of the cogitations of Stradius a Spaniard of mapps in Amster-
dam, first carried by graduate his mapps of the world, and of the 4 parts there of
According to the said proportion, which many others also followed afterwards.

The numbers scatteringly dispersed here and
there in this sea chart, signifie the variation of
the compasse The letters E and W shewe whe-
ther it be East or west The other letters following
signifie the observers names: as D. Davis, K. Ken-
dal H. Hall, L. Lynschet. C. candish, ca Iohn de
castro. &

This belongeth to y page 116

st shoare of America trendeth
Eastward, it may appeare by as Mr
as thereof m Mr Candish his Voya-
The coast of Tartarie and of the
found thus laid forth m asayre,
chart which we referre to the
discoverie

routes both by land and by sea and in what climate they were and what distinguished them as to seas and gulfs together with a knowledge of other lands and regions in all seven climates.[6]

The book was therefore driven by the political and administrative imperatives of a king who was pleased to see his Sicilian kingdom dominating the Mediterranean and inflated far beyond its actual size, but also happy to assimilate Muslim geographical traditions that placed south at the top and the Arabian Peninsula at the centre of the world.

Why North?

By the late fifteenth century different cultures oriented their maps with east, south or north (but never west) at the top. Quite how north came to predominate as a cardinal direction over subsequent centuries down to today remains a source of dispute among cartographic historians, but the shift seems to have happened decisively in European maps from the sixteenth century. One theory is that maritime maps, or portolan charts (discussed in greater detail in chapter 5) were often oriented towards the north as a result of taking compass readings according to the North (or Pole) Star. However, south would function just as well as a prime direction based on taking such a measurement, and indeed some portolan charts (and even several religiously motivated maps) were oriented with south at the top. As first the Portuguese and then the Spanish began seaborne voyages of exploration out into the western Atlantic and down the west coast of Africa at the end of the fifteenth century, European map-makers experimented with various projections using different cardinal directions. Some used oval projections, others centred on the North Pole (a variation seen more recently in the United Nations map logo, which attempts to avoid privileging any one nation-state at its centre), and there was even a fashion for heart-shaped (or 'cordiform') projections.

The one map projection created at this time that came to predominate over all others in the subsequent centuries

was published by the Flemish map-maker Gerard Mercator in 1569. Much has been written about Mercator and his projection, mostly concentrating on his ingenious solution to the problem of how to create a flat map that could take into account the curvature of the earth's surface. Prior to Mercator's projection, if pilots or navigators wished to draw a straight line of bearing across the earth's surface, especially on long-distance voyages over great distances, such a line would of course in reality be curved – because the earth is a sphere – rather than straight. Mercator's ingenious solution was to increase the degrees of latitude towards each pole in proportion to the lengthening of the parallels in relation to the equator. Although this method caused maximum distortion at the poles, it enabled navigators to plot a straight line of bearing that still accounted for the earth's sphericity, without sailing way off course.

What has often been overlooked on Mercator's map is that its north–south distortion paradoxically drives its decision to place north at the top. It is at its most accurate east to west to either side of the equator, and by the mid-sixteenth century this was the direction of travel for most maritime trade and exploration. By the 1560s Mercator and most navigators knew that travelling via the North Pole to reach Asia was far too challenging, and the South Pole was simply too far away to be considered an option. Both poles could therefore be sacrificed on global map projections, in contrast to the demands of accuracy sailing west to the Americas and east to Asia from Europe.

A later world map that confirmed this orientation by drawing explicitly on Mercator's projection was the English mathematician Edward Wright's *A True Hydrographical Description of so Much of the World as hath been Hitherto Discovered and is Come to our Knowledge* (1599). As well as being a trained mathematician, Wright had travelled on English privateering expeditions to the Azores, so he had first-hand experience of the problems of seaborne navigation. In 1599 he published *Certaine Errors in Navigation*, a book that provided a detailed mathematical explanation of Mercator's projection, enabling

Fig. 13 The Selden map of China, early 17th century. MS. Selden supra 105.

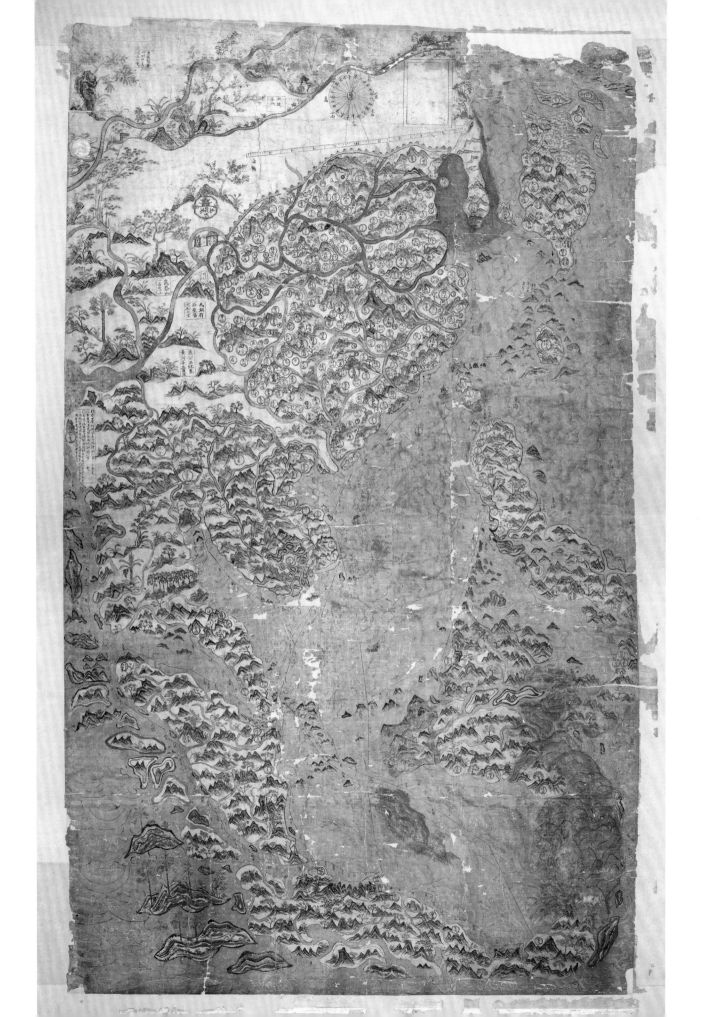

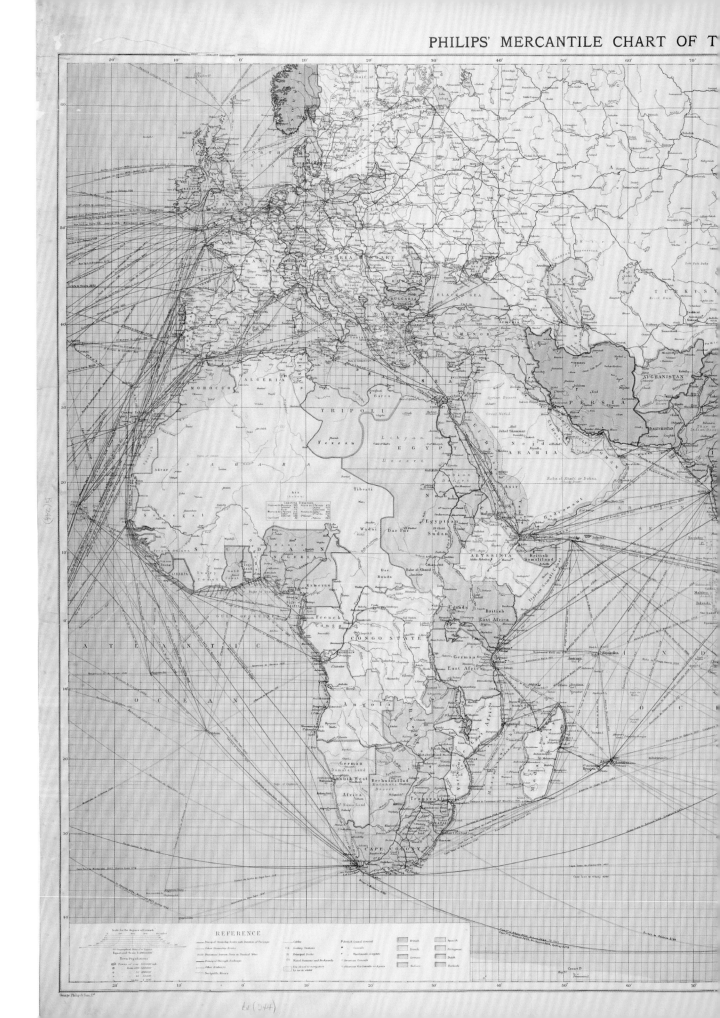

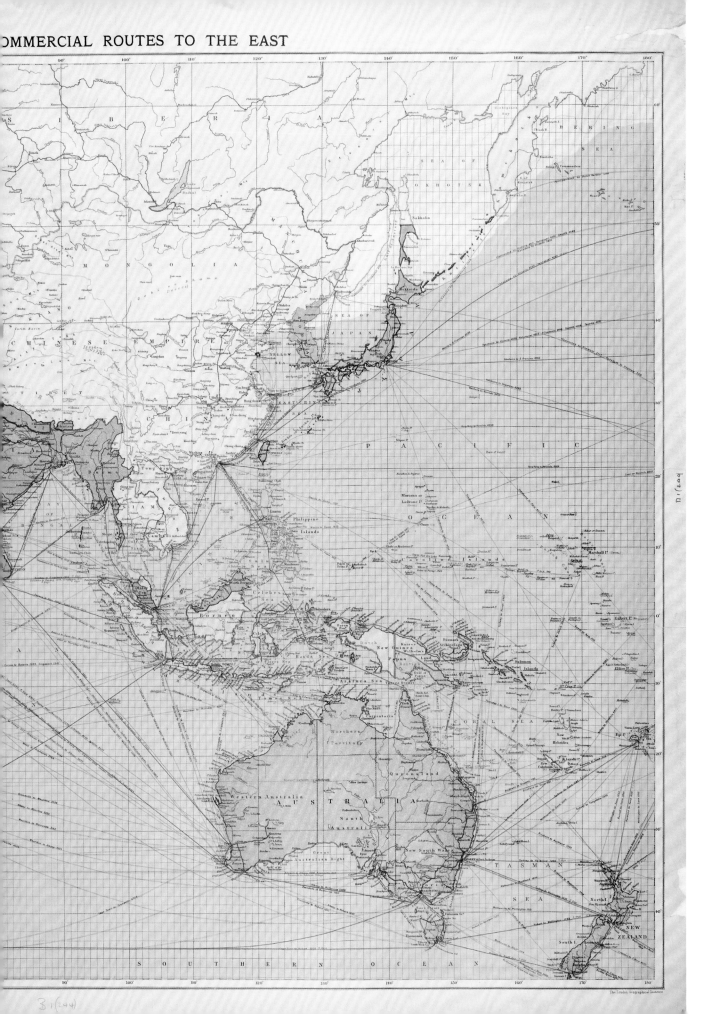

Fig. 14 *Philip's Mercantile Chart of the Commercial Routes to the East*, 1906. B1 (244).

pilots to reproduce and use it more effectively. A subsequent engraved world map attributed to Wright and drawn on the Mercator projection was published the same year in the second volume of Richard Hakluyt's account of English seaborne discoveries, *The Principal Navigations, Voyages, and Discoveries of the English Nation*. The map is characterized by its dense network of rhumb lines (straight navigational lines) crisscrossing its surface, based on Wright's understanding of Mercator's methods (fig. 12). It explained in the legends across the bottom and in the top right-hand corner how it had been constructed, and also drew on the latest reports of English, Spanish and Dutch discoveries to the west in the Americas and to the east, including South Asia and the beginnings of a northern coastline of Australia, or 'New Holland'.

In its scientific precision, detailed engraving and involvement in early English attempts at systematic discovery and exploration of new lands for commercial and imperial gain, the map marks a significant shift from the maps we have been discussing so far. It decisively placed north at the top because of its overriding concern with travel and discovery from east to west. The northern and southern poles are of such little significance on Wright's map that they do not even appear. With its blank spaces – particularly in North America – this is a map that is open to further discovery, and is turning its back on religious influences and the wilder fantasies of medieval map-makers. Both Wright and Hakluyt were deeply involved in English aspirations to settle plantations (or colonies) in the Americas, and were also to be involved in the foundation of the East India Company (formed in 1600), which would establish commercial operations in South Asia. It is a sign of the map's influence and preoccupations that even Shakespeare referred to it in *Twelfth Night* (1600). In describing Malvolio, Maria jokes, 'He does smile his face into more lines than is in the new map with the augmentation of the Indies'.[7] Malvolio's smiling face is lined like Wright's distinctive rhumb lines, but the map's equal significance lies in its 'augmentation of the Indies', or Asia. Wright, like Shakespeare, understood that the east was

now a commercial aspiration and a direction of early English imperial travel, rather than a cardinal direction. It was a shift that would come to define European map-making, with north firmly established at the top of the map.

Commerce and Empire

Even as maps like Wright's began to predominate throughout seventeenth-century Europe, the Chinese were producing their own maps with intriguing similarities, although driven by very different imperatives. One of the Bodleian's most recent significant cartographic rediscoveries is the so-called Selden map of China (fig. 13). The first known Chinese-made map to enter England, it came into the Library in 1659 from the collection of the English lawyer John Selden (hence its title). Little is known about this map other than that it was drawn by an anonymous Chinese map-maker working in the late Ming dynasty during the first two decades of the seventeenth century. It seems to have been acquired in South Asia by an East India Company official who brought it back to England. It is drawn and painted in ink and watercolour on three paper sheets glued together and was probably intended to be hung on a wall.[8]

The map follows the standard Chinese imperial tradition (discussed earlier in the chapter) of taking north as its cardinal direction. But unlike most surviving Chinese maps of this period which put the Ming empire at its heart, this one is centred on the South China Sea and shows South-East Asia, including Calicut in India and the Persian Gulf in the west, and the spice-producing islands of Indonesia, including Timor in the east (at bottom right). Although it depicts topographical features like Beijing and the Great Wall of China, the map's primary interest lies in maritime trade and navigation. On closer inspection, it is covered in a network of spidery lines depicting more than sixty ports and trade routes radiating outwards from Quanzhou on the eastern Chinese coast (shown in the middle of the map near Taiwan). During conservation work the old backing was removed to reveal a series of geometrical lines identical to the sea routes on the

other side, suggesting that maritime navigation was its prime motivation. The map's coastlines are remarkably accurate, as are its trade routes, which are all based on measurements taken using the compass rose and scale bar at the top. It represents one Chinese foot (*fen*) at a scale of approximately 1:4,750,000 and takes its orientation from compasses (*luojing*) pointing south (*zhinan*) that the Chinese had been using since the tenth century CE.

Although it is centred on South-East Asia and places north at the top for very different reasons to European maps, the Selden map tells a similar story to Wright's. It was driven by seaborne trade from east to west, shaped by the latest developments in scientific knowledge, and bereft of religious influences. One of the stories it may disclose as scholars continue to work on it is the level of exchange between European and Chinese pilots, sailors and map-makers as they compared and contrasted their maps in the early seventeenth century. What both maps undoubtedly tell us is that by the early seventeenth century north had been established as the cardinal direction in maps produced by literate societies from Europe to Asia. North had triumphed, although the reasons why were based on a series of contradictory and contingent reasons including trade and empire, rather than any objective reality.

The Wright and Selden maps created the cartographic conditions for an almost universally accepted world map that placed north at the top and prioritized a global axis of trade and empire running east to west. Over subsequent centuries, European colonial expansion combined with the power of print to disseminate standardized cartographic images of the world would cement this widely held belief as somehow 'true'. To emphasize this prevailing geographical belief, we end with a map produced in 1906 at the zenith of the British empire, showing the extent of the empire's overseas colonial possessions (infamously coloured in red): Philip's Mercantile Chart of the Commercial Routes to the East (1906).

Philip's chart was designed on Mercator's projection with north at the top (fig. 14). With its detailed geography of Europe, Africa and Asia as well as dozens of maritime routes running east to west that defined the commercial extent of the empire (each carefully measured in miles), the chart would have been instantly recognizable to both Wright and the maker of the Selden map. It was published in London by Philip's, one of the country's oldest and most respected publishing houses, famed for its atlases and educational maps (such as this one), which were widely distributed throughout the empire. The chart offers what seems to be a scientifically accurate, objective representation of the world. But it is based on the ideological assumptions underpinning the righteousness of British colonial rule in Africa and Asia, and a long history of establishing north at the top of the map to suit Britain's political and commercial place in the world.

What the story of cartographic orientation tells us is that the decision to orient a map to any of the four cardinal directions has always been driven by religious, political, commercial and ideological imperatives that define the map-maker and their society. Today, north sits atop most world maps published around the globe, but there is no particular reason why it should be so, other than the economic and political dominance of what we call the 'Western world', namely Europe and North America. In future generations, a different orientation might prevail. Or perhaps, with the increasingly local and personalized nature of online geospatial mapping, a cardinal direction may become irrelevant, and seem as quaint as putting south or east at the top of the map.

2

Administration

There can be no better place from which to embark upon the story of mapping the nation than by concentrating on the Gough map of Great Britain, the earliest surviving geographically recognizable map of an individual country.

King Edward I (r. 1271–1307) appears to have featured prominently in the map's genesis, but the manuscript that survives post-dates Edward's reign by around a century. Nevertheless, the monarch's influence remains written all over its surface. The map's subject matter appears to be geopolitical, with a clear focus on the accurate location of settlements. It has full cartographic references to places and regions that are key to governing the realm, which in themselves represent a paradigm shift from earlier cartographic representations of the country. The Gough map is showing us 'real' geography. It tells us where places *really* are. Earlier surviving maps are not so attached to these levels of locational precision. Instead they were largely created and prepared to a theological agenda, as can be seen in the work of St Albans-based Matthew Paris, who made four maps showing the whole of the island of Britain in the mid-thirteenth century. Another crucial change of direction is the physical nature of the artefact itself. The Gough map is the earliest known exemplar of any map in Britain produced as a separate sheet, rather than as a page in a book or designed to be hung on a wall for display purposes. The quality of the parchment, however, is poor, implying that the map was not created for a high-status client, nor was it expected to be prominently displayed, or indeed to last. Yet more than 700 years after its contents were first drawn, this enigmatic and complex map continues to tell us

the story it was designed to impart, and has the seemingly unlimited capacity to lead us along as yet uncharted journeys to uncover the practical requirements which brought such a critical and challenging map into existence in the first place.[1]

Freed from the shackles of a Christian narrative, the Gough map's purpose was not to visualize a pathway through life in accordance with the teachings of the church, but to lead the way in a completely new cartographic direction which remains current in the twenty-first century, where geographical veracity and the primacy of relative position are foremost in the map-maker's mind.

Nevertheless, more traditional map-making styles have not been entirely abandoned, as exemplified by the filling of empty spaces, as frequently seen on *mappae mundi*, where blank areas of the world were populated with monstrous people and creatures. This, to a small extent, is replicated on the Gough map, as north-west Scotland provides a home for both a deer and a wolf, the only land-based animals to be included on the manuscript, although these lack the demonic monstrosity found on *mappae mundi*.

Key questions remain, however. Who made this map? What was their background? Was it ecclesiastical or secular? Why was it made? And for whom? Clues to answering some of these questions might be found in a close examination of some of the places depicted on the map, as well as the routes between them.

How the Map was Made

The Gough map measures 116 cm × 55 cm, and is drawn on the hide of a sheep and a lamb. Immediately striking

opposite and pp. 40–41 Fig. 15 The Gough map, c.1390–1410. MS. Gough Gen. Top. 16.

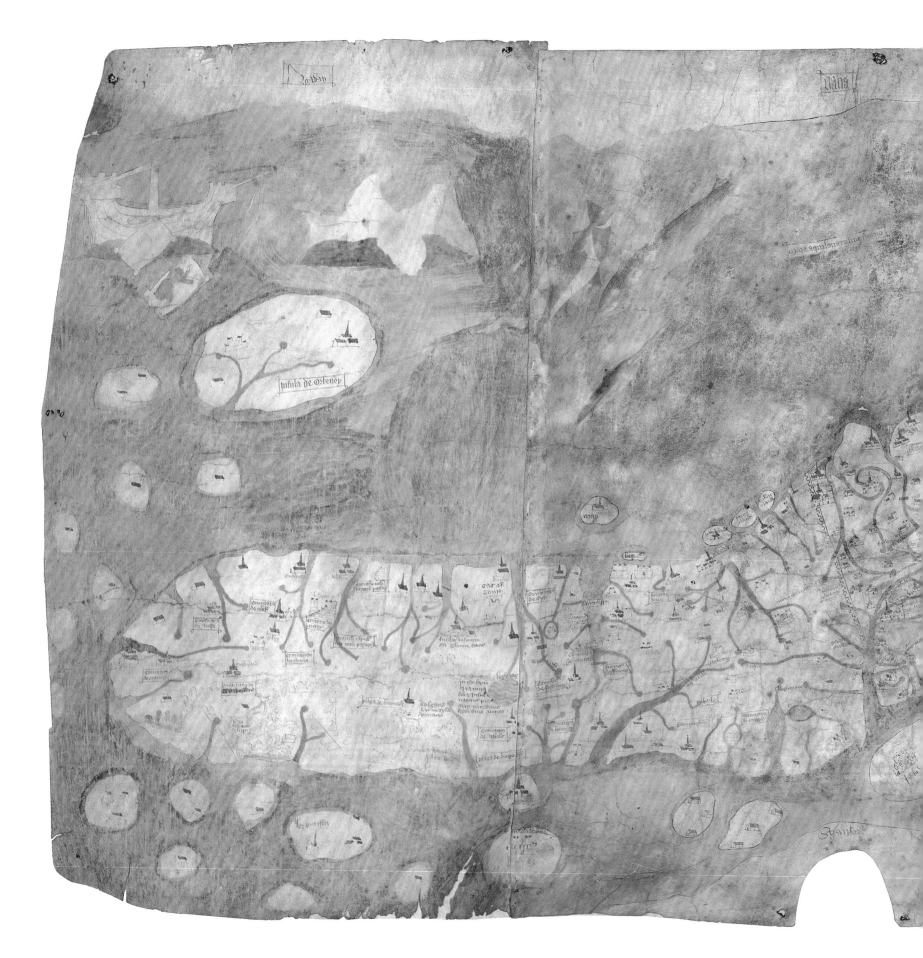

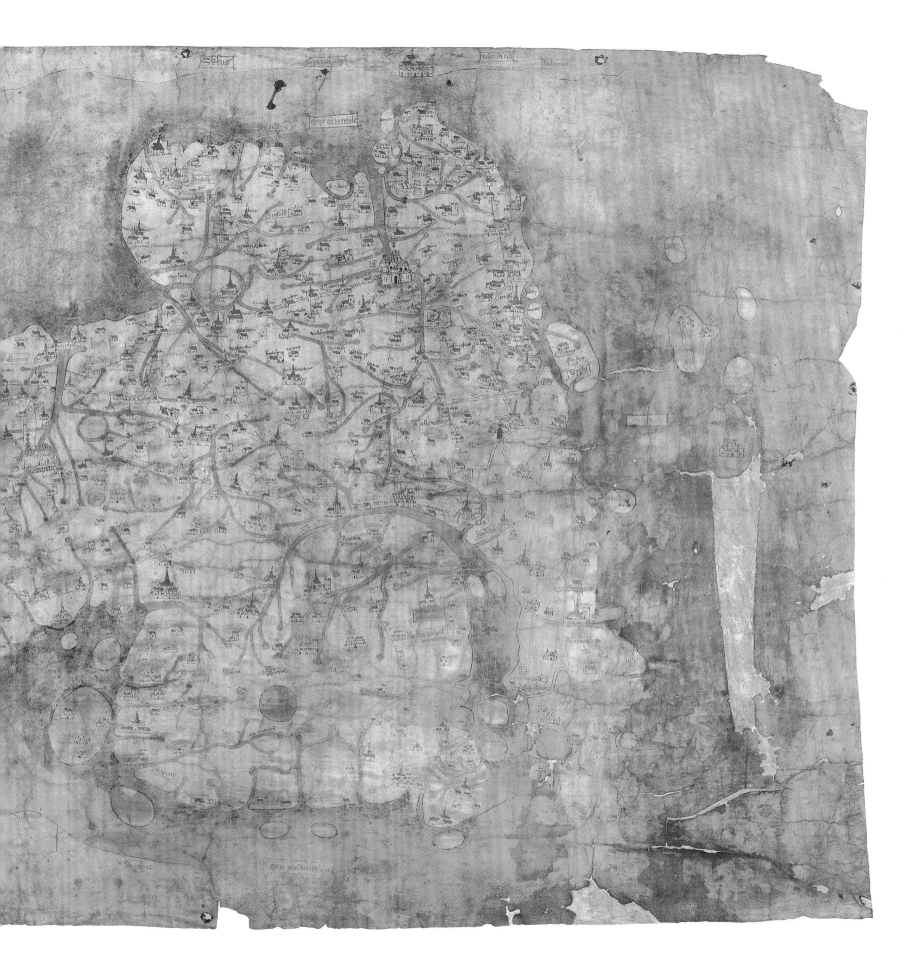

is the map's unconventional orientation, with east at the top. Scotland extends out to the left, rather simplistically represented, compared to the more familiar and detailed England and Wales. Its name derives from Richard Gough, the antiquary who purchased the map in 1776 for the sum of half a crown, adding it to his extensive collection of topography. On his death in 1809, Gough bequeathed the map and his extensive topographic collections to the Bodleian Library.

The map is rich in geographical content – over 600 toponyms are included, as well as in excess of 200 rivers, with the Severn, Thames and Humber predominant. There are trees to identify forestry, as can be seen with the New Forest and Sherwood Forest. Routes between towns are marked in red on the map, with distances included in roman numerals, also marked in red, best seen on those routes radiating out from London, and also along the Welsh coast. The network of red lines connecting selected settlements remains in need of investigation and explanation (fig. 16). For instance, it is unclear if these red lines are roads, but if so they make the Gough map the oldest surviving road map of Britain; more likely, the lines represent routes, and as such are more a series of geographical guidelines than a true portrayal of topographic reality. The lines may well be cartographic devices to provide geographical meaning to all those distance figures, which are roughly equivalent to old French miles, indicating pairs of settlements linked to match the value recorded on the map. Or could they be interpreted as a means of visualizing distances already known and gleaned from itineraries? These lines may well represent one individual's travels, such is the irregularity of the geographical distribution of the routes selected for this particular treatment. There is a consistency of style, however, which may well indicate that each of the lines was carefully added to the map at the same time, possibly as information contained within and transferred from another document.

Recent research is successfully, albeit slowly, unlocking the secrets of the map's age. The story it tells has to be considered

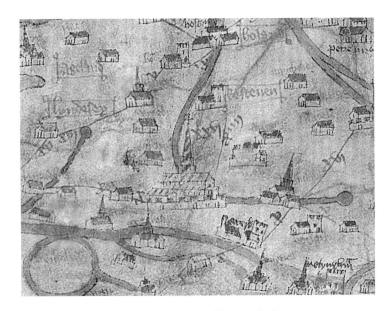

Fig. 16 Red lines on the Gough map, c.1390–1410, centred on Lincoln. MS. Gough Gen. Top. 16.

very much a work in progress, as the map was subjected to various phases of revision in the late Middle Ages. By examining the handwriting on the map, palaeographical evidence would suggest the late fourteenth century as its earliest possible date, so 1390–1410 looks to be the safest indication of the map's initial date of composition. A second, later phase can be distinguished in the repainted coastlines south of Hadrian's Wall, showing up as a broader and darker band – these characteristics extend over to Ireland and across the North Sea. New black ink was also added for the river banks. These double lines marking river banks were created first, then the river itself painted in. Similar techniques were used around the edge of the ship shown afloat in the North Sea – both present an artistic style and practice conventionally employed in medieval book illumination. A third phase shows compelling evidence of many over-written toponyms, giving the map a slightly darker colour. The Gough map is therefore a multilayered manuscript, with the most recent research findings now identifying firstly a

map of the whole of Great Britain, superseded by a map of the country south of the Wall, only to be followed by a third map of south and south-eastern England. Each stage seems to have been completed as a single task, although the intervals between those tasks cannot be established (they could range from days to years). Several different hands were probably at work on the completion of the final phase of revision, suggesting that this task was undertaken more gradually.

The map's roots strongly suggest the presence of a prototype. Pinholes on the map, clearly visible on a recent 3D scan on the manuscript,[2] have demonstrated that this particular map was created via a transfer of information from another artefact – presumably a map – which has not survived. The fact that the pinholes tend not to fully penetrate the parchment hints at the presence of another object placed above the Gough map employed as a 'marker'.

The clues left on the Gough map, especially the significance of the Welsh castles, as well as references to mythology and legend familiar to Edward I and his understanding of the concept of kingship, further suggest the presence of a prototype, probably created towards the end of Edward's reign (the very early 1300s), or perhaps slightly later.

Administrative Features

In medieval England, the fundamental value of graphic information as a practical aid to government was beginning to be understood, providing a fertile environment that was key to the creation of the Gough map. Medieval England was one of the most, if not *the* most, centralized European administrative unit of the time. The potential for a map to facilitate efficient governance was unlikely to have gone unnoticed, and may indeed have been actively encouraged. The evidence to suggest that the Gough map might have been devised for administrative purposes is demonstrated in a number of ways. The primacy of the church, so apparent in earlier surviving maps, is far less clear. Granted, churches, cathedrals and the occasional monastery can be found on the map, but an inspection of Canterbury, for example, reveals

nothing particularly remarkable in terms of the cathedral's depiction. One of the first things the viewer is drawn to is the gold leaf lettering, used only twice, to name London and the capital of the north, York. The vignettes for these two settlements are much grander than any others found on the map. Other impressive urban vignettes include Bristol, Chester, Coventry (of which more below), Gloucester, Lincoln, Newcastle, Norwich, Nottingham and Winchester, whilst Windsor is shown prominently as perhaps the largest castle on the map. Is this indicative of royal influence in the manuscript's compilation?

Also prominent is Hadrian's Wall, crossing the north of England in bright red, and in terms of the map, creating a very real boundary – both geographically and, more significantly, practically, in terms of the map's compilation (fig. 18). North of the Wall – in the whole of Scotland and most of Northumberland – the scribe's hand used to lay down the place names is significantly different, and older in style, than south of the Wall. The earliest writing on the map is that found in the red ink text, principally in Scotland, exemplified within those borders showing regional names. None of the rivers on the northern side have solid darker banks, yet all those to the south do. Why this should be the case remains a mystery.

Which maps would have provided the basis for the Gough map's outline? Later in the fourteenth century, portolan charts, as described in Chapter 5, were becoming more widely available for map-makers, and by inference those responsible for the Gough map. The accuracy of the south and south-east coasts of England reflects this newly found knowledge, suggesting that sections of the map's littoral were acquired from such a source. This level of detailed cartographic information would have been valuable to a monarch looking to expand the English realm into Scotland, Wales, Ireland and France.

By comparing the general style of the vignettes, we can tell how important specific places were to the map-maker and hence the administrators of the country. The vast

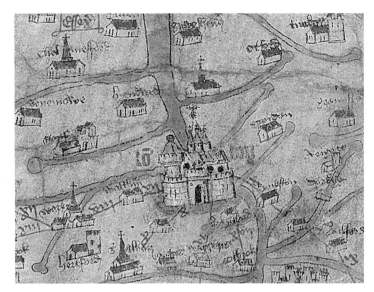

Fig. 17 London on the Gough map, c.1390–1410. MS. Gough Gen. Top. 16.

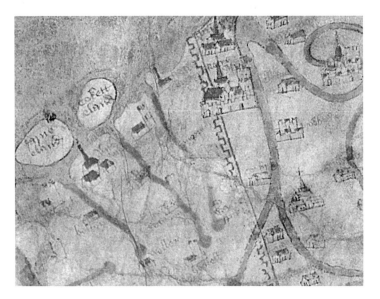

Fig. 18 Hadrian's Wall on the Gough map, c.1390–1410. MS. Gough Gen. Top. 16.

majority of the settlements shown are afforded a standard vignette – they all look more or less the same. The larger settlements, however, seem to be portrayed individually, which again demonstrates how the map's makers were keen to emphasize certain key locations. Yet a key question remains unanswered: why are certain places such as small villages like Charlesworth in Derbyshire shown, while other more substantial settlements, such as Bath, are omitted?

Scotland's less accurate portrayal can be attributed to its status at the time as a foreign country – which assumes, probably rightly, that the map's maker was English (the map was likely to have been made in London). Wales sits somewhere in between in terms of cartographic recognition, but the prominence of Edward I's castles around the coastline seems to be indicative of the map's origins as an object of governance. What is compelling however, is the map's lack of boundaries. Medieval world maps are full of boundaries – lines dividing the land's surface into provinces – but the Gough map eschews this convention. Is this because we are looking at a map created to show the English realm ruling right across Great Britain and beyond? Is this why Calais, still very much part of England in an administrative context at the time, is by some distance the most lavishly designed urban vignette beyond the mainland?

Coventry

It is fair to argue therefore that the Gough map is likely to have played an important role in the administration of the English state. In the late Middle Ages, one of the country's principal settlements was Coventry.

Coventry[3] stands at the crossroads of England. Two important medieval long-distance routes met there, one connecting London with Carlisle, the other linking Bristol with Grantham and the Great North Road to York. These key routes are shown on the Gough map as thin red lines, and to its users the map would have revealed how Coventry's location was at a crucial intersection at the heart of England

(fig. 19). Coventry's geographical advantage encouraged its economic and commercial prosperity. At around the time the map was compiled, by the end of the fourteenth century, Coventry was England's third largest city after London and York, and this era, after the Black Death, saw the medieval city at its zenith, thriving on its craft reputation and expertise in textiles.

With its circle of walls with two gates, encompassing two buildings and a spired church with a cross, the Gough map features an image of Coventry in a stylized but representative form. Despite the city's importance economically, its depiction on the map is less impressive compared with the 'icons' used on the map to signify other major urban centres of England such as Norwich, Bristol and York. Coventry's castle was long gone by the time the Gough map was compiled, and so unlike Bristol no castle is shown by the map; and in the fourteenth century, unlike York or Norwich, the city walls at Coventry were still incomplete, so comparably physically less imposing, as they appear on the map. The single-spired church used on the map for Coventry perhaps also reflects how its episcopal status was not a match for other cathedral cities, such as Chester or Lincoln, since the bishopric at Coventry was shared with Lichfield. Despite all this, at the time the Gough map was drawn, Coventry occupied an elevated and enviable position, prominent in England's urban hierarchy.

Through the intersection of those two red lines converging on Coventry, the map's makers indicated Coventry's pre-eminence. They confirmed the city's geographical significance at the crossing place of royal highways that spanned the realm. In Coventry itself, these two routes converged and met in the centre of the city. By around 1350, the principal road from London entering the city had been diverted to pass close to the precinct of Whitefriars, through Much Park Street. Here, archaeological excavations coupled with architectural study of late medieval buildings that survived the 'Coventry Blitz' have revealed Much Park Street's high status in the

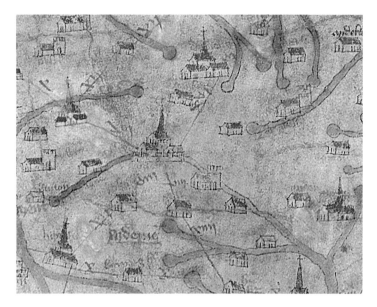

Fig. 19 Coventry on the Gough map, where two royal highways converged, c.1390–1410. MS. Gough Gen. Top. 16.

late fourteenth century. As well as stone and timber-built residential dwellings of two and three storeys fronting the street, various industrial activities took place in yards and gardens at the rear. The street and its properties were set out in the previous century when, in the 1230s, the earls of Chester moved their chief residence in Coventry to Cheylesmore Manor and created from their park there a new area for development, to accommodate and promote the significant commercial and population growth of Coventry that was then already occurring. This burgeoning wealth and prosperity was matched during the fourteenth century by important political changes in the governing of Coventry. First, in 1345, Coventry became incorporated as a city, with its own elected mayor, charter and seal, and then, in 1451, the city gained county status in its own right in another grant awarded by the Crown.

The London to Carlisle route, shown by the Gough map converging on Coventry, stretched through the city to form one of its main axes. Between suburbs extending to the east and west, this street ran for around a mile and a half

(three kilometres) spanning the widest extent of built-up area by 1350 and reaching well beyond the city's walls and gates. These suburbs of Coventry existed before the walling of the city began in earnest in 1356. To keep costs of construction down, the circuit of Coventry's walls was placed relatively tightly around the centre of the city, with the consequence that the walls' construction meant demolishing some existing housing and cutting off the outer suburban parts from those areas encircled by the new walls. The new walls required gates to be built for the main streets entering Coventry, for example at Much Park Street in the east, Spon Street in the west, and Bishop Street to the north. Some of the gatehouses still survive, as at Cook Street Gate and Swanswell Gate, as do parts of the city walls in places.

Other important survivals of buildings of later medieval Coventry that are contemporary with the Gough map include St Mary's Hall, situated in Bailey Lane and located opposite the once great parish church of St Michael's, which itself saw much rebuilding in the fourteenth and fifteenth centuries, only to be destroyed in the Second World War by bombing. Just adjacent to St Michael's, Coventry's other medieval parish church of Holy Trinity fared better, and contains renowned wall paintings dating to the 1430s. St Mary's Priory also lay nearby in this ceremonial and institutional core of Coventry, but its buildings succumbed in the Reformation, Coventry being the only city in England to lose its cathedral at the Dissolution. Domestic buildings in Coventry built during the fourteenth and fifteenth centuries were equally impressive, including timber-framed 'terraces' constructed in Spon Street.

The late medieval townscape of Coventry thus spoke of the city's wealth and prestige, which would have been particularly visible to those passing along those main routes in and through the city shown by the Gough map. Right at the centre of Coventry, the crossing point of the two main thoroughfares, was Broadgate. Here, a large triangular-shaped marketplace owed its origins to the time of Leofric and Godiva and their founding of St Mary's Abbey in c.1043. The marketplace was laid out beside the abbey's main gate and by the fourteenth century was still in the hands of St Mary's. Coventry was thriving at this time: a place important as a staging point in royal itineraries and visits, when the gates of the city were decorated and embellished.

While those who compiled and drew the Gough map may never have seen Coventry for themselves, the city's reputation and standing in England at that time ensured that it occupied an important and prominent place on their map.

What about maps that followed the Gough map? Examples dating from the early fifteenth century to around 1547 show features distinctly similar to the Gough map, for example the prominence of Flat Holm and Steep Holm islands in the Bristol Channel, the absence of a geographical feature so significant as Cardigan Bay, and similarities in the ways in which river systems are mapped – all of which suggests that the Gough map, or its prototype, or something very similar to the Gough map, were in circulation and sufficiently well known to have acted as the cartographic benchmark for the mapping of Great Britain for generations. Quite a legacy.

The power of the map to be employed as an administrative tool has been a constant from the Middle Ages onwards. We have seen how the Gough map could have been used to help the English Crown gain an understanding of the spatial layout of the country. In the following chapter we show how, almost two centuries later, Christopher Saxton's monumental county mapping project was seized upon by the Elizabethan state, effectively bringing to an end the Gough map's hegemony, its inferred status as cartographic template for the nation.

In the twenty-first century, administration delivered without the support of maps is unthinkable. The world may be very different to that described above in medieval Coventry, but wherever they are, administrators need maps to define the territorial limits of their powers – be they nation-states, a local government authority or an individual landowner. The Gough map may not have been the first, but it has survived as the earliest known example of such a map – a testament to a creative mind producing a cartographic image on a couple of animal hides that has endured for a period of extraordinary longevity.

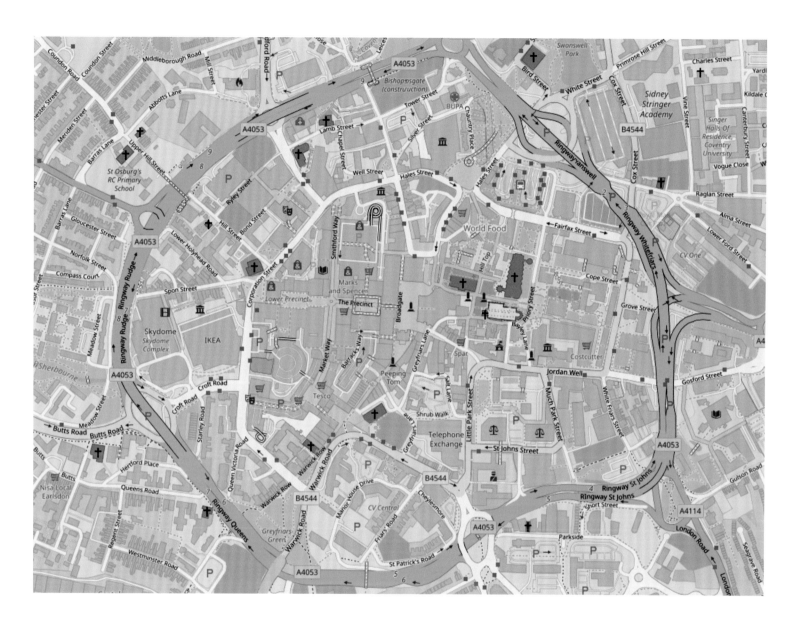

Fig. 20 Coventry on OpenStreetMap, 2018. Much Park Street and Spon Street are shown in the central area, and there is now a ring road diverting traffic from the city centre.

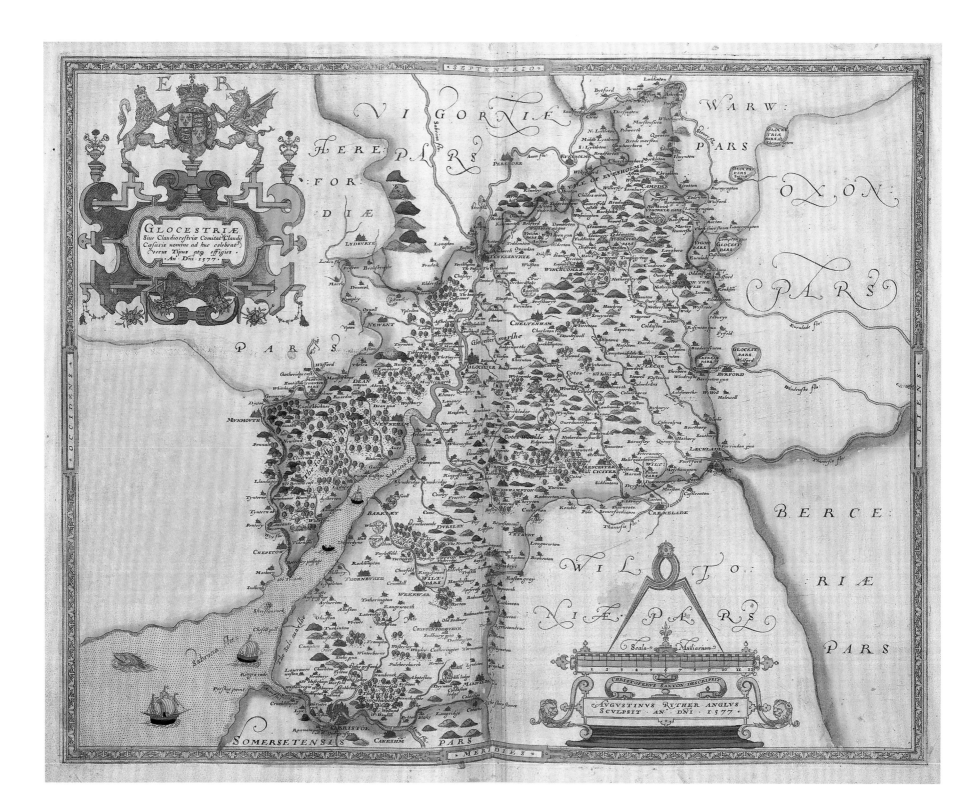

GLOCESTRIÆ Siue Claudiocestriæ Comitat Claudij Cæsarie nomine ad huc celebrat vera Typus atq effigies. An° Dñi 1577

SEPTENTRIO

OCCIDENS

ORIENS

MERIDIES

VIGORNIÆ PARS

WARW: PARS

OXON: PARS

HEREFORDIÆ PARS

BERCE: RIÆ PARS

WILTONIÆ PARS

SOMERSETENSIS PARS

Scala Miliarum

CHRISTOPHERVS SAXTON DESCRIPSIT

AVGVSTINVS RYTHER ANGLVS SCVLPSIT AN° DNI 1577

3

The Country

In this chapter we survey 'the country', focusing on England and Wales. 'Country' is one of the most evocative terms in both the English language and map-making. It is a word intimately connected with the historical landscape, one that takes in numerous towns and villages, rivers, hills and forests, what we could describe collectively as 'the country'. The noun 'country' has many rich and complex meanings and associations. It can be a synonym for the modern nation-state, yet it also has more emotive connotations of rural life ('the countryside' and 'the counties') as distinct from urban development – indeed, 'the country' is most often defined in negative opposition to 'the city'. Strictly speaking it can be defined as 'a native land and the rural or agricultural parts of it'.[1] In showing how the country has been mapped over time, we would like to add to this definition an understanding of how map-makers have sought to depict it as a landscape containing human settlements divided along regional and administrative lines. If we take the mapping of one county in England as an example, we can trace the story not only of landscape change and human activity on the ground, but also of cartographic evolution over four centuries. For our purposes we take southern Gloucestershire as our main focus, for reasons that will quickly become evident.

Christopher Saxton has been described as 'the father of English cartography',[2] and the sequence of maps under scrutiny here will go some way to explain why he is worthy of such an accolade. Born in Yorkshire in the early 1540s, he was educated at Cambridge, and by the early 1570s had relocated to London. His cartographic legacy was confirmed once he became responsible for producing the first national atlas of the counties of England and Wales, with the maps surveyed and drawn by Saxton himself. The fact that his work was not derivative cannot be over-emphasized. There was no cartographic precedent for what he achieved, and so successful was his undertaking that *his* maps became the template for mapping 'the country' in England and Wales right up to the early years of the Ordnance Survey at the beginning of the nineteenth century.

Saxton was to receive patronage from Thomas Seckford, Queen Elizabeth I's Master of Requests, and this financial support enabled Saxton to fulfil his ambitious project. In 1575 he was given royal permission to demand help on his travels:

> to be assisted in all places where he shall come for
> the view of such places to describe certain counties
> in cartes, being thereunto appointed by Her
> Majestie's bill under her signet.[3]

Furnished with such influential written approval, people with local knowledge were encouraged to help him carry out his work. Within two years, the queen had also issued letters patent giving Saxton sole right to publish his own maps for the next decade, crucially protecting him from others copying and profiting from his work.

The skill and clarity of his output was swiftly appreciated by those in power who were able to spot the potential of accurate maps, and Saxton's work became viewed as a powerful tool for the governance of the country. Map-consciousness had been growing among Tudor statesmen

Fig. 21a Christopher Saxton, map of Gloucestershire, *Atlas of the Counties of England and Wales*, 1579. MAP RES 76, fol. 12.

since Henry VIII's reign, emerging simultaneously with surveying techniques developed by Saxton, including triangulation to calculate distances between prominent points in the landscape. His county maps were to gain instant recognition at the highest political levels; so rapidly was their strategic value appreciated that between 1574 and 1578, the queen's chief adviser Lord Burghley acquired and amended early proof copies of his work for assessing potential religious challenges to Elizabeth's rule from dissenting nobles, and monitoring the coastline in case of Spanish invasion.

All subsequent county maps for well over a century were based on those made by Saxton. More broadly, his cartography placed him in the vanguard of Europe's late sixteenth-century map-makers. Elements of Saxton's groundbreaking and influential contribution are clear to see in the mapping of the English and Welsh counties produced both at home and abroad. The likes of John Norden (c.1547–1625) and John Speed (1551/2–1629) quickly adopted the Saxton blueprint: they settled on the use of a 'medium-sized' scale, and the depiction of key landscape features such as hills, rivers, settlements, woodland and parks, along with the employment of symbols, all of which required a carefully considered element of design. Low Countries map-makers such as Joan Blaeu and Jan Jansson issued English county maps based on Saxton in their monumental mid-seventeenth-century atlases published in Amsterdam, and well over a century later Philip Lea (d. 1700) drew heavily on Saxton, fully acknowledging his cartographic legacy. Lea had built up a large stock of map plates, amongst which were those that had belonged to Saxton. It took the Ordnance Survey one-inch map in the form of the Old Series, begun in 1801, to finally wean the cartographic representation of 'the country' away from Saxton's Tudor focus to a more modern and scientific interpretation of the layout of the land, the prominence of the landed gentleman's park slipping a little more discreetly into the landscape.

Saxton's atlas first appeared in 1579, his Gloucestershire map having been completed in 1577. This map measures 48 × 50 centimetres, and was produced at a scale of around 1:200,000, a practical choice given the size of the atlas in which it was to be placed, supported by a clear scale bar to the map's bottom right (fig. 21a). It depicts hills as rounded knolls, here coloured green and brown, located in the geographically correct area, although not named individually. Given that county mapping to a uniform specification was a novel concept, it therefore followed that Saxton's charmingly naive solution for depicting hilly terrain was a literal interpretation of what he could see on the ground. Other map-makers were clearly happy with this approach, because similar graphic interpretations of hills would be repeated, albeit in modified styles, over the next couple of centuries. Across the border into Worcestershire, the Malvern Hills can be seen – accurately somewhat larger in size than the hills of Gloucestershire, but still vaguely rounded in shape, and therefore not such a convincing portrayal of reality.

Apart from relief, Saxton added standardized symbols for settlements. Smaller settlements look the same, with a generally elliptical red inkspot (fig. 21b) overlaid on a black church-like structure, largely concealed beneath the ink (which was likely to have been added by the map's purchaser and not Saxton himself). Larger settlements show more complex urban forms beneath the red ink, for example Bristol and market towns such as Chipping Sodbury or Stow-on-the-Wold.

Key bridges are shown crossing rivers, with forests depicted by regular-sized 'lollipop' trees, seen in abundance in the Forest of Dean. Prominent in the landscape are noblemen's seats and their accompanying parkland, shown enclosed by wooden palings.

This particular map was engraved by Augustine Ryther, also known for his later engraving work on Ralph Agas's map of Oxford (1578) and John Hamond's map of Cambridge (1592). He too was a craftsman with an international reputation, a hint of which can be seen on the Gloucestershire

Fig. 21b Bristol and surrounding hills and woodland on Saxton's map of Gloucestershire, 1579. MAP RES 76, fol. 12.

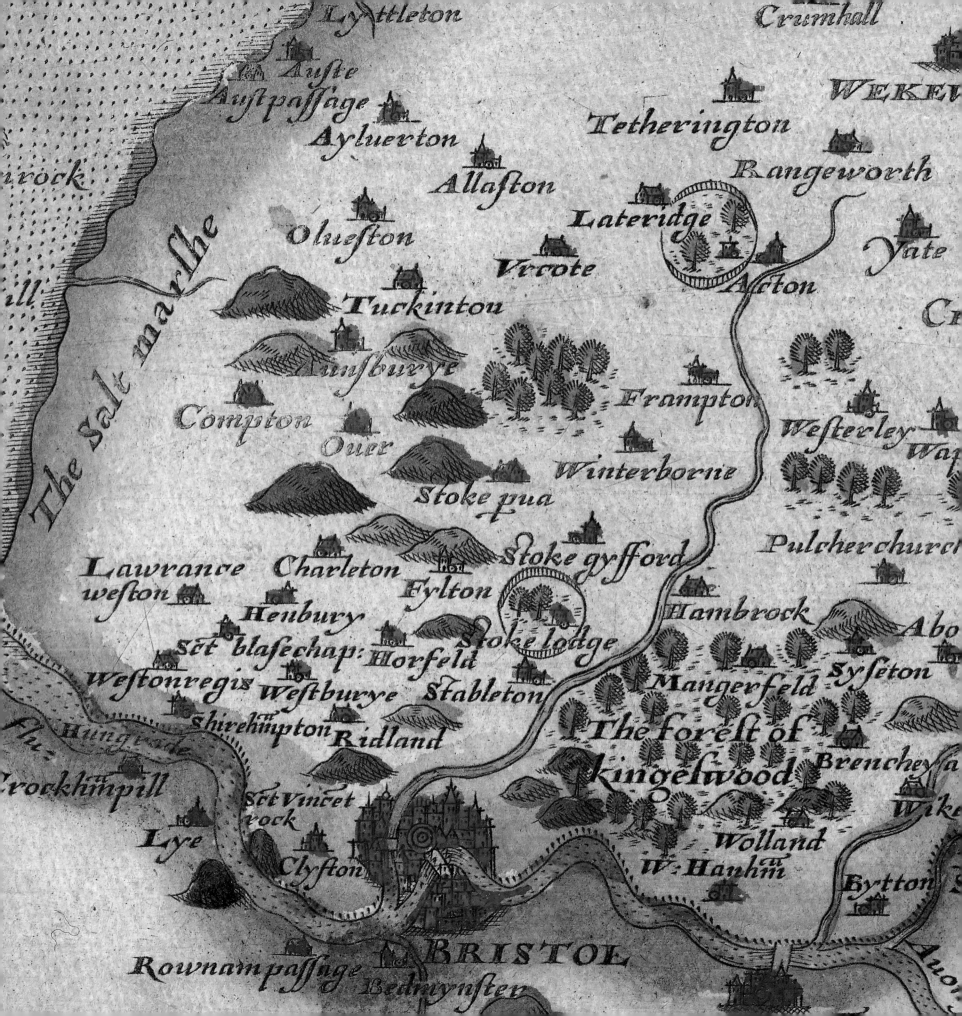

Lyttleton Crumhall

Auste

Austpassage WEKEV

Ayluerton Tetherington

rock Allaston Rangeworth

ll Olueston Vrcote Lateridge Yate

The Salt marthe Tuckintou Acton Cr

Tunfburye Frampton

Compton Westerley

Ouer Winterborne Wa

Stoke pua

Pulcherchurc

Lawrance Charleton Stoke gyfford

wefton Fylton Hambrock

Henbury Stoke lodge Abo

Sct blafechap: Horfeld Syfeton

Weftonregis Weftburye Stableton Mangerfeld

fhirehimpton Ridland The forest of

rockhimpill kingelwood Brenchey

Hungrode Sct Vincet Wike

Lye rock Wolland

Clyfton W: Hanhm

Bytton

Rownampassage BRISTOL

Bedmynster

map where he is referred to as 'Augustinus Ryther Anglus', the final word emphasizing his English identity at a time when Flemish engravers were recognized as being leaders in the field. Ryther also engraved Saxton's county maps of Durham, Westmorland and Yorkshire, as well as his map of the whole of England.

A final feature, in recognition of his generous financial support, is the presence of the Seckford family arms, placed on this map towards the bottom left, occupying much of Monmouthshire.

Weaving the Country

We can now see how Saxton established a defining cartographic template for representing the country. How might it be followed? The Sheldon tapestry map for Gloucestershire is woven in wool and silk, the surviving map fragment measuring 188 × 122.5 centimetres (fig. 22a). It is believed that, when complete, the tapestry's dimensions would have been around 610 × 460 centimetres. The geographical extent of the Gloucestershire fragment is from the northern suburbs of modern Bristol in the south-west, to just beyond Stroud in the north-east. The Forest of Dean, the Severn Estuary and the southern Cotswolds feature prominently. It was originally part of a set of four maps dating from around 1590. The set was commissioned by Ralph Sheldon for his home at Weston, near Long Compton in south Warwickshire. It concentrates on four midland counties of England, the tapestries' geographical extent covering all of the country from Shropshire to south London and from Leicestershire to the Bristol Channel. The total width of this panoramic view was approximately 23.5 metres (80 feet). Two of the original set, Oxfordshire and Worcestershire, are also owned by the Bodleian, which received them in 1809 as a gift from the antiquary Richard Gough. A final tapestry for Warwickshire is held by Warwickshire Museum. This set has no forebears in English map-making. They were ground-breaking developments at the time of their creation.

Sheldon was born around 1537 and became a Member of Parliament in 1563. He also set up a tapestry workshop in a Sheldon family property at nearby Barcheston. Whether the tapestry maps were woven at Barcheston is as yet unclear, but what is without doubt is his enthusiasm for and significant financial commitment to the delivery of this spectacular project.

So why were the tapestries commissioned in the first place? Sheldon was known to have an interest in cartography, and would have been aware of the interest generated by Saxton's innovative atlas. Saxton's map for Gloucestershire was made in 1577 and provided the source material for this tapestry. Almost everything that appears on Saxton's maps can be found on the tapestries, although Sheldon did bring a personal touch to the project by ensuring his properties were all shown, as well as those of his friends and relatives, thus embellishing the tale to project the Sheldon presence and seal of approval on the landscape described by Saxton.

Each tapestry had its titular county in the centre, the border shaded red and the surrounding counties depicted in varying pastel colours. The maps retain much of their original vibrant colour, and demonstrate a profound interest in the depiction of landscape, rivers and townscapes. Like Saxton's map, the tapestry shows hills as exaggerated rounded knolls, their right-hand flanks highlighted by darker colouring, another attempt at relief. They are located in the geographically correct area, though again not named individually. Bridges are rare, though there is a splendid arched crossing of the Wye at Chepstow, and an altogether more modest construction spanning the Little Avon at Stone. Forests are depicted by over-sized trees, soaring above churches and castles, unsurprisingly best seen in the Forest of Dean. The estates of the Crown, clergy and nobility define the landscape, all clearly identified within their wooden palings.

Unlike Saxton's map, each settlement is identified by its own unique vignette. The number of buildings portrayed is largely in proportion to the relative size of the settlement.

Fig. 22a Sheldon tapestry map of Gloucestershire, c.1590. MS. Don. a. 12 (R).

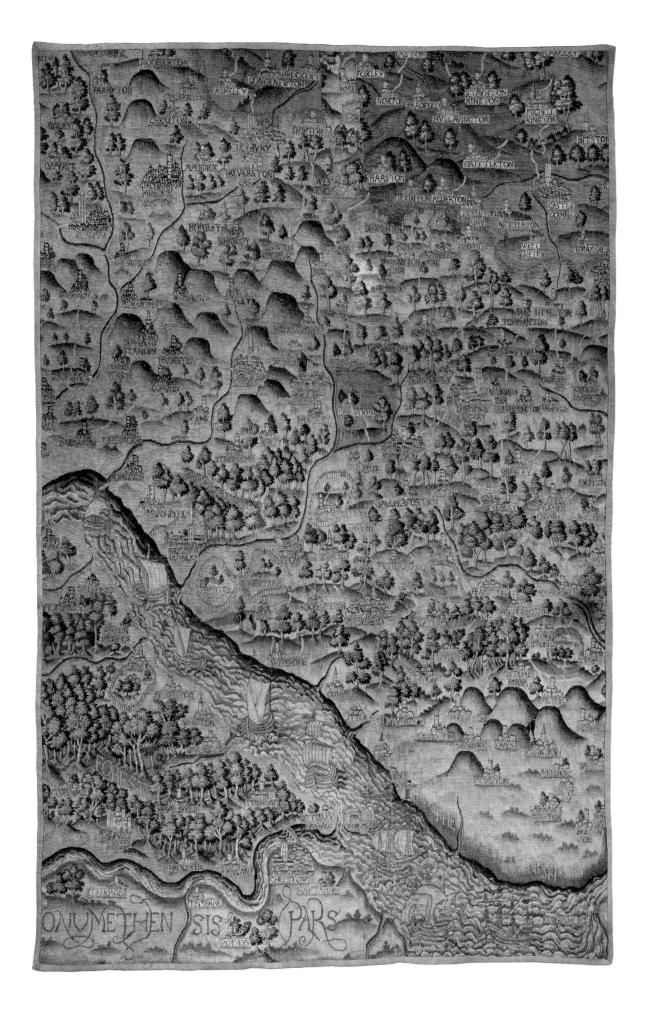

The fragment covers a largely rural area, but towns such as Chepstow, Stroud and Tetbury are somewhat grander in pictorial content than most, and present the viewer with a condensed image of the urban environment in Tudor times.

The story of the landscape is conveyed with remarkable clarity and precision, and displaying such a visually overwhelming artefact of the country, painstakingly woven in silk and wool on such a grand scale, clearly drove Sheldon's investment in the medium. Today we forget the power of tapestry to represent its owner's wealth and influence, as those that have survived are often faded and in poor repair after centuries of exposure to light. But in Sheldon's time they would have been a startling riot of colour and decoration, glittering in candlelight and dominating the domestic interior of Weston House. The house itself, and by extension Sheldon, is shown at the very heart of the country, all represented in a spectacular and novel fashion.

Over the subsequent centuries the Gloucestershire tapestry was broken up into many parts, not all of which have survived. All four tapestry maps were in the Sheldon family's possession until 1781, when they were sold along with the remainder of the contents of the now long-gone Weston House. In terms of their cartographic legacy, four more maps were woven in lower-grade second editions in the mid-seventeenth century, commissioned by Sheldon's grandson. The concept lived on, but the enthusiasm to create such magnificent artworks did not, as tapestry increasingly fell out of fashion from the late seventeenth century – hence their rarity, which is part of what makes them so intriguing to us now.

What also needs to be appreciated is the overall design concept for the tapestries. Whoever brought them to life in Sheldon's tapestry workshop was clearly aware of Saxton's project, but the genius here concerns the massive upscaling of the maps, almost by a factor of ten, to around 1:25,000, and the talent required to interpret each map and transfer it onto a loom to incorporate all the neighbouring counties, which Saxton was likely to have mapped at differing scales.

Fig. 22b Detail of Chepstow and the Forest of Dean, Sheldon tapestry map of Gloucestershire, c.1590. MS. Don. a. 12 (R).

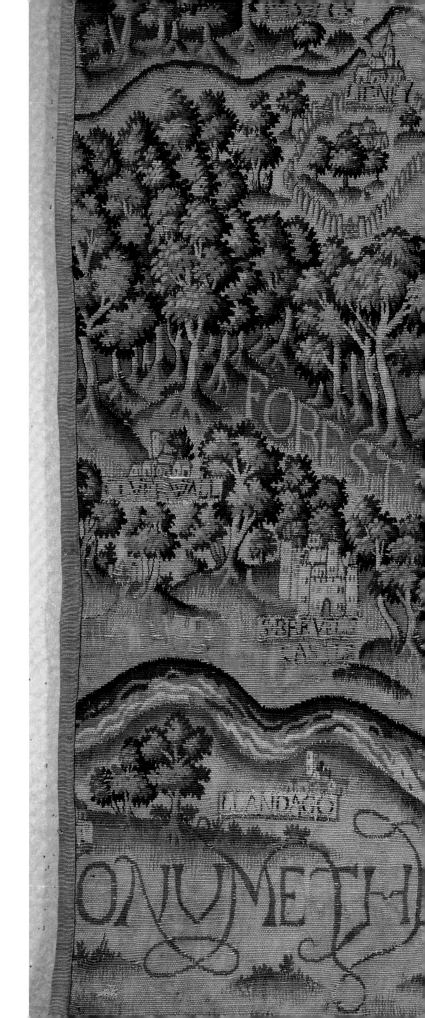

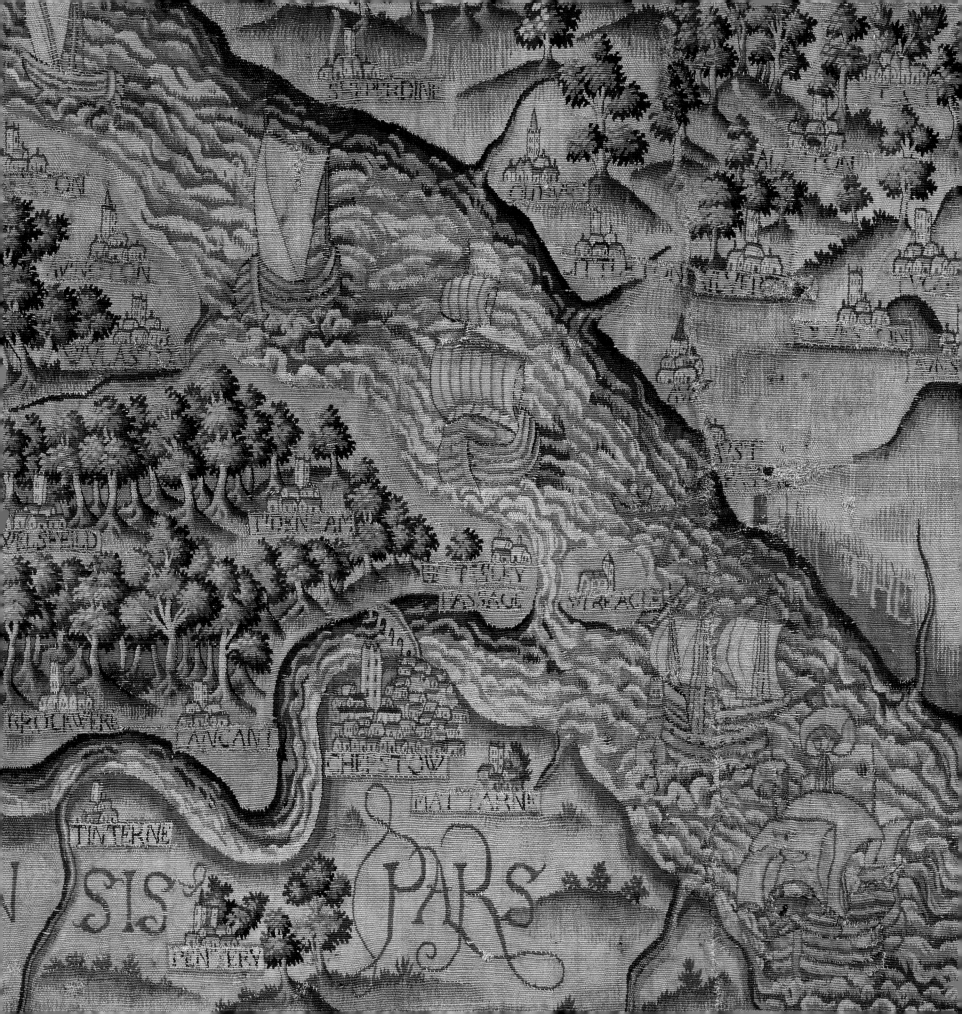

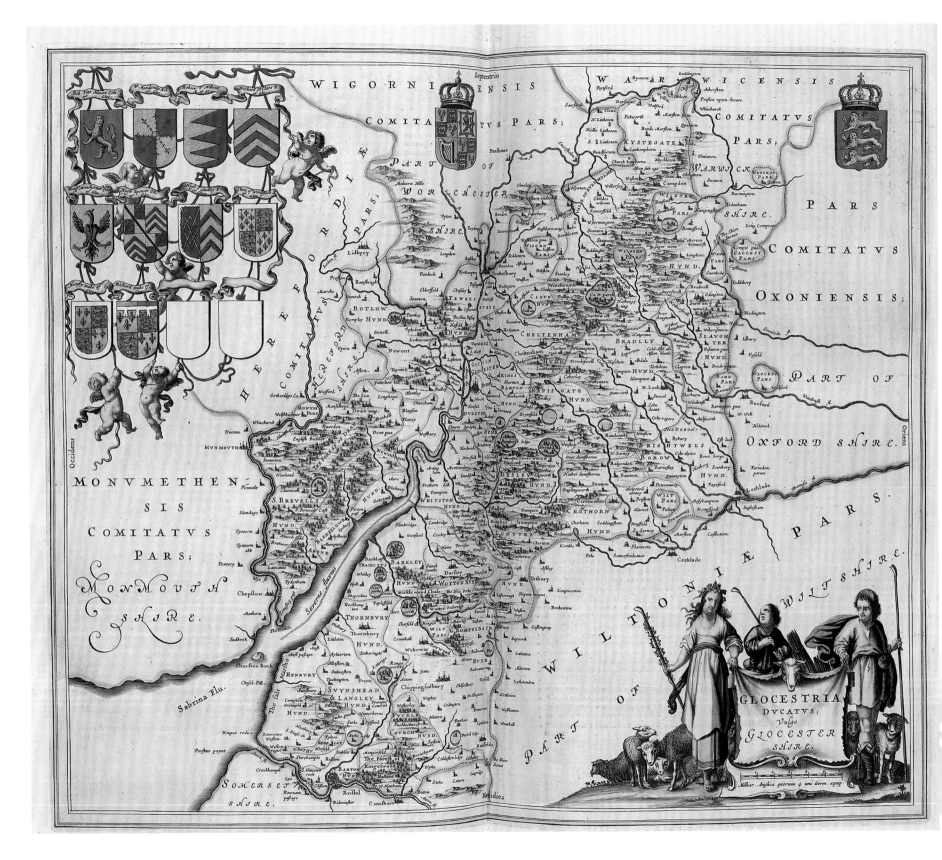

GLOCESTRIA
DVCATVS;
Vulgo
GLOCESTER
SHIRE.

The tapestry's designer managed to incorporate these maps alongside the central county, and to adjust scales accordingly. To add to the difficulty, all of Saxton's maps are oriented to the north, but the Gloucestershire tapestry, and also Warwickshire, place east at the top – a further design challenge, and perhaps an indication of the relative shapes of these counties and how they might have been envisaged hanging on display at Weston House.

The Dutch Connection

At first sight Joan Blaeu's 1648 map of Gloucestershire (fig. 23) bears distinct similarities to Saxton's. It appeared in his *Atlas of England*, published in Dutch, French, German, Latin and Spanish, and shown here in its French edition, the fourth volume of *Le Théâtre du Monde ou nouvel atlas*. Measuring 40 × 50 centimetres at a slightly larger scale of 1:180,000, this map is principally derived from John Speed's *Theatre of the Empire of Great Britaine* (1611–12), the county maps which were directly 'borrowed' from Saxton. The slightly larger scale renders the map marginally less cluttered, given that Blaeu altered little of the details Saxton chose to include.

In Blaeu's map, we see that the hills are not as rounded as Saxton's – they are flatter in profile but not really 'Cotswoldesque' in appearance, and as such have a more natural appearance. Blaeu's trees are more realistic, and he also includes bridges, which can be seen in the 'usual' places at Chepstow and Stone (as well as Berkeley and Stroud). Additional material inserted by Blaeu includes hundred boundaries, again taken from Speed. These are boundaries reflecting the administrative division of the land at the level below that of the county. Gloucestershire was divided into twenty-eight hundreds, which were in turn subdivided into parishes. Also added is the splendid cartouche adorned with sheep emphasizing the importance of wool to the Gloucestershire economy, and the coats of arms of ten earls and dukes of Gloucester; two shields remain unfilled.

Bryant's Map of Gloucestershire

Very little is known about Andrew Bryant, other than that he was active as a cartographer from 1822 to 1835. He was a surveyor and publisher, based in London's Great Ormond Street. His intention had been to produce an atlas of British county maps, but only twelve were completed in addition to his Gloucestershire map: Hertfordshire (1822); Suffolk and Surrey (1823); Norfolk, Oxfordshire, Buckinghamshire, as well as Gloucestershire (1824); Bedfordshire (1826); Northamptonshire (1827); Lincolnshire (1828); East Riding of Yorkshire (1829); Cheshire (1831); and finally Herefordshire (1835). Bryant and the more prolific Christopher Greenwood were the last principal county map-makers to flourish prior to the emergence of topographic mapping by the state on a national basis in the form of the Ordnance Survey. The pre-eminence of the county map was about to be superseded.

Unlike Greenwood, Bryant's project failed to deliver his proposed *British Atlas, or, A Series of Maps of the Counties of England and Wales, Made from New Surveys, under the Superintendence and Direction of A. Bryant*. His thirteen completed maps, however, were magnificent, as can be seen in the detail of Gloucestershire (fig. 24a), completed at the relatively large scale of just under 1:44,077, or 1⁷⁄₁₆ inches to the mile. The map is dedicated to Gloucestershire's Lord Lieutenant, the duke of Beaufort, as well as the county's 'Nobility, Clergy and Gentry', which is very much reflected in the map's content: Bryant was always keen to show gentlemen's landholdings, and here they can been seen in a rich green colour, distributed across the landscape. Some things seldom change, and Bryant was adhering to the formula devised by Saxton, and witnessed in the tapestry and Blaeu's map – keeping the wealthy and influential as defining 'the country'.

Bryant was only twenty years old when he began work on his first county map of Hertfordshire in 1820. He issued a prospectus for the map, inviting subscriptions in 1821 and promising publication in 1822. He was able to use survey data generated by the fledgling Ordnance Survey,

Fig. 23 Joan Blaeu, map of Gloucestershire, *Atlas of England*, 1648. MAP RES 31, pp. 171–2.

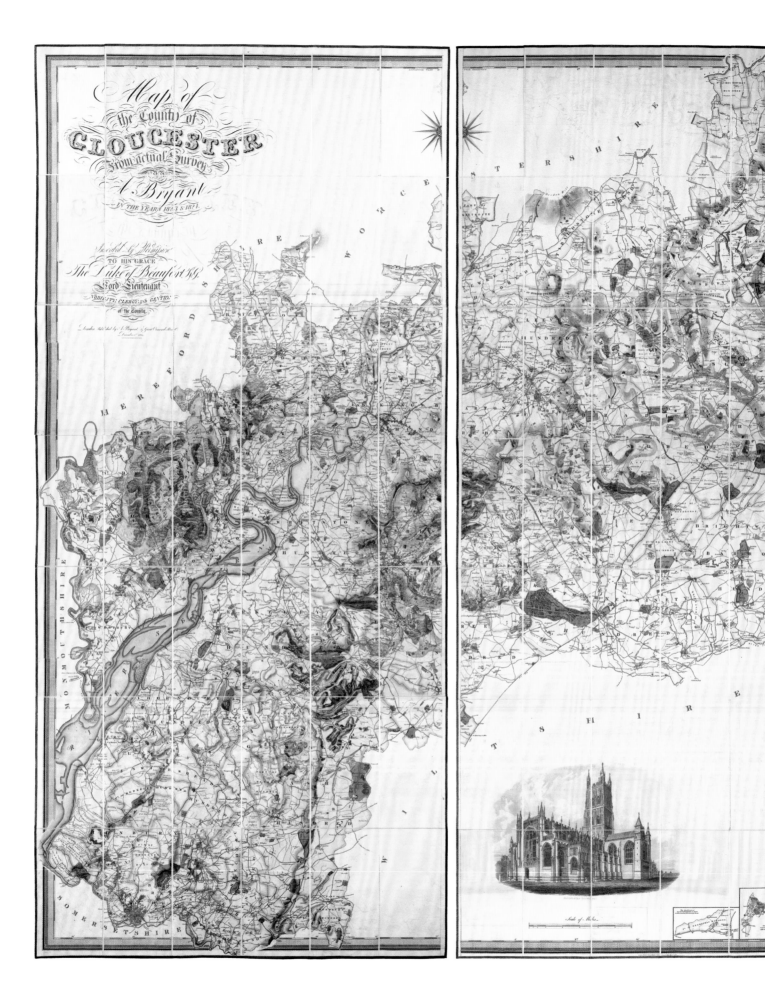

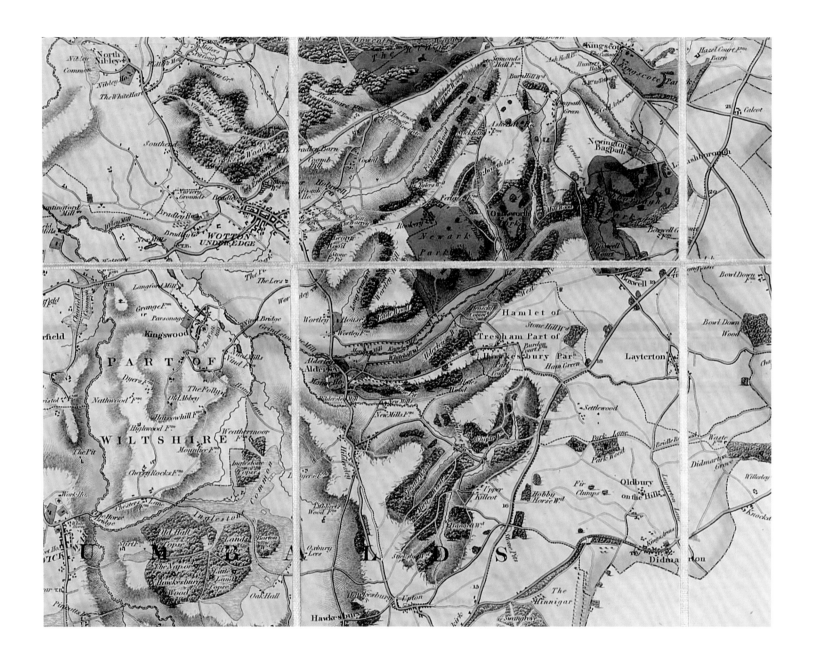

left Fig. 24a Andrew Bryant, map of
Gloucestershire, 1824. Allen 189.

above Fig. 24b Detail showing parkland (in green)
at Badminton and depiction of hills using hachures
around Wotton-under-Edge on Bryant's map of
Gloucestershire, 1824. Allen 189.

Explanation

Names of Hundreds		as S.ᵗ BRIAVELS
Market Towns		NEWNHAM
Parishes		Lydney
Villages, Gentlemens Seats, Lanes, Heaths,		in Italics
Commons, Marshes, Woods, Hills, Water &c.		

Buildings .. 35

Churches & Chapels

Parks

Castles

Nursery Grounds and Gardens

Wind and Water Mills

Rivers and Ponds

Canals

Heaths and Commons

Marshes

Woods

Hills

Turnpike and Mail Roads

Good Cross or Driving Roads

Lanes and Bridle Ways

Roman Roads

Iron Rail Roads

Number of Miles distant from London 87

Toll Bars TB

Fox Covers △ ▽ ▷

County Boundary

Hundred D.º

Parish D.º

reducing the amount of first-hand surveying undertaken in the field. Not that Bryant was inactive beyond his London premises. He sent out surveyors to walk the landscape and to acquire existing maps, and was thus able to draw up a fresh interpretation of 'the country' by combining new observations with information extracted from existing maps. His intention was to map each county's internal administrative divisions, gentlemen's seats, settlements, vegetation types, industrial sites, waterways and roads. This included the booming canal network, witnessed on this map in the Berkeley and Gloucester Canal and the network of canals serving the coal pits in the Forest of Dean. All are apparent in Gloucestershire, with the hundreds gorgeously depicted in pastel colours. Many of the principal roads feature running mileages on the map, which according to the legend show distances from London. This is not the case in reality, and only the course of the modern A44, running across the north of the county through Moreton-in-Marsh towards Evesham actually does this – the remaining mileages depicted around the county have local origins, frequently using Gloucester and not the capital as the starting point. The legend is itself a thing of beauty, placed on the eastern edge of the Cheltenham half of the map. Such explanatory detail was omitted by the likes of Saxton and those who followed – their maps were insufficiently detailed to require a legend. Relief depiction is achieved by finely engraved hachures, graphically bringing the Cotswolds to life. Mapping at a larger scale enabled Bryant to be more precise when representing hills, and by using hachures he was able to mark the exact locations of hills, and their undulations as seen from above; earlier cartographers had settled for a vaguer three-dimensional interpretation, leaving what lay 'behind' the hill very much to the map user's imagination.

The Gloucestershire map was therefore one of Bryant's earlier productions, completed at a time when his project appeared to be on the way towards delivering full national coverage. The Bodleian's copy of this map consists of two sheets, each measuring 192 × 89 centimetres and covering the western and eastern halves of the county respectively. The county had seen nothing to match this since William Faden published Isaac Taylor's 1777 one-inch map in 1800, so Bryant was offering something cartographically new, and refreshingly striking, as well as an 'upgrade'. To add to the intrigue, however, Greenwood also published a map of the county, also in 1824, but at the smaller scale of 1:63,360 – one inch to the mile. Whether or not this had an impact, the following year saw Bryant begin to reconsider the viability of his project. A new prospectus mentioned fewer features to appear on forthcoming maps, and smaller-scale mapping was being proposed. Already the uniformity of his scheme was being abandoned.

In total, Bryant succeeded in mapping around 30 per cent of England. Like Saxton before him, and Saxton's successors, there was a focus on including the aristocratic and entitled on his maps – a trait that the state-sponsored Ordnance Survey could afford to downplay, as it had no requirement for individual subscribers to bankroll its map-making. Bryant's project was not a financial success, but the ensuing cartographic product most definitely was. His maps were visually attractive, and incorporated the likes of 'ancient encampments', as well as paying thorough attention to the most basic of administrative units, both civil and ecclesiastical.

Ordnance Survey Old Series

A paradigm shift was ushered into the mapping of Britain with the emergence of the Ordnance Survey. Gone was the idea to map the country on a county-by-county basis. A truly national map was conceived. The Ordnance Survey was created in 1791, initially in response to the threat of invasion from France – yet following the lead from the grand eighteenth-century French project masterminded by the Cassini dynasty to accurately map the whole of France. In 1801 the intention was to map the entire country to standard specifications at a scale of one inch to one mile

Fig. 24c The key to Bryant's map of Gloucestershire, 1824. Allen 189.

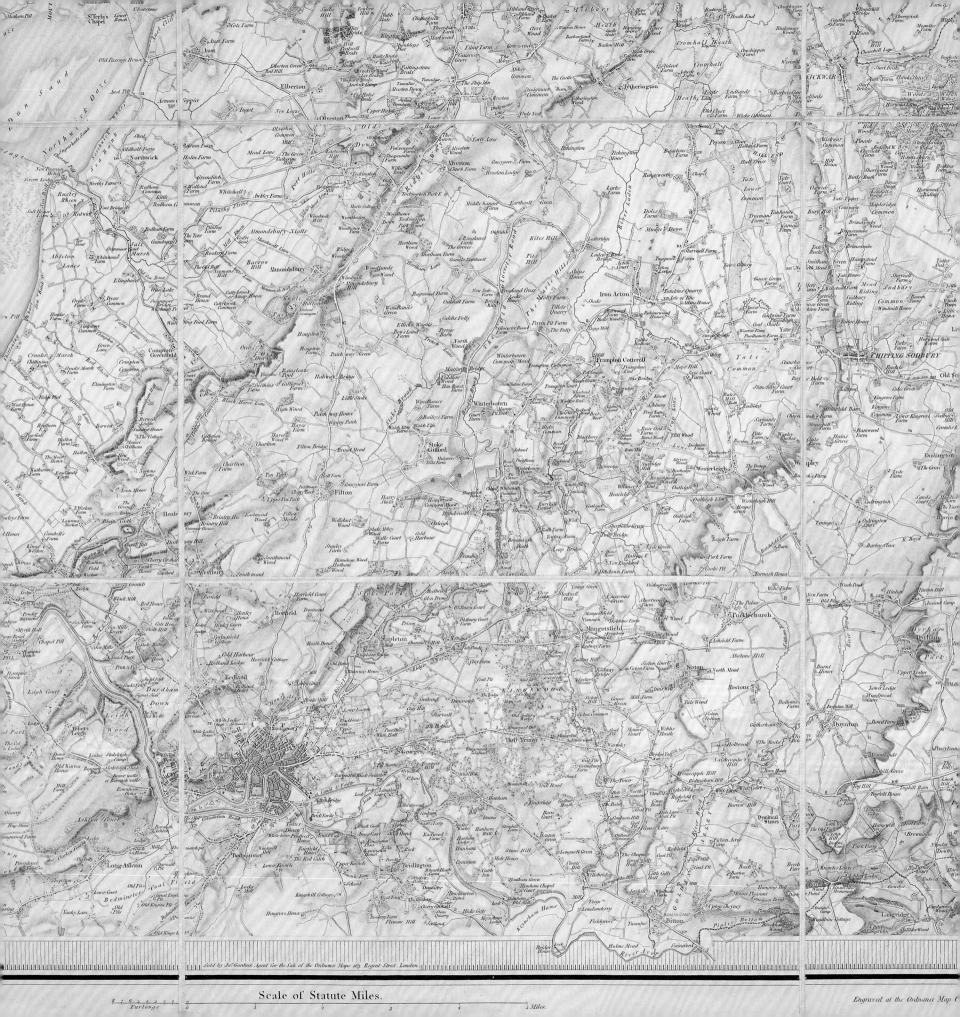

Scale of Statute Miles.

Furlongs

Miles

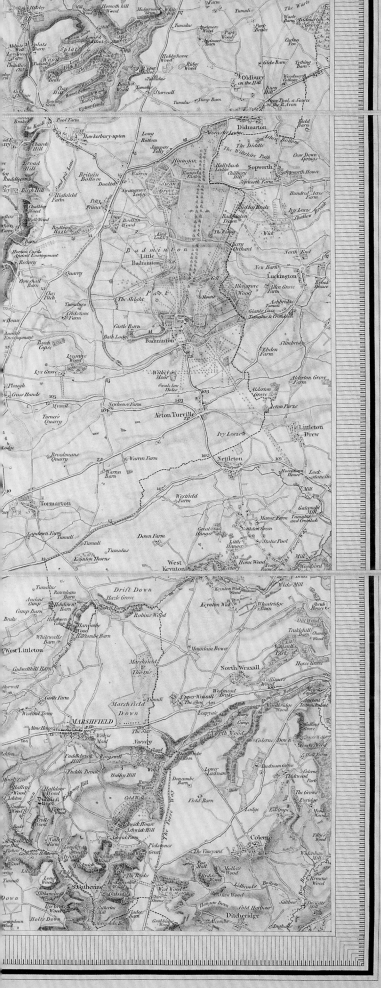

(1:63,360), the first published sheet covering Kent. Designed to commence with the south coast of England, what became known as the Old Series for England and Wales was only finally completed with the Isle of Man in 1874, fully seventy-three years after its inception. It was made up of 110 regular-sized sheets, laid out in a grid without any overlaps.

Old Series maps performed the same basic function as a modern much-loved magenta-coloured Landranger map. The scale is now slightly larger at 1:50,000, many maps in the series overlap, hachures have been replaced by contours, and they are printed in colour, but the aim of both series is to map the whole country at a standard scale. The principal difference is the employment of symbols, a technique largely unused in Ordnance Survey's earlier maps. The landscape is presented with a degree of uniformity, despite the one-time military stimulus for the maps being quickly superseded by civilian requirements.

Measuring 78 × 62 centimetres, sheet 35 (fig. 25) covers an area not too dissimilar to what remains of Sheldon's tapestry map. The monochrome appearance at first sight looks like a downgrading of cartographic quality, but a glimpse of the high standard of engraving in evidence quickly confirms the beauty of this most precise of cartographic enterprises. Hachures dominate the map, whilst the major centre of population, Bristol, sits quite understatedly beneath the neighbouring heights of Clifton Down. The lack of symbols is significant. Where is the 'church with a tower' or 'public house' that we might expect to see now? Nowhere. Symbols would be added to the Ordnance Survey one-inch map in due course. But the roads and canals are clear, individual buildings in rural areas stand out, and the presence of bridges is inferred rather than marked as such. Those by now familiar river crossings at Chepstow and Stone are still shown, but only as a road *above* a river. There are no arches or parapets in sight. Does this mean that map users had become more sophisticated?

Ordnance Survey's influence on subsequent cartography is clear to see. 'Ordnance Survey map' is a frequently used term, and often an incorrectly attributed reference to an

Fig. 25 Detail of Ordnance Survey Old Series of England and Wales, sheet 35, published 1830. Allen 385. On this map, the use of finely engraved hachures to indicate relief has replaced perspective views.

authoritative map: in Britain, Ordnance Survey is perceived to be the benchmark of cartographic veracity, the story of its success regularly seen in the Bodleian Library with requests taking the form 'do you have Ordnance Survey maps of …?'. It constitutes an impressive legacy – one that the pioneering Christopher Saxton could never have foreseen, but would probably have admired.

Our story of 'the country' has witnessed the democratization of cartography, from privately funded tapestry projects to maps designed for sale to the wealthy and influential, through to Ordnance Survey's mapping for all. The online OpenStreetMap has extended this concept:

mapping not just *for* all, but *by* all. Its copyright-free cartography is created by a global community of enthusiastic map-makers wandering over the landscape and constantly adding content, not just to south Gloucestershire, but to the whole world.

The same tale has been told in very different ways. We have seen southern Gloucestershire's progression from largely agrarian Tudor times to the dawn of the railway age. Those initial questions posed at the start of this chapter can now be answered. Colour is not essential, but as the illustrations have shown, it certainly adds to the aesthetic appeal of any map. The move from monochrome to colour at Ordnance Survey was partly driven by commercial considerations, with

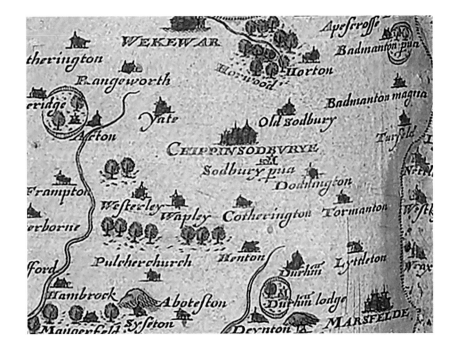

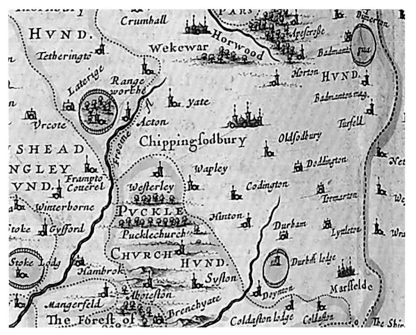

the attractive products of cartographic rivals like John Bartholomew and Son Ltd encouraging Ordnance Survey to create maps capable of luring in potential customers.

The 'country' map's scale has generally seen a steady increase from Saxton's time, and this makes sense, especially as the landscape has gained features, as we might expect given the increase in population for southern Gloucestershire over the intervening centuries: for example, more buildings as settlements grew, or the arrival of man-made developments such as canals. Relief depiction has become ever more scientific, evolving from rounded hills that look like hills to a series of curved lines that look nothing like hills

whatsoever, but can be interpreted by the map's user and reimagined into undulations far more accurately portrayed than a stylized hilly view.

The examples of text used on each of the featured maps has clearly altered, ranging from the bold uppercase place names inserted into the tapestry to the disarmingly subtle abundance of toponyms artistically positioned on the Old Series map. Both are clear to read, but which complements the map better? Without a doubt the carefully chosen, multiple-sized serif lettering preferred by Ordnance Survey is easier on the eye. An appropriately fine conclusion to this particular story.

Fig. 26 Four maps showing the area around Chipping Sodbury in Gloucestershire: Saxton (1579), Blaeu (1648), Bryant (1824) and Ordnance Survey (1830).

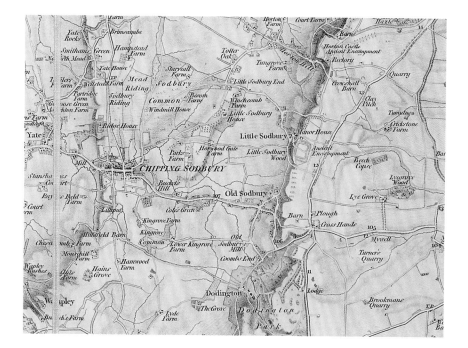

PARTE OF KIRTON LORDSHIP

PARTE OF ECMONTON LORDSHIP

PARTE OF WESTON LORDS:

PARTE OF OMPTON LORDSHIP

PART OF OSSINGTON

PART OF

LORDSHIP OF

OSSINGTON.

PART OF RVFFORD ABBY FIELDES

PART OF THE LORDSH OF AKERING

PARTE OF THE LORDSHIP OF KARSALL.

PARTE OF

4

The Land

The story of the management of the land is best told graphically. Cartographically. Our focus in this chapter sees the written word brought spectacularly to life by a map created in the Stuart period, one designed to visualize a manuscript text by graphically transferring words on a page and repackaging that information as an easily recognizable manifestation of space on the ground. Yet this map still resonates with a contemporary audience, as the landscape depicted in such intricate detail remains, in many ways, substantially unaltered almost four centuries later. It is known simply as 'the Laxton map'.

Laxton is a village in Nottinghamshire remarkable because its current pattern of agricultural land use remains unusually similar to that in place since feudal times. This manuscript map, made in 1635, shows the layout of the open field system surrounding the village, and its accompanying book or terrier describes each of the thousands of strips of land, measuring each strip's area, and identifies the strips' occupiers. Laxton and its inhabitants are brought back to life, via cartography, as this one map tells the story of those who populated the landscape surveyed on the map under the reign of King Charles I.

The agrarian landscape of much of England had been built upon Norman feudal foundations with the layout of small thin cultivated strips micro-managed on behalf of the lord of the manor. Villages would conventionally be divided into three large fields subjected to annual crop rotation, alongside an area of common land. The eighteenth-century agricultural revolution, however, encouraged enclosure and its enhanced efficiency, which in practical terms saw the three large fields plus the common reimagined into a patchwork of smaller *enclosed* fields, farmed by far fewer individuals, no longer in the service of the lord of the manor. As a result, those people who no longer had strips on which to work found their place on the land had disappeared, and mass migration to the rapidly expanding towns and cities ensued. Therefore, not only did the landscape take on a completely new appearance, but the social make-up of the countryside was fundamentally altered. This happened throughout the country, but failed to occur in Laxton.

The Laxton map was drawn and painted by the land surveyor Mark Pierce (fl. 1600–35), who had previously completed surveys in Cullompton (Devonshire), and in tandem with his father, Samuel, in Belhus (Essex) and Maidstone (Kent). Its vibrant explosion of colour and character appears with the grandiose title of *A Plat and Description of the Whole Mannor & Lordship of Laxton with Laxton Moorehouse in [y]e County of Nottingham and also of the Mannor & Lordship of Kneesall Lying Adiacent to [y]e Aforesaid Mannor of Laxton*. The cartographic content of this map is not particularly unusual for maps of this genre from the early Stuart period, but it is the map's legacy which has fortuitously set it apart.

Rural Life

The Laxton map tells a dynamic story which has ramifications on a variety of geographical, historical and sociological levels. What at first sight seems to be a map depicting the rural landscape in a small area of Nottinghamshire has numerous tales to impart. We are

Fig. 27a Detail of the Laxton map, 1635, showing the open-field system of land management. MS. C17:48 (9).

easily transported into the Laxton of 1635, the cartographic depiction of the countryside redolent of a landscape painting. Not only do we see fields and settlements, but we also see people busy working in the landscape. We can even see what sort of clothes they wear. They are engaged in harrowing, harvesting, haymaking, milking, mowing, ploughing, scything, shepherding and sowing. These activities do not all take place at the same time of year, so the scenes need to be viewed with care. We also witness people indulging in rural sporting activity, hunting deer and hares, as well as hawking. Aside from those animals being hunted, there are the domesticated creatures visible in the fields – cattle, horses and sheep (fig. 27b). This map is vividly alive in its content. Such is the sheer size of the map that the viewer can be drawn in at any location and begin to read the story of rural life.

Buildings are represented as perspective views, and only the occasional structure is to be found beyond the confines of the two villages of Laxton and Kneesall. Farmsteads are not generally surrounded by fields, but farm buildings are located at the roadside within the villages. Other than three splendid windmills towards the centre of the map, almost all the buildings are to be found concentrated within both villages. Indeed, there are no smaller lanes leading off the principal thoroughfares, and no concomitant suggestion of

human habitation other than a peculiar outlier on Westwood Common towards the map's north-western corner (labelled as Edward Harrison's 'cottage and little croft' and marked as plot 124). Everybody lived within the tight confines of the villages themselves and virtually nobody occupied accommodation beyond the villages' bounds; there are no farms set aside in the fields as we might expect to find in the early twenty-first-century Midlands.

The Open Field System

The importance of Laxton, its map and its accompanying terrier is underlined by the relevance of artefacts today. Laxton has not abandoned the open field system of land management that functioned in 1635, and as a result twenty-first-century Laxton looks very similar cartographically to seventeenth-century Laxton (fig. 28). The road network is practically the same, and the village's buildings and farms are still located alongside these roads. Most importantly, those strips of land so clearly visible on Pierce's map can still be seen in the landscape today (fig. 29). Kneesall, to the south-west on the map, was enclosed in 1778, but only small parts of Laxton met this fate, and that was a much more gradual process. There was a major consolidation of land holdings in the four years from 1903, whereupon the average strip size increased fivefold in area from around three-quarters of an acre to roughly three and three-quarter acres. In 2019, only a quarter of the current parish of Laxton remains as open fields.

Fig. 27b Detail showing animals depicted on the Laxton map. MS. C17:48 (9).

We can clearly read the map as a comprehensive narrative, which shows us detail from the everyday reality of life within this feudal English landscape. Around Laxton village are marked 3,333 strips of land, many of them tiny (and there are another 2,030 in Kneesall). They occupy three large fields, as well as Laxton demesne and village, plus neighbouring Moorhouse, each strip labelled with a unique alphanumeric identifier. So extensive is the amount of information associated with each individual parcel of land that observers have branded Pierce's map 'the first GIS [Geographical Information Systems]'.[1] Over three and a half centuries before such arrangement of spatial information became commonplace, the Laxton map worked by mapping *attribute data*, precisely the task that a GIS performs in the twenty-first century.

The key, however, to disclosing the map's story comes in the shape of the accompanying folio manuscript terrier, entitled *A Booke of Survaye of the Whole Mannor and Lordshipp of Laxton with Laxton Moorehouse in the County of Nottingham*. The volume consists of around 400 pages, with lord of the manor Sir William Courten's arms placed on the cover. It lists all those alphanumerically identified strips, clearly marked page after page in numerical order. Each line of information not only refers to every strip by its unique number, but also names the occupier and owner responsible for farming each parcel of land, and states the area of each plot in acres, roods and perches at the time of the survey. Once the strips

have been described, there follows a recording of the status of the meadows, pasture land and arable land which remained under the full control of the lord of the manor. The terrier consists of 228 openings, bound in parchment and measuring 35.5 × 48.5 centimetres, all beautifully laid down in secretary hand, the handwriting used chiefly in legal documents from the fifteenth to the seventeenth centuries. This volume, with its wealth of detailed information, allows us to discover even more stories about daily life in seventeenth-century Laxton. If we select an individual named in the terrier at random, we can work our way through the book's pages and observe that individual appearing time after time, tied to locations across the map, and we can quickly begin to understand the spatial distribution of that person's daily routine, and to grasp the rhythm of everyday rural life.

So, by selecting Robert Rosse, for example, we can see that he has been recorded as being 'in question for freehold', occupying just over twenty-six acres in total, twenty-four of these being 'pasture and arable' and the remaining two being 'meddow land'. He is shown to be dwelling in a cottage and yard in the tenement of Edward Alicock (plot 60, just north-east of Laxton church), and as paying two shillings per annum to the parsonage of Laxton. Elsewhere in the village Rosse occupies a further seven acres a short stroll along the road to the east (plot 68). This is the largest plot to fall under his charge, and is described as 'a Messuage yard & 2 Houses'.

Fig. 28 Laxton area, 2018.
Fig. 29 Aerial photograph of Laxton.

Laxton Towne

				
44	John Jepson a Cottage & yard —	0	0	38
45	George Smalpage a Cottage & yard —	0	1	23
46	James Smalley a Cottage & yard —	0	0	32
47	Mr Broughton a Cottage & yard —	0	0	36
48	Mrs Hinde a Cottage yard Fr —	0	0	22
49	Rowland Tailer a Cottage & yard Fre —	0	1	13
50	Mr Broughton a Cottage & yard Free —	0	0	34
51	Lee Late Rich Tailer a Cottage yard Fre —	0	0	27
52	Tho: Severs a Cottage yard & orchard —	0	2	3
53	George Page a house & yard —	0	1	4
54	Richard Sheave houseth west croff & close —	8	0	11
55	John Hurst a Cottage & yard —	0	3	19
56	John Hurst & Rowlands house —	2	2	11
57	The Parsonage barne & yard —	1	2	28
58	Mr Broughton a Coff & close —	1	3	1
59	William Graybrough a Cottage yard —	2	2	11
60	Robt Rosse a Cottage & yard —	1	1	16
61	Thomas Parker a Cottage & yard —	0	3	19
62	Robt Cadman a Cott yard & Chantry Land —	1	1	14
63	Thomas ffreeman a Cott & close —	4	0	1
64	Mrs Hinde a Cottage & yard Fre —	1	3	0
65	Charles Candaile a Cottage & yard —	1	0	31
66	Nicholas Palthrop a Cottage & yard —	1	1	1
67	Mr Brought a Messuage yard & close Fre —	3	2	1
68	Robt Rosse a Messuage yard & 2 Houses —	7	2	25

Marginal notes: "Bob in 1653." (near 49); "Bob in 1665." (near 51); "5 : 0 : 10" (near 56).

There is another small plot just south of the village green (118), and a further strip of land off the westbound road to Mansfield (26). In addition, Rosse is shown to be working five strips in West Field, one of which is relatively substantial in size (454). In East Field there is another strip, very close to that relatively large patch of 'a Messuage yard & 2 Houses' (793), five more strips in Long Meadows, seven in South Field, twelve in Mill Field, a plot in Shitterpoole Meadows, another in South Lound Meadows, and finally a strip in East Kirk Inge. None of these thirty-six pieces of land are adjoining with the exception of a pair which straddle the road in West Field. The most distant from Rosse's home was the East Kirk Inge plot (2865), almost five kilometres away when following the road and tracks heading east from the village. So, would Robert Rosse have concentrated his farming activities where the greatest concentration of the land he was farming lay, that is just south and just west of the village centre? It is impossible to say for sure, but what is clear is just how wide-ranging Rosse's land was, his plots of land distributed over 16 square kilometres (figs 30–33).

Making the Map: Mark Pierce

The manor of Laxton had been purchased from the duke of Buckingham in 1625 by Sir William Courten, an East India merchant of the City of London, and ten years later Courten commissioned Pierce to make both the map and the terrier. Courten had employed Pierce in the past, on his 1619 survey of Belhus, so he would have known he could rely upon the quality of Pierce's cartographic output. Courten's interests were not solely associated with east Nottinghamshire. He was heavily involved in financing the establishment of the English colony of Barbados, which had been discovered by a vessel from his fleet of twenty trading ships in 1624, although by 1635 he no longer had a financial stake in the island. This fleet traded with Portugal, West Africa and the West Indies, so the Atlantic Ocean had become very much part of Courten's commercial repertoire.

Measuring 178 × 203.5 centimetres, and drawn at a scale of roughly 1:3,960, the map survives on nine rectangular

Fig. 30 Extract from the Laxton terrier referring to plot 68, 1635. MS. Top. Notts c. 2, fol. 16r.

James Nicholson, Tenem: in mortmaine, wch ye Lord may ceasse on to his own vse	12	1	20
Whereof { Meddow land	0	1	23
{ Pasture & arable	11	3	37
ffor this Tenem: is paid iij s iiij d p añm to ye Parsonage of Laxton, & it is set down among ye Cheife rents.			
Robert Rosse, in question for freehold	26	0	23
Whereof { Meddow land	2	0	15
{ Past: & arable	24	0	8
ffor a cottage & yard (pcell of this Tenem: in ye tenure of Edw: Morot) is paid iiij d p añm to ye Parsonage of Laxton, exprest in ye Cheife Rents.			
John Bullivant, a small Tenem: of Pasture and arable land contayning	1	3	10
ffor wch he payeth ye yearly rent of		xxvj s	
George Smallpage, Tenem:	7	3	10
Whereof { Meddow land	1	1	22
{ Pastu: & arable	6	1	28
ffor wch he payeth ye yearly rent of		xl s	
John Jepson late widd: Nicholson	2	3	36
Whereof { Meddow land	0	1	26
{ Pasture & arable	2	2	10
ffor wch he payeth the yearly rent of		xxxx s	

John ffreeman, Jn the town 38. Jn West field 135. 151. 206. 238. 241. 264. 273. 304. 322. 326. 328. 334. 357. 385. 432. 434. Jn South field 907. 942. 1042. 1190. 1253. 1329. 1440. 1451. 1501. 1507. 1536. Jn Mill field 1666. 1675. 1684. 1708. 1751. 1772. 1792. 1796. 1845. 2013. 2015. 2037. 2063. 2069. 2126. 2130. 2222. 2366. Jn Shitterpoole meddow 2455. Jn Longe medd: 2597. 2620. 2662. Jn East kirk Jnge 2863. 2894. 2907.

Samuell Bothem, Jn West field 133. 139. 339. 358. 391. 400. 413. 427. Jn the East field 632. 758. Jn South field 956. 1111. 1185. 1266. 1342. 1409. 1457. 1495. Jn Mill field 1643. 1725. 1755. 1839. 1888. 1958. 2070. 2144. 2203. 2330. 2368. 2382. Jn Shitterpoole medd: 2453. Jn Long medd: 2510. 2572. 2626. 2677. Jn South lound medd: 2771. Jn East Kirke Jnge 2805. 2822.

Laxton Parsonage. Jn the town 57. Jn West field 159. 209. 333. 373. 520. 532. Jn East field 775. Jn South field 895. 1000. 1051. 1158. 1193. 1425. 1486. 1554. Jn Mill field 1649. 1652. 1672. 1720. 1734. 1815. 1938. 1999. 2032. 2043. 2115. 2160. 2169. 2293. 2313. 2361. 2369. Jn Shitterp: medd: 2443. Jn Long medd: 2502. 2581. 2646. 2682. Jn South lound medd: 2737. 2784. Jn East kirk Jnge. 2855. 2887.

James Nicholson, Town land 33. 114. Jn West field 183. 243. 340. 475. 511. 516. 572. Jn East field 728. Jn South field 1073. 1116. 1173. 1257. 1346. 1429. Jn Mill field 1625. 1676. 1704. 1733. 2041. 2260. Jn long medd: 2639. 2673. 2701.

Robt Rosse. within ye town 26. 60. 68. 118. Jn West field 177. 208. 412. 454. 531. Jn East field 793. Jn South field 867. 879. 886. 889. 1008. 1115. 1231. 1273. 1284. 1519. Jn Mill field 1738. 1746. 1762. 1778. 1984. 2183. 2312. 2340. Jn Shitterpoole medd: 2464. Jn Long medd: 2504. 2583. 2629. 2711. 2716. Jn South lound medd: 2782. Jn the East kirk Jnge 2865.

John Bullivant 37. Jn West field 556. Jn South field 993.

Fig. 31 Extract from the Laxton terrier referring to Robert Rosse's landholdings summarized in brief, 1635. MS. Top. Notts c. 2, fol. 108r.

Fig. 32 Extract from the Laxton terrier referring to locations of Robert Rosse's landholdings summarized, 1635. MS. Top. Notts c. 2, fol. 199v.

pieces covering an area in the region of 25 square kilometres containing the villages of Laxton and Kneesall, around a dozen kilometres north-west of Newark-on-Trent in the eastern part of Nottinghamshire. The map is a manuscript in ink and paint, laid down on sheepskin or parchment, set out in a 3 × 3 grid, which when placed correctly results in one large rectangular map. Much of what is known about the map's creative origins can be gleaned from the block of text framed within the splendidly detailed title cartouche, based on a square panel towards the bottom right. Pierce's comments describe the map's origins, explaining why and by whom it was commissioned. We also learn that Pierce used two 'generall platts' or maps made in 1625 by Francis and William Mason which had been commissioned by the previous lord of the manor, the duke of Buckingham.

These maps appear not to have survived, but Pierce tells us he 'reviewed and perfected' them. In order to complete the map, Pierce would have used a plane table, along with other staple tools of the surveyor such as a sighting pole and a twenty-two-yard-long metal chain, and perhaps those instruments of the trade found adorning his cartouche (fig. 34) as surrounding decoration, all of which are extremely instructive in terms of placing the map in its cartographically creative context.

Across the top of the cartouche we see tools of the land surveyor's trade. At the top left corner are a measuring ruler, a pair of dividers and a set square; a much larger pair of dividers and a ruler adorn the centre

point; to the right corner, the combination of ruler, dividers and set square is repeated. Beneath both of these corners we can also see two bound volumes and, below these, two rolled maps. Below, a globe has been included along the base of the cartouche, directly in the centre, with the viewer's eyes drawn to the northern Atlantic Ocean. To add to the intrigue is the appearance of a man. This individual can be seen four times, and is clearly the same person. He sports a green tunic and pinkish cloak, and has auburn hair. In each image, he is performing tasks that lead us to assume that it is Mark Pierce himself. Towards the top left, he is unrolling a map. On closer inspection, it bears more than a passing cartographic resemblance to the Laxton map itself; the compasses on this tiny map are exactly where the grander compasses and scale bar are located on the completed map, at the south-west corner; even those field boundaries which are visible look correct. At the bottom left corner of the cartouche 'Pierce' can be seen writing what might be the terrier. At the bottom right, he is perched with dividers and ruler, taking measurements for his map. Towards the upper right, 'Pierce' seems to be reading from the terrier. Stylistically, Pierce was ambitious. His map also includes two tiny world maps: one at the bottom centre of the title cartouche alluded to above; and a second one at the centre of the compass rose, an extravagant addition to the colourful depiction of seventeenth-century agrarian life.

The compass rose is another elaborate cartographic construct,

Fig. 33 Map showing the location of Robert Rosse's plots.

prominent at the map's centre right. The sumptuous colour palette is embellished with the second globe, located in the middle of the rose. As with the globe beneath the cartouche, the Atlantic Ocean is prominent, but this time the view is centred on the equator rather than the northern Atlantic. Why was Pierce so keen to add a global perspective to what is very much a local map? Perhaps he sought to curry favour with the map's commissioner, Sir William, who, as a man with global trading interests, was very familiar with the Atlantic north of the equator.

Innovative Cartographic Techniques

In Pierce's detailed description beneath the title details, he outlines the colour scheme adopted on the map. Every furlong (the subdivision of land within each open field) has a unique letter code on the map and is painted in a different colour to aid identification. Imagine a contemporary political map of the world where individual countries are designated different colours; Pierce is employing the same broad principle. Where the colours differ from the pastel-like hues, a rich dark green indicates woodland, a paler green common land and meadows, uncoloured areas freehold land (that is, land not set aside to be farmed by tenants), generally, and a pale yellow tint land recently purchased by Courten himself and not set out in strips.

Pierce's cartographic talents can also be witnessed by a pair of techniques that we might expect to see carried through into the twenty-first century. The first of these is a simple dotted line as a boundary device, separating the parishes of Laxton and Kneesall. This is precisely what we would expect to encounter today. The line is clearly seen running west to east in the western central section of the map. The boundary runs between fields before falling away to the south. Another notable technique is Pierce's use of shade, perhaps best seen towards the bottom of the map around various isolated trees. He consistently shows the sunlight shining from the west. Not only does this give the map an additional artistic appeal, but again it transcends

the centuries. In modern medium-scale topographic mapping hill shading is most effective when the sun appears to be 'shining' from the north-west, as may be seen in Swiss 1:25,000-scale topographic maps. Pierce clearly contemplated the design of his map with great care, and possessed the necessary cartographic vision to deliver an eye-catching end product.

Provenance

How did this very local Nottinghamshire map make its way to one of the world's great academic institutions? The history of its provenance is another example of the stories maps can tell us. Papers from Oxford University Archives and Bodleian Library Records reveal that the map was taken into the Bodleian Library in early 1942 after protracted negotiations between Earl Manvers, then owner of the Laxton estate; his agent, Hubert Argles, based at the Thoresby Estate Office in Nottinghamshire; the University of Oxford, for whom C.S. Orwin, Director of the Oxford Institute for Research in Agricultural Economics, played a pivotal role; and the Bodleian, represented by the Librarian, Edmund Craster.

In November 1941, Orwin contacted Thoresby Estate Office to ask whether Manvers would be prepared to deposit the map and terrier on loan in Oxford, primarily for the use of students of economic history. Orwin added that the Bodleian was to be preferred to the British Museum as it was likelier to be a safer wartime location. Manvers quickly responded, offering to sell rather than deposit the map. It was sent to Oxford the following January for inspection by Bodley's Librarian, Craster, and the Library initially offered Manvers £200. Manvers held out for £500, but by mid-March had accepted Craster's improved bid of £300. In May 1942 the Curators of the Bodleian noted 'extra-ordinary expenditure of £300 on a manuscript field-map and terrier of Laxton, Notts., formerly the property of Lord Manvers'.[2]

Orwin's plan to use the map to tell the story of Laxton to the University's students was eventually realized.

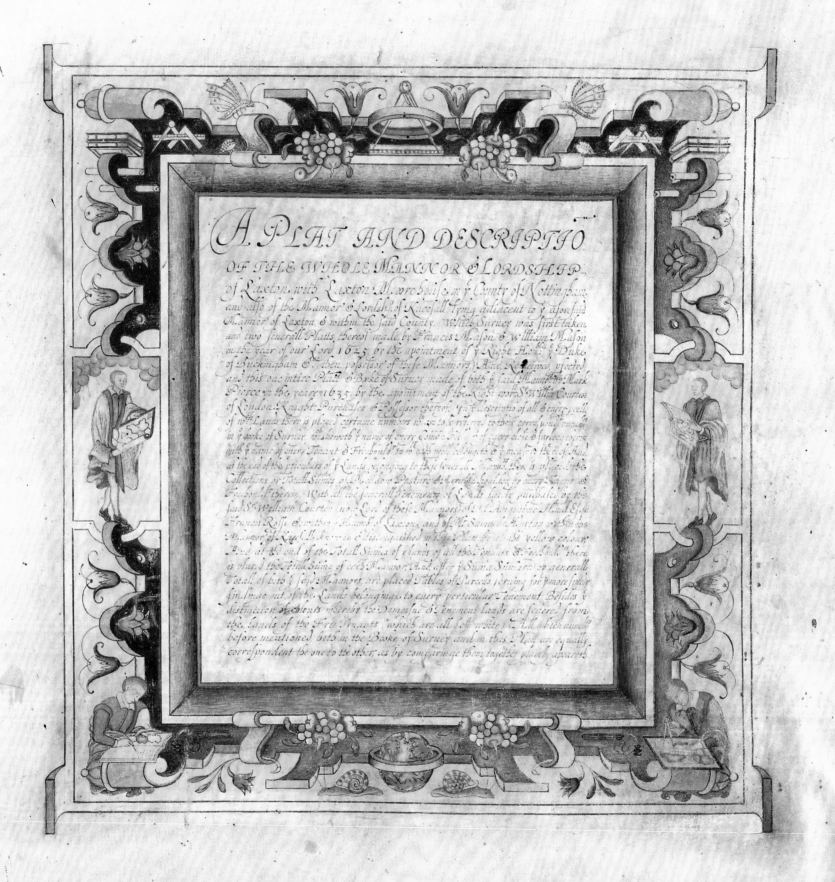

A PLAT AND DESCRIPTIŌ

OF THE WHOLE MANNOR & LORDSHIP,
of Laxton, with Laxton Moorehouse, in ye County of Nottingham,
and also of the Mannor & Lordshipp of Kneesall lying adiacent to ye aforesaid
Mannor of Laxton, & within the said County, Which Survey was first taken,
and two severall Platts thereof made, by Francis Mason & William Mason
in the year of our Lord 1625, by the apointment of ye Right Hono:ble ye Duke
of Buckingham &c then possessor of these Mannors, And, afterwards, viewed
and this one intire Plat & Boke of Survey made of both ye said Mannors, by Mark
Pierce, in the yeare 1635, by the apointment of the Right worshipfull Sr Willm Courten
of London, Knight, Purchaser & Possessor thereof, In ye description of all & every parcell
of weh Lands there is placed certaine numbers weh are to be referred to their corresponding numbers
in ye Booke of Survey, which sheweth ye name of every Cloase Feild or every close & harbouring therein
with ye name of every Tenant & Freehoulder to weh each parcell belongeth & in what Feild the ech Plat
at the end of the particulars of ye Lands, beelonging to these severall Farmes, there is placed the
Collections or Totall Summs of Medow Pasture & Arrable Land lying by every Tenant &
Freehoulder therein, With all the severall Tenements & Lands late purchased by the
said Sr William Courten, now Lord of these Mannors, of S:r Augustine Hind Esq:r
Francis Rosse & others, Tennants of Laxton, and of St Saunders Hartop in & of these
Mannors of Kneesall, known to be distinguished in this Plat by theyr yellow colour,
And, at the end of the Totall Summs of eluirs of all the Tennants & Freehold: there
is placed the Totall Summ of ecch Mannor, And, after ye Summa Summarum or generall
Totall of both ye said Mannors, are placed Tables of Parcels serving for ye more speedy
findinge out of the Lands belonging to every perticular Tenement Besides ye
distinction of eluirs whereby the Demasne & Tenement lands are severed, from
the lands of the Free Tenants, which are all left white, &c. All which accordinge
before mentioned, both in the Booke of Survey and in this Plat, are equally
correspondent the one to the other, as by comparinge them together plainly apparieth

Laxton in the Twenty-First Century

The Laxton map still speaks to students and scholars at the University of Oxford and beyond, transporting them deep into the seventeenth century. But Laxton still has much more to tell. How does a system of agriculture, tracing its origins to the Norman era, manage to flourish still in contemporary Britain?

The open field system that survives in Laxton is a pared-down but recognizable version of the landscape mapped by Pierce. Laxton's current land-management arrangements remain unique in Britain. Its three-field rotation system is now overseen by the country's only surviving legally constituted manorial court, called the Court Leet. The *Oxford English Dictionary* defines the leet (a word of Anglo-Norman origin) as a 'special kind of court of record which the lords of certain manors were empowered by charter or prescription to hold annually or semi-annually'. No other equivalent body now exists in England.

Today's farmers are tenants of the Crown Estate, and their tenancy agreements stipulate that they must adhere to the farming protocols whose origins date back to the Middle Ages. Fourteen tenant farmers currently lease the land and farmhouses from the Crown Estate, and there are also an additional five smallholdings as well as a handful of token strips, held by the Dovecote Inn and Thoresby Hall, all of which together constitute the current arrangement for open field farming in the village. Three large fields survive: Mill Field, South Field and West Field, all clearly discernible on Pierce's map, and each still follows a traditional pattern of rotation. Year one is set aside for wheat; year two for spring or winter crops, again including wheat, but also barley, beans and oats; and year three is fallow – no crops are grown.

To administer such a complex system of land management, the Court Leet, functioning as a manorial court, annually appoints a jury, known as an *homage*, whose role is to inspect the village's fields, roads and drainage ditches found within the fields, and report back its findings to the court. When irregularities are encountered, the Court Leet has the power to impose fines on those tenants deemed to have been at fault. The Court Leet meets on the first Thursday in December, assembling in the Dovecote Inn (parcel 76 on the map). This meeting takes place a week after 'Jury Day', when the jury of a dozen Laxton tenants walk the course and inspect all the strips in each of the three aforementioned fields. Small wooden stakes mark the correct bounding points for each of the strips, and tenants found to have ploughed beyond the limits of their strip, and indeed not reaching the full extent of their allotted landholding, become liable for fines when the Court Leet meets the following week. To provide an indication of the scale of this task, in 2019 individual strips measure somewhere in the range of one to seven acres in area, and generally fines incurred fall in the £5–£10 range.

How secure might Laxton's future be as the sole surviving outpost of the open field system? This is a matter for conjecture. The practicalities of farming small strips of land, often with challenging irregular shapes, has immediate implications when it comes to imposing modern agricultural equipment on a medieval landscape. How straightforward is access? Often this can present problems, and there is a fear that many of the implements and much of the machinery required to cultivate the strips are nowadays likely to be obsolete. Whatever Laxton's future, the map will endure, telling the story of a unique moment in the agricultural history of England.

Fig. 34 The Laxton map cartouche showing tools of the surveyor's trade as well as self-portraits of Mark Pierce, 1635. MS. C17:48 (9).

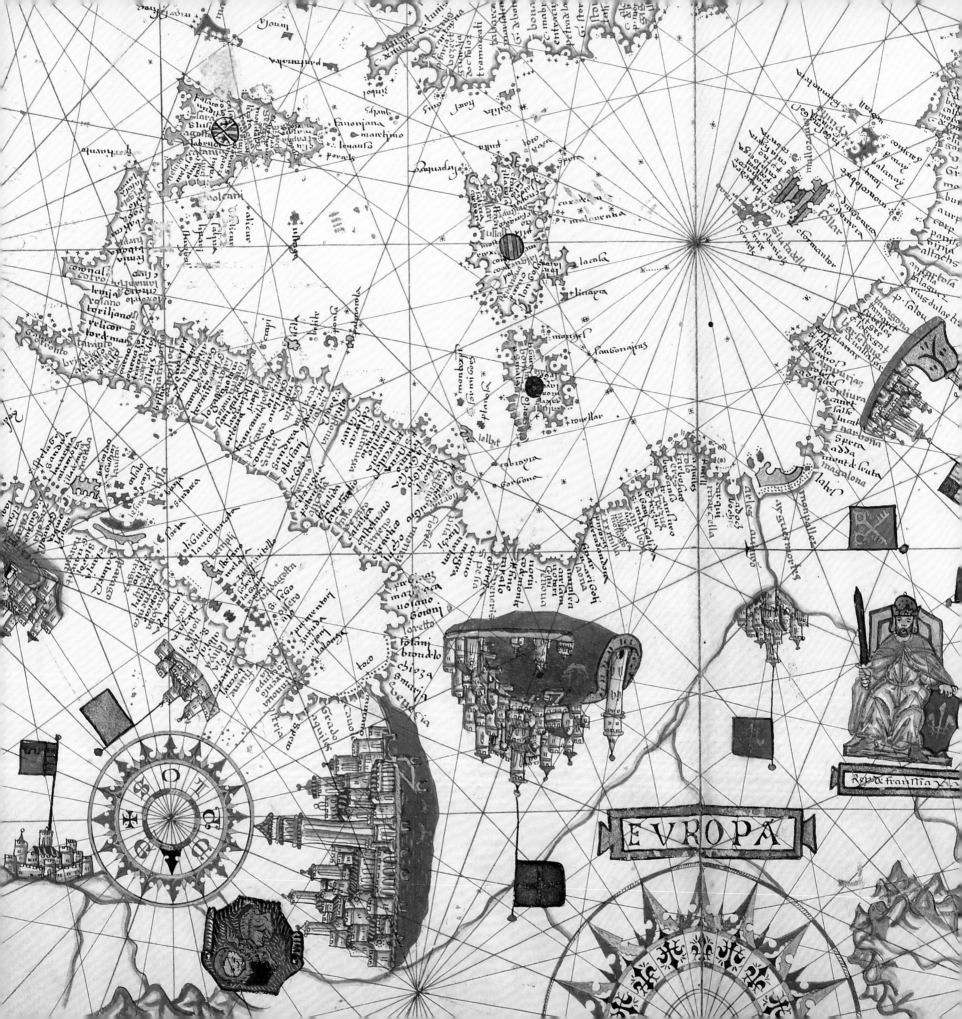

EVROPA

5

The Sea

We live on the land and map it according to our needs as social animals, but the sea is a very different matter. It poses a singular elemental challenge to us as humans because it is not our natural environment, and as a consequence we map it in very different ways. While we orient ourselves on land, we *navigate* the sea. It is a hostile place over which we have little or no control; it can lead to physical deprivation, loss and death, but it is also where human endurance, discovery and regeneration occur in their most dramatic form, as witnessed in many of our most abiding myths and legends. Attempts to master the sea are driven by a desire to explore new worlds and discover others and, in the process, ourselves. Yet at other times people are motivated to cross the oceans to escape danger or persecution or to seek goods and riches they lack at home.

For most of recorded history the sea has not been seen as a destination but as a dangerous elemental object to be overcome in the pursuit of somewhere – or something – else (tellingly the root of 'navigation' comes from the Latin word for 'to travel over'). But without the ability to navigate across the sea, the history of our encounters and interactions with other peoples and cultures would be hugely diminished (although that story also comes with its own tragic consequences of colonization and imperialism). So powerful is our need to move over the sea that the term 'hydrography' – from the Greek word for 'writing of water' – was developed in the sixteenth century to describe the cartographic measurement and description of the sea. In this chapter we tell the story of the writing of the sea, one that is very different from the mapping of the land, although as we will show, the two are inevitably related.

Stories of the sea have defined literature since at least the time of Homer. In the *Odyssey* the wandering hero Odysseus embarks on a ten-year voyage to return to his homeland in Ithaca following the Trojan wars described in the *Iliad*. His perpetual struggle with 'the wine-dark sea', enduring shipwrecks and encountering sea monsters and divine nymphs before he reaches home, has become a template for many of Western literature's stories of humanity's attempts to understand itself in the act of navigating across the seas and oceans, from Shakespeare's *Tempest* and Coleridge's *Rime of the Ancient Mariner* to Joseph Conrad's *Lord Jim* and Iris Murdoch's *The Sea, the Sea*. In most of these stories the sea acts as an extended metaphor, across which the protagonists navigate their own emotional journey, returning to where they started, the same but different as a result of the effects of seaborne travel. Maps of the sea operate in a similar, although more prosaic, way: in the process of charting faraway seas, they invariably offer a route back home. How they do this depends on the specific maritime conditions from which they emerge, and their culture's relationship with the sea, both of which give rise to very different kinds of maps telling disparate stories.

Wave Pilots

The sea's nature does of course vary widely in different places across the earth's surface, based on a range of environmental factors. Such factors have shaped different cultures' cartographic response to the sea, nowhere more strikingly than in Micronesia, and in particular the Marshall Islands. The islands are a chain of twenty-nine

Fig. 38 Detail of Bartolome Olives, portolan chart of the Mediterranean and Atlantic, 1559

atolls shaped in two rows stretching over 800 kilometres and comprising more than 1,100 islands. Most of the islands lie in the 'doldrums', where the seasonal light north-east trade winds which, coupled with strong currents, create deep, powerful oceanic swells. These swell patterns are disrupted and refracted by each island in ways that could send a Marshallese pilot sailing in a canoe between islands and only using dead reckoning (navigating by using a predetermined line of bearing) way off course.

To represent the swell patterns and how they shifted around each island, the Marshallese developed a type of map known as a 'stick chart' (fig. 35). Stick charts were made from wood, cane and coconut fronds tied together to create a lattice frame with shells or knots used to designate islands. Each stick represents swells or distances between the islands. Marshallese pilots – called *ri-metos*, also known as 'wave pilots' – would memorize their stick charts as well as consulting the prevailing wind, season and stars before embarking on their journey. They would then position themselves by either crouching or lying prone in the prow of their canoe, matching the way it pitched and rolled with the representation of swells shown on the stick chart and steering accordingly.

Writing in 1962 about his anthropological fieldwork in the Marshall Islands, William Davenport explained that the stick charts were 'used to teach navigators and possibly to store knowledge against memory loss. They are most assuredly not used to lay out courses, plot positions and bearings, or as aids in recognizing land forms as the European navigator uses his chart. Nor are they mnemonic devices to be taken along on a voyage for consultation. The Marshallese navigator carries his information in his head.'[1] The stories of inter-island travel passed down through generations created these 'mental maps', with their knowledge and reproduction jealously guarded by rival chiefs struggling for political pre-eminence across the islands. The stick charts probably go back hundreds of years, although the only surviving examples date to

the late nineteenth century, when Europeans first noticed and began acquiring them. Robert Louis Stevenson and his cousin and biographer Graham Balfour were keen stick chart collectors, and in 1897 Balfour presented the Pitt Rivers Museum with the stick chart reproduced here. He had acquired the chart from Dr Georg Irmer, the *Landeshauptmann* (colonial administrator) of the Marshall Islands, which had been claimed as part of the German colonial empire in 1884. Irmer had obtained the chart in 1896, perhaps as a political gift, from the Marshallese chief Nelu, a native of the Jaluit Atoll, where the Germans based most of their commercial operations.

The Pitt Rivers stick chart remains one of fewer than sixty documented examples held in museum collections across the world.[2] Just as the unique relationships between land, sea and oceanic swells created the conditions for the emergence of these stick charts, so have they also led to their decline. The rise of steam- and motor boats in the 1950s witnessed the collapse of inter-island canoe travel and with it the need for stick charts, although recent scientific and anthropological work in the islands is trying to retrieve the fading stories told about navigating across the Micronesian seas.[3]

Mediterranean Stories

It is impossible to judge the historical origins of the Marshallese stick charts. But between the eleventh and fourteenth centuries a very different method of mapping the seas emerged on the other side of the world, 14,000 kilometres from the Marshall Islands, in an extremely dissimilar maritime environment: the Mediterranean. Between 1020 and 1050, an anonymous Muslim scholar working in Fatimid Cairo compiled *The Book of Curiosities of the Sciences and Marvels for the Eyes*, a cosmographical treatise copied in a late twelfth- or early thirteenth-century recension now owned by the Bodleian. Its dramatic reappearance and acquisition by the Bodleian Library in 2002 has led to an ongoing reassessment of medieval cartography, and in particular the role played by Muslim scholars in mapping the known world.

Fig. 35 Marshall Islands stick chart,
c.1896. Pitt Rivers Museum 1897.1.2.

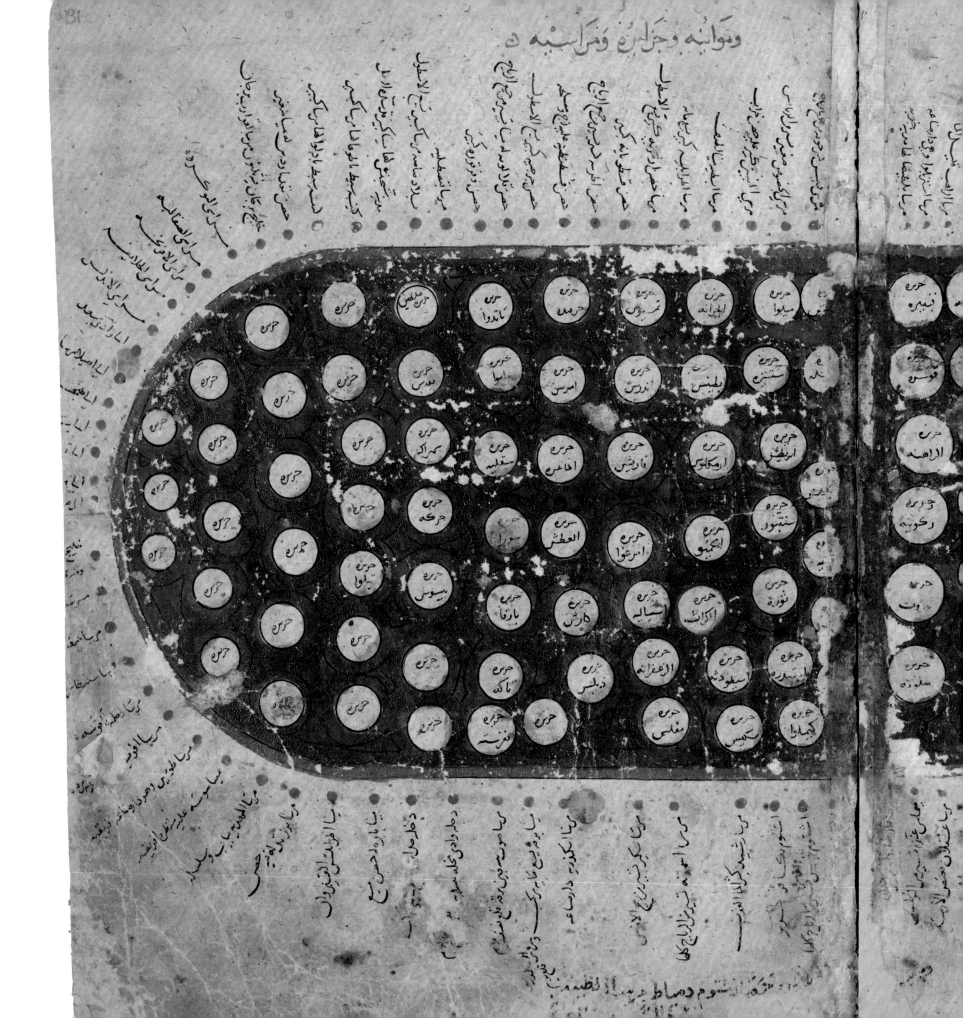

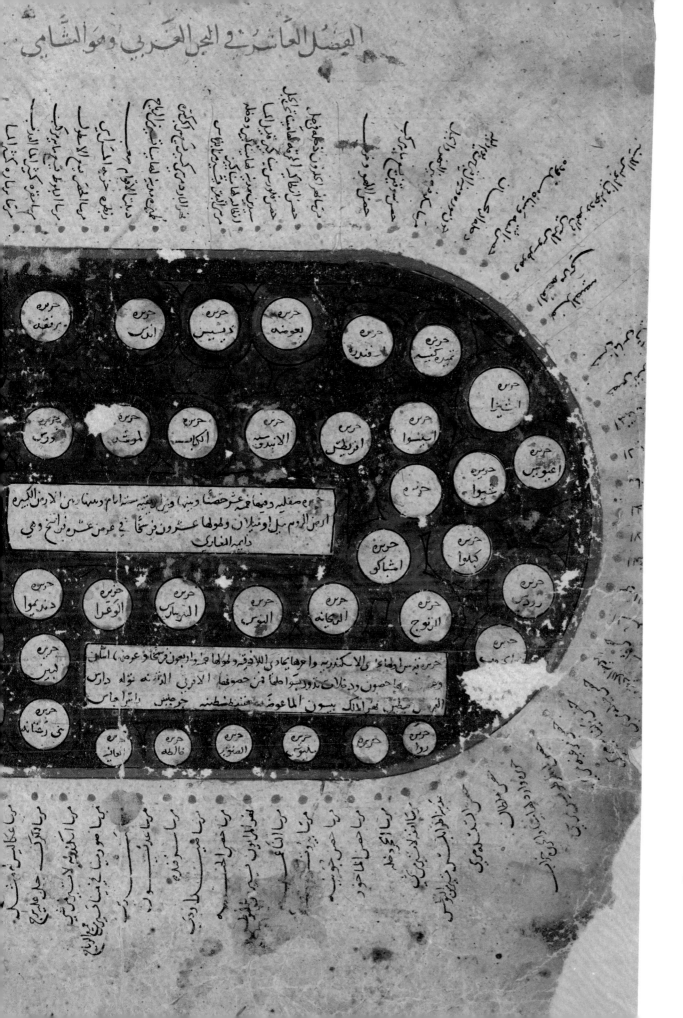

الفصل العاشر في البحر العربي ومواشي...

Fig. 36 Map of the Mediterranean, in
The Book of Curiosities, 1020–50.
MS. Arab. c. 90, fols 30b–31a.

The *Book of Curiosities'* thirty-five chapters encompass the known universe as it was understood by scholars working under the Fatimid Caliphate (909–1171 CE). It follows a classical Greek approach to the compilation of cosmographical texts in describing the features of the universe, including the Earth, all illustrated with diagrams and maps. These included world maps (discussed briefly in chapter 10) and a remarkable regional map of the Mediterranean, labelled in Arabic 'The Western Sea – that is, the Syrian Sea – and its Harbours, Islands and Anchorages'. There is no historical precedent for this geometrical, oval Mediterranean map, the earliest to show the sea in such detail (fig. 36). It depicts 118 islands and 121 harbours and anchorages around its rim. It is oriented to the north, with the Straits of Gibraltar – the limits of the classical world – on the far left, moving clockwise through a limited number of western European harbours (though with very little description of Iberia and Europe), before reaching Constantinople at top left, then moving with increasing detail and confidence through Byzantine territory across the Aegean, Cyprus (the rectangular island bottom right), the coasts of Syria and Palestine (far right), into the Fatimid coastline of Egypt, Libya (bottom) and Morocco (far left). This is a maritime map that shows islands and coasts from the perspective of the sea; the land and its interior are not even shown.

What story does this map tell? The answer lies in a paradox: its form is abstract and diagrammatical, making no attempt whatsoever to depict the shape of coastlines, and yet the labels for harbours are packed with seafaring information on the capacity for anchoring a specific number of ships, defensive installations and prevailing winds. In its content the map appears to draw on Roman *periploi*, written accounts of coastal navigation providing the kind of detail shown on the *Book of Curiosities* map. The *periploi* tell a sequential story of moving from one harbour, island or bay to another, prior to the advent of the compass, whose usage allowed pilots to determine the direction and by implication

the shape of coastlines. The Fatimids inherited the *periploi* tradition which gave rise to a highly effective map of the Mediterranean that told a detailed story of how to move along the coastline from one harbour and port to another.[4] The kind of orientation, direction and coastal shapes associated with later maps and charts based on compass readings were useful but not essential in the maritime space of the Mediterranean, where there was little need ever to sail out of sight of land for any significant length of time (indeed, charts represented the plane surface of the Mediterranean as flat rather than curved, as over such a small surface of the earth's curved surface a straight line of bearing was generally sufficiently accurate for navigators to sail from one point to another). The information provided in the *Book of Curiosities* would have been completely legible to pilots and naval commanders from any culture or religion within the Mediterranean basin wanting to trace voyages clockwise or (more likely owing to prevailing winds) anticlockwise along its coastlines.

A very different story emerged around 1300 when a new type of chart began to appear in the Italian and Iberian peninsulas. These are known as portolan charts – derived from the Italian *portolano*, a collection of written sailing directions. They provided a detailed outline of the Mediterranean basin as described in the *Book of Curiosities*, from the Black Sea to parts of the northern Atlantic. Map historians have described their appearance as 'one of the most important turning points in the whole history of cartography',[5] which established the conditions for all subsequent modern maritime charts and hydrographic surveys. Cartographic historians are still puzzled as to why portolan charts suddenly appeared around this time, although the development of the compass now seems to be a determining factor in shaping their appearance and obvious differences from the kind of charts we have examined so far – not least in the compass roses that appear on many portolan charts, showing a wind system usually composed of thirty-two points.

Fig. 37 Portolan chart showing Italy and the Adriatic Sea, 15th century. MS. Douce 390, fols 5v–6r.

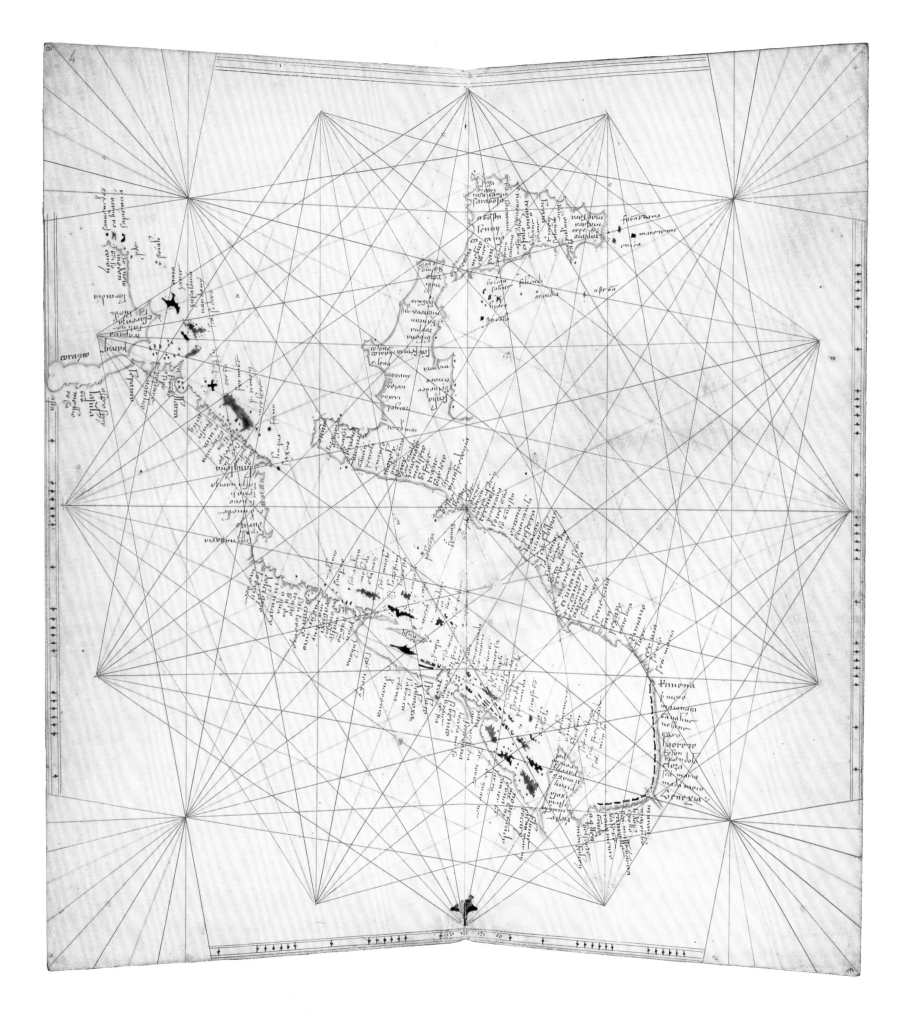

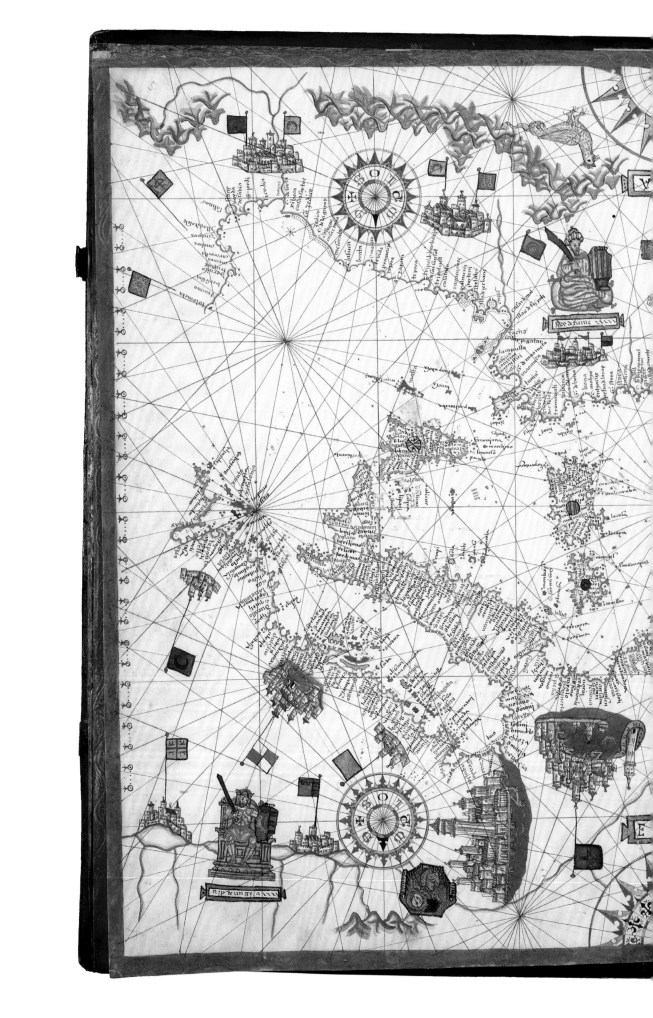

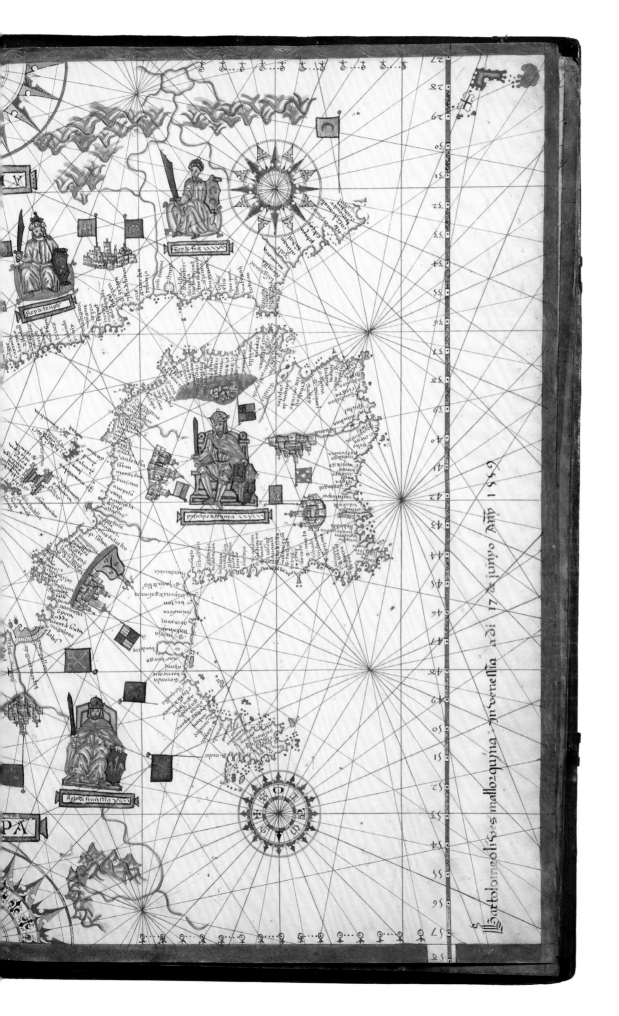

Fig. 38 Bartolome Olives, portolan chart
of the Mediterranean and Atlantic, 1559.
MS. Canon Ital. 143, fol. 3r.

The Bodleian possesses a very beautiful example of an atlas of portolan charts made in the early fifteenth century and attributed to an anonymous Venetian map-maker known as the Douce Atlas (fig. 37). It is made up of six illuminated portolan charts on parchment each measuring 28 × 29 centimetres. Sequentially the charts move in an arc from the Black Sea in the north-east, through the Mediterranean and north-west Africa and ending in the North Atlantic (including the British Isles). Each chart follows the conventions of most Italian portolan charts: a network of rhumb lines (straight lines of bearing that cross meridians at the same angle) enabling pilots to navigate using dead reckoning; toponymy illuminated in black and red ink (the latter identifying large cities, ports and islands), all shown at right angles to the coast; black dots signify rocks, red ones sandy shallows; there is little or no description of interiors; the scale shifts according to the map-maker's location (in the Douce Atlas the chart of Italy and the Adriatic are drawn on a larger scale); and virtually no imperial or theological embellishments are to be found as they are on contemporaneous *mappae mundi* – although portolan charts of the Catalan tradition are often more decorated. Like the *Book of Curiosities* maps, the focus here is exclusively on the sea and its coastlines.

The role and function of portolan charts remain unclear. They appear to have fulfilled instructional as well as practical purposes, as the pristine and highly illuminated nature of many surviving examples suggests they were never meant to be taken to sea, and conversely no remaining portolan charts provide indubitable evidence of their use on board ships (fig. 38). Instead, examples like the Douce Atlas tell a more complex story that transcends straightforward navigational use.

Examination of the atlas as a physical object suggests that it also fulfilled some form of administrative, ceremonial or theological role. It was carried in a decorated container made of *cuir bouilli*, moulded leather embossed with decorative designs and inscriptions, as well as (now missing) suspension shoulder straps. Bound in a cover of wood inlaid with ivory, the atlas opens to reveal an exquisite diptych showing the Annunciation with the angel Gabriel and the Virgin. Both figures take on added significance at the front of an atlas of maps: Gabriel is the patron saint of messengers and communication, while the Virgin is also known as the *Stella Maris* or 'Star of the Seas', a synonym for the mariner's Pole Star. The atlas's last folio features a second diptych showing St Mark, the patron saint of Venice, and St Paul (a shipwreck survivor), representing the iconic biblical voyages across the Mediterranean (fig. 39). All four figures offer a talismanic significance for whoever owns the atlas and wishes to travel across the Mediterranean, and perhaps represent a theological claim to the region in the name of Christianity, under whose iconic figures they could spiritually 'navigate' their way through life's 'journey', protected on the sea and in life. The condition of the atlas indicates that it was never designed to be used for onboard navigation, so although they are very different from the Marshallese stick charts, portolan charts and atlases such as this one similarly acted as both navigational aids and mnemonic devices that enabled their owners to navigate across the sea at many different theological, practical and commercial levels.

By the late fifteenth century the impact of portolan charts shaped by the use of the compass came to define not only Christian but also Islamic chart-making throughout the Mediterranean. While the region has often been regarded as split across this religious divide, the sea of course has no interest in theology, and both Muslim and Christian seamen used – and, it is now evident, shared – similar cartographic information. One such shared convention was the *isolario*, or book of islands, produced by map-makers including the Venetian Bartolommeo dalli Sonetti (fig. 40). In describing islands like Rhodes and its adjacent Ottoman Turkish territory in charts and facing sonnets, these *isolarios* and the information they contained were produced for Christian and Muslim pilots in almost identical idioms.

In 1521 the Turkish naval commander known as Pīrī Re'īs completed a manuscript entitled *Kitāb-ı bahrīye* ('Book of Sea

Fig. 39 Diptych showing St Mark and St Paul, 15th century. MS. Douce 390, fols 9v–10r.

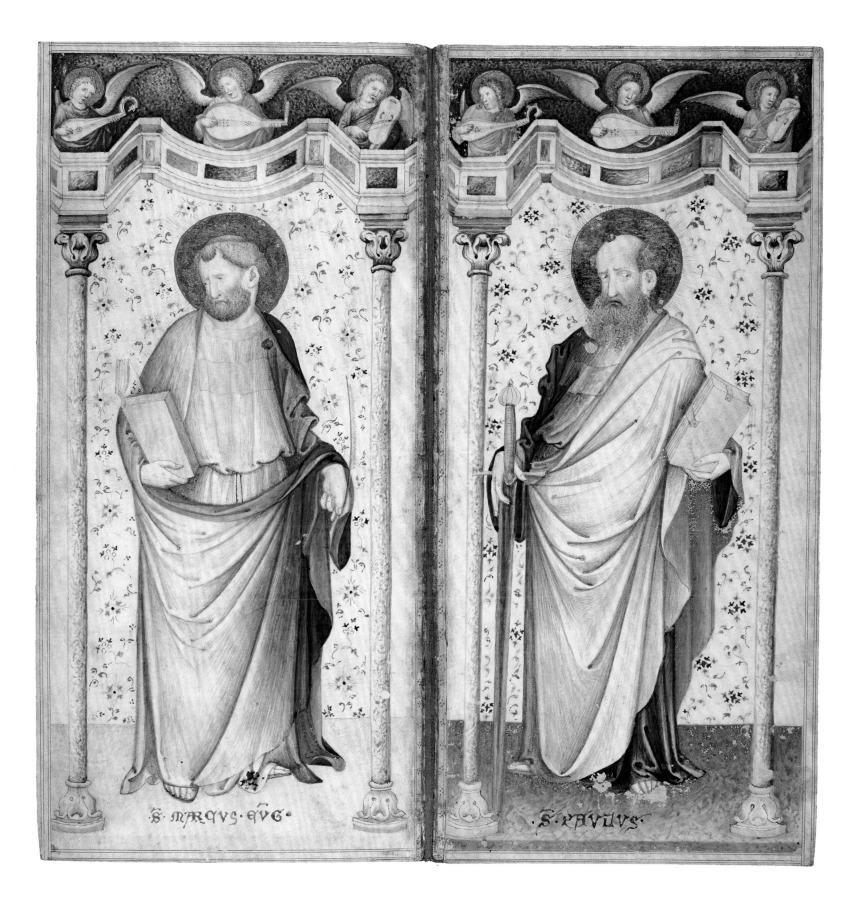

· S · MARCVS · EVG · · S · PAVLVS ·

Fig. 40 Bartolommeo dalli Sonetti, map of Rhodes, *Isolario*, c.1486. Auct. Q 5. 29, fol. 25r.
Fig. 41 Pīrī Reʾīs, map of Chios, in *Kitāb-ı bahrīye* ('Book of Sea Matters'), 1521. MS. D'Orville 543, fol. 19.

Matters'). It contained 130 chapters and charts describing the Mediterranean and how to navigate across it, moving counter-clockwise from the Aegean (fig. 41). In a second, longer version written in verse in 1526 (with over 200 charts), Pīrī Re'īs explains the use of compasses, charts and other navigational instruments at great length, as well as discussing the nature of storms, winds, ports and harbours.

Aside from being written and labelled in Ottoman Turkish, the book shares remarkable affinities with the *isolario* tradition, and its charts would have been completely legible to Christian pilots sailing in the same waters. However, like the author of the *Book of Curiosities*, Pīrī Re'īs acknowledged that charts form only one aspect of understanding the sea:

> Such knowledge cannot be known from maps; it
> must be explained.
> Such things cannot be measured with dividers,
> And that is why I have discoursed by writing at such
> length.[6]

In line with the earlier Islamic tradition, both written text and visual chart are required in the act of navigating the sea. Yet like the Douce Atlas, the *Kitāb-ı bahrīye* also fulfilled both practical and ceremonial purposes. The book was first commissioned to celebrate the accession of Sultan Suleiman the Magnificent in 1520 at a particularly aggressive period of Ottoman naval expansion in the eastern Mediterranean. It therefore functioned not only as a practical aid in navigating the sea but also as a blueprint for Islamic imperial control over the region. In contrast to the Christian claims of the Douce Atlas, the *Kitāb-ı bahrīye* shows how the Mediterranean was sometimes a space over which cultures and religions clashed and fought, and at other times a space where they came together and shared ideas and stories as they moved across the sea.

Charting News

Combining the use of portolan charts for imperial propaganda as well as navigation was not confined to the Mediterranean. When Queen Elizabeth I's fleet unexpectedly defeated the Spanish Armada in the English Channel in August 1588, her naval commanders and senior advisers immediately began commissioning reports and maps celebrating the victory. The manuscript and engraved charts depicting the victory – already discussed in the introduction – show how sea charts could be used to quickly and effectively circulate news about a specific geopolitical event, in this case Protestant England's naval triumph over the militarily superior Spanish empire.

When viewed sequentially, the ten charts can be seen as an example of cartographic war reportage. Each one takes approximately one day in the naval campaign, telling a story that moves in time from west (left) to east (right) as the two fleets first encounter each other and then engage repeatedly along the length of the English Channel from Lizard Point in Cornwall to the coast off Gravelines (Spanish-controlled Flanders). The outlines of the English coastline are drawn from Christopher Saxton's county *Atlas of England and Wales* (1579), and the compass roses gesture towards the usual portolan chart design, but these charts have no scale or rhumb lines. Instead, they are more interested in recording the naval battles in time. The chart showing the engagement between Portland Bill and the Isle of Wight during 2–3 August depicts first the English fleet attacking the Spanish on the left, followed by its subsequent regrouping and division into four squadrons shown on the right (fig. 42). The viewer is being asked to move across the space of the sea in time, rather like a story, whose end is the destruction of the Spanish fleet and the triumph of the English.

These graphic depictions of the defeat of the Armada draw on the conventions of portolan charts (as well as topographic maps like Saxton's) to give their political message greater veracity and realism. By charting such a significant naval victory in the seas surrounding England, the Elizabethans were using traditional mapping techniques to announce their control over them. The story conveyed by these charts would have been clear to those who saw them in

the weeks and months after the Armada's defeat: woe betide anyone who tried to cross the seas to invade this island kingdom.

Encompassing Seas

By the end of the sixteenth century the portolan chart had been adapted and developed as a tool in celebrating naval power and imperial hegemony as well as trans-oceanic travel and discovery, first by the great Iberian empires of Portugal and Spain, and subsequently by the English and Dutch East India joint-stock companies. Charts using the basic navigational techniques developed in the Mediterranean with the compass were expanded to assimilate astronomical observations taken when sailing out of sight of land in the Atlantic and Indian oceans. Yet even as the Dutch and English were navigating global trade routes into South-East Asia, a chart arrived back in England in 1659 that provided yet another very different story of how the sea shaped a culture's approach to maps.

The Selden map of China has already been discussed at some length in chapter 1. Like the discovery of the *Book of Curiosities*, its reappearance after centuries of neglect is transforming our understanding of non-Western cartography, especially where mapping the sea is concerned. Following its owner, John Selden, in defining this map as representing China is doubly misleading. China occupies less than half of the map, the rest of which is concentrated on the South China Sea and South-East Asia's islands and coastlines. What is so surprising about this map is not its depiction of mainland China, which can be found in many printed maps of the time, but the remarkable accuracy of its depiction of the sea and coastlines.

Like the *Book of Curiosities'* Mediterranean map, the starting point of this map is the sea, not the land. We know this because the route lines first drawn using technical instruments on the reverse of the map are exactly the same as the ones on the finished side. This tells us that the map-maker began by drawing maritime route lines first and then (for whatever reason) turned the paper over, redrew them, and only then added in the coastlines and more than sixty ports around them. Compass bearings are given along each route and are broadly aligned with the compass rose and scale bar at the top of the map (fig. 44). The Chinese compass, with its south-pointing needle, even tries to account for the change of magnetic declination (the small variations between geographical or 'true' north and magnetic north due to the earth's shifting magnetic field). The compass rose on the map is tilted slightly to the left by six degrees, and each maritime route tries to compensate for declination in an attempt to ensure more accurate lines of navigational bearing (although the failure to represent the earth's curvature also made this rather difficult).

What the map represents is a remarkably crowded East Asian network of maritime commercial routes connecting Ming China to Japan, Korea, Indonesia and even India, as well as the emerging seaborne power of the Dutch and English in the region. Probably commissioned in the first decade of the seventeenth century by a wealthy Chinese merchant from Fujian, a prominent trading area on the south-eastern coast, the map seems to draw on Chinese 'rutters' (pilots' handbooks of written sailing directions) and even European maps of the region. It is a remarkable fusion of a diverse body of mercantile, scientific and artistic knowledge that came about because of their exchange on the sea that is the map's defining feature, and from which everything else is measured.[7]

The map probably came to England on a returning East India Company ship shortly after it was made. From the late seventeenth century, sea charts made by the English and Dutch joint-stock companies trading in South-East Asia were increasingly professionalized and produced by hydrographic offices based in Amsterdam and London. The Dutch were particularly zealous in training their pilots in navigation and chart-making, with professional, salaried cartographers appointed to oversee the creation and updating of standardized charts showing navigational

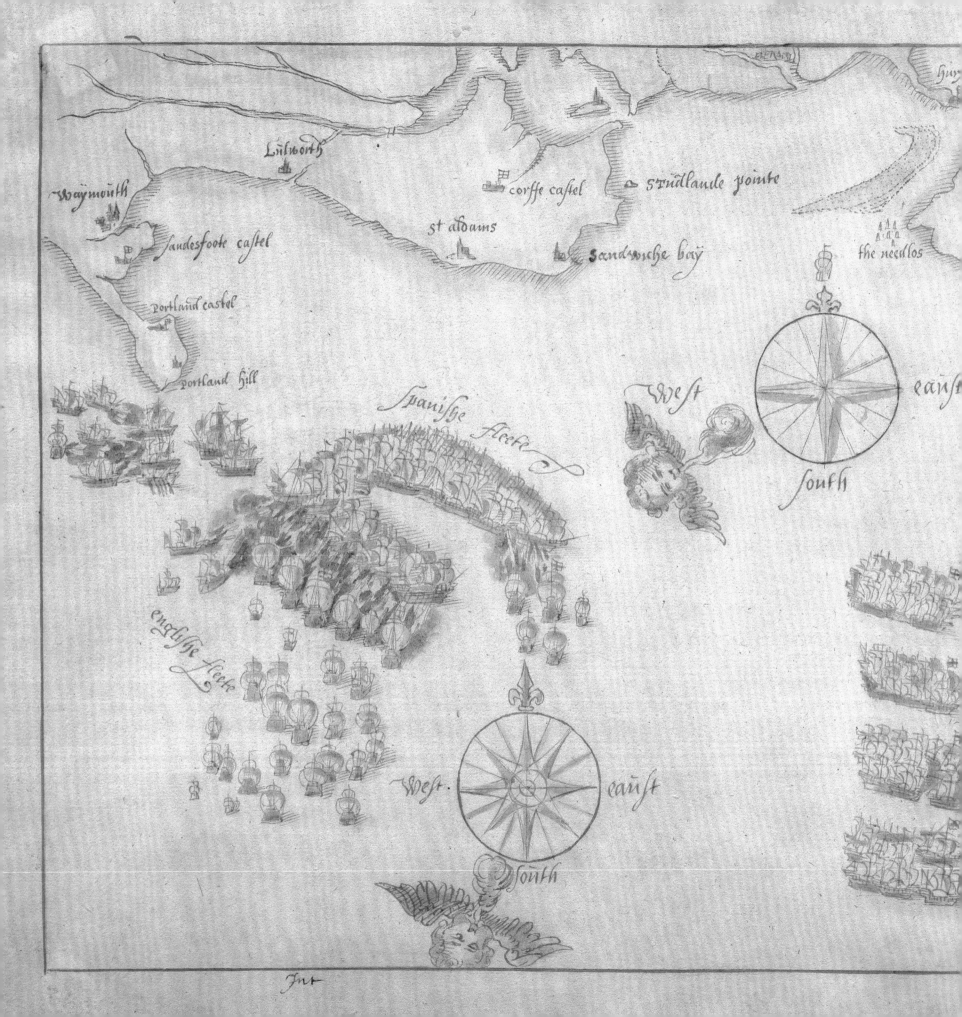

Waymouth

Lilworth

corffe caftel · ftudlande pointe

fandesfoote caftel

st aldams

Sandwiche bay

the needlos

Portland castel

West

eaſt

Portland hill

Spanifhe fleete

south

englyfhe fleete

West

eaſt

South

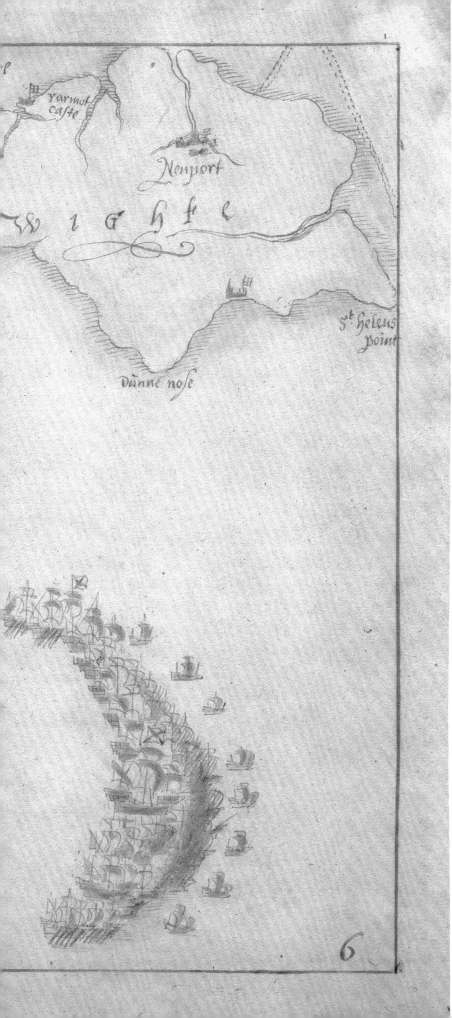

routes between Europe and Asia. This new generation of cartographic technocrats jealously guarded their charts (on pain of hefty fines) in the interests of global seaborne trade.

The drive towards standardization and scientific precision would soon embrace printed sea charts, but the cost and time involved in updating them meant that detailed and decorative manuscript portolan charts were still being produced for the East India Company in the late seventeenth century. One such chart-maker was John Thornton, hydrographer to the East India Company and a member of the Thames School of Chart Makers, based in London's docklands. Thornton's exquisite chart of the Indian Ocean from South Africa to Java represents a turning point in representations of the sea, not only because it acknowledged the recent 'Dutch discovery' of Australia, but also because it signalled a moment when European powers increasingly turned away from hand-drawn manuscript charts to embrace printed ones produced by hydrographic teams to master the oceans, in an extension of early Portuguese map-making, which broke away from the portolan tradition of sailing close to land (fig. 45).

In eighteenth-century England, the competing interests of the East India Company, the Royal Navy and the Royal Society meant that it was not until 1795 that the Hydrographic Office of the Admiralty was founded under the direction of Alexander Dalrymple. Along with the Ordnance Survey, established four years earlier, it was designed to coordinate national and maritime mapping in the state's interests when facing war with France. In 1808 Dalrymple was succeeded by Captain Thomas Hurd, who transformed the office by persuading the Admiralty to make its printed charts available to the civilian merchant marine and working more closely with the Ordnance Survey. The result was an increasing standardization of sea charts not only along the English coastlines but right across the globe, including the polar regions (fig. 46). These charts could be purchased for the benefit of all navigators, regardless of their national, religious or imperial affiliations.

Fig. 42 Engagement of the fleets between Portland Bill and the Isle of Wight, Tuesday –Wednesday 3 August 1588. The Astor Armada Drawings, ink on watercolour, late 16th–early 17th century.

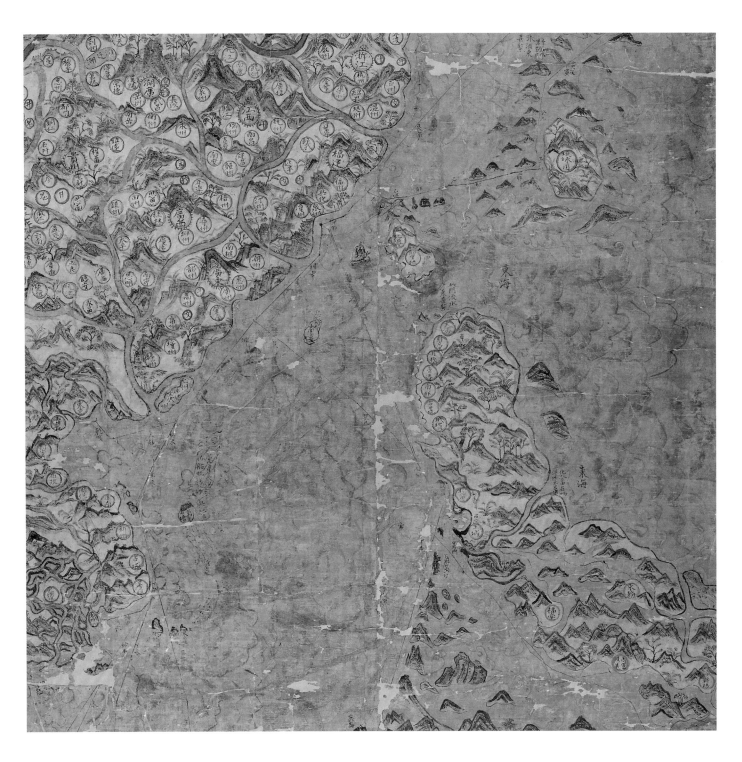

Fig. 43 Detail of the coastline and the port of Quanzhou on the Selden map of China, early 17th century. MS. Selden supra 105.

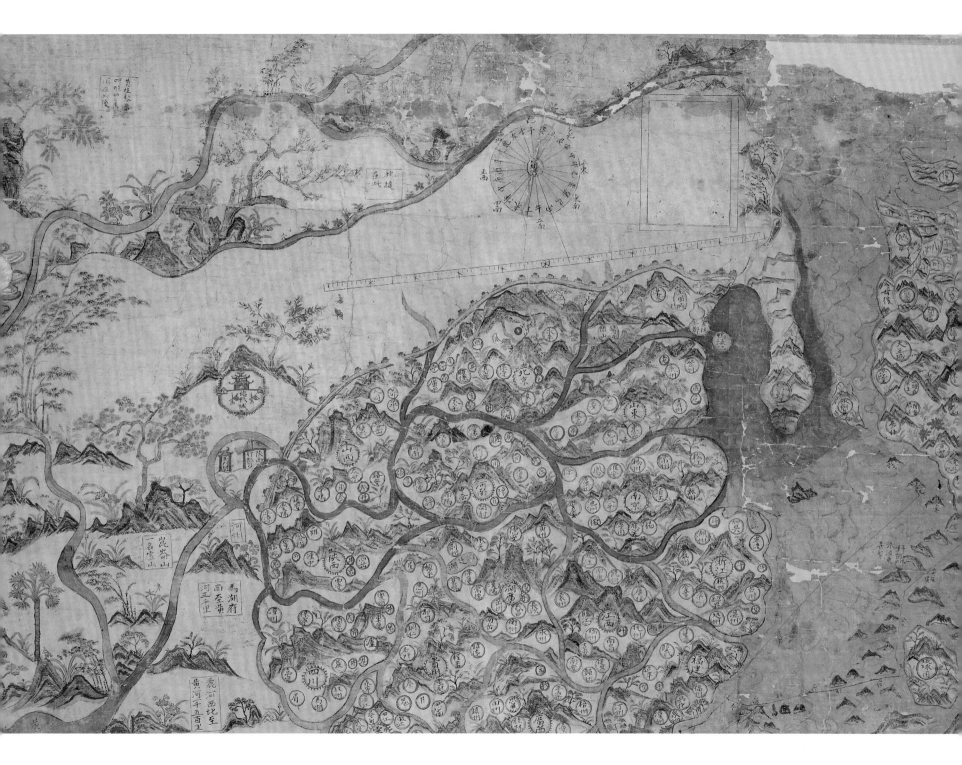

Fig. 44 Detail of compass rose and scale bar, Selden map of China. Part of the Great Wall of China can also be seen. MS. Selden supra 105.

What Lies Beneath

Two inventions during this time would further transform the mapping of the sea. John Harrison's chronometer allowed pilots to accurately determine longitude and to measure distances from east to west on the globe's surface. It was adopted on English vessels just as steam began to transform the shipping industry. As charts could more accurately plot longitudinal routes to the east and west of Europe, so steam meant that shipping times were no longer determined by wind patterns. Instead of mapping the sea's surface in terms of wind and coastal dangers, sea charts began to investigate what lay beneath as well as above the oceans.

In 1872 the Royal Society, in collaboration with Edinburgh University, sponsored the *Challenger* expedition to undertake the largest seaborne scientific voyage of its time. The HMS *Challenger* was refitted, with its guns making way for laboratories and its scientific crew under instructions to investigate the physical and biological conditions of the world's ocean floors and great basins. Over the next four years it circumnavigated the globe, covering 110,867

Fig. 45 John Thornton, portolan chart of
the Indian Ocean, 1682. MAP RES 117.

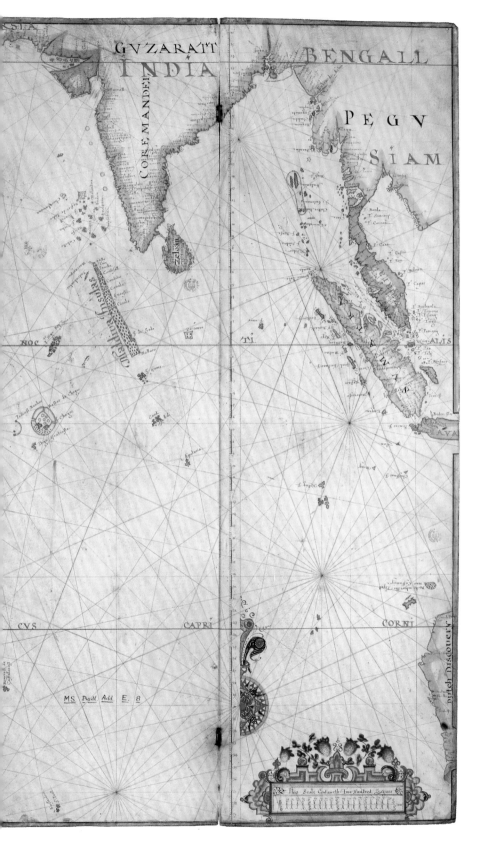

kilometres, stopping at 362 observation stations to take deep-sea soundings and over a hundred bottom dredges of the ocean floor (fig. 47). In March 1875 the crew recorded a sounding of 4,475 fathoms (8,184 metres) off Guam in the south-west Pacific in an area now known as the Mariana Trench. Subsequently recorded as 'Challenger Deep' on maps charting the expedition's course, it remains the deepest known point on the earth's seabed. The bathymetric data collated by the *Challenger* voyage is now seen as the foundation of the scientific discipline of oceanography.

Today, oceanographers estimate that the majority of the ocean floor has been mapped to a resolution (or image detail) of around five kilometres, but that only 10 to 15 per cent of it has been mapped at a resolution of 100 metres, similar to that achieved in global maps of Mars and Venus.[8] Mapping at this greater resolution is already proving of commercial interest to oil and gas companies. Once again, as humanity's priorities shift, our approach to the oceans changes, with much of it still to be mapped at a level of detail that will allow us to really understand what lies beneath the sea.

pp. 98–99
Fig. 46 Thomas Hurd, chart of the North Pole, 1818. (E) M1 (155).
Fig. 47 Bathymetric map of the Pacific Ocean showing the route of HMS *Challenger*, 1914. J1 (181).

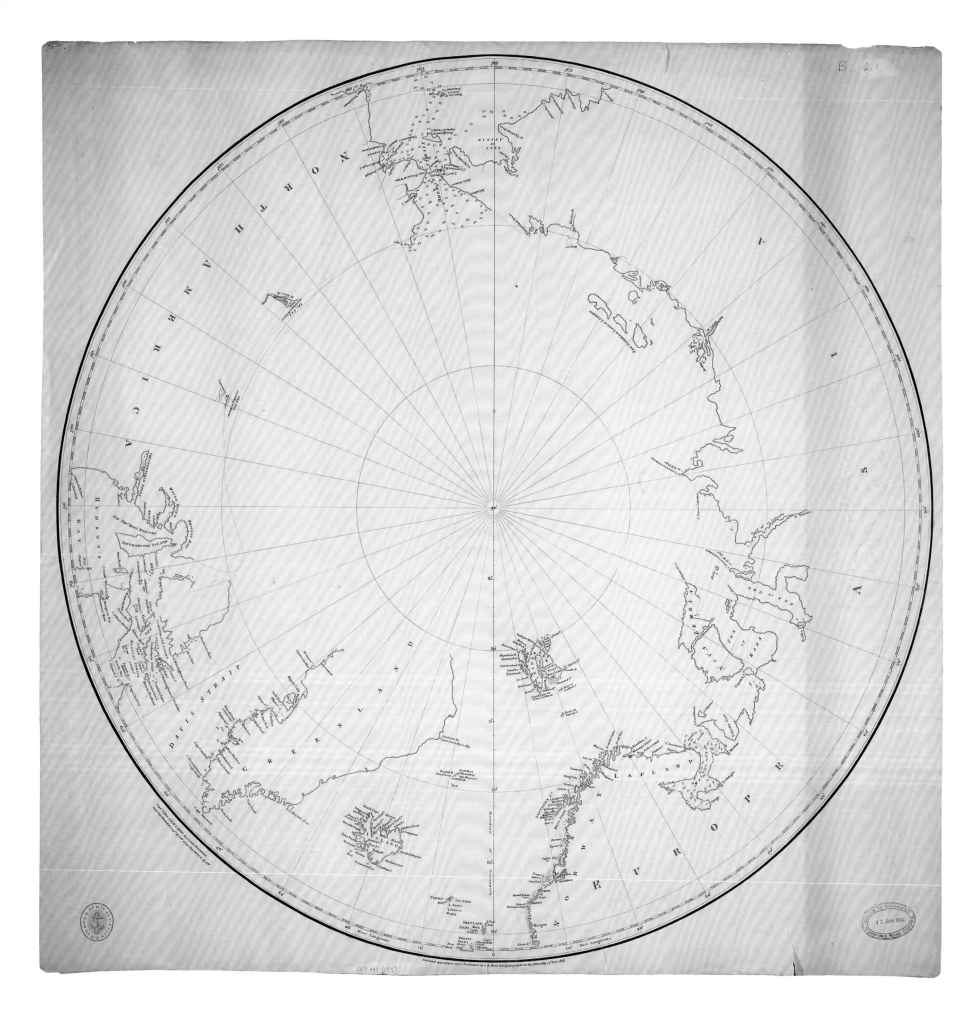

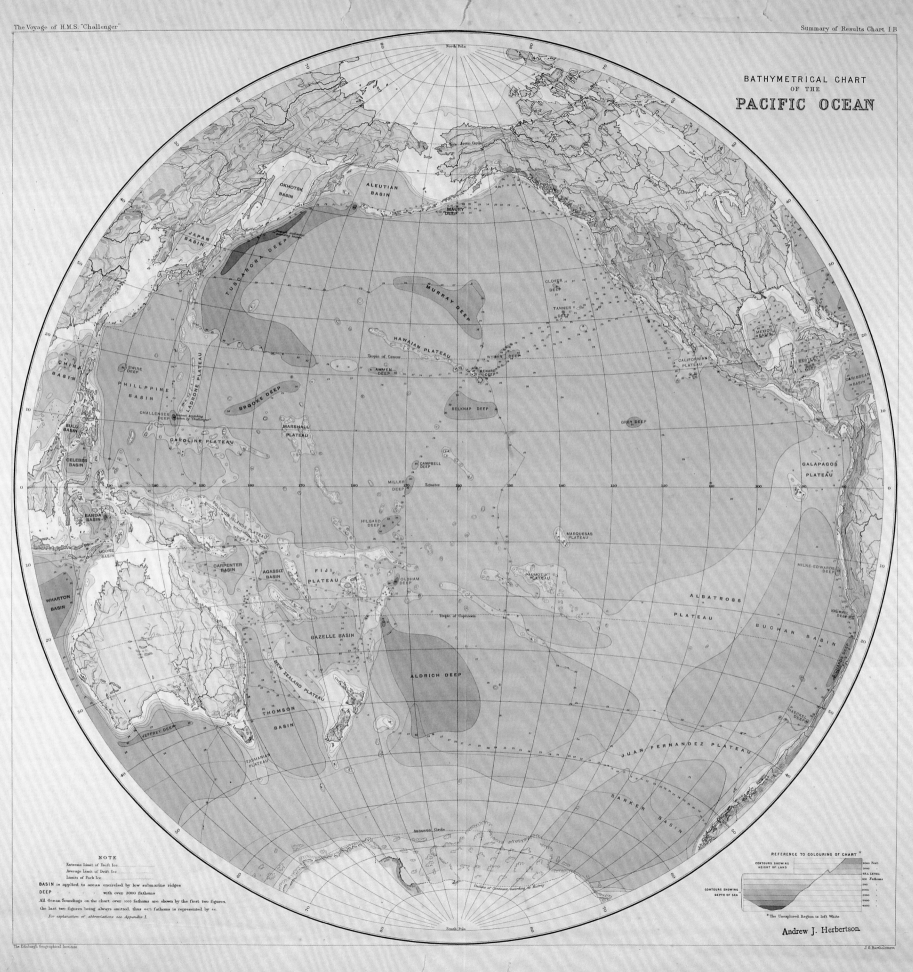

BATHYMETRICAL CHART
OF THE
PACIFIC OCEAN

Andrew J. Herbertson.

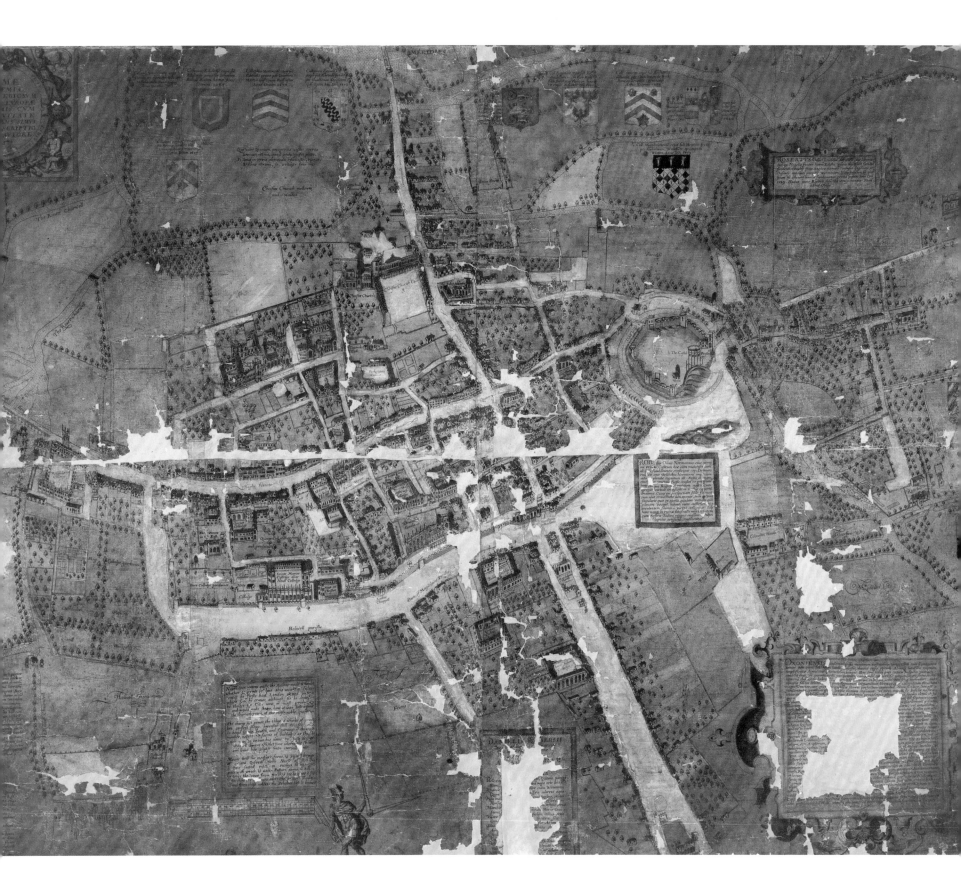

6

Oxford

Anyone living in a city needs a map to navigate its urban topography, whether it be ancient Rome or modern Oxford, where both authors currently live. Oxford is first mentioned in the historical record in 911 as a military settlement on the Thames. Its world-renowned university was founded in the twelfth century and it played a prominent role in the English Civil War. It is no surprise, therefore, that Oxford is a well-mapped city. Its cartographic history goes as far back as Ralph Agas's 1578 plan – the oldest surviving map of the city (fig. 48). But by comparing a selection of maps over time, we can also see how cartography reflects the city's changing sociological and political concerns.

Agas's map challenges the viewer with its apparently unconventional orientation – south is at the top, and the viewer's perspective is that of a bird in flight looking down on the city from the north. But once key landmarks are identified the city's surviving medieval street pattern can rapidly be discerned. St Giles is clearly visible at the bottom, Broad Street (living up to its name) runs across the map, High Street plots a parallel course just above it, and St Aldate's leaves the map at the top centre where it bridges the River Thames.

This fragile map's story is embellished thanks to the work of Robert Whittlesey, whose entrepreneurial nous led him to re-engrave Agas's masterpiece on behalf of the University of Oxford in 1728. The map remains commonly available and is straightforward to read, unlike the original. What is interesting, however, is that a number of new maps of Oxford were published before Whittlesey undertook his project, so the city had undergone significant development in the interim period. Geographically expansion was limited, but when we consult David Loggan's *New and Most Accurate Scenography of the Most Celebrated University and City of Oxford* (1675), what becomes apparent is the amount of infilling of plots in the century since Agas was at work (fig. 49). Trees occupied much of the city's urban area in 1578, but by Loggan's time, there had been an increase in building, notably in the area between the Sheldonian Theatre and St Mary's Church (towards the map's centre) as well as developments around the gardens that had extended from Carfax (at the central crossroads) to Christ Church (at the top centre).

Loggan's map is something of a tour de force when it comes to the interpretation of buildings. Working at a large scale of around 1:3,250 (almost twenty inches to the mile), aside from the map's orientation, Loggan also chose to emulate Agas's viewing perspective, that of the bird's-eye view, seeing the town as it would present itself to anyone passing over it. The city's buildings are, unlike conventional maps, given a three-dimensional appearance, so their relative heights are shown as well as their locations on the ground. The combination of urban dwellings, university buildings and ornamental gardens does give a vivid sense of what 1670s Oxford actually looked like. Granted we cannot hear or smell the city, but we are given a unique impression of what could be viewed from the ground.

Loggan became involved in the project following his move to Oxford in the late 1660s. In March 1669 he was appointed to the role of engraver to the University. Within six years he had produced *Oxonia illustrata*, an album of

Fig. 48 Ralph Agas, map of Oxford, 1578.
The earliest surviving map of the city.

stunning bird's-eye views of the city's academic buildings, into which he had the great foresight to incorporate his map. It was only after his death in 1692, when his surviving plates were sold to the print-seller Henry Overton, that his engraving of Oxford, as well as another for Cambridge, became more commonly available and appreciated for both the information they portrayed about the University and also their remarkable aesthetic quality.

A 'False' Map of the City

Placing south at the top of Oxford town plans remained in vogue until the late eighteenth century. An earlier seventeenth-century map of the city, made during the Civil War, some thirty years before Loggan's work, offers a different perspective on the adoption of this orientation. The city is shown in full detail at the top of the page, whilst below the map's scale is drastically reduced, and like a balloon on a string, Oxford appears to float away, the string representing the River Thames with 'Abbington' (Abingdon), Wallingford and 'Reding' (Reading) shown as walled towns downstream (fig. 50).

The strange juxtaposition of scales is only part of the story. At first glance the city's internal layout appears usual enough. We can see the castle to the west and Magdalen Bridge to the east, linked by the Queen Street/High Street route. On closer examination, the search for familiar landmarks starts to generate considerable doubts. If we focus on Carfax, Oxford's central crossroads, and head south along St Aldate's towards Folly Bridge, we find ourselves on St Giles. When we look for St Giles to the city's north, we see what must be St Aldate's, and a bridge over the Thames. The map has an alphanumeric legend at the bottom left, identifying key buildings, and these confirm that the urban layout appears to be a mirror image along its north–south axis. But a mirror image of what? The answer is John Speed's map of Oxford from 1611 (fig. 51), which uses an identical alphanumeric notation. The locations of all the sites have been 'reversed', yet the identifying numbers and letters

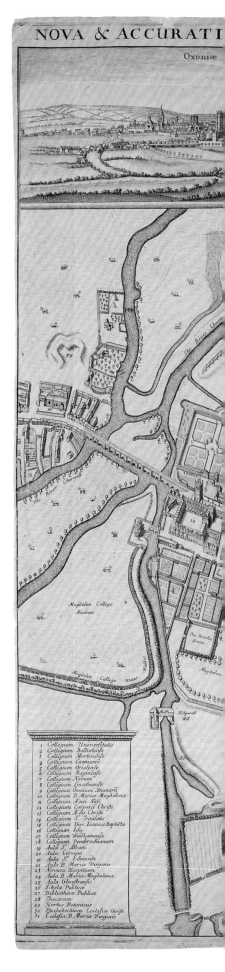

Fig. 49 David Loggan, map of Oxford, 1675. (E) C17:70 Oxford (12).

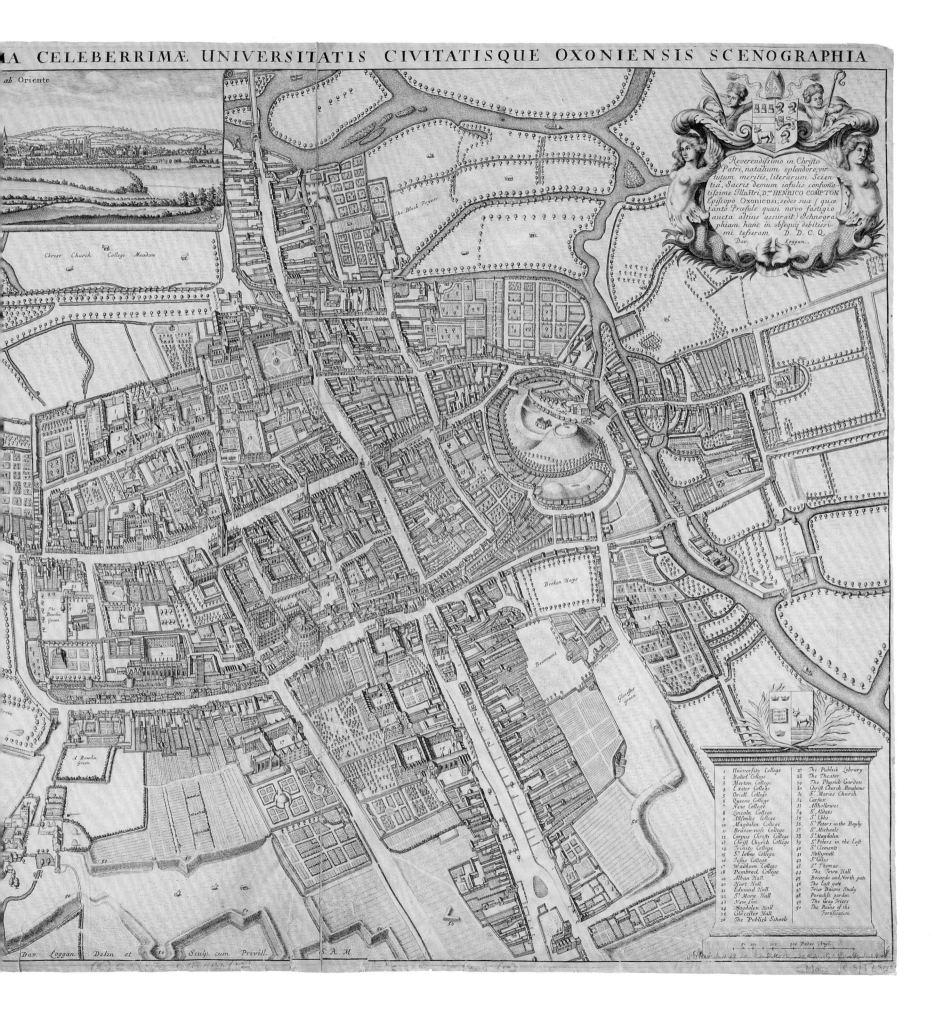

ab Oriente

The Black Fryers

Christ Church College Meadow

Reverendissimo in Christo Patri, natalium splendore, virtutum meritis, literarum Scientia, Sacris demum infulis consumatissime Illustri, D.no HENRICO COMPTON Episcopo Oxoniensi; sedes suas quæ tanto Præsule quasi novo fastigio aucta altius assurgit) Schnographiam hanc in obsequij debitissimi tesseram B. D. C. Q. Dav. Loggan.

The Castle

Broken Hays

Beaumont

Gloster green

A Bowling Green

Dav. Loggan Delin et Sculp. cum Privill. S. R. M.

1	University College	27	The Publick Library
2	Baliol College	28	The Theater
3	Merton College	29	The Physick Garden
4	Exeter College	30	Christ Church Almshous
5	Oriell College	31	St. Maries Church
6	Queens College	32	Carfax
7	New College	33	Allhollowes
8	Lincoln College	34	St. Albans
9	Alfoules College	35	St. Ebbs
10	Magdalen College	36	St. Peters in the Bayly
11	Brazen-nose College	37	St. Michaels
12	Corpus Christi College	38	St. Magdalen
13	Christ Church College	39	St. Peters in the East
14	Trinity College	40	St. Clements
15	St. Johns College	41	Hollywell
16	Jesus College	42	St. Giles
17	Wadham College	43	St. Thomas
18	Pembrock College	44	The Town Hall
19	Alban Hall	45	Bocardo and North gate
20	Hart Hall	46	The East gate
21	Edmund Hall	47	Frier Bacons Study
22	St. Mary Hall	48	Paradise garden
23	New Inn	49	The Gray Friers
24	Magdalen Hall	50	The Ruins of the
25	Gloester Hall		Fortification
26	The Publick Schools		

OXFORDE
AS IT NOW LYETH
Fortified by his Ma^ties forces
an. 1644.

Gray friers

Abbington

Wallingford

Reding

The Cheife places in the
Citie obserued by seuerall letters

A	s Giles	P	The Castle
B	s Iohns Colledg	Q	S Thomas
C	Trinitie Colledg	R	S Ebbes
D	Balliol Colledg	S	S Aldates
E	Magdalain Colled	T	Christs Church Coll
F	S Michaells	V	Chryst Church
G	Iesus Coll	W	Corpus Chr Coll
H	Exeter Colledg	X	Merton Coll
I	Vniuersitie scho	Y	S Maries
K	Lincolne Colled	Z	All Soules Coll
L	All Hallowes	1	Vniuersitie Col
M	S Martins	2	Brasenose Col
N	Corne Markett	3	Oriall Col
O	S Peters my Baile	4	Eastgate

This map is made very false

opposite Fig. 50 Map of Oxford made during the Civil War, 1644. Wood 276b, fol. XXX.
left Detail of bottom left corner showing inscription.

Fig. 51 John Speed, map of Oxford, 1611, used in mirror image form on the 1644 map (see fig. 50). (E) C17:49 (114).

have not, in what seems a deliberate yet puzzling editorial decision.

Why has this been done? The date of the map, 1644, might be a clue. Was it made by Royalists based in the city to confuse the enemy Parliamentary forces? The city became the country's Royalist headquarters in January 1644, but was subjected to three separate sieges before surrendering to Parliamentary forces in June 1646. The map shows defences, cannons and soldiers, so clearly the war was in the mind of its creator. There is a telling manuscript addition at the bottom of the page by the late seventeenth-century Oxford antiquary Anthony Wood that reads 'This map is made very false'.

A Sober Map?

We can now move from stories of deliberate confusion to explicit attempts at conversion. While not a conventional town plan in concept and delivery, the Temperance Union of Oxfordshire's *Drink Map of Oxford* (1883) is heavy on message and effective in design (fig. 52). While this map lacks the artistic finesse of Agas or Loggan, it certainly packs a punch.

The monochrome cartographic background is perhaps not the finest example of map-making, but the street pattern is undeniably Oxford, and it is correctly placed. What brings this map to life is the striking use of red symbols. Each represents one of the 319 drinking establishments in the city, divided into four classes, all of which stand out dramatically.

The symbols tell only part of the story. The reverse of the sheet exhibits the full weight of this map's moralizing with an evangelical condemnation of the evils of alcohol, entitled 'The Drink Traffic in Oxford'.

We are told that every twenty-second house in Oxford is a 'drink shop', and that this figure is 50 per cent higher than the national average. The Temperance movement is 'zealously striving to counteract the pernicious effects of drink', yet there remains 'an appalling amount of misery' in the city. Drink is described as the precursor to 'idleness and

ill-health', which in turn can bring on poverty and crime. Less drinking would mean greater prosperity.

This clarion call for sobriety and prohibition makes a point of analysing the map's content, rather than using text to convey a familiar message. The Drink Map's uneven geographical distribution of the red ink offers a graphic insight into the city's late nineteenth-century demography. There are evident red clusters in Jericho (north-west of the centre), St Ebbe's (south-west), and St Clement's (east), all areas which are noted as being home at that time to those in the lowest income bracket. North Oxford is almost free from 'drink shops', and remains so in the twenty-first century. As the text notes, 'Magistrates rarely grant a licence for any house near their own homes'. The magistrates are reminded that every licence is due for renewal on an annual basis and that, following recent guidance from the Home Secretary in the House of Commons, there was no obligation for automatic renewal. Indeed, refusing renewals of licences was actively encouraged: '[l]icences should be granted in the interests of the people, and not for the benefit of the publican'.

Whilst the Oxford of today has nothing like the same high level of drinking establishments – the Temperance Union's message seems to have had some effect – what is striking is the clustering of current public houses, and how the greatest concentrations currently tend to match what is portrayed on the Drink Map.

Suburban Apartheid

Oxford's northern suburb of Cutteslowe is not a particularly remarkable part of the city. To the uninitiated it looks like a typical example of 1930s suburbia, found in most British cities, largely made up of brick-built semi-detached houses with front and back gardens. Cutteslowe today is very different from when its initial construction work took place, and therein lies a dark tale of social engineering and legal chicanery which brought small-scale economic apartheid to the city and arguably drew Cutteslowe symbolically into line with historically divided communities in places such

Fig. 52 *Drink Map of Oxford*, 1883. C17:70 Oxford (7).

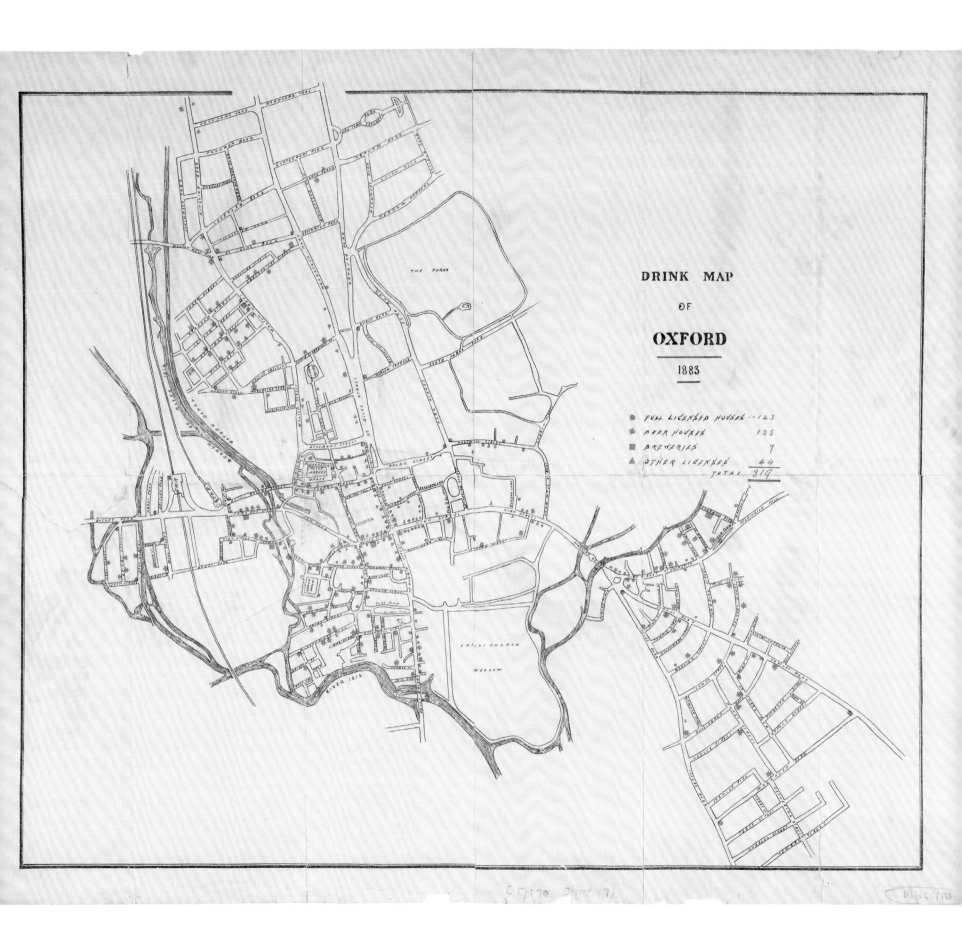

DRINK MAP

OF

OXFORD

1883

● FULL LICENSED HOUSES — 143
✱ BEER HOUSES 125
■ BREWERIES 7
▲ OTHER LICENSES 44
 TOTAL 319

as Belfast and Berlin. A wall was built. The intention was to divide Oxford City Council's housing estate constructed to the east (to accommodate people in need of rehousing following the St Ebbe's slum clearances close to the city centre, which had commenced in the early 1930s) from the neighbouring private development of considerably more expensive private houses constructed a few years earlier. Those living in the city council's houses were obliged to pass through the more affluent estate in order to reach Banbury Road, and by extension the city centre. The private developer – Clive Saxton – feared his houses would not sell if they were sited adjacent to homes built for the less advantaged, as was the case in Cutteslowe. His solution, a brick wall almost six feet (two metres) high, topped with iron spikes, was constructed on land owned by his property company in 1934.

The council tenants set up a petition asking for the walls to be taken down, but since they were built on private

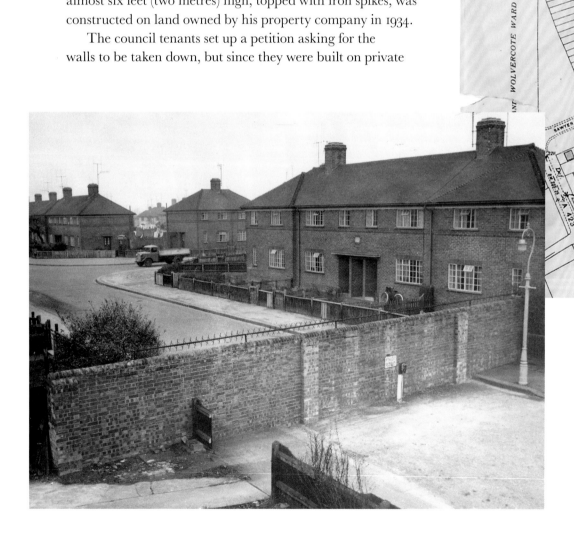

left Fig. 53 The Cutteslowe Wall between Wolsey and Carlton Roads, March 1959.

above Fig. 54 Detail of the Cutteslowe walls, depicted by a black line. Ordnance Survey County Series 1:2500, 1940. C17 (8), Oxfordshire sheet XXXIII.7.

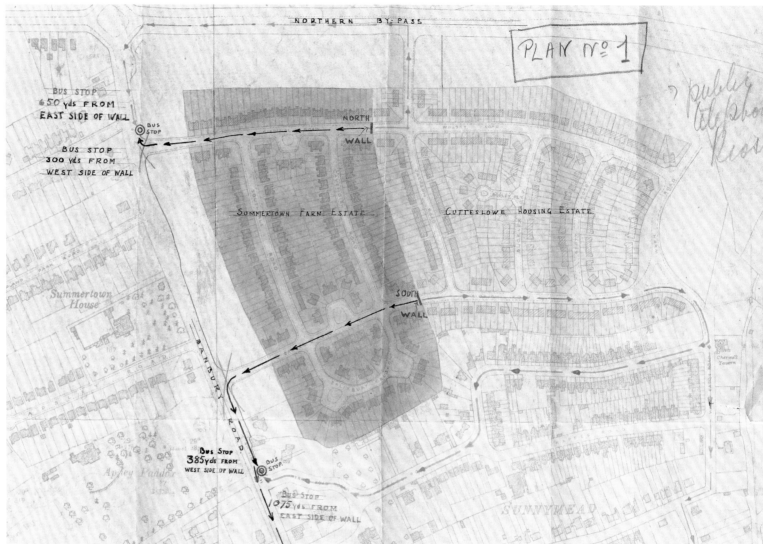

above right Fig. 55 Oxford City Council's plan showing the North Wall and the South Wall. J.F. Richardson, 1934.

land, there was little the council could do. The tenants were even prevented from demolishing the walls by police in an organized protest in 1935. Two years later the city council finally dismantled the walls with a steamroller, albeit against legal advice, but the law fought back, and the city was ordered to rebuild it, having been successfully sued by Saxton's Urban Housing Company. During the Second World War, a tank on exercises ploughed through one of the walls accidentally – the crew had assumed the wall to be a dummy erected for this particular training episode – and the War Office was obliged to pay for its reconstruction.

It was not until March 1959 that the walls finally disappeared, demolished in a ceremonial manner orchestrated by the city council, which had managed to buy the land on which the walls were built under the recently granted powers of compulsory purchase. In the year in which they were demolished, these walls had existed for almost the same length of time as the Berlin Wall.

Walls represent a challenge to map-makers. The Ordnance Survey sheet at 1:2,500 scale dating from 1940 (fig. 54) does show the walls, but the map reader needs to know what they are looking for. A black line can be seen crossing Carlton Road/Wolsey Road, and then further south at the point where Wentworth Road becomes Aldrich Road. These barriers to movement are not named and look more like a cartographic error, as they form part of a continuous north–south line separating gardens. The line makes sense only if the user is aware of the existence of the Cutteslowe Walls. It is incredibly easy to miss or dismiss a line that represented casual but shocking social and urban divisions within living memory.

Oxford City Council did produce a plan for internal use in 1934 based on Ordnance Survey material (fig. 55). Manuscript additions have been placed on top of the monochrome base map, so we can clearly see Saxton's estate in pink, and the City Council's houses in yellow. On this map 'North Wall' and 'South Wall' are indicated in red. What this map conveys is the distance from either side of the wall to bus stops along Banbury Road and the local school on Church Street, facilities that would have been used by residents of both blocks of housing. The bus stop by Hernes Road is shown to be a 385-yard walk from the west side of the South Wall; from the east side, those living in the council-built houses would have to walk 1,075 yards to the same point.

Thomas Sharp and Oxford Replanned

Returning to the city centre, Oxford's urban core has changed little since medieval times. The street pattern remains largely intact, although a number of those street names have changed over the centuries. The historical layout of the city has brought problems, largely concerning the movement of traffic, an issue constantly discussed since the mid-twentieth century. Debate continues today about the status of buses in Queen Street, whether buses should return to Cornmarket Street, and congestion on High Street and its associated impact on air pollution. Much of this recent discussion might have been avoided if the plans of Thomas Sharp had been implemented.

Sharp was a prominent figure in UK planning in the middle of the twentieth century, both as a writer on planning issues and as a producer of plans. He was employed as a consultant by Oxford City Council in the aftermath of the Second World War from May 1945. His remit was to prepare a report on the planning and redevelopment of the city. It was in his daring vision, *Oxford Replanned*, where the ideas about his concept of *townscape* (as opposed to landscape) crystallized. Sharp considered the High Street a 'great and homogenous work of art', not because of the architectural quality of the buildings but because of the relationships between them.[1] The neighbouring sequence of the Old Bodleian Library, Radcliffe Camera and the University Church of St Mary's was held to be 'a first class aesthetic experience … to be treated with awe'. He considered that crucial to both was the movement through space which he termed 'kinetic experience', a fundamental tenet of *townscape*.

In the introduction to *Oxford Replanned*, Sharp stated, 'The task has proved to be an onerous one, and now it is completed

I cannot with certainty expect that the result will be generally acceptable even in its main features, let alone in all its details. Indeed I know very well that some of the suggestions I make will rouse bitter opposition in some quarters.'² He made clear that he was neither 'pro-town' nor 'pro-gown', but pro-Oxford, and he was adamant that any approach he suggested be bold – he was not going to 'play safe'.

Two of Sharp's maps capture his unique vision for the city. The first (fig. 56a) shows his plans for the area in a westerly arc pivoting around Carfax. Here is the new road network, graceful curves sweeping from a roundabout near the police station in a northerly direction to a similar-looking interchange at Broad Street's western end. This new road would pass through another major junction at a location currently occupied by Bonn Square. In the centre of this gathering of five radial roads would be the relocated conduit – the elaborately carved tower from which fresh water direct from Hinksey Hill was dispensed, returned to the city centre from its current exile at Nuneham Courtenay to where it had been banished from Carfax in 1795. There is a grand building labelled 'Town Hall' at the spot where County Hall now stands; the Oxford Union has been transferred east to the site of the Covered Market; the Friary is a new east–west road cut to the north of George Street; the slums of St Ebbe's have been torn down and replaced by three-storey flats; and all these plans have been designed to interweave around and accommodate Nuffield, Pembroke and St Peter's, the three colleges located within the affected area.

Sharp produced another stunning map to illustrate how he planned to alleviate the High Street's traffic congestion levels (fig. 56b). His proposal was to link St Aldate's and The Plain (the open area at the eastern end of Magdalen Bridge where three radial routes converge) with a new road, Merton Mall, taking traffic out of the built-up area and across Christ Church Meadow instead: a radical suggestion, as the meadow delivered a rural landscape directly into the city's centre.

Merton Mall can be seen tearing up the ground at the southern frontage of Christ Church, bisecting Broad Walk and dropping over the Cherwell to a roundabout at The Plain, where the entrance to Cowley Road has disappeared beneath a verdantly landscaped park.

To this end, Sharp even went as far as to devise a timetable for his reconstruction plans. Merton Mall would be completed first, and a further six incremental phases were set down, with the project's concluding phase being the completion of George Square and the eastern end of the Friary (today's George Street/Cornmarket Street/Broad Street area).

An exhibition was held in March 1948 which gave Sharp the opportunity to tell his story. In the accompanying pamphlet Sharp issued the following challenge:

> It is now for the citizens of Oxford, and for all those who love the city and have its future at heart, to decide what shall be done. The city is their charge. Theirs is the responsibility for its future.³

These proposals failed to materialize (although St Ebbe's was subjected to a massive programme of urban renewal), but what is particularly striking is the beauty of these two town plans. Their attraction almost demands to be acted upon, but even these delightful portrayals of townscape were unable to persuade Oxford's decision makers to accept and act upon Sharp's controversial urban make-over blueprint. The discussion surrounding Sharp's proposals continued for many years. The planned relief road across Christ Church Meadow was not rejected until the mid-1960s, having been subjected to numerous revisions over the intervening decades. Sharp's prediction that his plans would not be 'generally acceptable' had come true. For better or worse, depending on your view of urban planning, this was indeed the eventual outcome of his labours.

Soviet Oxford

While Sharp's radical vision of Oxford foundered, a new and very different plan of the city emerged in 1973. It was so different from any of its predecessors that it remained

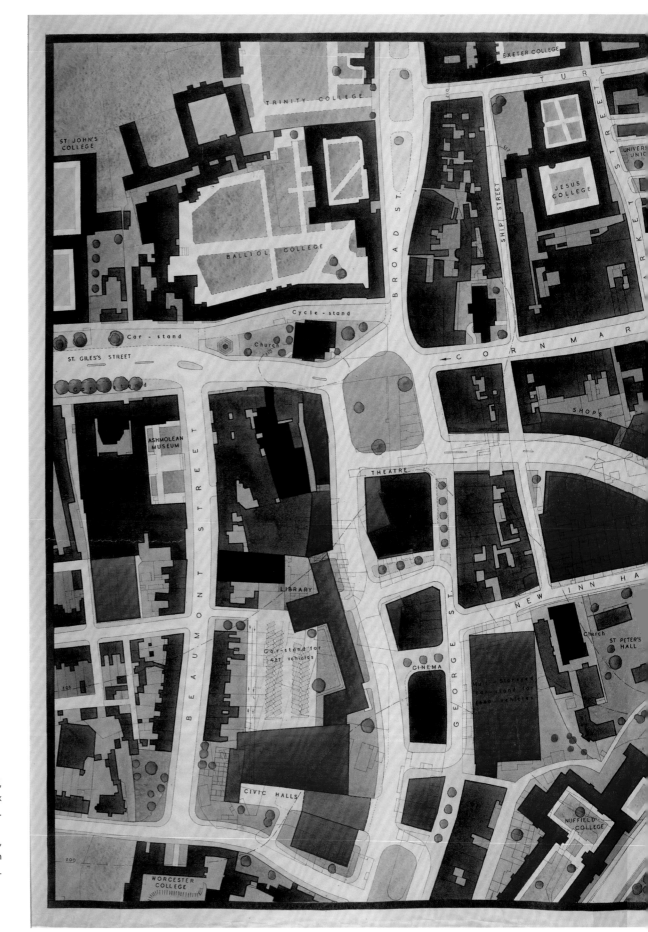

Fig. 56a Thomas Sharp, *Oxford Replanned*, 1948, showing a proposed new road network for the city. (R) C17:70 Oxford (246).

pp.114–15 Fig. 56b Detail of Thomas Sharp, *Oxford Replanned*, 1948, showing Merton Mall. (R) C17:70 Oxford (246).

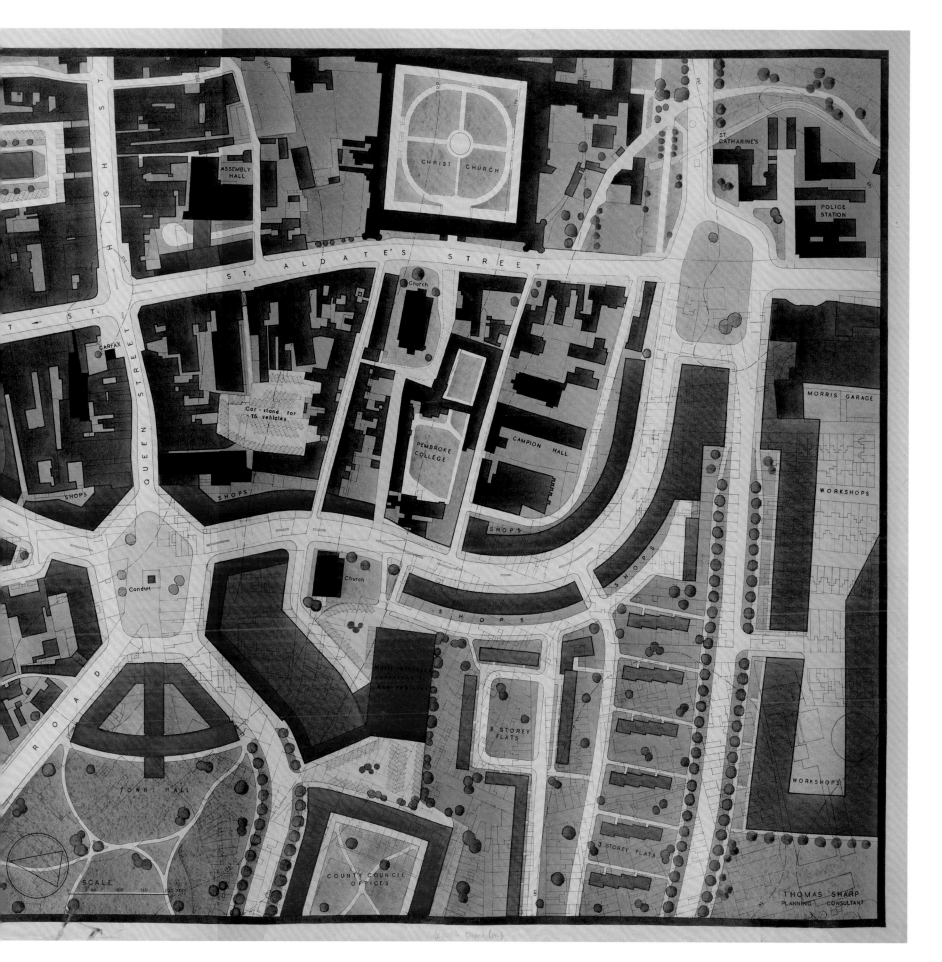

ASSEMBLY HALL

CHRIST CHURCH

ST CATHARINE'S

POLICE STATION

ST. ALDATE'S STREET

Church

CARFAX

HIGH ST.

QUEEN STREET

Car-stand for 15 vehicles

PEMBROKE COLLEGE

CAMPION HALL

MORRIS GARAGE

SHOPS

SHOPS

SHOPS

SHOPS

WORKSHOPS

Conduit

Church

SHOPS

3 STOREY FLATS

Multi-storied motoring for vehicles

ROAD

TOWN HALL

3 STOREY FLATS

WORKSHOPS

SCALE
0 50 100 150 200 FEET

COUNTY COUNCIL OFFICES

THOMAS SHARP
PLANNING CONSULTANT

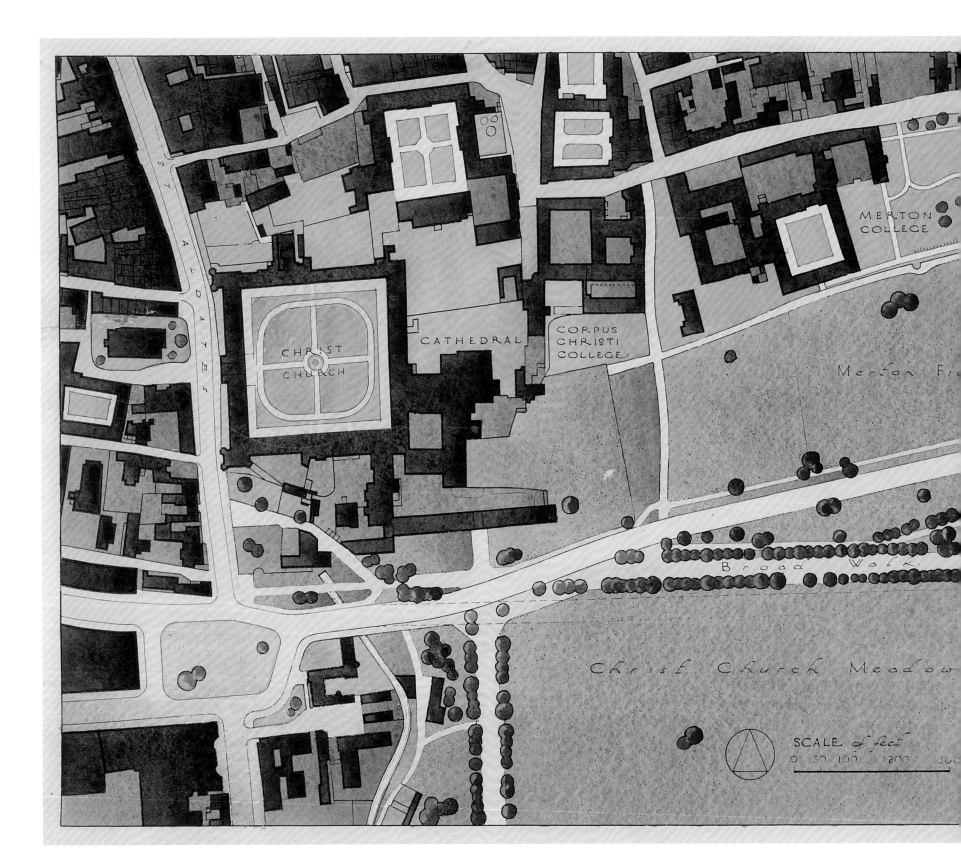

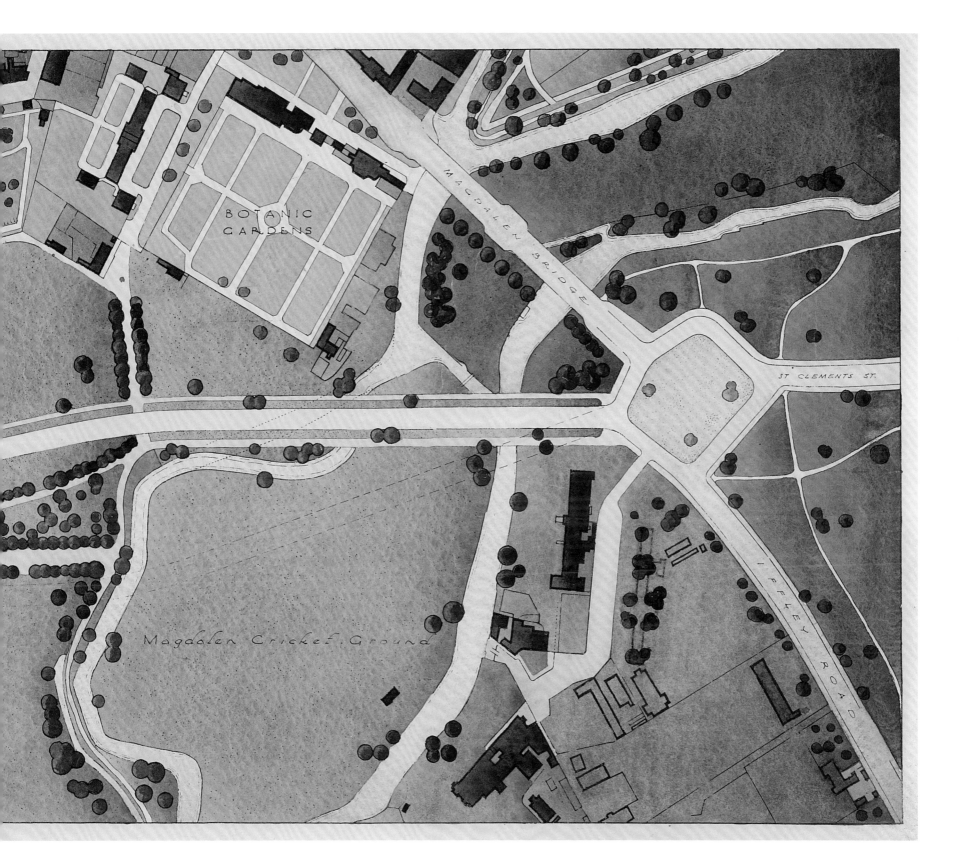

unknown in the West until twenty years after it was created. At a scale of 1:10,000, and occupying two large sheets, Оксфорд, transliterated as 'Oksford', lavishly printed in ten colours, was created by the General Staff of the Soviet military (fig. 57a).

This genre of cartography was unknown in Western Europe until the breakup of the Soviet Union, and first came to public attention at the International Cartographic Association's conference in Cologne in 1993, when a Latvian map dealer brought some material mapping Western Europe to display to delegates. These maps had been rescued from a military map depot in Latvia that was abandoned by the Soviets following the dissolution of the USSR. The information these maps contained was largely beyond comprehension in the West, which was blissfully unaware of this covert cartographic act of Soviet global surveillance.

A number of British map collections soon set about buying whatever Soviet maps they could acquire, with an understandable focus on the United Kingdom. Without catalogues to consult, collections have been developed in a piecemeal fashion. From what has survived it appears that from the mid- to the late twentieth century the Soviets made numerous town plans of many of the United Kingdom's principal settlements, ranging in size from London to small towns such as Gainsborough and Pembroke.

At this stage we can examine the map produced for Oxford. The city is divided into West and East sheets, covering an area of 11 × 7 kilometres (West) and 11 × 6 kilometres (East). The West sheet extends from Yarnton through the city centre down to Kennington, and from Cumnor across to South Parks; the East sheet runs from Beckley to Toot Baldon, and from South Parks over to Wheatley. All streets are included and named, as are principal buildings. A gazetteer is included on the East sheet.

There is a wealth of topographic information included in addition to the street layout. Forty-one key installations are identified and numbered, ranging from named locations – for example the John Allen and Sons engineering works (7) –

and W. Lucy & Co.'s ironworks (10) – right through to small post offices. Not everything is correct: University College is mistakenly identified as the 'University' (39). It is the only mention of the word 'University' on the map. A few colleges are named as such, for example Magdalen, whilst others, like Balliol, are simply named 'College'. Another error is the omission of Marston Ferry Road linking the north and east of the city – this road was opened to traffic in November 1971 but fails to feature on the map.

The text has been transliterated and not translated, so the suburb of New Hinksey is named Нью Хинкси, instead of the direct translation Novyĭ Hinksey. This must be indicative of the map's potential usage – to help native Russian speakers when conversing with locals.

Especially noteworthy on the map is the presence of metric contours at a time when Ordnance Survey contour information output was still measured and displayed in imperial units. The map is unlikely to have been copied directly from contemporary English-language maps, but the indications are that 1930s Ordnance Survey maps were used. Some of the earlier surviving Soviet plans of British towns actually credit their sources on the map itself.[4]

This was cartography on a global scale. Soviet town plans similar to these Oxford sheets have now been seen for cities throughout the world. These maps are much more than conventional street maps. Other town plans go into levels of detail unimaginable to Western cartographers: for example, bridges are featured with details of the materials from which they are constructed, their height, their height above different tidal limits of the water beneath them, their carrying capacity and much more. There is even mapping of the density of woodland, naming the dominant tree species in the vicinity as well as the average distance between them. This was the result of a spectacularly productive operation involving thousands of cartographers, and an unknown number of 'researchers' recording and passing on geographical data from a location 'near you'. The Oxford map, however, is not as sophisticated as many, perhaps indicating that the city was not seen as

Fig. 57 City centre detail of the Soviet map of Oxford, 1973. C17:70 Oxford (154).

Fig. 58 Rochester Bridge, detail of Soviet map
of Chatham, 1984. C17:70 Chatham (4).

a strategic priority by the Soviets. Their intention was clearly to map as many cities globally as they could, with as much detail as possible, and the Oxford map is just one example of this monumental undertaking. The cartographic conceptualization behind these maps was simple enough – to show what was on the ground in as much detail as possible.

This was a long way from the individuality of Agas and Loggan, and even Sharp. The Soviet mapping exercise aimed to create an internationally standardized framework through which the globe's urban settlements could be instantly understood, and potentially shoehorned into the house style of the homogenous global vision portrayed by Soviet cartography. At a time when much of the world was considering the merits of command economies largely drawn from the Soviet model, the rationale behind this monumental project is clear. It was preparing the cartographic ground for a uniform map portraying the global landscape to embrace a Soviet-style world picture as and when the situation arose.

Historic Towns Trust Maps

Today, a very different initiative is mapping Oxford. Work is currently being undertaken by the Historic Towns Trust to produce a Historic Towns Atlas of Oxford which involves the creation of new maps to depict how the city may have been laid out in the past. This will include a main map at a scale of 1:2,500, which has been created to map urban changes over time. The team creating the atlas are also producing material on the same digitized base map to enable comparisons of urban form to be made, with nine maps at a scale of 1:4,000 scheduled for completion showing snapshots from 1050, 1150, 1279, c.1400, c.1500, 1578, the Civil War period, 1675 and 1800. It involves two methods: using historic texts and archaeological finds as evidence, then constructing a map around them; and directly employing maps such as those by Agas, Loggan and Richard Davis (the Lewknor-based cartographer who in 1797 published a stunningly detailed map of all Oxfordshire with an inset map of the city), then plotting the results of their labours onto this common base map. What this offers is a degree of quality control, separating accurate from questionable and unreliable cartographic endeavours, with Loggan's 1675 map proving to be an outstanding representation of Oxford's urban topography. Buildings (and gaps between them) are accurately set down, and can be laid down on the base map with confidence. Other well-known maps, such as that by Wenceslaus Hollar (1643), were simply too unreliable to be used.

The Historic Towns Trust has published an appetizer of a map showing medieval and post-medieval Oxford overlaid on an Ordnance Survey 25-inch base map dating from 1876 (fig. 59).

Technically the city depicted here has never existed as shown – the Historic Towns Trust has focused on urban development over time, so this is simultaneously a static and a dynamic map, showing buildings that have existed, or still exist, yet never all together at the same time. This is quite an achievement: the map captures Oxford's enduring medieval foundations, so painstakingly and beautifully recorded by Agas and Loggan, as well as its ever-changing more recent urban topography, and by combining both it effectively reflects the experience of navigating the city today.

pp.120–21 Fig. 59 Historic Towns Trust map of Oxford, 2016. C17:70 Oxford (267).

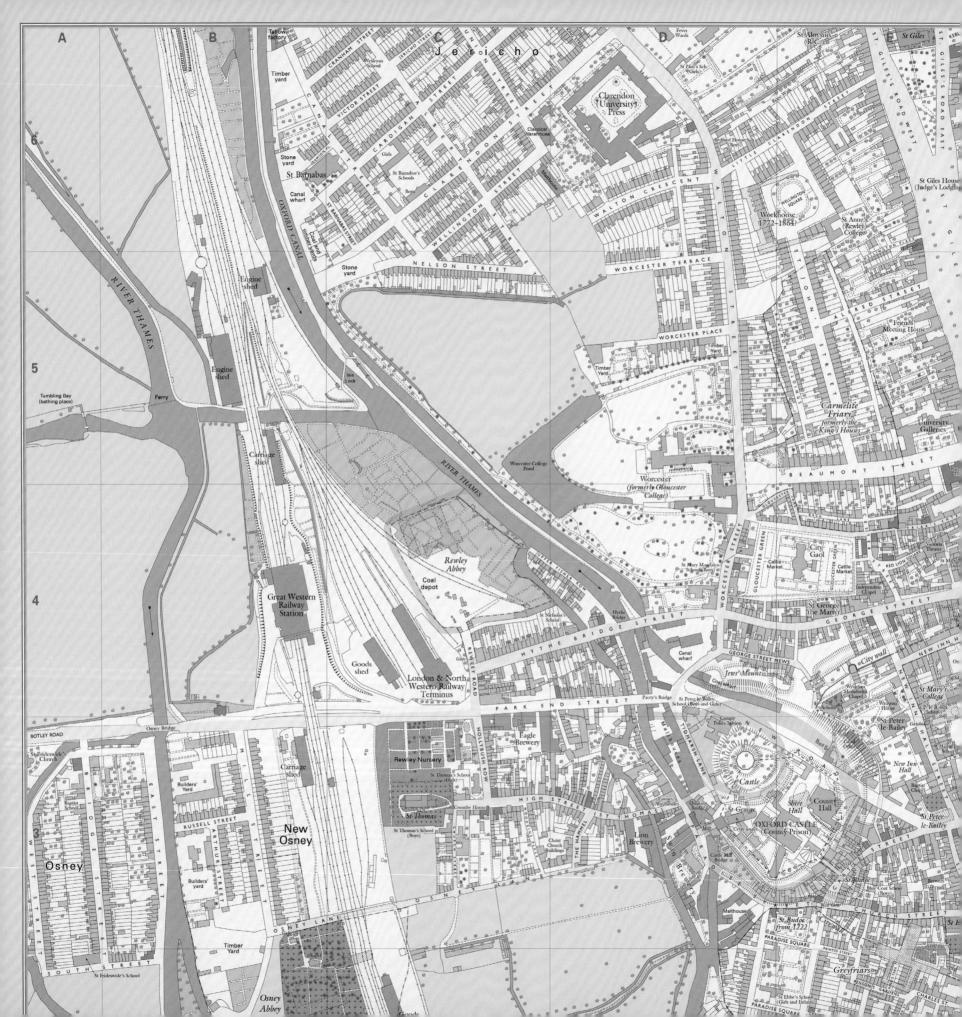

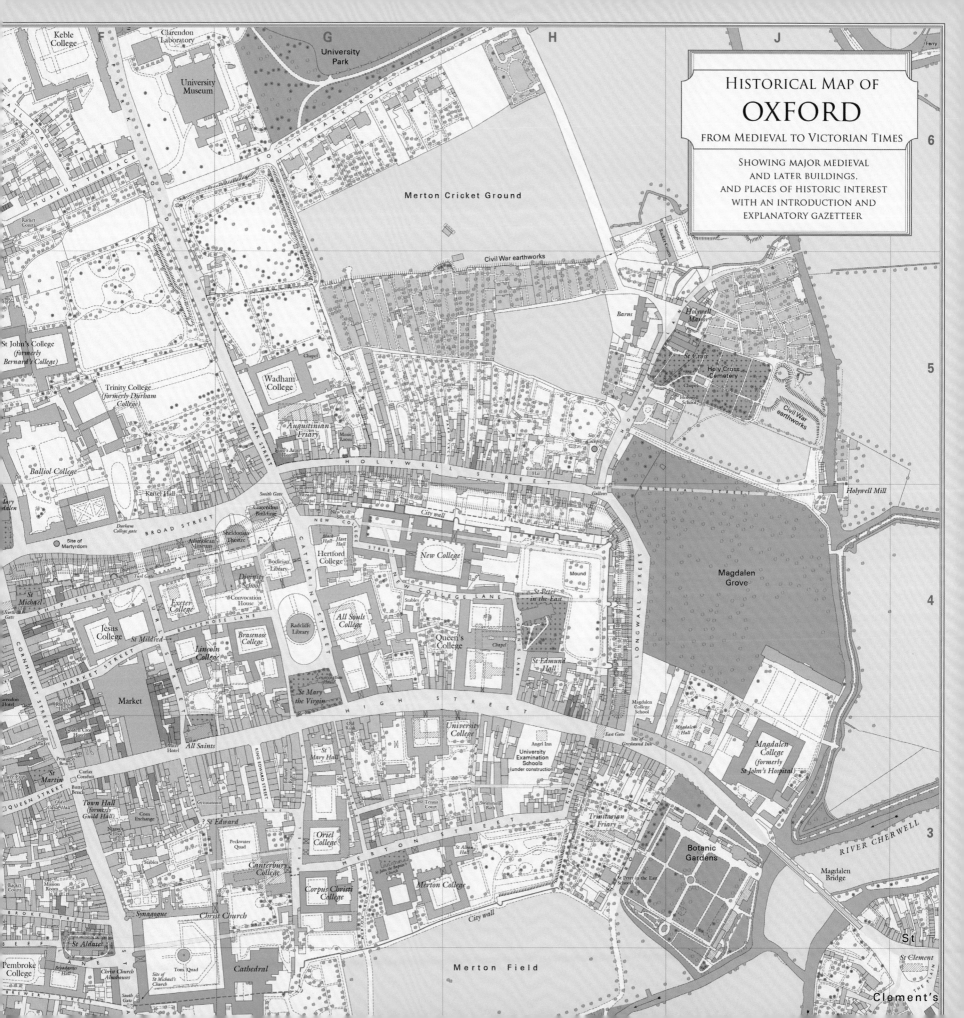

HISTORICAL MAP OF
OXFORD
FROM MEDIEVAL TO VICTORIAN TIMES

SHOWING MAJOR MEDIEVAL
AND LATER BUILDINGS,
AND PLACES OF HISTORIC INTEREST
WITH AN INTRODUCTION AND
EXPLANATORY GAZETTEER

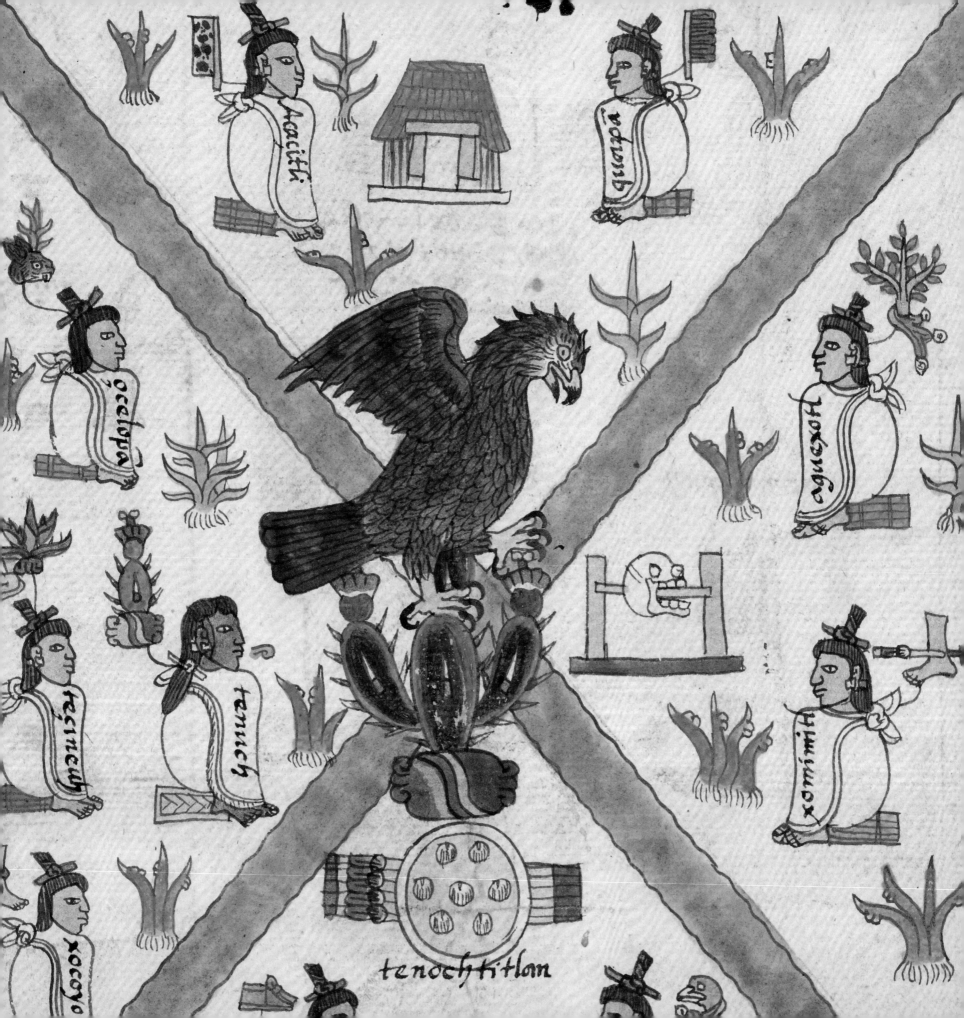

Acaciti

quapa

ocelopa

tenuch

xocoyo

tenochtitlan

Hoxoyug

Hxixuoy

7

Sacred Topographies

Maps guide their users across sea and land; they visualize the country and the city; plots and charts enable us to administer the land and shape the stories we tell each other and the wars we wage. They can also depict routes into the afterlife and describe places that are quite literally out of or beyond the terrestrial world we inhabit. These sacred topographies include spiritual realms like heaven, hell, purgatory and paradise, and the more intangible realms of *nirvana* shared by those who believe in rebirth and reincarnation. Such maps can offer their cultures a graphic representation of the beginning of the world ('cosmogonies'), and its end. What unites most of these maps is a belief that life is a journey that requires spiritual as well as geographical orientation, where death is only one element in the individual's quest for salvation, enlightenment, rebirth or even oblivion. In this chapter we explore various sacred places and journeys drawn from across the globe and through time, asking why maps are the medium through which they are so often expressed.

Paradise: Mapping the Unmappable

A belief in a state beyond our present world that is characterized by eternal peace and harmony is common to most cultures. The Egyptians, Greeks and Romans all possessed such visions of alternative worlds of timeless happiness, as do all of the world's organized religions, from the Christian Garden of Eden to the Islamic conception of heaven as a garden, or *jannah*, whose highest level is called *firdaws*. The Arabic *firdaws* was derived from the mixed Persian, Hebrew and Greek term *parádeisos*, referring to a verdant garden or royal park. Early Christianity took the

garden metaphor a stage further with the Old Testament concept of the Garden of Eden, or earthly paradise, the garden of God where humanity is first created in the shape of Adam and Eve.

But how is it possible to map an apparently unmappable space like paradise? It inhabits a spatial and temporal realm that is somehow part of but separate from the terrestrial world. For the Christian faithful it was helpful to provide a theological route map, visualizing both paradise lost and the heavenly one to come, and guiding them on their worldly pilgrimage across the surface of the sinful earth. Medieval *mappae mundi* often depicted Eden and the expulsion of Adam and Eve at their apex (often oriented eastward), with Jerusalem at their centre.

Around 1350 the English Benedictine monk and chronicler Ranulf Higden wrote a universal history entitled the *Polychronicon* which includes a *mappa mundi* showing paradise as both part of the physical world and separate from it (fig. 60). His map is less a spatial representation of physical geography, and more a story of the passage of biblical time from the Old to the New Testament, moving down the map from humanity's creation in the Garden of Eden at the top to Christ's crucifixion in Jerusalem in the middle. Implicit in this and in most *mappae mundi* is the belief that the representation of the sinful post-lapsarian world anticipates the Last Judgement, when 'the first heaven and the first earth' give way to 'a new heaven and a new earth' (Revelation 21: 1). In this cartographic-eschatological 'rough guide' to salvation, time and space will end and make way for the reign of an eternal paradise.

Fig. 68 Detail of Aztec map of Tenochtitlan, 1542.

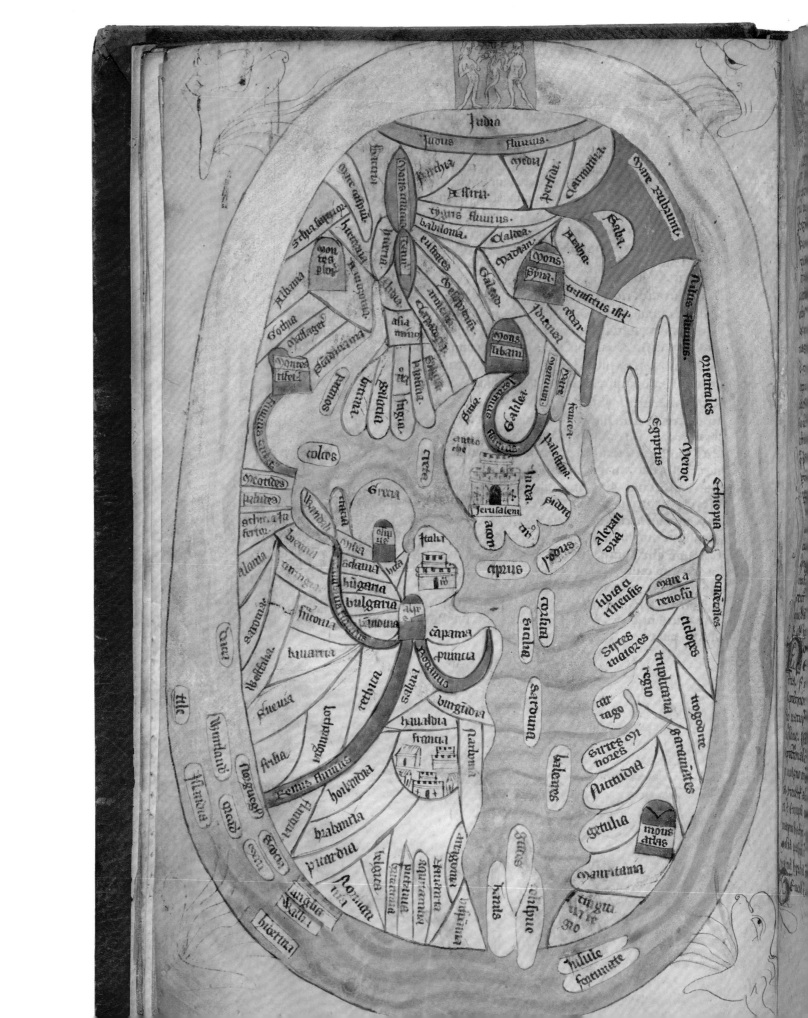

Muslim Pilgrimage

Many organized religions require some form of pilgrimage on the part of their believers to attain paradise. Such spiritual travels invariably require maps in some form as practical route-finders and portals into the afterlife. By their very nature every religion has different forms of worship and beliefs in the afterlife, so each in turn produces very different maps of its sacred places. In Islam images of heaven and hell are relatively rare. This is partly the result of the Islamic tradition of aniconism, with paradise an unrepresentable destination. Instead figurative representations focus on re-enacting the Prophet Muhammad's *isra*, his angelic journey from Mecca to Jerusalem and up through the seven ladders of heaven (known as the *miraj*). The Prophet's journey is replayed by the pilgrimage (*hajj*) that every Muslim is required to undertake in their lifetime, as part of their own journey towards paradise.

Unlike Christianity which simply privileges Jerusalem as the centre of its theology, Islam requires its believers to pray and perform specific rituals in a sacred direction, or *qibla*, namely the Kaaba in Mecca, the navel of the known world. As Islam spread outwards from the Arabian Peninsula from the seventh century it became increasingly important for Muslims to orient themselves in relation to the Kaaba during prayer, which led to the development of *qibla* maps based on complex mathematical and astronomical calculations. One twelfth-century Egyptian treatise on the *qibla* contains a map oriented with south at the top and the Kaaba in the upper left, each of its four corners labelled with a cardinal direction (fig. 61). From left to right the four lines radiating outwards from the Kaaba show the *qibla* from Aleppo, Damascus, Jerusalem and Cairo.

As well as orienting the faithful, *qibla* maps could be expanded to represent a comprehensive sacred geography of the Islamic world divided into sectors centred on the Kaaba. A particularly vivid example of this kind of map can be found in a nautical atlas dated 1571 by the Tunisian scholar 'Ali ibn Ahmad Ṣifāqsī. The atlas contained not only nautical charts for navigation that drew on Christian geography, but also astronomical, chronological and theological tables and maps to enable the faithful to conduct their everyday rituals and observe the *qibla*, including a map of Mecca (fig. 62). The map is oriented to the south, with the Kaaba at its centre. The surrounding topography is extremely precise, with the Maqam Ibrahim ('Station of Abraham') and the Well of Zamzam at bottom left, and the horseshoe-shaped Hijr-Ismail ('Stone of Ismail') top right. The Kaaba sits at the heart of a thirty-two-point wind rose, each point radiating outwards to a *miḥrāb* (prayer niche) containing the names of groups of Muslim regions or cities shown on a much smaller scale than Mecca.

The faithful could use al-Sharafī al-Ṣifāqsī's map to comply with Koranic injunctions concerning prayer, fasting, burial and the slaughtering of animals while facing the direction of the Kaaba. It could also be used to re-enact the *isra* through undertaking the *hajj*. This is as much an imaginative act as a scientific method of orientation: most of the calculations on the map are inaccurate, but it still enables the faithful to imagine they are pilgrims standing in Mecca in front of one of the Kaaba's four doors, even though they may in reality be hundreds of miles away from it.

Christian Pilgrims

Medieval Christianity had its own tradition of pilgrims travelling to its sacred places, as well as imagining heaven and hell. These spaces were mapped in ways that reflected personal experiences, and acted as guides to the faithful. Although pilgrimage to the Holy Land described in the New Testament was not a prerequisite of the Christian faith as it is in the case of Islam, examples of such pilgrimages were first recorded in the fourth century CE. With the spread of Islam from the seventh century, these pilgrimage routes faced significant disruption, a factor that significantly influenced the Christian Crusades from 1096 to 1291.

Pilgrims continued to flock to Jerusalem over the subsequent centuries on 'all-inclusive' tours arranged by

Fig. 60 Ranulf Higden, *mappa mundi* in the *Polychronicon*, 14th century. MS. Tanner 170.

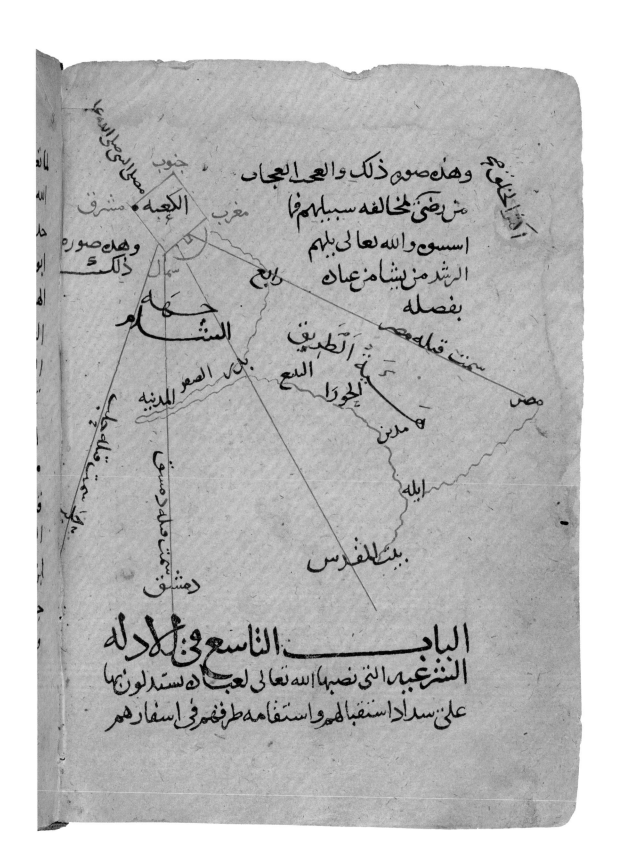

وهذا صورة ذلك والعمد العجاب
من رضى لمخالفه سبيلهم فا
اسسوق والله تعالى يلهم
الرشد من بشام من عمان
بفصله

الكعبه

وهذا صوره ذلك

جنوب

مشرق

مغرب

شمال

الشام

جبل الصو المدينه

الطريق
النبع
الحورا

مدين

ايله

بيت القدس

دمشق

الباب التاسع في الادله
الشرعيه التي نصبها الله تعالى لعباده يستدلون بها
على سداد استقبالهم واستقامه طرقهم في اسفارهم

Fig. 61 *Qibla* map from a treatise by al-Dimyāṭī,
c.1150. MS. Marsh 592, fol. 88v.

Fig. 62 ʿAli ibn Ahmad Sharafī al-Ṣifāqsī, map
of Mecca, 1571. MS. Marsh 294, fol. 4b.

فان الله العظيم يحكم كتابكم وحيث ما كنتم فولوا وجوهكم شطره

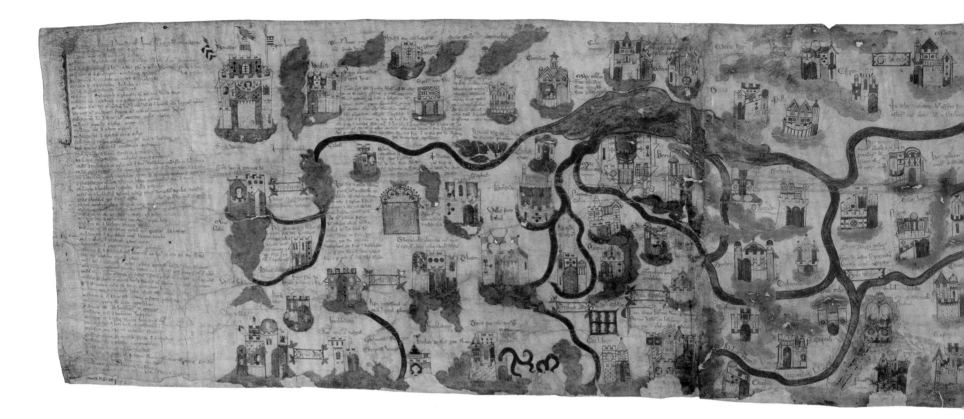

ship-owners mainly working out of Venice. One of the most vivid testimonies that survives of such a journey was made in the late fifteenth century by a priest from Devon called William Wey. In the 1460s Wey undertook two pilgrimages to the Holy Land which he wrote about in his *Itineraries* (*c.*1470). 'Having been asked by devout men to compile an Itinerary of my pilgrimage to the most holy sepulchre of Our Lord, Jesus Christ,' Wey described his 'journey across the various seas beyond which one must sail, the cities, towns and countries through which one must travel and the sacred places in the Holy Land'.[1] The book recreated in meticulous detail Wey's route overland to Venice, then by boat to Jaffa and overland to Jerusalem, a journey there and back which took him nine months. In it Wey gave a dizzying account of the exchange rates from one currency to another along the way, provided mnemonic verses describing the Holy Land's

key sites, and listed the extensive provisions recommended for the journey, including frying pans, laxatives and a chamber pot. He also offered useful tips on where to stay in Venice and on hiring the best donkeys in Jaffa.

Wey's *Itineraries* contained two chapters listing nearly 400 locations which he described as 'on my map of the Holy Land'. He also included a chapter on nearly fifty 'distances between places in the Holy Land'. Nearly all of Wey's geographical data can be found on an earlier fourteenth-century map of the region (fig. 63a) that drew on a treatise describing the Holy Land written in the 1130s by Rorgo Fretellus, the archdeacon of Nazareth. Wey appears to have acquired this map (or one almost identical) and used it in describing his pilgrimage – indeed the match between Wey's *Itineraries* and the map is so close that until recently it was attributed to him.[2]

Fig. 63a Map of Palestine, late 14th century.
MS. Douce 389.

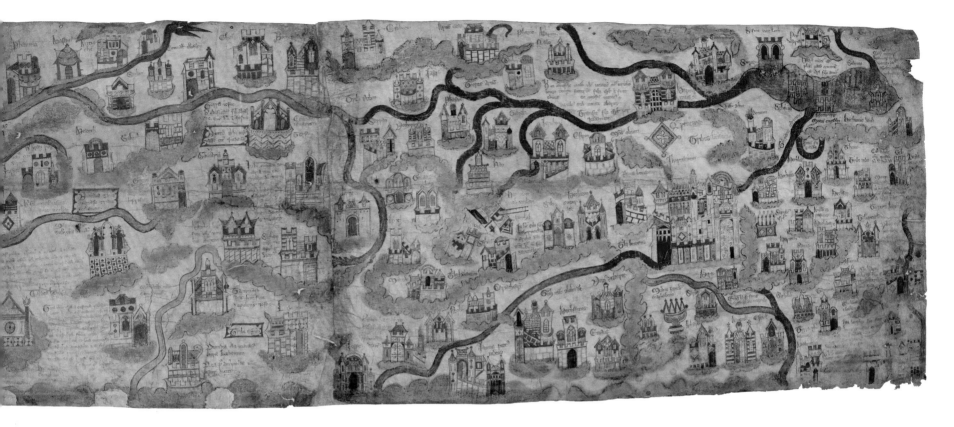

Examining the map alongside Wey's *Itineraries* provides a unique insight into the experience of fifteenth-century pilgrimage, and the part played by maps in understanding such events. Drawn on parchment and measuring 41 × 212 centimetres, the map teems with detail of the Holy Land's cities, rivers, mountains and sacred sites. Oriented with east at the top as pilgrims would first encounter the region when arriving in Jaffa from Venice, it moves from Damascus (top left) and Sidon on the Mediterranean coast (bottom left) to the north, to Beersheba and Hebron (far right) in the south, with the Jordan River running across the top and Jerusalem to the right. On the far left are fifty-two distances in miles between locations that match almost exactly those in Wey's *Itineraries*. Some describe key biblical moments: 'Two miles from Damascus is the place where Christ appeared to Saul'; 'One mile from Bethlehem the star shone on the shepherds'.

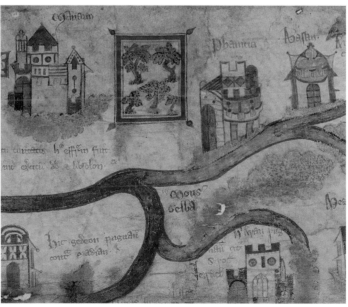

Fig. 63b Detail of Eden, map of Palestine.
MS. Douce 389.

Others simply record distances. The map also uses symbols to depict biblical places and stories, including the Garden of Eden, shown on the eastern edge and represented by five framed trees (fig. 63b).

Despite its detailed geography, the map does not purport to offer a specific route through the Holy Land. Instead it seems to have been intended as both a physical visualization of the entire region and an inducement to a spiritual and imaginative pilgrimage that intensified belief in and devotion to holy territory. Like *mappae mundi*, such maps combined the biblical past and present by layering history with geography to create a comprehensive devotional image of a Christian world picture. But the larger scale of these pilgrimage maps allowed the faithful to actually imagine they were in and moving around the Holy Land, at a time when many of them never had the opportunity to leave their towns and villages, let alone travel all the way to Jerusalem. William Wey was an exception, but like al-Ṣifāqsī, he seems to have understood how to utilize the unique nature of maps to narrate *and* visualize both events and places. In the process his fellow believers were transported to a place of salvation that was simultaneously real and imagined.

To Hell and Back

The thin line between real and imagined pilgrimage has led many religions into projections of travel into the afterlife, be they heavenly, infernal or transmigrational. These travels are invariably represented by or accompanied by maps. The most famous Christian example of an imagined pilgrimage is Dante Alighieri's three-part narrative poem the *Divine Comedy* (1308–21), describing the poet's journey from this world through Hell, Purgatory and Heaven. The poem is one of the great medieval statements of the Christian system of belief, both a realistic explanation of the geography of the three realms of the afterlife and an allegorical account of the believer's journey towards the divine. Hell – or 'Inferno' – is the most captivating book of all. The region is an infernal funnel stretching from underneath Jerusalem in the northern hemisphere to the centre of the earth, directly opposite Mount Purgatory in the southern hemisphere. Each of its nine circles corresponds to increasingly sinful behaviour, descending through a list including lust, gluttony, anger, heresy and treachery before culminating in a terrifying vision of Satan.

From the late fifteenth century Italian scholars began to use Dante's poem to provide a scientific theology of the exact location and dimensions of hell. The Florentine mathematician and architect Antonio Manetti produced the first printed map of Dante's hell, published posthumously in 1506. Manetti's was just one of many such maps made in sixteenth-century Italy in what has been labelled 'the heyday of infernal cartography'.[3] Manetti's map (fig. 64) drew on his knowledge of geometry and astronomy as well as the scientific projections found in the Greek geographer Ptolemy's *Geography* (150 CE) to create a theological projection of hell. According to Manetti, hell is shaped like a cone (a shape drawn from Ptolemy's geography as much as Dante's theology) with the *vano* (void) of hell an estimated 3,245 *miglia* (miles) deep. It lies directly beneath Jerusalem, with Mount Purgatory its antipodes, and the vague outlines of the terrestrial world and its oceans even suggesting the recent discoveries in the 'New World' of the Americas, including those of Manetti's fellow Florentine Amerigo Vespucci, who gave his name to America following his four voyages there between 1499 and 1502.

Manetti's painstaking mathematical calculations on the proportions of Dante's Hell were far in excess of the poet's own geographical pronouncements, which remained poetically ambiguous. What drove Manetti and many other Florentines to represent Dante's Hell in such cartographic detail seems to have been a desire to celebrate the veracity of their fellow Tuscan's verse, as well as to represent God's creation – including hell – in all its divine mathematical and geometrical proportion and harmony. However, over time the drive for greater geographical realism in these infernal maps led to an erosion of the physical reality of hell in the

Fig. 64 Antonio Manetti, map of Dante's Hell, in Girolamo Benivieni, *Dialogo di Antonio Manetti*, 1506. Toynbee 893.

Imaginatrui che questo tondo sia tutto el corpo
dello aggregato dellacqua & della terra, &
che questo triangolo che occupa (come uoi uede
te) la sexta parte di decto aggregato, & che

O iiii

minds of many Europeans. By the seventeenth century such maps increasingly fell out of fashion, as scientific map-making found it hard to justify mapping the geography of a place that even for its believers had more of a symbolic than a topographical dimension. If scientific exactitude initially helped believers like Manetti to clarify their understanding of the afterlife, it would also end up playing a part in questioning its very existence.

Out of this World

The dharmic – Hindu, Jain and Buddhist – cosmological traditions of India, Tibet and South-East Asia contain radically different beliefs in soteriology (doctrines of salvation) which are in sharp contrast to the eschatology of Christianity and Islam, and which are manifested in strikingly disparate sacred topographies. At each faith's core is a conception of the soul's potentially infinite transmigration through a dizzying plurality of heavens and hells within a multidimensional universe. These are explicated in elaborate paintings, diagrams and even woven artefacts, many of which offered graphic representations of a spatial understanding of their particular world pictures, which can be broadly categorized as maps.

In the English-speaking world one of the most influential, yet often misunderstood, texts popularizing Tibetan Buddhist accounts of the afterlife is the *Bardo Thödrol*, or 'The Great Liberation through Hearing in the Intermediate State'. The *Bardo Thödrol* is a funerary manual whose text and images were read and shown to those on the point of death. It was designed to help the soul navigate through the liminal world (*bar do*, meaning 'gap' or 'interval') between death and rebirth, and the hallucinogenic visions and extreme emotions experienced on the journey. Like Dante's poem, the *Bardo Thödrol* offered a spiritual route map to salvation, although in very different terms to those of Christianity.

The text has a remarkable history. It is believed to have originated in a lost eighth-century work that was rediscovered by Tibetan savants in the fourteenth century.

The *Bardo Thödrol* remained unknown outside Tibet until 1919, when the American anthropologist and devotee of the esoteric religious movement Theosophy, Walter Evans-Wentz, travelled to the Himalayan foothills – a region believed to be the home of Theosophy's secret brotherhood of masters – and acquired a copy of it (fig. 65). Despite little knowledge of the Tibetan language, Evans-Wentz worked

with a local translator called Lama Kazi Dawa Samdup to produce a highly selective English edition of the *Bardo Thödrol*, which was published by Oxford University Press in 1927 as *The Tibetan Book of the Dead*. Drawing on the Western fascination with the Egyptian *Book of the Dead*, Evans-Wentz's annotations were shaped more by his eccentric theosophical beliefs than by the historical and theological nuances of

the Tibetan text. Nevertheless, after the slaughter of the First World War and the West's fascination with spirituality and the afterlife (including the fashion for seances), the book became a bestseller and exerted a huge influence on counter-cultural movements and figures throughout the later twentieth century, from Jack Kerouac and Allen Ginsberg to Timothy Leary and even David Bowie.

Fig. 65 Page from *The Tibetan Book of the Dead* showing a soul transmigrating, 18th–19th century. MS. Tibet c. 60 (R), fol. 67.

Lama Kazi Dawa Samdup claimed that the text Evans-Wentz obtained in 1919 was around 200 years old. The text and its fourteen illustrations describe increasing states of emotional disturbance, chaos and confusion as the soul moves towards rebirth or a higher state of purification. As in Dante's *Inferno*, the imagery is knowingly cartographic. It offers those on the point of death a meditative map of consciousness, charting the soul's journey towards liberation through an acknowledgment that all stages of existence are contingent and intermediate. Migration – whether of a group of people or of an individual from one state of consciousness to another – will always be facilitated by a map.

The cartographic story told in the *Bardo Thödrol* visualizes the central tenet of the Tibetan Buddhist *samsara* – the cycle of transmigration and rebirth – in the soul's quest for release (*nirvana* in Buddhism and *moksa* in Hinduism). The cycle is also captured in an even more cartographic visualization that is unique to the region: the *Bhavacakra* or 'Wheel of Life/Becoming' (*srid pa'i 'khor lo* in its Tibetan transliteration). The *Bhavacakra* is depicted on painted silk or cotton hangings called *thangkas*, often made by monks and displayed in monasteries and religious festivals for instruction and meditation. The earliest surviving examples have been dated to the eleventh century CE, although archaeological evidence suggests that, like texts such as the *Bardo Thödrol*, their origins go back even further.

Many surviving *thangkas* such as the one shown in fig. 66 date from the eighteenth or nineteenth centuries. They represent the states, or realms of existence, within the Tibetan conception of a tripartite, vertically structured cosmos, divided into ascending realms of desire, form and non-form. This one shows the first realm of desire, or *Kāmadhātu*, in the terrifying embrace of *Shinjé*, a wrathful deity who presides over death and the soul's journey through the infernal realms (*naraka*) in the process of *samsara*. The *Kāmadhātu* is subdivided into circles or segments of a giant wheel. The central first circle shows the three destructive, defining emotions – known as 'poisons' – that drive the cycle

of existence: desire, anger and ignorance, embodied in a cock, a snake and a pig. The second circle shows positive and negative postures or actions (karma) that one can choose to adopt from the three poisons. The third circle is divided into the six realms of *samsara*: three upper 'favourable' domains showing gods, demigods and humans, and three lower 'unfavourable' domains depicting chaotic scenes of infernal regions or 'hell realms' (some hot for desire, others cold for anger) populated by 'hungry spirits' and various scenes of physical torment caused by the 'poisonous' emotions. The outer circle refers to twelve links in what is known as a 'dependent origination' cycle (*Pratītyasamutpāda*), leading from death through the formation of consciousness to conception and birth in a potentially infinite cycle.

Although the Tibetan *thangkas*' depiction of rebirth represents a very different theology from Christianity, they have much in common with Dante's cosmology and medieval *mappae mundi*. They all represent a physical landscape as a way of heightening emotional and spiritual states and of tracing a metaphysical journey that is more symbolic than real: but to the believer, whatever their faith, this only heightens their soteriological power.

Ideal States

As well as guiding the faithful through death and into the afterlife with stories of salvation and liberation, maps can disclose visions of ideal civilizations and states. Some of the most intricate of these cosmologies come from one of the world's oldest religions, the ancient Indian religion of Jainism. Jains reject divine creation in favour of a belief in an eternal and infinite universe (*Loka*). Even more than Buddhism (with which it shares a belief in transmigration), the complex Jain cosmology is given vivid expression in its labyrinthine maps that attempt to capture Jains' conception of a multidimensional yet geometrically precise *Loka*.

Like Christianity the Jain universe is structured vertically, with the divine Upper World (*Urdva Loka*) broad at the top, tapering to a Middle World (*Madhya Loka*) containing the

Fig. 66 Tibetan *thangka* of the *Bhavacakra*, showing the Wheel of Life, late 19th century. Ashmolean Museum, EA 1956.185.

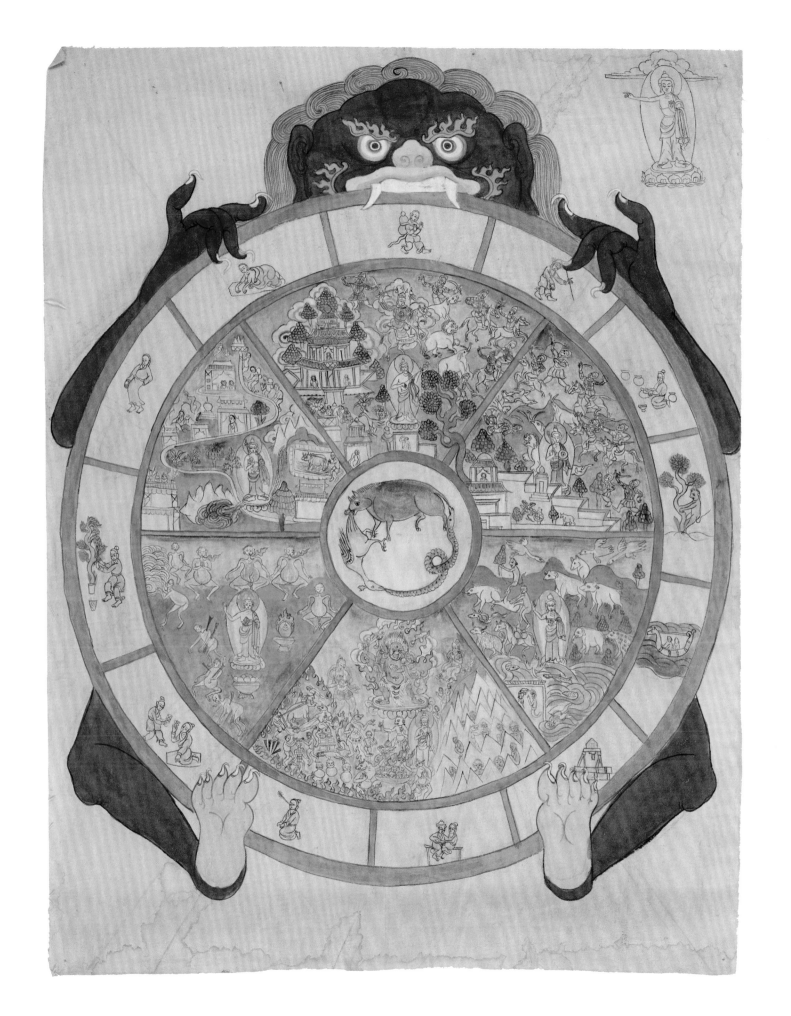

terrestrial world, or *Jambudvipa*, before widening again exponentially into the infernal regions of the Lower World (*Adho Loka*). Most Jain maps like the one shown in fig. 67 represent *Jambudvipa*, capturing a tiny cross-section of the universe with the holy mountain of Meru (possibly the Pamir Mountains of central Asia) sitting at the centre of the universe. Meru's four tusk-like protrusions represent mountain ranges, with humanity dwelling in the surrounding sixteen rectangular provinces (*videhas*). Directly south of Meru is India, with the Indus and Ganges rivers on either side flowing into the first of two encircling oceans. Yet these oceans are more symbolic than geographical. The animals and fish depicted represent metamorphosis and the ability to migrate from one body and state into another. In each corner and at various points within the map sit Jinas ('conquerors' or 'liberators'), divine guides who show the soul's path to liberation. Like many of the Christian and Buddhist maps discussed above, these Jain cosmologies were primarily designed for display in temples to show believers their world picture and anticipate their paths towards reincarnation across time and space.

The Jain, Buddhist, Muslim and Christian maps shown here all project an ideal view that embraces this world and the next. They offer a topography of how to live in one world and move into another, whether it be heaven or hell, through some form of rebirth and transmigration (a term replete with cartographic associations). Each one depicts a terrestrial world created according to a divine geometrical order.

Beyond the Indo-European world, cultures such as those of Mesoamerica used similar techniques to convince believers how their deities shaped physical and human geography, despite their very different cosmologies. A map of Tenochtitlan (modern-day Mexico City), the capital of the Mexica (Aztec) empire, after it fell to the Spanish conquistador Hernán Cortés in 1521 shows this sacred capital just before its destruction (fig. 68). In Aztec mythology Huitzilopochtli, the god of warfare and sacrifice, ordered the Aztecs to call themselves 'Mexica'

and build a city where they saw a snake perched on a cactus (modern Mexico's national symbol). On the map Tenochtitlan's lake and canals are reduced to the precise geometry of four main zones encircled by water, presided over by the city's founding fathers, including the Mexica ruler Tenoch (centre left) who gave the city its name. The hieroglyphs running around the map's border each represent a year, beginning with the city's foundation, dated 1325 CE. At the bottom are scenes representing key Mexica victories over rival cities, and across the map the depictions of weaponry and sacrifice show that, while this may be an ideal visualization of a sacred city, it was also a place built on a violent culture of warfare and death. The irony is that it would be wiped out by a Spanish empire that was even more ruthless than the Mexica, whose conquests were carried out with the aim of establishing a Christian heaven on earth – though many enslaved Mexica may have felt it was a living hell.

Whatever their beliefs, all organized religions are based on a conception of physical, spiritual or imagined travel from one world to another. They all tell stories about such journeys in their sacred texts, but as we show throughout the course of this book, these itineraries invariably take on added meaning and significance if they are visualized in some form of map. While most of the maps illustrated here come from the pre-modern era, we might reflect on the fact that a version of sacred mapping is still with us today, though in a very different, secular, form. Geospatial applications used in online search engines usually emanate from the searchers' own interests and preoccupations – indeed most people use applications like Google Earth and OpenStreetMap to look up where they live and situate themselves on the map. Today's sacred topography is less concerned with particular gods or the afterlife, and more with our obsession with the modern self and identity politics. Maps have always allowed individuals to situate themselves within a much larger cosmos, whether the idols we worship are sacred, profane or simply ourselves.

Fig. 67 Jain map with the holy mountain of Meru at its centre, 16th–17th century. MS. Or. Evans-Wentz 1.

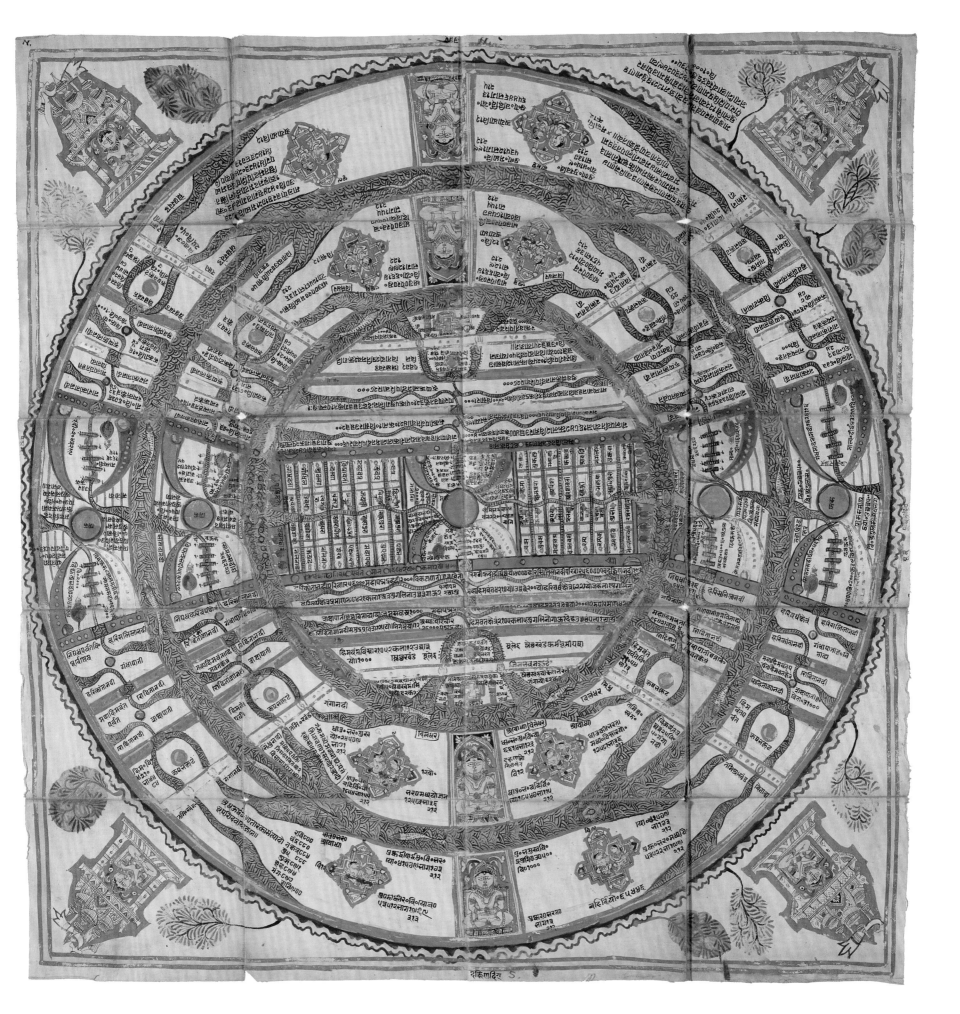

tenazncan / E onsi mismo parece doze demostracion por lo
lo qual pareso enel discurso del señorio de temuch... figurado
con cuenta y son omos / y al remate dellos / murio / E fueron

X lo figurado de azul enlos margines desta ystoria / cada bna ca
sita / o apartado significa vn año / y son el numero de años y bisa
E tuvieron los señores de mex... da / lo figurado y la cuenta y nonbres dela abiertamente y clara se entien
cadavan apartado contavon por el año es q enlos puntos se
llegar a treze puntos / y se alli adelante tornabon a dar principio
en vn cuenta a vn año y sucesivamente con discurriendo hasta
ta llegar a los treze puntos / von q enlos apartados y casita
eston diversas figuras / vn q enlos apartadas y casita la
puntos / pero la principal cuenta esta dela
casita los nobres delos años q nonbravan y ponian apartad
mmero del primer punto hasta los treze puntos / pa q se entend
se doze aqui por si señal y demostracion delos nonbres con sus
ynterpretaciones para dar nota al letor /

X Enla orden y regla delos apartados / o casitas numeradas por
años / enla casita donde pende vn año y siempre y otra
nera de flor / significa vn año pero en forma con siruie
temian y temian / diziendo que sus predecesores los mexicanos como
memorial les avian dexado aviso q enlos tales años yn
dion de cincuenta dos en cincuenta años eran q si suce
fortuytos e aziagos por causa de q entales años avia sido el
dilluvio de aguas general / e onsi mismo la tenebrosidad
eclipse del sol / y terremoto vniversal / y onsi enel tal año
azian grandes sacrificios y ceremonias a sus dioses y se
con a dozer penitencia y se absteniom de todos errores para
quando llegase el proprio dia y ora del tal año / enel qual
dia generalmente apagavom todos las lumbres y fuegos hasta
q pasase el dia / y pasado encendian lunbre nueva trayda
de vna sierra sacada por vn sacerdote

come.	yei.	nahui.	macuili.	chiquacen.	chicome.	chicna	matlac		
ce tuchtli /	acatl /	tecpatl /	cali - /	tuchtli /	acatl. /	tecpatl /	hui.cali /	tli.tuchtli /	x.oce x.omo. x.omey
								acatl / me.teepa cali	

| on conejo | dos cañas | tres pe dernales | quatro casas | cinco conejos | seis ca ñas | siete pe dernales | ocho casas | nueve conejos | diez cañas | onze pe dernales | doze casas | te con |

lo de suso que esta escrito de colorado son los nombres que ponian a los años
que es cada vn aparte / y la ynterpretacion de los tales nombres son
los de abaxo de vn apartado / enlo delo colorado donde esta nume
merado bna. X. que son diez / nonbram. matlactli /

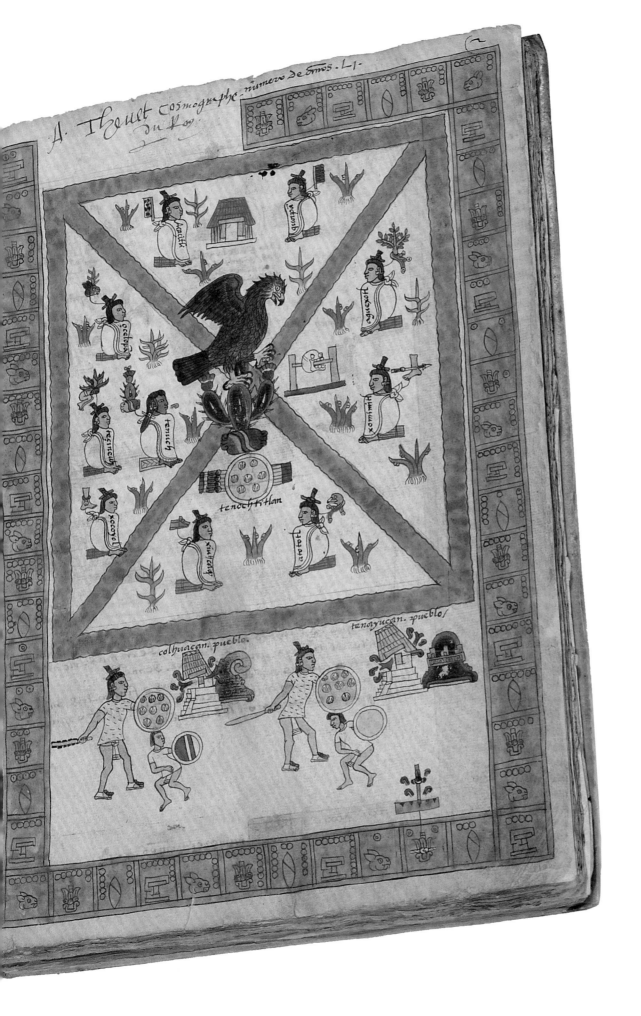

Fig. 68 Aztec map of Tenochtitlan, 1542,
Codex Mendoza. MS. Arch. Selden A1, fol. 2r.

8

Imaginary Plots

Throughout recorded history map-makers as well as writers, artists and philosophers have all projected alternative places and parallel universes in the shape of maps that have little or no apparent connection to the physical world in which we live. From the earliest surviving petroglyphs depicting the travels of shamans through prehistoric spirit worlds, to maps used in science fiction and online role-playing gaming applications, maps of fantasy and the imagination are ubiquitous, but also difficult to assess and explain as part of such an ostensibly objective and scientific discipline as cartography (although, as we point out throughout the course of this book, scientific objectivity is just one relatively recent manifestation of map-making). This chapter provides a survey of imaginary maps and shows how various artists and writers have used mapping to enhance their creativity, while also shedding light on the wider role of maps in culture and society.

The difficulty of interpreting imaginary maps comes from trying to define them in all their variety. They could be defined as showing places with invented place names (toponyms) that are completely detached from the terrestrial world as it was known to the map-maker. The most obvious examples are maps of utopia, where a 'better' society is projected outside and beyond the known world. But any attempt at a comprehensive list should also include maps of dreams, emotions and the imagination, the afterlife, extra-terrestrial worlds, imagined journeys, allegories and propaganda and, as every schoolchild knows, treasure maps.

However, even this list should give us pause in making an absolute distinction between imaginary maps and those, like the Ordnance Survey's, that purport to depict the 'real' world. For non-believers, maps of heaven and hell are obviously imaginary, but for believers in the faith that produced them they are very real manifestations of and guides to the afterlife. Cosmogonic maps purporting to show the origin and creation of the world that may have been accepted as 'true' by past communities would now seem fantastical to modern societies. Even supposedly 'real' maps that use science and technology to claim that they survey the known world represent a highly selective imaginative projection that is shared between both map-maker and user. 'The map', as the Polish American philosopher Alfred Korzybski argued, 'is not the territory'.[1] All maps work through analogy: their graphic signs and symbols for roads, towns, forests and rivers are analogous to but not copies of the reality they purport to represent. The only way a map could actually mirror the reality of the known world would be for it to be created on a scale of 1:1. But as many writers have pointed out, such a map would be of no practical use and doomed to failure. To be successful all maps have to work on the basis of selection, condensation and the imaginative representation of the vast, teeming, overwhelming world 'out there', most of which many of us will never visit, but which we want to have mapped precisely because we wish to 'see' it. For most of its history prior to the advent of flight, mapping involved an imaginative, almost divine, vision of recording the world through the mind's eye, rising above the earth and gazing down at it from above. Rather like fiction, maps invite us to be in two places at once, both in the world and beyond (or above) it, looking in (or down). And just like fictional writing, maps always

Fig. 69 Ambrosius Holbein, map of Utopia, woodcut, in Thomas More, *Utopia*, 1518. Wood 639.

manage reality, offering up a version of it to their users. And like fictional worlds, such maps are created by the subjective beliefs and prejudices of those who make them. This is not to deny that maps have highly specific and practical applications in the worlds of navigation, politics, governance, finance and many other realms, but what becomes apparent in what follows is that the division between real and imagined mapping is far less distinct than may at first appear to be the case.

Mapping Utopia

Oscar Wilde once remarked that 'a map of the world that does not include Utopia is not even worth glancing at, for it leaves out the one country at which Humanity is always landing. And when Humanity lands there, it looks out, and seeing a better country, sets sail.' Wilde's mischievous yet typically insightful point is that we use maps to dream and imagine; they can fuel our desire for a better, happier existence or place, although if we ever reach such a state, human nature dictates that we immediately want to find an even better place and move on. Such desires are exemplified in maps of utopia.

The word 'utopia' reveals the paradox we have been discussing between real and imagined worlds. Its etymology comes from the Greek *outopos*, meaning 'no place', but map-makers and writers have also punned on its homonym *eutopos*, or 'happy place'. The description of an ideal state goes back as far as Plato's *Republic* (*c*.380 BCE), though the noun 'utopia' was first used in December 1516 by Sir Thomas More with the publication of *Utopia*, or, to give it its full title from the original Latin, *Concerning the Best State of a Commonwealth and the New Island of Utopia*. From the beginning More's book blurs the boundaries between fact and fiction. It tells the story of More's visit to Antwerp as Henry VIII's diplomatic representative, where he meets Peter Giles, his friend and fellow humanist scholar. Giles introduces More to the fictional character of Raphael Hythloday, a Portuguese traveller who, having sailed to the 'New World'

of America with Amerigo Vespucci, subsequently discovers the mythical island of Utopia, which he describes as an ideal commonwealth whose people lead an orderly, prosperous and happy existence through communal living practices.

From the beginning More's playful and punning style questions the veracity of this ideal commonwealth. In Greek Raphael Hythloday's surname means 'expert in nonsense'; as we have seen, Utopia can mean a 'happy place' but also 'no place'; even the name of Utopia's capital, Amaurot, comes from the Greek for 'dark' or 'unknown'. At the end of the book More reflects on Hythloday's lengthy account of Utopia, equivocally concluding that 'in the Utopian commonwealth there are many features that in our own societies I would like rather than expect to see'.[2] Even Utopia's location is subject to More's ambiguous humour. He admits to Peter Giles that, after their (fictional) meeting with Hythloday, 'it didn't occur to us to ask, nor for him to say, in what area of the New World Utopia is to be found'.[3] More draws his readers into the classic fictional suspension of disbelief, asking us to imagine that, if only he had asked for Utopia's location, everyone could go there and live the good life.

To compound More's verbal jokes, the second edition of the book was illustrated with a printed woodcut map of the island in two different states, created by Ambrosius Holbein (fig. 69). The map shows Utopia as More describes it: it is crescent-shaped and 320 kilometres wide, with a large bay and river running through the middle. However, like all maps, this one is selective about what it shows: More describes Utopia as having fifty-four cities, the same number as Tudor England, but Holbein's map reduces them to just six. In the foreground Hythloday converses with More (or Giles), and points to the island. It is as if we are watching the unfolding of More's story before our eyes.

More probably authorized Holbein's map to add to the subtle game he was playing in moving between fact and fiction. The map is ostensibly a 'real' representation of an imaginary place. It allows the reader to visualize More's fictional world when of course both are imagined.

Utopia is 'no place': it exists only in More's and Holbein's imaginations. The map draws us into a complex representational game, asking if we want to believe in the existence of a world that is clearly illusory. As if to emphasize the point, Holbein adds one further twist. On closer inspection, his map resembles a grinning skull.[4] The ship in the foreground represent teeth, its rigging a nose, the water below the chin, and the boat to the left a curl of hair. Hythloday represents the neck, while the town in the foreground and hill behind it are an eye and its brow. This visual pun literally mimics More and his verbal games: the image of the skull evokes the medieval tradition of *memento mori*, a warning to 'remember your mortality' in the face of worldly temptation. But *mori* can mean both 'of death' and 'of More'. The skull is therefore a joke about *Utopia*'s author: 'remember More', it seems to say. But it may also imply that any attempt to engineer humanity with utopian projects only leads to failure and death. Like so many imaginary maps, this one discloses a deeper reality about our hopes for a better world, and the limitations of such aspirations.

Fictional Plots

Islands have always fascinated map-makers and writers in creating imaginary places. They are worlds unto themselves, with fixed boundaries within which adventures can begin and end safely insulated from the 'real' world. From More's *Utopia* to Shakespeare's *Tempest*, Defoe's *Robinson Crusoe*, Swift's *Gulliver's Travels* and Ursula K. Le Guin's *Earthsea* novels, islands have enabled fictional writers to address issues close to home by projecting them on to faraway imaginary islands. Such islands are often described as somewhere within the lived world, as in the case of More's *Utopia*, and invariably their stories are accompanied by a map, either drawn by the author or commissioned by them.

We have seen how map-makers like Ambrosius Holbein responded to fictional worlds like More's Utopia, but writers also generate stories from maps. The connection between writing fiction and map-making is closer than we might

imagine. A plot is central to any fictional work: it is defined as 'the plan or scheme of a literary or dramatic work; the main events of a play, novel, film, opera, etc., considered or presented as an interrelated sequence'. This definition first emerges in the seventeenth century, but even earlier usages define 'plot' (or its more archaic form, 'plat') as 'a ground plan, a map; a nautical chart'.[5] The word's common root stems from the Middle English root *platen*, meaning 'to fold or entwine'. Just as maps tell stories, so is a story structured like a map. In *Maps of the Imagination: The Writer as Cartographer*, Peter Turchi points out that 'writers rely on something very much like charts and graphs as part of their process of composition' as they 'plot' their story. He argues that 'a story or novel is a kind of map because, like a map, it is not a world, but it evokes one'. Like a map-maker, the writer is a guide who takes the reader into a fictional world, asserting that 'You Are Here. Trust me in this and we may proceed.' If we accept this pact, then 'like maps, fiction and poetry enable us to "see" what is literally too large for our vision'.[6]

The most eloquent statement on the relationship between maps and fiction comes from one of the greatest of all adventure stories about imaginary islands: Robert Louis Stevenson's *Treasure Island* (1883). Stevenson's story of piracy and lost treasure, the escapades of plucky young Jim Hawkins, Billy Bones's treasure map and Long John Silver has permeated every schoolchild's imagination from burying treasure in the playground to *Pirates of the Caribbean* (just one of over fifty film and television adaptations of the book).

Without an imaginary map, *Treasure Island* may never have been written. In an essay entitled 'My First Book – Treasure Island', published in *The Idler* in 1894, Stevenson explained how he came to write the book and also provided one of the most revealing accounts of the importance of imaginary maps in the creation of fiction. In August 1881, while staying with his family in Kinnaird in Scotland and playing with his stepson, he recalled that 'I made the map of an island; it was elaborately and (I thought) beautifully coloured; the shape of it took my fancy beyond expression; it contained harbours

that pleased me like sonnets; and with the unconsciousness of the predestined, I ticketed my performance "Treasure Island".[7] Having drawn his imaginary 'plot', Stevenson realized the 'map was the chief part of my plot', and the story soon followed: 'as I pored upon my map of "Treasure Island", the future characters of the book began to appear there visibly among imaginary woods; and their brown faces and bright weapons peeped out upon me from unexpected quarters, as they passed to and fro, fighting, and hunting treasure, on these few square inches of a flat projection. The next thing I knew, I had some paper before me and was writing out a list of chapters.'[8]

The story of Stevenson's map did not end there. Having submitted the manuscript of the map together with his novel, Stevenson was 'aghast' to learn that his publisher then lost it. 'It is one thing', he reflected, 'to draw a map at random, set a scale in one corner of it at a venture, and write up a story to the measurements. It is quite another to have to examine a whole book, make an inventory of all the allusions contained in it, and with a pair of compasses painfully design a map to suit the data. I did it, and the map was drawn again. … But somehow it was never "Treasure Island" to me.'[9] In drawing his original imaginary map, Stevenson became an explorer, 'discovering' the reality of his story as he went, one imaginative plot leading to another. In trying to reproduce it once the story was finished he became just another map-maker, filling in the gaps. Yet what he realized was that the lost map, 'with its infinite, eloquent suggestion, made up the whole of my materials'.

Stevenson concluded his essay by writing: 'it is my contention – my superstition, if you like – that he who is faithful to his map, and consults it, and draws from it his inspiration, daily and hourly, gains positive support, and not mere negative immunity from accident. The tale has a root there; it grows in that soil; it has a spine of its own behind the words. … As he studies it, relations will appear that he had not thought upon. He will discover obvious though unsuspected shortcuts and footpaths.'[10] The imaginary map

allows the writer to discover a deeper fictional reality, but for Stevenson it also enabled him to play one final trick. The published map with its compass rose, scale bar and depth soundings mimics traditional maritime charts; but at the bottom Stevenson adds the legend, 'Facsimile of chart, latitude and longitude struck out by J. Hawkins' (fig. 70). The book opens with Jim Hawkins announcing, in line with the map's legend, that he has been asked 'to write down the whole particulars about Treasure Island, from the beginning to the end, keeping nothing back but the bearings of the island, and that only because there is still treasure not yet lifted'.[11] As with More's Utopia, we will never reach Treasure Island, because the coordinates are lost; nor will we ever extract all its treasure. The 'treasure' lies in re-reading Stevenson's book and poring over his imaginary map whose original remains lost (unless it too was another figment of Stevenson's fertile imagination).

Fantasy Maps

Where imaginary maps helped shape Stevenson's island adventure story, subsequent twentieth-century fantasy literature by writers such as J.R.R. Tolkien and C.S. Lewis required maps that invented whole new imagined worlds and parallel universes. Tolkien's epic and elaborately interconnected high fantasy trilogy *The Hobbit* (1937), *The Lord of the Rings* (1954–5) and *The Silmarillion* (1977) have retained an enduring popularity among readers in their stories of 'Middle-earth', an imagined mythological continent from the prehistory of the Earth (called 'Arda') populated by dwarves, elves and wizards.

Tolkien was a fine draughtsman and throughout his life he drew dozens of intricate maps depicting all aspects of his trilogy (figs 71–73). 'I had maps of course', he told a BBC interviewer in 1964. He continued, in terms recalling Stevenson's approach to mapping *Treasure Island*, 'If you're going to have a complicated story you must work to a map, otherwise you can never make a map of it afterwards.'[12] As he prepared *The Lord of the Rings* for publication in 1953 he told

Fig. 70 ˆ Robert Louis Stevenson, 'Treasure Island' map, 1883, from the first edition of his novel. Arch. AA e. 149.

A Scale of 3 English Miles.

Foremaft Hill

North Inlet

Spye glass penetleaft Hauks

Ham going

Skeleton Cove

Strong tide here

Spring

Spye glass Hill

Swamp

Cape of ye Woods

Bulk of Silver here

Mizzenmast Hill

White Rock

Haulbowline Head

Skeleton Island

Foul ground

Treasure Island
Augt. 1750. G.F.

Given above I.F. & Mr. W. Bones Maste of ye Walrus Savannah this twenty July 1754 W. B.

Facsimele of Chart; latitude and longitude struck out by J. Hawkins

Fig. 71 J.R.R. Tolkien, 'ILU/The World: From Formen (North) to Harmen (South)', 1930s. MS. Tolkien S 2/III.

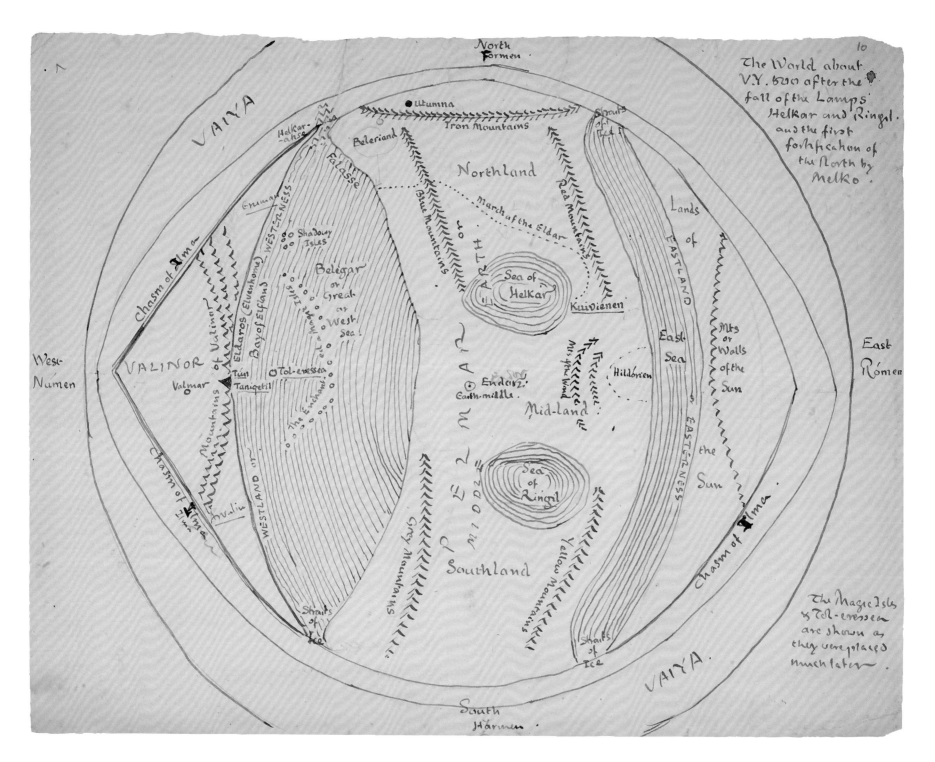

Fig. 72 J.R.R. Tolkien, 'The World about V.Y. 500 after the fall of the
Lamps', 1930s, pencil and black ink. MS. Tolkien S 2/III, fol. 7r.

HELM'S DEEP
& the HORNBURG

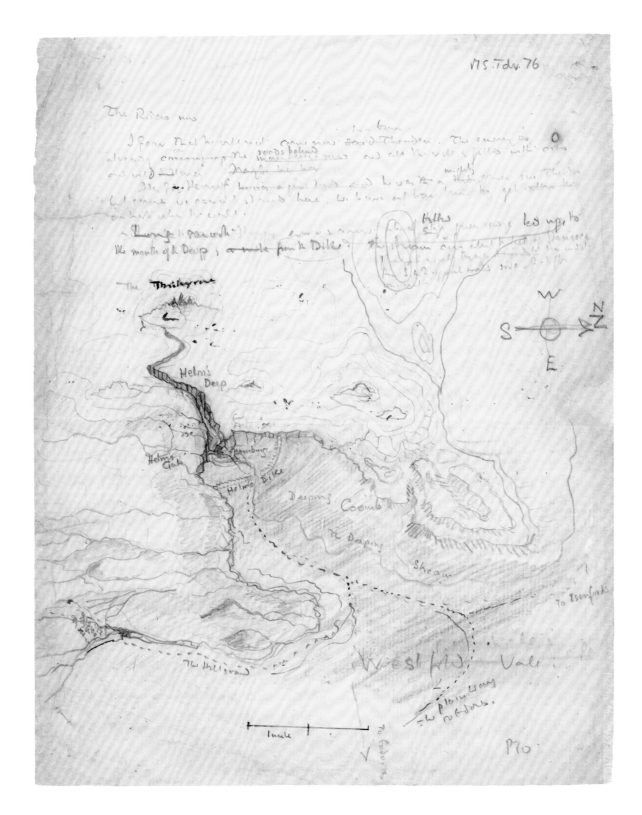

Figs 73a and 73b Two illustrations of Helm's Deep valley and the Hornburg fortress, drawn on a student's examination paper. J.R.R. Tolkien, 'Helm's Deep & the Hornburg', c.1942. MS. Tolkien Drawings 76r–v.

his publisher, '[m]aps are worrying me', because 'in such a story one cannot make a map for the narrative, but must first make a map and make the narrative agree'.[13] This approach to maps enabled Tolkien to adopt a variety of different cartographic styles and conventions throughout the writing of his trilogy, depending on whichever aspect of the story he wished to convey.

In the mid-1930s Tolkien composed maps to accompany his short text 'The Ambarkanta', subtitled 'Of the Fashion of the World'. Both maps and text chronicle a mythical cosmogony explaining the origins of his fictional world, which he called a 'legendarium'. In keeping with his scholarly expertise in the medieval world, Tolkien's maps took their inspiration from *mappae mundi*, based on an established T-O shape. The earth ('Ambar') is enveloped in air ('Vista') and light ('Ilmen') and bounded by an 'Enfolding Ocean' (labelled 'Vaiya'), beyond which is a dark void ('Kúma').

Subsequent maps built on this basic shape as Tolkien expanded his legendarium and peopled it with mythological figures, beginning with the supreme deity, Eru Ilúvatar. Eru created the Ainur, the most powerful of which, known as the Valar, brought light upon the earth by creating two vast ice lamps. Melkor (subsequently Morgoth, the 'Dark Enemy'), the most powerful Valar, destroyed the lamps, plunging the world into darkness, flooding the land and creating the seas of Helkar and Ringil. Melkor 'fortified the North and built there the Northern Towers, which are also called the Iron Mountains', and the fortress of 'Utumna'.[14] The Valar retreated westwards to Valinor, making a mountainous range between it and 'Middle-earth', a term used by Tolkien for the first time in 'The Ambarkanta', and labelled on his accompanying map. In envisaging the earth's creation Tolkien adopted a classic cartographic perspective, drawing a world map on a small scale, with little attempt to represent the relief of physical geography beyond the rudimentary depiction of seas and mountains. He was quite literally mapping out the cosmological foundations of his

trilogy, before going on to people it with characters and their adventures on a far larger scale as they moved through fictional space.

As Tolkien's stories evolved and their protagonists developed, so his maps changed accordingly. As Tolkien drafted the stages of *The Lord of the Rings* from the late 1930s he composed various maps, each one described by his son Christopher as 'a continuous development, evolving in terms of, and reacting upon, the narrative it accompanied'.[15] Tolkien was particularly fond of writing and drawing on blank sheets of paper from Oxford University examination booklets, particularly during the Second World War when rationing required materials like paper to be reused. In an examination paper he was marking, written by an English undergraduate usually dated to 1942, he used both sides of the sheet to draw two maps from different angles of Helm's Deep valley and the Hornburg fortress, the scene of the climactic battle between the armies of Saruman and the Rohan under King Théoden in *The Two Towers*, the second volume of *The Lord of the Rings*.

On one side of the sheet Tolkien drew the scene from an aerial perspective, with a compass rose, scale bar and stippled routes showing the movement of the armies. At the top is a draft of an exchange between the fortress's defenders. As Tolkien began to shape the story, this first map similarly took a broad perspective from above, sketching out the story's salient features. On the other side of the sheet (with the unfortunate undergraduate's essay turned upside down) Tolkien took a different but complementary perspective, zooming in on the Hornburg, with Helm's Deep in the background, both shown from a much lower angle, as though he was immersing himself in the landscape, developing the narrative action as the scene draws the eye towards the fortress. In the top left corner is a small burn hole, probably made by Tolkien's inveterate pipe smoking.

Tolkien's friend C.S. Lewis also used maps in writing his children's fantasy novels *The Chronicles of Narnia* during the 1950s. Lacking his friend's drawing skills, Lewis took Tolkien's

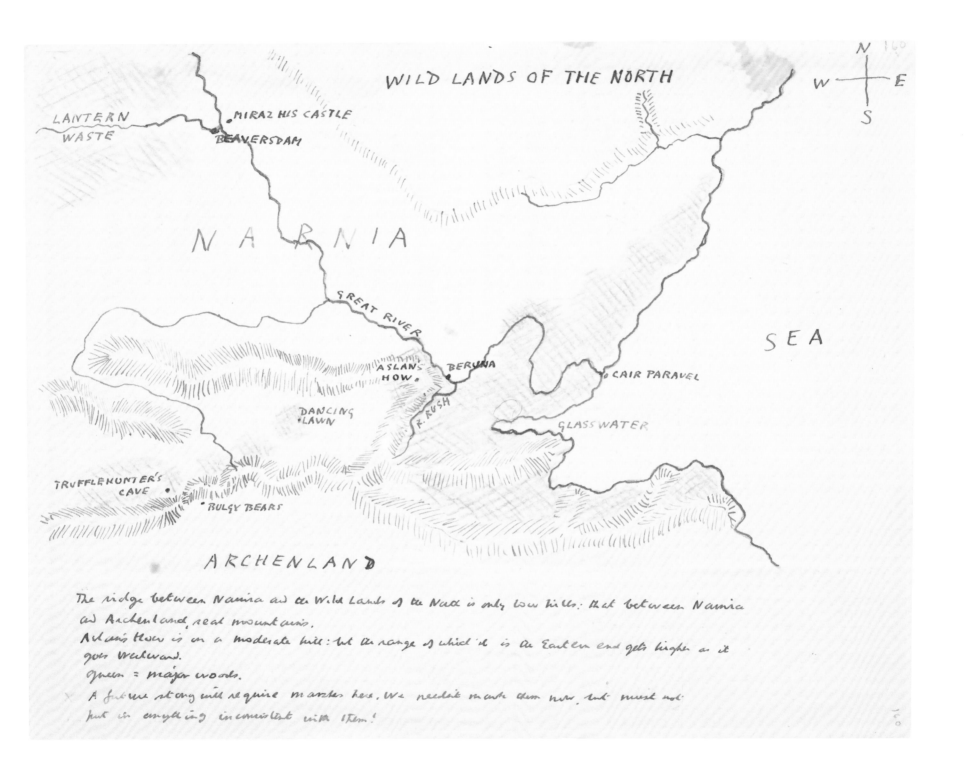

WILD LANDS OF THE NORTH

N 160
W — E
S

LANTERN
WASTE

MIRAZ HIS CASTLE
BEAVERSDAM

N A R N I A

GREAT RIVER

SEA

ASLANS
HOW
BERUNA

DANCING
LAWN

R. RUSH

CAIR PARAVEL

GLASSWATER

TRUFFLEHUNTER'S
CAVE

BULGY BEARS

ARCHENLAND

The ridge between Narnia and the Wild Lands of the North is only low hills: that between Narnia
and Archenland, real mountains.
Aslan's How is on a moderate hill: but the range of which it is the Eastern end gets higher as it
goes Westward.
Green = major woods.
A future story will require marshes here. We needn't mark them now, but must not
put in anything inconsistent with them!

Fig. 74 C.S. Lewis, map of Narnia for *Prince Caspian*, 1951.
MS. Eng. lett. c. 220/1, fol. 160r.

recommendation to entrust the illustrations for his books to the artist Pauline Baynes. Nevertheless, Lewis's early hand-drawn map of Narnia, designed to illustrate *Prince Caspian*, the second book in the series, has survived, although it was never published in Lewis's lifetime (fig. 74). As with Tolkien, Lewis's scholarly expertise in the literature and history of the Middle Ages led him to envisage his map accordingly. 'My idea', he wrote in a letter to Byrne in January 1951, 'was that the map should be more like a medieval map than an Ordnance Survey – mountains and castles drawn – perhaps winds blowing at the corners – and a few heraldic-looking ships, whales and dolphins in the sea'.[16] Like Tolkien's maps of Middle-earth, Lewis's map establishes a ground plot for his story. Narnia is oriented with a simple compass point in the top right corner, and key locations central to the *Chronicles* are labelled – 'Lantern Waste' (the first Narnian location described in Lewis's books, where Lucy Pevensie meets Mr Tumnus) 'Cair Paravel' (Narnia's capital), 'Miraz's Castle', and 'The Wild Lands of the North' (where the White Witch was exiled) – from which Lewis was able to build his narrative, and upon which readers could subsequently project their own imaginative engagement with the unfolding story.

The Art of Mapping

Like writers of fiction, visual artists have been drawn to the power of maps both as representations of reality and as windows onto fantasy and the imagination. Throughout history mapping has been shaped by artistic skill – draughtsmanship, colour, illustrative motifs – as much as by science, and artists have been quick to exploit the visual possibilities of maps, as well as to question the conventions of establishing orientation, borders, boundaries and many of the devices that seem to create meaning among a community of users. Many have also taken up Korzybski's point that 'the map is not the territory' to explore how maps are always selective representations of the world they seek to portray – just like any artwork. Since the late twentieth

Fig. 75 Layla Curtis, *NewcastleGateshead*, digital printed collage, 2005. O1 (30).

century there has been a proliferation of art using maps, perhaps in direct response to the politicization of mapping by nations and empires, with maps being used as ideological tools that divide rather than unite cultures and peoples. Such maps attempt to codify and limit experience, whereas most artists want to question or transcend such limitations in order to explore the relationship between the individual and the world and to enable us to see this relationship in new and surprising ways.

In 2005 the English artist Layla Curtis created a digital printed collage artwork entitled *NewcastleGateshead*. Its intention was to ask viewers to rethink what they see when they look at a modern map that claims to use scientific techniques to accurately portray the topography of a familiar place, in this case Tyne and Wear in the north-east of England, centred on Newcastle, Gateshead and the surrounding area (fig. 75). On initial inspection the region's topography looks recognizable, but on closer examination it becomes disconcertingly unfamiliar. Curtis has created a cartographic bricolage of the region, drawing on its regional namesakes from countries as diverse as Australia, Canada, Jamaica and Ireland. There are fifty-two Newcastles or New Castles, twenty Northumberlands, fifteen Washingtons and ten North Easts, while the only Gateshead on the map is an island floating out in the North Sea.

This is not an imaginary map of an alternative world as described by Stevenson, Tolkien or Lewis, but it does draw our attention to the imaginary dimensions of all maps, whatever their claims to truth and objectivity. Having grown up in the north-east and then travelled all over the world, Curtis suggests that any place is overlaid by subjective memories and overlapping travels and experiences of places across the globe that share the same name. As an area that sat at the heart of England's Industrial Revolution (indicated by the numerous references on this map to 'Coal'), Tyne and Wear generated a proliferation of place names throughout the world that created various Newcastles, all with different topographies and experienced in different ways by those who live there. Curtis's *NewcastleGateshead* is an ever-changing palimpsest that always requires updating and rewriting as its history, topography and place in the world keeps changing. Any static map of the kind Curtis uses here will capture only one aspect of the territory it represents at one moment in time, and will never truly capture the memories, aspirations and subjective reality of those who move in and out of its space across time. Beware of any map that tells you otherwise may be the lesson she asks us to take away from this deceptively simple, yet profound, object that crosses cartography and art with such alarming ease.

Curtis's work has been labelled 'psychogeography' because it draws the objective appearance of maps into a closer conversation with the subjective experiences of their users. Other artists go further back into the history of cartography, using a variety of media to explore how mapping is itself an existential act that enables people to understand who they are by first asking *where* they are. Maps have been a central preoccupation for the English artist Grayson Perry, especially the medieval tradition of *mappae mundi*, cited as a source for imaginative inspiration by writers like Tolkien and Lewis. Like Curtis, Perry is less interested in creating imaginary worlds than in subverting cartographic conventions to disclose a deeper reality behind modern maps.

In *Red Carpet*, a tapestry map of the United Kingdom made in 2017 (fig. 76), Perry uses the medium of weaving to produce a hospitable 'red carpet' in response to the Brexit vote to leave the European Union in June 2016, which suggests that the 'kingdom' he depicted is anything but welcoming or united. Stylistically the carpet draws on war rugs made in Afghanistan following the Soviet invasion of 1979. Perry described the carpet as 'a map of British society as evocative and inaccurate as a geographical one made by a medieval scholar. The distortions partly reflect the density of population rather than the lie of the land.' Like medieval maps, his topography is based on population density and political power, so Scotland appears tiny in contrast to London, which is shown as a carpet within a

Fig. 76 Grayson Perry, *Red Carpet*, woven tapestry, 2017.

carpet, complete with what Perry describes as the 'words and buzzphrases that I felt typified the national discourse in 2016'.[17] London's physical geography is sacrificed in favour of the human geographical features changing the lived environment, like 'Millennials', 'Extremists' and 'Gentrification'. In contrast, an area such as the north-east (the focus of Curtis's map art) is characterized by 'Old Labour' and 'Zero Hours Contract'. As well as drawing on medieval maps, Perry's carpet is also a reflection on how contemporary digital online mapping works: it is characterized by personalization and miniaturization, where online geographical searches invariably offer localized spaces and places in relation to the location of the individual searcher, usually at the expense of the bigger physical geographical picture.

Perry's interest in medieval and modern forms of egocentric mapping is given its most celebrated form in his *Map of Nowhere* (2008). This etching (fig. 77) draws explicitly on medieval *mappae mundi* that show the world embodied as Christ, simultaneously confirming and parodying the notion that all art is effectively self-portraiture: Perry portrays

himself as god-like, but with divine light shining out of his rectum. Like *mappae mundi*, Perry's etching teems with detail, from the sacred and the philosophical to the profane and banal. Theological institutions and beliefs are replaced with multinational corporations like Microsoft and Starbucks, and modern fears and doubts about identity, including 'Despair'. The pilgrims in the foreground head towards a monastery lit by light from Perry's rectum. Where medieval *mappae mundi* placed Jerusalem at their centre, Perry's map is centred on the island of 'Doubt'. For Perry, personal, theological or topographical certainty is an illusion.

Map of Nowhere is a fitting map with which to end this chapter, and it brings us full circle, back to the pun on 'utopia', which Perry knows can be both a happy place and one that does not exist: it is 'nowhere'. Fictional and artistic maps of nowhere have an important place in the history of map-making, reminding us that they can disclose deeper truths about ourselves and the world above and beyond maps of the 'real' world. As Herman Melville wrote of the fictional island home of Queequeg in *Moby-Dick*, 'it is not down in any map; true places never are'.[18]

Fig. 77 Grayson Perry, *Map of Nowhere*, etching, 2008.

NOWHERE

9

War

Warfare has often been seen as a catalyst for cartographic invention and advancement. Some of the West's most iconic military rulers invested in map-making as central to successful military campaigns, from Henry VIII commissioning 'plats' of Tudor England's coastal defences, to Napoleon's use of the Carte de Cassini (France's great eighteenth-century national survey). These and many other rulers and governments understood that military conflict throughout the ages has always required some understanding of the site of engagement. Plans of individual battles and of fortifications, trench maps, 'goings' maps (showing the condition of the terrain) and maps showing the layout of the land beyond enemy lines are examples of what might be found in or around the time of hostilities.

The maps featured here show how levels of cartographic production and innovation increase as a direct consequence of war; why maps have become such fundamental tools of war, both to prepare for and to prosecute military action; and how they have mutated in form as war has progressed. The historical range of material available to us is huge, so we have chosen to focus on what might be termed 'collateral' mapping by highlighting modern British maps mainly from the twentieth century. Most of these maps arose as a consequence of specific military action during the First and Second World Wars, but they were not necessarily conceived to help or hinder the war effort.

First World War Trench Map

Trench maps are one of the most obvious manifestations of the impact of war on cartography. It has been estimated that over 34 million British-produced sheet maps – surveyed, printed and frequently revised – were issued for use on the Western Front by the end of the First World War.[1]

Our story begins with a 1:10,000-scale sheet entitled 'Zonnebeke' which includes the village of Passchendaele in north-western Belgium, scene of the Third Battle of Ypres, or the Battle of Passchendaele (fig. 79a). The area saw heavy fighting from July to November 1917 as the Allies sought to gain control of the ridges to the east of Ypres; Passchendaele was situated on the easternmost ridge. The village was eventually taken by Canadian forces in November that year.

The map's origins go back to early 1915 when the War Office's Geographical Section of the General Staff (GSGS) began to produce trench maps. A small military team was gradually augmented by Ordnance Survey surveyors and individuals from the Royal Engineers with map-making experience. During the course of the war this team would evolve into a larger organizational operation of Field Survey Companies.

The Zonnebeke map was derived from existing Belgian cartography enlarged from a scale of 1:20,000. Source material was readily available in Britain, as much of Belgium's contemporary cartographic output had been rescued from Antwerp in 1914, just before the city fell to the Germans. The mapping of this sheet, as part of the Ypres area, was undertaken by the 4th Field Survey Company and given the War Office series designation GSGS 3062. This particular series was inaugurated in the summer of 1915 and covered the Western Front in its entirety. The sheet was updated from the original Belgian map thanks to

Fig. 88 Detail of *Prussia Pausing*, Stanford's Franco-Prussian War serio-comic map, 1871.

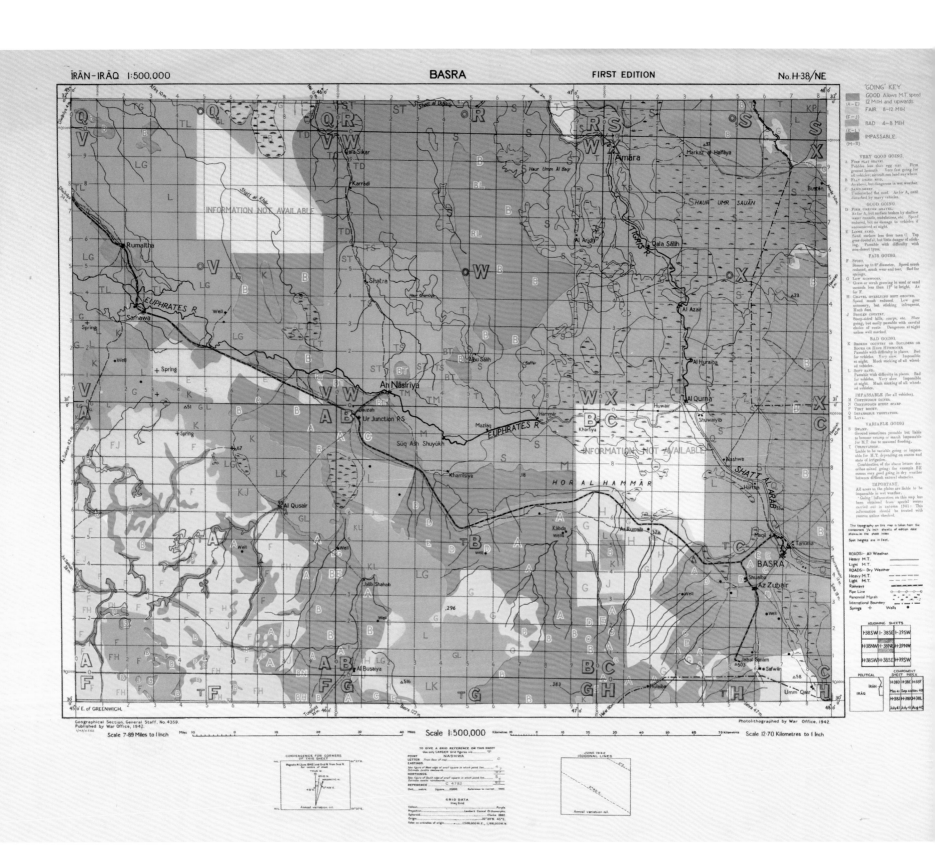

Scale 1:500,000

Scale 7·89 Miles to 1 Inch

Scale 12·70 Kilometres to 1 Inch

Geographical Section, General Staff, No. 4359.
Published by War Office, 1942.

Photolithographed by War Office, 1942.

aerial photography, which enabled cartographers to plot with great accuracy features behind enemy lines such as machine gun emplacements and shell holes. It would have been issued to front-line soldiers on the battlefield.

However, as we will see, the challenge of matching familiar grids with available maps proved too difficult operationally, hence the implementation of a system known as 'squaring'. For the Allies, unused to the metric measurements used in Belgian mapping, a new purpose-designed grid system was superimposed, based on imperial units of measurement and consequently more efficient to use in the field for those trained to work in and to recognize yards and feet. The practical value of these squares is outlined in the legend to the right, with tick marks found at fifty-yard intervals along every thick black line which divided the sheet into 500-yard squares (themselves then subdivided into quarters). This system was superimposed on all the Belgian-sourced maps, providing invaluable detail for artillery soldiers and enabling them to fire with precision and devastating effect into enemy territory.

The German trenches are indicated in red and in considerable detail. Less so those of the British, marked in blue behind a heavier pecked blue line showing 'Approximate British front line 29-11-17', curving south and east around the village of Passchendaele itself. British trenches would appear in detail only on 'Secret' editions. Indigenous place names were considered difficult to pronounce, and given the lack of movement on the ground, alternative, easier-to-remember names were coined by the Allied soldiers and given alongside them. These toponyms often reflected the soldiers' own geographical origins or regimental references, or even an anglicized take on a French or Flemish name. Behind the British lines are names like Nile, Toronto and Wimbledon, which identify individual buildings. These co-exist alongside Germanic names like Mühle, Pommern and Potsdam, evidence of ground formerly held by enemy forces. Of note beyond the German lines are toponyms in English, the vast majority beginning with the letter E, such as Edge, Edit and Effect. The clue to this convention is found in the map's eastern third – the two large grey capital E letters which were employed to identify 6,000-yard square blocks of territory. The only named trench is shown as 'Easel Trench'. This tendency can best be seen where the D, E, J and K blocks converge towards the bottom of the map, in a German-held area, and place names are allocated accordingly.

Also important to understanding the map is its marginalia, representing immediacy in terms of publication data. The bottom right of the map states 'Ordnance Survey, December 1917', but the top right goes into even more detail with 'Edition 9A' and 'Trenches corrected to 5-12-17'. The first edition of this sheet had been produced only the previous July, indicating how quickly updated cartographic intelligence had to be conveyed to the troops on the ground.

left Fig. 78 Tank 'Goings' map, indicating terrain suitable for driving tanks in the Second World War, 1942. D19: 13 (1).
above Fig. 79b Detail showing Passchendaele area on a First World War trench map of Zonnebeke, 1917. C1 (3) 720.

Fig. 79c Detail showing area where D, E, J and K blocks converge,
First World War trench map of Zonnebeke, 1917. C1 (3) 720.

Fig. 79a First World War trench
map of Zonnebeke, 1917. C1 (3) 720.

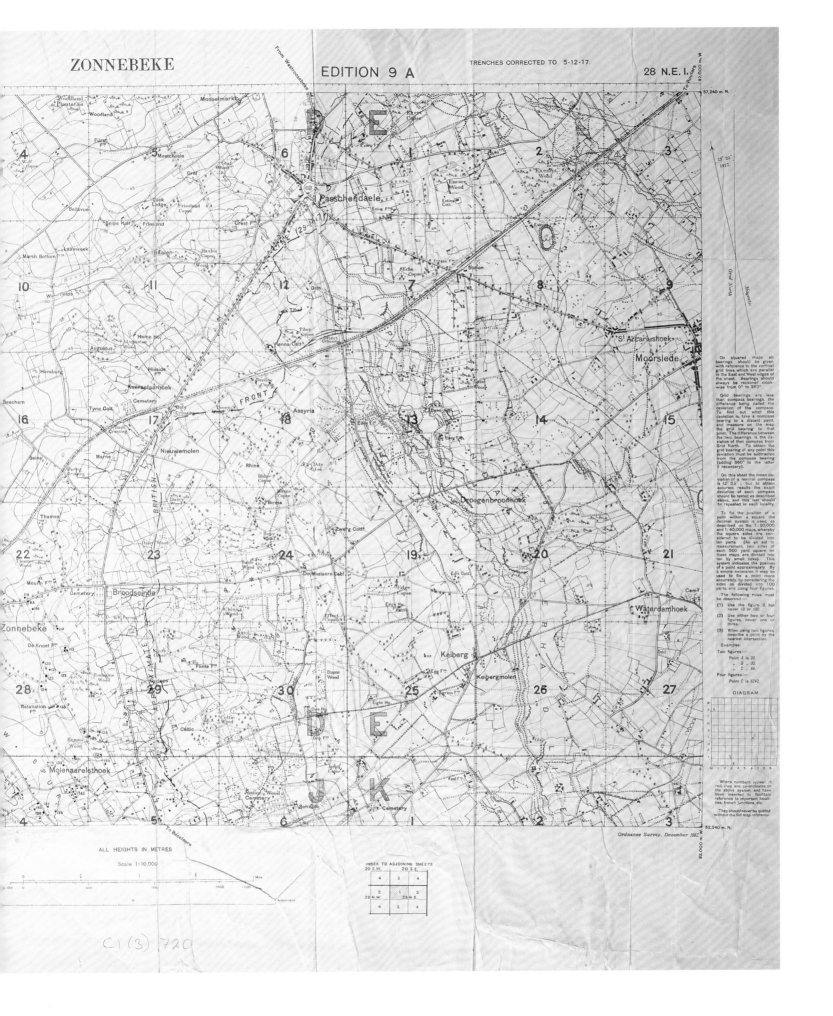

ZONNEBEKE

EDITION 9 A

TRENCHES CORRECTED TO 5-12-17.

28 N.E.I.

ALL HEIGHTS IN METRES

Scale 1:10,000

INDEX TO ADJOINING SHEETS

Ordnance Survey, December 1917.

C I (3) 720

A 'Recycled' Map

Next, we consider the tale of one very particular cartographic object. Very much a product of war, this map was created to be used for a more benign purpose. The story this apparently unremarkable piece of paper discloses is one of resourcefulness and serendipity, repurposing and recycling, advance planning and opportunism. This singular grubby artefact has mutated into four different maps, with four different stories of provenance covering in essence two map-making enterprises with very similar purposes.

We begin with what can be called 'Map A' (fig. 80). Map A was published in Britain by the Ordnance Survey in 1921 and is commonly referred to as sheet 98 of the Popular Edition One-Inch Map series, bearing the title *Clacton on Sea & Harwich*. The map is part of a series of 146 sheets covering the whole of England and Wales produced during the period 1918–26.

The modern Landranger map is a direct descendant of this series, and Map A holds few, if any, surprises for the average twenty-first-century map user. The largely rural Essex landscape depicted here is nowadays somewhat less agricultural, and the colours and symbols employed by Ordnance Survey have altered, but this map remains easily legible to map users.

We now move on to 'Map C' (fig. 81). 'Map B' will join our story shortly. Map C initially came to light in 1880 when it was surveyed and published by the Prussian surveying department. This edition of the Topographische Karte was published in 1932 by the Reichsamt für Landesaufnahme in Germany. As with Map A, this represents cartography compiled to a national specification and as part of a map series, in this case at a scale of 1:25,000, covering all of interwar Germany in a regular pattern of over 3,000 each covering ten minutes' longitude by six minutes' latitude.

Here are two apparently unrelated maps, both made as part of national mapping exercises for the purpose of recreation, yet neither could have anticipated such a

Fig. 80 'Map A': *Clacton on Sea & Harwich*, 1921, Ordnance Survey Popular Edition. C17 (29), sheet 98.

Engraved at the ORDNANCE SURVEY OFFICE, Southampton.
Surveyed in 1862-83 and Published in 1884-5
Revised in 1893 and in 1904.
Revised 2nd Revision 1914-19.
Published by Colonel Sir Charles Close, K.B.E., C.B., F.R.S., Director General.
Printed at the Ordnance Survey Office, Southampton. 1921

Scale of One-Inch to One Statute Mile or so

Kilometres

The Altitudes are given in Feet above Ordnance Survey Datum, which is about 0.65 of a Foot below the general Mean Level of the Sea, and are indicated thus (326)

The Contours are spaced at intervals of 50 Feet reckoning from Ordnance Survey Datum.

The Submarine Contours are given in Fathoms, and are taken from the Soundings of Admiralty Surveys.

Crown Copyright Reserved.

N.B. The representation on this map of a Road, Track, or Footpath, is no evidence of the existence of a right of way.

close and enduring future relationship. 'Map B' (fig. 82) is essentially the same as Map A, but with a few subtle changes imposed during a very delicate repurposing exercise.

In the lead-up to the Second World War, a copy (or copies) of Map A were acquired by agents and shipped over to Germany. If Germany were to invade Britain, its military would have needed top-quality maps to help them identify their location in hostile territory, so what better cartographic object than a recent Ordnance Survey map? However, the German military were understandably not familiar with maps produced at a scale of one inch to one mile or 1:63,360. But 1:50,000-scale mapping was a different matter, and so the German General Staff embarked upon a project to enlarge the Popular Edition to a more familiar scale. That was not all. As the German military used the Gauss–Krüger grid, based on meridians at frequent intervals of three degrees, using a transverse Mercator projection, which was commonplace in Central and Eastern Europe, the Ordnance Survey maps (using the very different Cassini projection) needed to be re-projected in order to link up with a co-ordinate system in use in Germany, otherwise it would be impossible to amalgamate the maps because of the different mathematical formulae used to account for the curvature of the Earth's surface. A new grid was laid onto the map, and this explains its offset nature, best seen in the lower section. The new German series "England 1:50.000" was therefore created, with the maps dated 1940, ready for a planned invasion of Britain.

The suite of symbols employed by Ordnance Survey made perfect sense to the British map user, exploring the landscape at leisure. But Germany was not planning to use the map to identify picnic sites or to plan visits to historic churches. Interestingly, no additional symbols have been superimposed onto the map, so there is no indication of potential target destinations or likely hazards put in place for unwelcome visitors. Of final interest, however, is the surrounding marginalia. The explanatory German text gives clues to the adaptation of the map, with text such as 'ostw. v. Greenwich 0°50′', and a description of how to deal with the peculiar 'English foot' (the retained Ordnance Survey contour lines were in imperial units and needed to be explained to metric-trained map users).

The story now moves forward a few years. With the military balance of power shifting, Allied troops found themselves on the ground in Germany. Like the Germans in 1940, the British military managed to acquire maps from the enemy in order to help their campaign. One of these is Map C: Topographische Karte, sheet number 1321, entitled 'Jörl', the name of a small village in Schleswig-Holstein, not too far from the Danish border. The British map-makers faced the same problem of unfamiliar co-ordinates and the challenge of how to adapt the map for their specific needs.

On this particular map, symbols have not been amended, but a legend in English has been created on the map's right-hand side, along with a glossary of German abbreviations employed on the map and conveniently translated into English. The rest of the accompanying marginalia acknowledge the source of the map as the German Topographische Karte of 1932, and the sheet we see here is the second Allied edition, revised from air photographs and rebranded as series GSGS 4414, published by the War Office. As with Map B, a new grid has been superimposed on the map, this time considerably more skewed than that on Map B. This is the North European Zone 3 grid, based on the 'Danish Geographical System', devised in the late 1930s and employed by the British for the mapping of Denmark, southern Norway, southern Sweden and the northernmost fringes of Germany. The idea was to divide Western Europe into ten interlocking zones, each with a modified grid, as a method to reduce the cartographic distortion inherent when retaining just the single projection and grid. North European Zone 3 was

Fig. 81 'Map C': Jörl sheet, 1932, German Topographische Karte. C22 (15), sheet 1321.

Topographische Karte 1:25000 (4-cm-Karte)

1321 Jörl

Zeichenerklärung:

Prov. Schleswig-Holstein
Reg.Bez. Schleswig
1. Kreis Husum
2. Landkr. Flensburg

Herausgegeben von der Preußischen Landesaufnahme 1880
Metafarbig herausgegeben vom Reichsamt für Landesaufnahme 1933
Ausgabe 194

1:25000 (4 cm der Karte = 1 km der Natur)

Neigungsmaßstab

Nadelabweichung für Mitte 1936

Planzeiger 1:25000

Politische Grenzen

Aufnahme
Berichtigungsstand:

Nachdruck und Vervielfältigung jeder Art, auch einzelner
Teile, sowie die Anfertigung von Vergrößerungen oder
Verkleinerungen sind verboten und werden gerichtlich
auf Grund des Urheberschutzgesetzes verfolgt.

Place names visible on the map:
Lindewitt, Schobüll, Schobüllhaus, Sillerup, Sillerupfeld, Oxlund, Oxlundfeld, Grünberg, Barslund, Krugstedt, Seeland, Seeland-Moor, Süderkolbhaus, Janneby, Groß Jörl, Jörl, Großjörl, Stiegland, Löwenstedt, Kollund, Oestgaard, Wanderup, Wanderupfeld, Staatsf. Flensburg, Wallsbüll

Achtung!
Mit deutschem Gauß-Krüger-Gitterneß im 0. Streifen
Es dürfen zur Berechnung nur Werte ein und desselben Streifens verwendet werden!

Das deutsche Gauß-Krüger-Gitterneß
ist in Abständen von 2 km in Rot durchgezogen.

Alle Höhenangaben auch Höhenlinien sind in englischen Fuß
angegeben. Zur groben Umrechnung auf Meter gilt: 3 Fuß = 1 m.
Alle Höhenangaben der Karte sind also durch 3 zu teilen, um
Meter-Angaben zu erhalten. Für genauere Umrechnungen
siehe Tabelle.

Maßstab 1:50.000

Höhenangaben in engl. Fuß über mittl. Meeresspiegel. Abstand der Höhenlinien 50 engl. Fuß (= ca. 15 m)
Tiefenangabes in englischen Faden bezogen auf mittleres Springniedrigwasser.
Abstand der Tiefenlinien 5 engl. Faden (= ca. 9 m)

Planzeiger für England.

Lage der Anschlußblätter

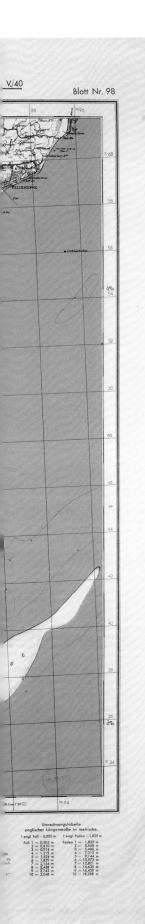

Fig. 82 'Map B': German overprinted Ordnance Survey map, *Clacton on Sea & Harwich*, 1940. C17 (21), sheet 98.
Fig. 83 'Map D': Hybrid British/German map sheet, rolled to show both sides. C22 (15A), sheet 1321.

one of the ten such zones. What we now have is 'Map D': the Allied invasion map (fig. 83).[2]

The final twist to the tale is delivered as all four maps become inextricably connected. A combination of the good fortune of capturing German maps of Britain, plus the economic realities of wartime paper shortages, led to the inevitable repurposed conclusion. Map D was printed on the blank reverse of Map B. Map B was rendered obsolete by the addition of those broad oblique blue bands labelled 'CANCELLED'. This leaves us with a fascinating artefact and a classic example of wartime ingenuity: a map used by the British and their allies to invade Germany printed on the reverse of a map intended to aid the Germans in their planned invasion of Britain.

D-Day Landing Planning Map

We now turn our attention to France and the D-Day landings of June 1944. Aerial photography of Brittany and Normandy had been planned and undertaken, then interpreted by the Allied Central Interpretation Unit (based at RAF Medmenham in Buckinghamshire) since 1942. The resultant mapping was compiled using stereo photographic techniques by a combined team of British, American and Canadian surveyors. This sheet, named 'Sword Area', was produced at a scale of 1:12,500 on the French Lambert Zone 1 grid (used uniquely in north-western France), covering an area of 7 × 7 kilometres, and was one of a set of five such sheets prepared shortly before D-Day (fig. 84). When the map is held up to the light, the words 'TOP SECRET' can be seen beneath the dark black strip at the map's top right. The key to the map is the purple overprint which has its own hastily added superimposed legend at the bottom left of the sheet. More explanatory purple text is visible at the top right. A basic English-language legend appears at the bottom right identifying non-military features such as churches, roads, sea lights and woodland.

The purple text shows that the information depicted on the map was current on 6 April 1944, two months ahead

of the eventual invasion. It warns the map's users that additional underwater obstacles were rapidly being added along the Normandy coast – in effect a troubling disclaimer about the map's reliability. The 'O.N.1.' notation refers to Operation Neptune, the initial assault phase of Operation Overlord (the codename for the landings). Under the heading 'Symbols' is a list of thirty-nine different categories of hazards that invading troops would need to prepare to encounter, such as mines, anti-tank walls and various types of guns, often including information on their relative sizes.

Sword Beach itself was eight kilometres wide, and this map shows its eastern flank. Ouistreham was the easternmost point of all the D-Day beaches, and this beach was to be the responsibility of the British army, with assistance from the British, Norwegian and Polish navies. The names in bold running along the beaches – Peter, Queen and Roger – were further codenames identifying seventeen sectors of beach, named alphabetically from west to east. Within these sectors, the beaches were further subdivided into three – Green, White and Red – each of unequal length. The final decision on landing focused on the almost three-kilometre-wide strip designated the White and Red beaches in the Queen sector, towards the centre of the map between Lion and La Brèche. The principal reason for this choice of location was the presence of offshore shoals across the remaining sectors of Sword.

Was this map successful? Given that the military objectives for the landings were largely achieved, the verdict must be a resounding 'yes'. The initial intelligence made available to the cartographers was clearly highly reliable, and so the details presented on this set of five maps were pivotal in the planning of the assault on the German defences.

Air Photomosaic

With the end of the Second World War, the Royal Air Force was commissioned to photograph large swathes of Great Britain on behalf of the Ordnance Survey, resulting in a

Fig. 84 D-Day landing map: Operation Neptune 1, Sword Area, 1944. C21:37 (28).

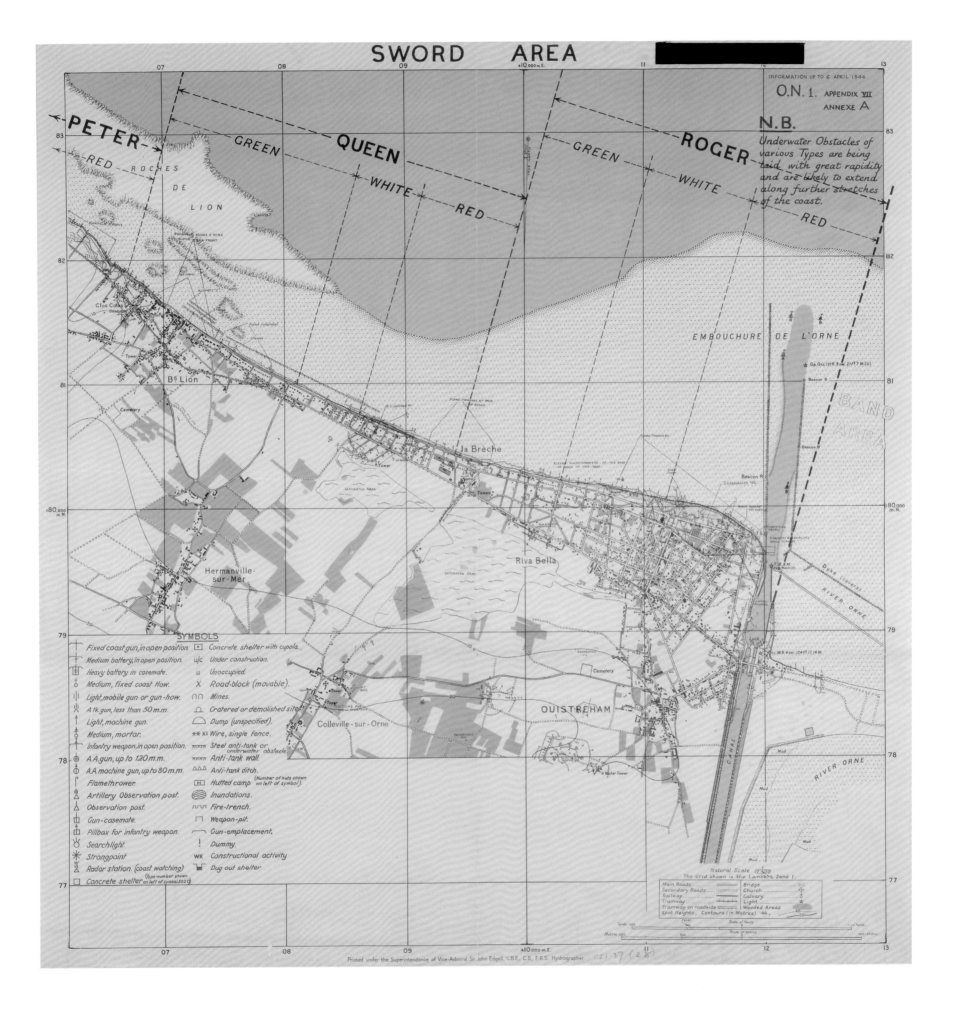

SWORD AREA

PETER GREEN QUEEN GREEN ROGER

RED WHITE RED WHITE RED

N.B.
Underwater Obstacles of various Types are being laid with great rapidity and are likely to extend along further stretches of the coast.

ROCHES DE LION

Clos Cotes

Tower

Bᵍ Lion

Cemetery

la Breche

Tower

Tower

Hermanville-sur-Mer

Riva Bella

EMBOUCHURE DE L'ORNE

BAND AREA

Beacon R

RIVER ORNE

Dyke (covers)

Colleville-sur-Orne

OUISTREHAM

Cemetery

CANAL

Lock

RIVER ORNE

Mud

Mud

Mud

SYMBOLS

Fixed coast gun, in open position.		Concrete shelter with cupola.	
Medium battery, in open position.	u/c	Under construction.	
Heavy battery in casemate.	u	Unoccupied.	
Medium, fixed coast How.	X	Road-block (movable).	
Light, mobile gun or gun-how.	∩∩	Mines.	
A tk gun, less than 50 m.m.		Cratered or demolished sites.	
Light, machine gun.		Dump (unspecified).	
Medium, mortar.	** xx	Wire, single fence.	
Infantry weapon, in open position.	xxxx	Steel anti-tank or underwater obstacle.	
A.A. gun, up to 120 m.m.	xxxx	Anti-tank wall.	
A.A. machine gun, up to 80 m.m.	△△△	Anti-tank ditch.	
Flamethrower.	H	Hutted camp (Number of huts shown on left of symbol).	
Artillery Observation post.		Inundations.	
Observation post.	∼∼∼	Fire-trench.	
Gun-casemate.	⊓	Weapon-pit.	
Pillbox for infantry weapon.		Gun-emplacement.	
Searchlight.	!	Dummy.	
Strongpoint.	WK	Constructional activity.	
Radar station. (coast watching)		Dug out shelter.	
Concrete shelter (Type-number shown on left of symbol 502)			

Natural Scale 1:12,500
The Grid shown is the Lambert Zone 1.

Main Roads	Bridge
Secondary Roads	Church
Railway	Calvary
Tramway	Light
Tramway on roadside	Wooded Areas
Spot Heights, Contours (in Metres) 44.	

Yards Scale of Yards

Metres Scale of metres

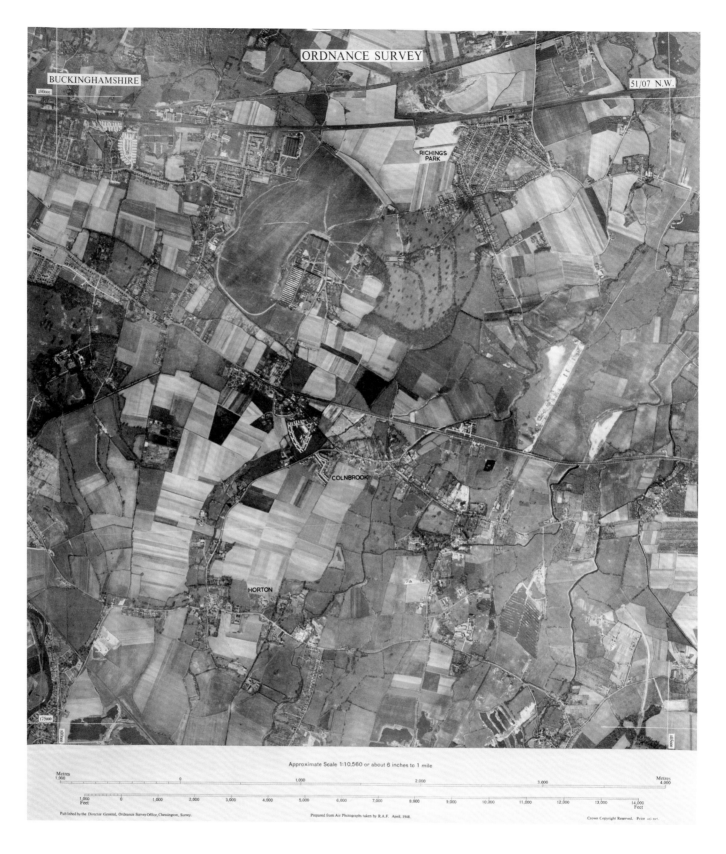

Fig. 85a Ordnance Survey, 'Air Photo Mosaic' centred on Colnbrook, including industrial buildings, sheet 51/07 N.W., A edition, 1948.

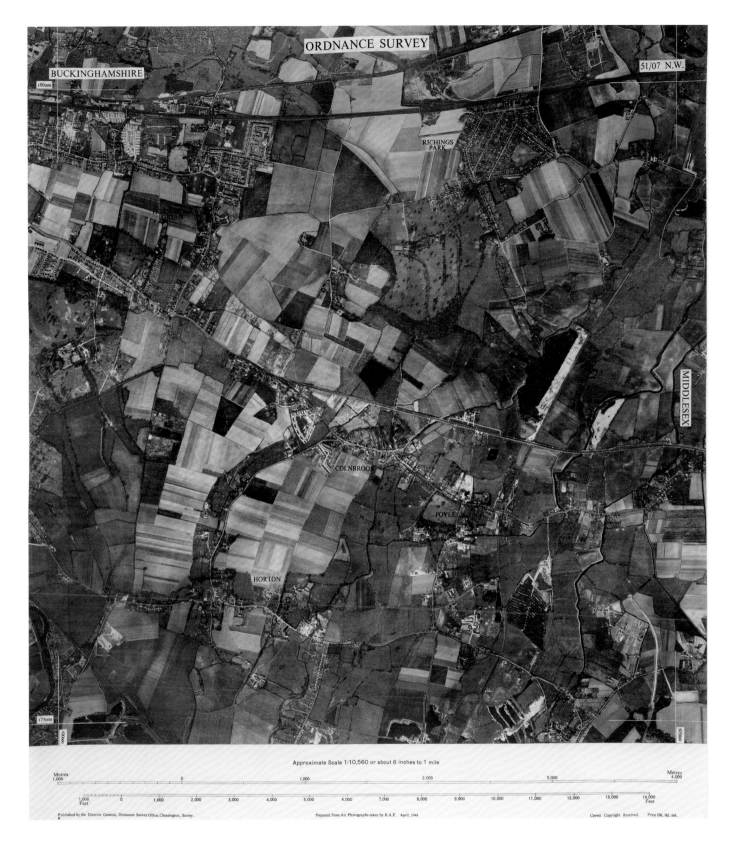

ORDNANCE SURVEY

BUCKINGHAMSHIRE

51/07 N.W.

RICHINGS PARK

MIDDLESEX

COLNBROOK

POYLE

HORTON

Approximate Scale 1:10,560 or about 6 inches to 1 mile

Metres
1,000

0

1,000

2,000

3,000

Metres
4,000

1,000
Feet

0

1,000

2,000

3,000

4,000

5,000

6,000

7,000

8,000

9,000

10,000

11,000

12,000

13,000

14,000
Feet

Published by the Director General, Ordnance Survey Office, Chessington, Surrey.

Prepared from Air Photographs taken by R.A.F. April, 1948.

Crown Copyright Reserved. Price 10s. 0d. net.

Fig. 85b Air photomosaic, sheet 51/07 N.W., B edition, 1948. Industrial buildings have been replaced by fields. Detail of area around Colnbrook.

series of black-and-white 'photomosaics' produced at a scale of 1:10,560 or six inches to one mile. These photographs were designed to match the geographical area covered by Ordnance Survey's new-look National Grid sheet lines for its own six-inch mapping, so photograph and map could be placed side by side for comparison if required. Both items used the same alphanumeric numbering system, so they could easily 'talk' to each other. The photographs were enhanced with a small number of overprinted place names.

Overall, geographical coverage of the photomosaics was far from complete when production ceased in 1952, but it took in much of Scotland's Central Lowland valley and Ayrshire, the South Wales Coalfield, and most of England south and east of Wolverhampton and Birmingham. The objective of this exercise was not, however, military. The photomosaics were commissioned to aid post-war infrastructural reconstruction, and therefore they were created with urban planning very much at the forefront. Initially produced for government departments, they were quickly made available for sale to the general public.

From such practical and worthwhile intentions, the focus of the photomosaic was subject to drastic and dramatic change. The authorities quickly became aware that these items were being legitimately purchased by individuals from overseas and, as the images showed everything visible on the ground, they became concerned about the security implications. In the wrong hands, such detailed information could be used to infiltrate sensitive locations to disastrous effect.

The area selected in fig. 85a is centred on Colnbrook, and the area covered by the photograph measures 5 × 5 kilometres. This area has changed significantly since the image was taken in 1948. Nowadays the M4 runs east–west across the centre, the M25 north–south along its eastern edge, and much of the land south-west of Colnbrook has been submerged under the Queen Mother Reservoir. Wraysbury Reservoir extends into the south-east corner, and the western limit of Heathrow Airport lies immediately to the east.

When we introduce a second photomosaic, covering exactly the same area and also dated 1948 (fig. 85b), our story takes a surprising turn. At the bottom left, tucked away in the marginalia, is a tiny letter B. This letter indicates that a second edition of sheet 51/07 N.W. was published, which tells us right away that some features on the previous edition ought not to have been publicized. We are now confronted with a game of 'spot the difference', and for 51/07 N.W. there is a major, albeit subtle, alteration. The top centre of the image is where the change has taken place. The earlier edition shows an open expanse of land with industrial buildings just south of the railway at the north end of the site, and a much larger complex of buildings further south. All of this has disappeared under a pattern of innocuous-looking fields in the B edition. New roads have even been slotted into the landscape. To add to the intrigue, the later Ordnance Survey six-inch map of exactly the same 5 × 5 kilometre area chooses to show this new-look area as a completely white blank (fig. 86).

The 'Works' at the north end of the plot do make it onto the map, but the only other geographical entity to feature is a dotted line indicating a boundary – something that cannot be seen on the ground in any case. So what were the authorities so keen to remove from the map? It was the Hawker Aircraft factory and airfield, south-east of Langley near Slough. It is just possible to make out a few small aeroplanes to the west of the main suite of buildings.

Some of the photomosaics employed far less ingenious concealment techniques – cotton wool was used to create a fake 'cloud' and placed onto the initial image, which was then re-photographed. There is something that *might* represent this on 51/07 N.W. but it seems unlikely: the B edition shows a white fluffy feature above a lake north-east of Colnbrook, though the earlier edition shows nothing untoward in this area.

Alas, the photomosaic was never a commercial success, and for this reason the planned extent of geographical coverage was quickly reduced.

Fig. 86 The area around Colnbrook is blank on this map produced ten years later. Ordnance Survey, sheet TQ 07 NW, A edition, 1960.

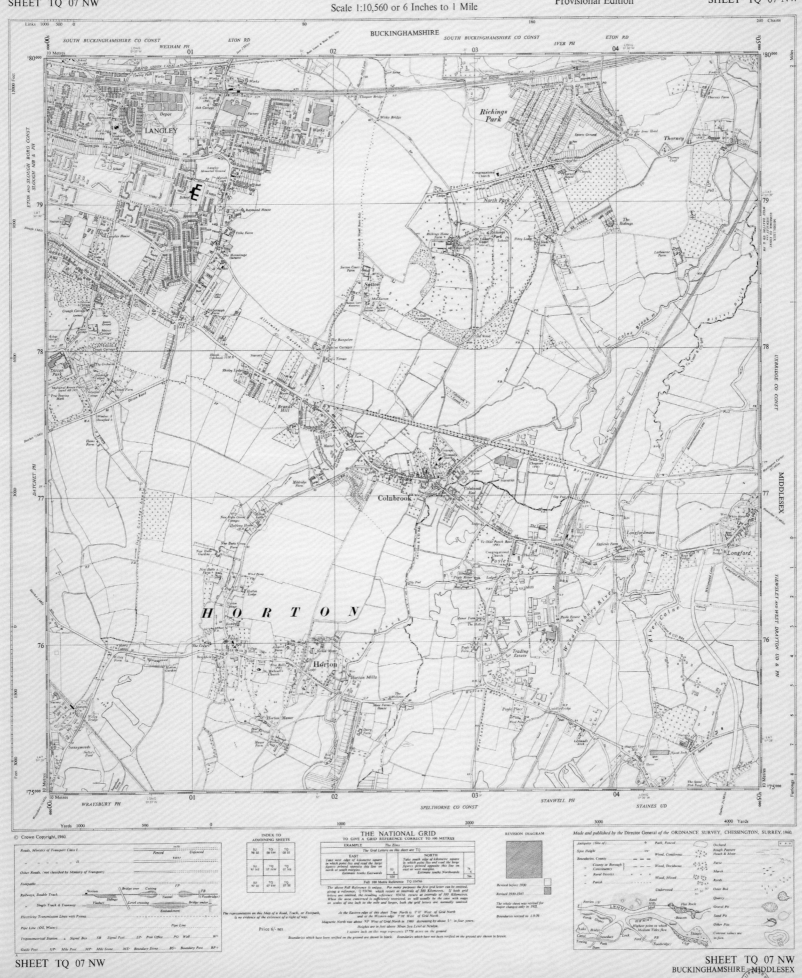

© Crown Copyright, 1960.

Made and published by the Director General of the ORDNANCE SURVEY, CHESSINGTON, SURREY, 1960.

Surprise Packet

Given the security concerns which preoccupied the photomosaic production programme, it is evident that, in the immediate aftermath of the Second World War, concern about future hostilities was never too far from the thoughts of the military. Any security breach that might encourage enemy interest in Britain was quickly erased from the map (or photomosaic in this case). On the ground, the armed forces were taking no chances, and this can be demonstrated by a curious little map dating from 1951, which looks fairly ordinary at first glance (fig. 87). But a closer inspection quickly reveals some intriguing cartographic oddities. The geographical area that we at first assume to be most of England and Wales has been labelled 'Anglian Peninsula (South)'. What is going on here? A glance below to the inset raises more questions. Great Britain is shown joined to continental Europe (renamed Europa) via a land bridge across the North Sea towards Scandinavia. The 'Anglian Peninsula' has two east–west red pecked boundary lines, subdividing this landmass into three distinct geographical units: Fantasia, Midland and Southland. Is there a certain resemblance between the Anglian Peninsula and the Korean peninsula, or is that purely coincidental? (The Korean War was being fought at this time.) The main body of the map emphasizes the boundary lines, yet, despite their peculiarity, the towns (and airfields) marked are all correctly located. The real interest is towards the bottom of the map along the Midland/Southland boundary where there is a greater density of settlements and some unexpected additions: much of Essex is shown as inundated; there is something called the Chequers Line running along the Southland side of the border from Berkshire across the Chilterns and into Essex; and two big lakes appear in Wiltshire.

What is this map telling us? 'Sketch Map "A"' from Exercise Surprise Packet is the map's title, and 'Exercise Surprise Packet' is the key to the story. The map has been given an official War Office series designation: *Geographical Section, General Staff (Misc.)* 1540. This gives it an air of authenticity, including Ordnance Survey involvement.

Other Ordnance Survey overprinted maps were created to support Surprise Packet: a series of 1:25,000 sheets (GSGS 4627); fifteen one-inch sheets (GSGS 1560); and a selection of quarter-inch maps placing the whole exercise area on a single sheet, each set marked with the 'international boundary', the 'new' lakes and the extent of the training exercise area.

A short Pathé News clip first broadcast on 18 October 1951 described Surprise Packet as Britain's biggest military manoeuvres since the Second World War, involving 50,000 troops over four days in eight counties. The reporter was embedded with a column from Southland whose mission was to seize an atomic plant at Broad Hinton near Swindon, before invading troops from Fantasia in the north managed to get there. All of this was conducted under the watchful eye of Field Marshal Montgomery, facilitating what the commentator calls 'our search for security'.

In our preceding examples we have shown how maps are required to assist in times of war. The trench maps and D-Day landing maps were created especially to facilitate battle plans. The 'recycled' map may not have begun life with war in mind, but through serendipity it evolved to take its place on the front line. The photomosaics were edited as a result of a perceived threat to national security. Surprise Packet was created for a mock military event, and although knowingly fictitious in content, it was produced with military confrontation in mind.

Such conflicts have acted as artistic catalysts over time. The Franco-Prussian War of 1871 proved inspirational for the London publisher Edward Stanford, who produced a cartographic perspective on France at the time of the Prussian invasion (fig. 88). What at first sight looks like a basic map of France divided into its *départements* becomes something altogether different when we look at the north and east of the country. Superimposed on the buff-coloured background is a face, part-human, part-lion, extending westwards from a long maned head, its fearsome fangs coming to rest above Tours.

The title of the map is instrumental in telling its story: 'Prussia pausing. Or the accurate armistice demarcation line'.

Fig. 87 Sketch Map 'A' from Exercise Surprise Packet, 1951. C17 (532) [1].

EXERCISE SURPRISE PACKET

SKETCH MAP "A"

ANGLIAN PENINSULA (SOUTH)

FANTASIA

ANTHORN
OUSTON
NEWCASTLE
CARLISLE
PENRITH
MIDDLETON ST. GEORGE
MIDDLESBROUGH
THORNABY
LEEMING
TOPCLIFFE
SCARBOROUGH
DISHFORTH
SPEETON
LANCASTER
DRIFFIELD
YORK
LECONFIELD
LEEDS
HULL
LIVERPOOL
MANCHESTER
RINGWAY
SHEFFIELD
HARWARDEN
CREWE
HUCKNALL
NOTTINGHAM
GRANTHAM
SHAWBURY
SHREWSBURY
REARSBY
NORWICH
WOLVERHAMPTON
CASTLE BROMWICH
LEICESTER
PETERBOROUGH
BIRMINGHAM
KIDDERMINSTER
NORTHAMPTON
CAMBRIDGE

MIDLAND

BEDFORD
MORETON-IN-THE-MARSH
THAXTED
COLCHESTER
CHELTENHAM
HITCHIN
BISHOPS STORTFORD
GLOUCESTER
Inundation
ASTON DOWN
CIRENCESTER
OXFORD
WALLINGFORD
SWANSEA
WANTAGE
SWINDON
LAMBOURN
LONDON
CARDIFF
BROAD HINTON
CHIPPENHAM
MARLBOROUGH
HUNGERFORD
WOOLWICH
BRISTOL
FILTON
NEWBURY
BRADFORD ON AVON
TROWBRIDGE
SAVERNAKE
BASINGSTOKE
WHITCHURCH
ANDOVER
ALDERSHOT
DOVER
SALISBURY PLAIN
LARKHILL
WARMINSTER
WINCANTON
SALISBURY
GRIMSDITCH CAMP
WINCHESTER
CALAIS
TAUNTON
YEOVILTON
SHAFTESBURY
SHERBORNE
SOUTHAMPTON
THORNEY ISLAND
FORD

SOUTHLAND

BLANDFORD
CRANBORNE
BRIGHTON
EXETER
DORCHESTER
POOLE
HURN
PORTSMOUTH
STRATTON
BOVINGTON
BOURNEMOUTH
WEYMOUTH

CHEQUERS LINE
CHILTERN HILLS

EUROPA

SCALE

10 5 0 10 20 30 40 50 MILES

Geographical Section, General Staff, (Misc.) 1540
(650/9/51.

Drawn and reproduced by Ordnance Survey, 1951.

LEGEND

TOWNS	●
AIRFIELDS	◉
AIRFIELDS UNDER CONSTRUCTION	○
GROUPS OF AIRFIELDS	▨

Inset map

PETERHEAD GROUP (3 AIRFIELDS)
FANTASIA
FIFE GROUP (3 AIRFIELDS)
AYR GROUP (4 AIRFIELDS)
ANGLIAN
NEWCASTLE GROUP (5 AIRFIELDS)
WIGTOWN GROUP (5 AIRFIELDS)
PENINSULA
MIDLAND
SOUTHLAND
EUROPA

DIRECTORATE OF MILITARY
CANCELLED
1978
CATALOGUE (REG) DISPOSAL
MCE REFERENCES

Sheet. 15
C17 (532) [17 (11)
Exercise 40

The subtitle makes the map's intentions clear: 'The outlines of the animal denote with ABSOLUTE ACCURACY, the lines held by the Belligerents during the Armistice as specified in the full text of the convention, and the area of French territory occupied by the Germans at the date of the FALL OF PARIS'. What is more, the accompanying brief text makes perfectly clear the sympathies of the map's creators:

> Attention is drawn to the extraordinary coincidence of the Armistice boundaries representing the outlines of a carnivorous animal typical of the relentless voracity of Prussia, as evinced by the rapacity of her present demands.

This is a map using art as propaganda, a neat device imaginatively delivered, helped by using an imaginary creature to present its argument. The viewer is clearly being asked to take an anti-Prussian view when it comes to this conflict. France's role is merely contextual. We are told that Prussian aggression is to be abhorred, whilst nothing is suggested about France. It has no caricature. It simply acts as the stage on which this drama is being acted.

War can therefore influence cartography in many ways, and we should also ask whether the reverse is true: can cartography influence war? Critical levels of accuracy shown in the trench and the beach maps would certainly have been vital in decision-making. The ability of these maps to speak clearly to their users supports claims that these items helped alter the course of history at critical moments of international conflict. The recycled map eloquently describes the vagaries of conflict and demonstrates how a series of divergent initiatives can unwittingly come together as one, offering us a practical perspective on the values of maps and map-making. The Surprise Packet map shows how cartography can be used to simulate and perhaps stimulate war. The photomosaic used censorship and concealment to protect sites that were likely to be needed if a military conflict were to arise. And the serio-comic map might have amused its viewers, but its impact is unlikely to have been anywhere near profound enough to enlighten and influence decision makers – although it might just have made those viewing the image think carefully about the story being conveyed to them.

Fig. 88 *Prussia Pausing*, Edward Stanford's Franco-Prussian War serio-comic map, 1871. C21 (110).

PRUSSIA PAUSING.
OR
The ACCURATE ARMISTICE DEMARCATION LINE.

The Outlines of the Animal denote with ABSOLUTE ACCURACY, the lines held by the Belligerents during the Armistice as specified in the full text of the Convention, and the Area of French Territory occupied by the Germans at the date of the FALL OF PARIS.

Attention is drawn to the extraordinary coincidence of the Armistice boundaries representing the outlines of a carnivorous animal typical of the relentless voracity of Prussia, as evinced by the rapacity of her present demands.

PUBLISHED BY EDWARD STANFORD. 6. CHARING CROSS. LONDON. 14TH FEB. 1871.

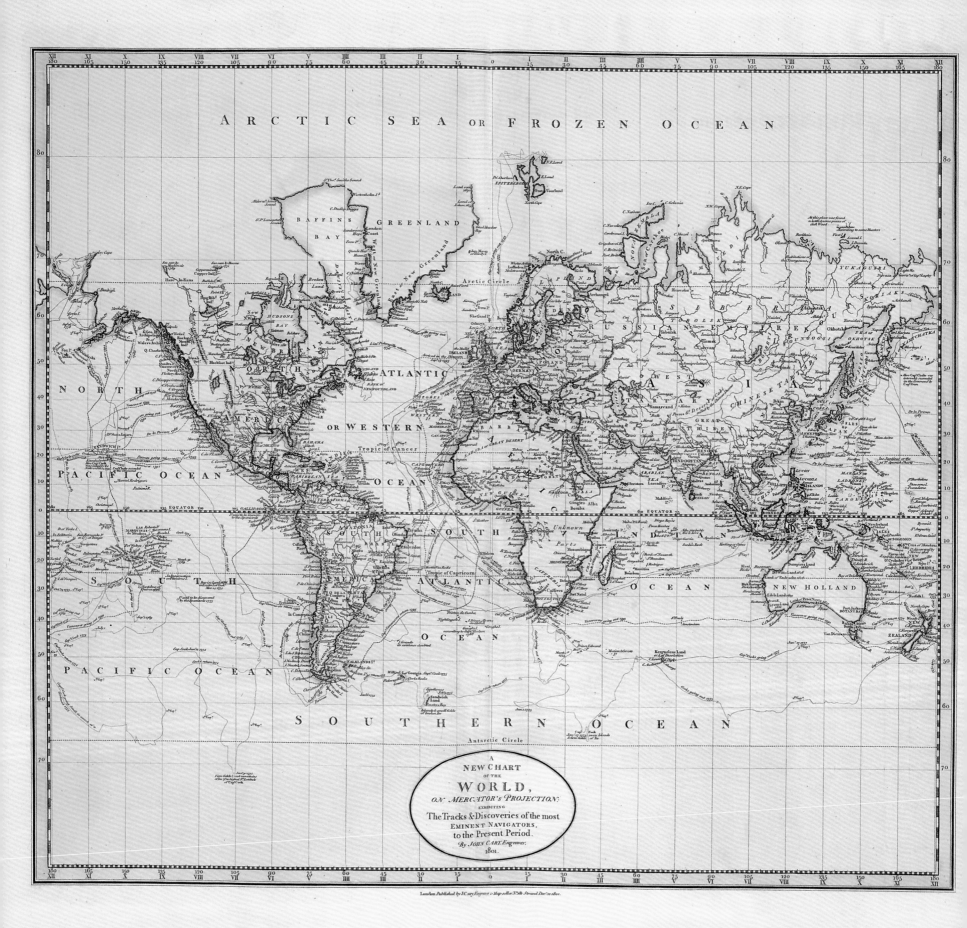

A
NEW CHART
OF THE
WORLD,
ON MERCATOR'S PROJECTION:
EXHIBITING
The Tracks & Discoveries of the most
EMINENT NAVIGATORS,
to the Present Period.
By JOHN CARY, Engraver.
1801

10

The World on the Move

The story of digital map-making has its roots in the long history of globalization that stretches back as far as the fifteenth century. As a process, globalization has not only changed the way the world works, but also the way we, as those affecting and being affected by it, see and perceive the planet. Graphic displays have a long history of translating the complexity of our environment into understandable visual representation, and maps provide the most fundamental image of the spaces in which we live.

Projections are a key element of mapping techniques. They continue to have a considerable impact on our understanding of the world, especially (but not only) in a global perspective, where different methods of projection can result in greatly varying representations of land areas. As a result of the compromises that are necessary to display a three-dimensional space on a flat surface, maps will always remain subject to interpretation and debate. But the power of maps lies in the imperfect nature of a projection. Maps create images of a space that we cannot capture with the human eye (not even an astronaut can see all continents at one time in the enviable view from space), and in doing so they shape our concepts of the planet and its spaces.

The Influence of Projections

The links between the process of globalization and its graphic representations are important in explaining how the world itself and our image of the world have changed in the last 500 years, and what crucial role cartography has played in this context. They are also relevant in understanding the most recent trends in cartography and data visualization, which are closely linked to an increasingly human-influenced planet and interconnected world. Cartographic innovations such as the Mercator projection (1569) – which solved the problem of how to create a two-dimensional map that could accurately reflect the curvature of the Earth's surface (see chapter 1) – helped seamen, tradesmen and colonists to increase global connectivity through mapping a network of transnational trade and exchange (fig. 89). As a result, humans have become the determining factor that shapes and changes not only the social, but also the physical, functioning of the world in our current geological age of the Anthropocene.

Beyond enabling a period of expansive European exploration across the globe, these developments in early modern cartography have left another lasting legacy. Five hundred years later, Mercator's map projection is ubiquitous in online mapping environments. All commercial mapping providers, including Google and Apple, use an adapted web-Mercator projection that is most practical to use for navigational purposes in a local context. But this becomes problematic when their services are used to create thematic maps where the heavy distortion towards the polar regions reinforces this widespread view of the world. In the Mercator projection the areas closest to the poles are shown considerably larger than their real size, so that the northern part of the northern hemisphere dominates world maps that use such a projection. It is an almost political statement to see these regions as much larger, while some of the most populated regions in southern Asia and Africa appear considerably smaller in comparison.

Fig. 89 Mercator projection world map, 1801. Allen LRO 183.

Ongoing societal changes throughout the earlier period of Western industrialization led to another transformation of cartography and data visualization in the eighteenth and nineteenth centuries through the growing amounts of socio-economic data that started to be shown in cartographic visualizations. The diversification of societies during this period led to the creation of the term 'cartography' as a way of giving map-making a veneer of scientific respectability. It also saw the introduction of modern censuses and the demand to understand substantial data and statistics through new methods of analysis and visualization. Many contemporary statistical visualization and thematic mapping methods originate from this 'golden age of statistics'.[1]

Among these innovations were line graphs, pie charts and many other forms of diagrams that were often combined with maps, as well as the broad field of thematic cartography which started putting data into maps. Innovations here were shaded choropleth maps (maps using shaded colours to display data), dot density maps, isolines of equal value in contour maps and other diagrammatic maps.

The Digital Turn in Cartography

The most recent developments in cartography and data visualization are closely related to a new dimension of globalization in the second half of the twentieth century. This was characterized by the complex network of economic, political and cultural links and the growing importance of computer processing in many aspects of social life. Digital cartography and computational statistics began to transform the possibilities of data analysis and their visualization, and opened up new ways of showing the increasing complexity of a globalized world. After the first working programmable computers emerged in the 1940s, from the late 1950s statistical data began to be processed digitally. The first steps in digital cartography were made in the 1960s with the developments of the earliest Geographical Information Systems. The pioneers in this field triggered the invention (and sometimes

reinvention) of graphical techniques for digital data that gradually enabled new dimensions of multidimensional quantitative data analysis and their visualization.

As computers found their way into offices as well as private households in the second half of the 1980s, they quickly became the cartographer's most important tool, until GIS techniques became a standard utility in geographical sciences in the 1990s. The changes that took place between the 1950s and the end of the century – the emergence of GIS software and GIS methods – can be called the 'digital turn' in cartography. It has radically changed cartographic practice in a way that is comparable to the innovations (such as major advances in printing techniques) that took place in the first half of the eighteenth century. The computer has now replaced manual map production and has also led to the abolishment of printing altogether in those applications where maps are only used and consumed on digital screens. But it has also fundamentally changed the way maps are created. Even if handcrafted cartographic practice still exists and often produces remarkable pieces of cartographic work, digital methods have generally replaced manual cartographic techniques. Automated processes and enhanced data processing and data analysis have therefore become integral to today's map-making.

Neocartography

The growing importance and accessibility of the internet is today crucial to cartographic innovation. The term 'neogeography' was coined in 2006 in response to the new technical potential that was opened up by digital mapping environments, new geographic data repositories on the internet and a more user-centric view. This transformation started to take cartographic practice out of the domain of professional cartographers and led to the emergence of 'new geographies'. Web cartography with digital globes, crowd-sourced maps and other innovations are the most obvious manifestations of this phenomenon. These are ongoing processes and are now also described as 'neocartography'.

All the recent developments of digital cartography originate in the changes triggered by computers and the development of GIS. As a consequence, map-making is not a profession limited to trained cartographers any more (if it ever was), but is open to anyone interested in it. Easy-to-use tools now enable anyone with internet access to present their results to a wider online audience.

The internet plays a vital role in making available the continually growing body of geodata, which helps in the analysis of underlying changes and makes cartographic visualization a central element in understanding our changing world. A wide variety of data sources have now been made available online – a process that started only about two decades ago and which has triggered a new age of data visualization. However, inaccurate maps and even misleading depictions of a subject remain a danger for cartography (not that they are a phenomenon that is unique to the digital age).

On the positive side, these developments have led to a renewed engagement with maps, which have entered everyday life in new forms. Digital devices such as smartphones now utilize maps in manifold ways. Navigation tools are ubiquitous, used in vehicles as well as by pedestrians. The ability of mobile devices to show a user's location has led to further innovation whereby maps provide the basis for an interaction with the surrounding real world. The map has become a digital canvas that stores and records people's interactions with their environment. Social media blends the digital and the real world, and cartographic displays are an important connecting element in applications that enable these interactions.

Professional cartographers may feel threatened by the emergence of this huge number of self-made cartographers. But the growing demand for maps and the interest in geographical issues represent an opportunity to revive the importance of maps in a world which might to many seem to have already been comprehensively mapped.

Cartograms as Alternative Map Projections

Maps are central to the description of the different spheres of the human and physical worlds, and have helped to illustrate the phenomena that explain our contemporary lived environments from a very early age through school atlases to their frequent use in print and other media and their advanced application in science and research. For many centuries, physical space has remained the focus of the map depiction onto which these phenomena are projected. But physical space adopts very different appearances in map form, as the two-dimensional representation of a three-dimensional space requires certain compromises. Depending on the purpose of a cartographic depiction, the question of the appropriate map projection has always been an important element in the process of map-making and has contributed to the changes in cartographic practice throughout the course of its history.

New understandings of the complex relations and the different natures of the spheres in which globalization and environmental and social change take place also require new ways of showing the heterogeneous nature of social space. Projections are a key element in such visualizations. They have a considerable impact on our understanding of the world, especially (but not only) in the way that they can influence a global perspective.

The Gall–Peters projection (1973) is an example of how map projections are used to challenge the notion of power, and to question culturally biased or bigoted world views. It is based on the concept of a cylindric equal area projection in which every continent and every country is shown in its true physical size but appears deformed in horizontal dimensions towards the higher latitudes and in vertical dimensions towards the equator. Its creator, the German historian turned geographer Arno Peters, also decided to move the central meridian of the map slightly eastwards, so that Russia is no longer cut off in its easternmost parts. The Peters projection is therefore no longer centred on the Prime Meridian at zero degrees longitude, which is a minor change

that makes a larger political statement. Following its release, Peters's map was hailed as a fairer view that addresses the perceived imbalance between the wealthier global north and poorer global south.

Peters challenged the political imbalance of the world by claiming to have drawn a map that is fairer to people living in the 'developing' world. His world map is indeed a more equitable view of the continents when seen through the lens of physical space. Fewer people live in the regions closer to the poles, which are overemphasized on a Mercator projection. However, an even fairer picture of the actual people living in these countries is given in a rather more unusual cartographic display which is commonly known as a cartogram.

Although the term 'cartogram' was originally used for maps showing statistical symbols or statistical information, it is now mainly used with reference to maps that are transformed on other than a true scale. This means that the sizes of areas do not follow mere physical principles but use other statistical data as a basis. The digital turn – and with it the utilization of computerized processing power – has led to an extensive range of cartogram transformations. All try to solve the problem of overall readability of the resulting cartogram, while at the same time being a representation of the underlying quantitative information.

To take our first example: a series of electoral maps from the United Kingdom's 2017 general election (fig. 90) demonstrates the differences between a conventional land area map (*geographic view*), a hexagonal cartogram where each constituency is represented by a hexagon-shaped area (*constituency view*) and a gridded population cartogram where each area is proportional to its total population living there (*population view*). Each representation allows for a slightly different interpretation of the information visualized in it, and therefore broadens perspectives on how the political landscape of the country can be understood.

How such map depictions are actively used for creating certain narratives has become clear following the presidential election in the United States in 2016. When the legitimacy of Donald Trump's electoral victory was questioned by parts of the media because of Hillary Clinton's numerically larger share of the popular vote, the newly elected president handed out paper copies of the 2016 electoral map of the United States to reporters with his proportional vote share depicted in red and clearly dominating the map. A more accurate picture of the votes could be given using a cartogram depiction, similar to the one shown here for the United Kingdom. Conventional maps highly over-represent less densely populated rural areas which are often also very different in their electoral geography from the most populated urban areas. This is why conventional map projections usually provide a distorted picture of the actual vote share. The largest populations in the cities are largely omitted in such map projections.

Contiguous Area Cartograms

The pioneering work of the American-Swiss geographer Waldo Tobler, and his assessment of the mathematical construction of cartograms, is perhaps the most significant contribution to the computer-assisted generation of cartograms. Tobler was the first to suggest the use of cartograms as map projections. He proposed mathematical approaches that enabled the creation of cartograms using the same technique as conventional map projections, which allowed for the transformation of a conventional map into a cartogram and back again. His enormously influential work forms the basis for many of today's computer-generated cartogram types.

Concepts of so-called contiguous area cartograms are particularly close to the wider field of other geographic map projections. In contiguous area cartograms the transformation of the real geographical shape of an area is of central interest, and the relative geographical location remains preserved in some form. These cartograms differ from conventional map projections because they are developed for a different purpose and thus use other base parameters for the actual map transformation (or deformation).

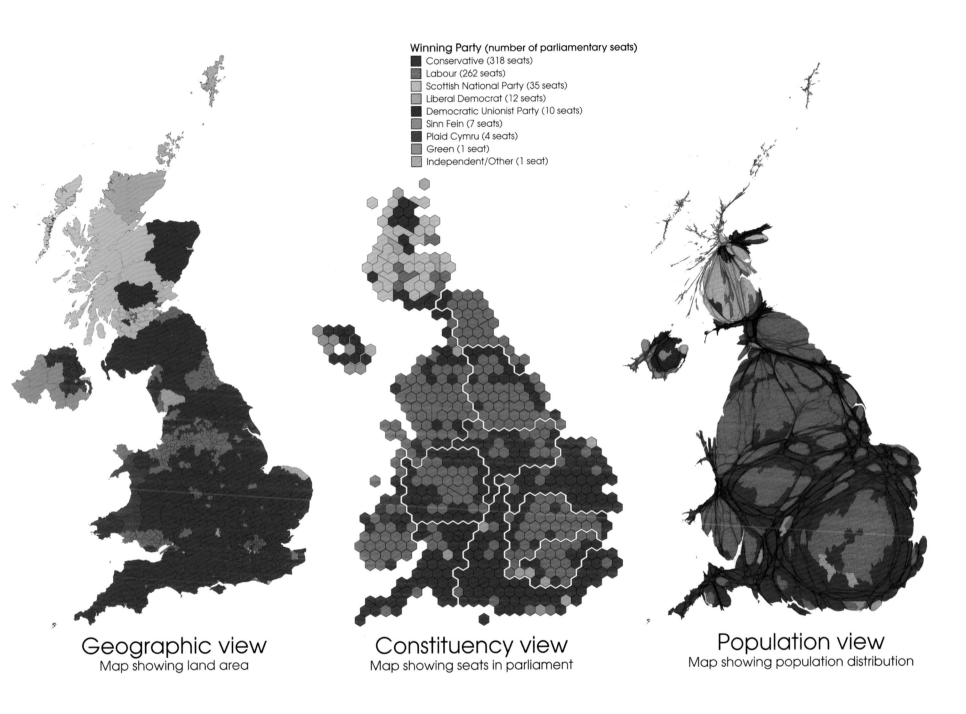

Winning Party (number of parliamentary seats)
- Conservative (318 seats)
- Labour (262 seats)
- Scottish National Party (35 seats)
- Liberal Democrat (12 seats)
- Democratic Unionist Party (10 seats)
- Sinn Fein (7 seats)
- Plaid Cymru (4 seats)
- Green (1 seat)
- Independent/Other (1 seat)

Geographic view
Map showing land area

Constituency view
Map showing seats in parliament

Population view
Map showing population distribution

Fig. 90 Map representations of the 2017 general election results in the United Kingdom: conventional map projection (*left*), hexagonal constituency cartogram (*middle*), and gridded population cartogram (*right*). Benjamin Hennig, June 2017.

One of the most recent approaches to creating contiguous area cartograms is the so-called diffusion-based method for producing density-equalizing maps proposed by Gastner and Newman.[2] The two physicists translated the idea of a diffusion process in physics into the process of a map transformation. Their approach simulates what happens when two liquids with a different density, such as water and ink, are mixed, and the liquid with the lower density spreads out until it has an even distribution. In the map transformation, the same principle changes the shape of the geographical areas, for example according to the number of people living in an area, while the people (virtually) spread out to reach an even-density distribution. The resulting cartogram therefore retains the contiguity of the countries and preserves their relative geographical location, while it also conserves the original geographical shape. This also works with any other geographical unit (such as people, money or rainfall) and on any other geographical scale (beyond countries), as long as a consistent set of data is available.

The Worldmapper project uses these methods to visualize some of the most challenging and pressing issues in contemporary human geography. Initiated at the University of Sheffield and then moved to the University of Oxford, it now continues as an independent online publication. Similar to other data-driven projects such as Gapminder and Our World in Data,[2] it aims to contribute to an improved understanding of global social and environmental changes through cartographic visualization of the continuously growing and publicly available data. Worldmapper follows the principle that the visual perception of a topic can support an immediate understanding of the underlying data, and that visualization can turn complex data into simple representations. These allow a much easier interpretation of the information that is shown. For data with a geospatial background, a cartographic depiction such as a map remains a very obvious choice to visualize quantitative data. A cartogram transformation is a valuable alternative for making quantitative dimensions easier to understand, but also for challenging the map-reader and provoking a response.

Gridded cartograms take this one step further. These cartograms move away from the arbitrary national (or administrative) level in conventional cartograms. Instead of country-level data, an equally distributed grid is used as the basis for the cartogram transformation.[3] A conventional population cartogram and gridded population cartogram are both based on population figures. They both use the same algorithm in their transformation, yet look very different compared to a conventional map such as the Gall–Peters projection, and also between the two cartogram types (fig. 91). These differences are produced by the gridded approach, which aims to provide a more detailed and objective perspective on the data.

A comparison with the original country shapes (fig. 91, top) demonstrates that the shapes of the countries in the conventional population cartogram (fig. 91, middle) can still be recognized in many cases, often differing solely in their (sometimes extremely altered) sizes. This is different in the gridded cartogram (fig. 91, bottom). For example, the area that represents China appears to have been squeezed together in the western region and extended significantly in the east because the population mainly lives in the eastern provinces. The main part of the United States is also slightly larger in the east. Even more strikingly, Alaska in the north-western corner of the map almost disappears in the gridded cartogram, being shown as a small long stretch on the global view. Other countries, such as Germany or Poland, appear closer to their original land area shape. The overall size of the countries generally matches the spatial extent of the countries in the original Worldmapper cartogram (because they are based on their total populations), while the shapes of the countries appear to be significantly different in many cases.

The gridded cartogram is based on hundreds of thousands of individual data points (visible as grid cells), while the normal cartogram uses approximately 200 numbers for the territories that are part of this world map. The gridded

Fig. 91 Comparison of a conventional map and contiguous cartograms: Peters-style cylindric equal area projection showing major geographic regions (*top*), Worldmapper-style density-equalizing population cartogram (*middle*) and gridded population cartogram (*bottom*). Benjamin Hennig, March 2018.

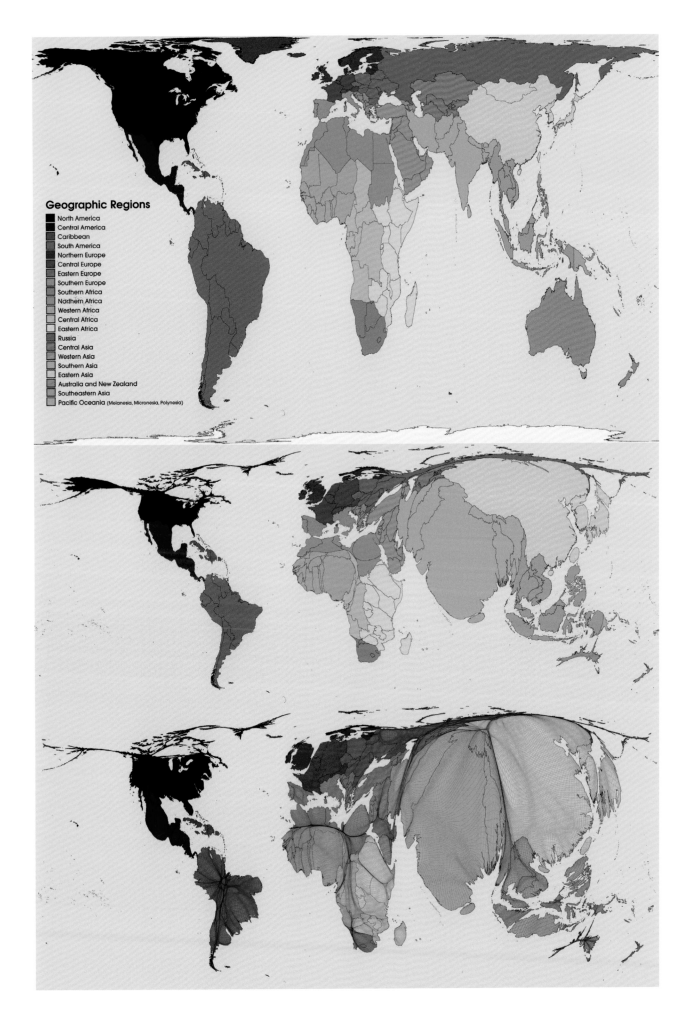

Geographic Regions

- North America
- Central America
- Caribbean
- South America
- Northern Europe
- Central Europe
- Eastern Europe
- Southern Europe
- Southern Africa
- Northern Africa
- Western Africa
- Central Africa
- Eastern Africa
- Russia
- Central Asia
- Western Asia
- Southern Asia
- Eastern Asia
- Australia and New Zealand
- Southeastern Asia
- Pacific Oceania (Melanesia, Micronesia, Polynesia)

approach therefore allows us to see much more geographic variation of the data regardless of features such as national borders. At the same time, such an approach makes the resulting map slightly more difficult to read. With a correct understanding of the technique (and guidance), however, it allows us to gain a more complex understanding of the topic mapped than the more simplified cartogram.

A more extreme and conceptual modification of the gridded approach can be found when sea areas are included in the cartogram transformation (fig. 92). This is achieved by allowing the oceans to be included in the proportional distortion of the world. Since these are not populated, the resulting map reduces the space that is occupied by the sea to a minimum, which leads to a highly abstract and unique perspective. The cartogram crosses the boundaries of art and science by applying ideas of the medieval *mappae mundi*, discussed throughout this book, to a contemporary view of the world. With the emergence of more scientific geographic maps from the sixteenth century, *mappae mundi* started to disappear, so that the cartogram shown here can be seen as a modern reinterpretation that resembles a similar visual appearance by removing the oceans. It shows what the modern planet dominated by seven billion people looks like in a visually provocative way.

In this modern *mappa mundi*, India and East Asia are now in the centre of the world, telling the story of today's shifting political centre of gravity. The centre point in India is a symbol for the effects of recent demographic changes. The global population centre is gradually shifting from the currently most populated region in Asia towards the rapidly growing African continent, which in this map pushes the significance of Europe and the Americas literally towards the edge of the earth.

The gridded cartogram approach arguably works more like a traditional map projection since it allows the cartogram to be used as a base map for other geographic information. It is also scalable down to the level of individual countries with an even more detailed view of geographic

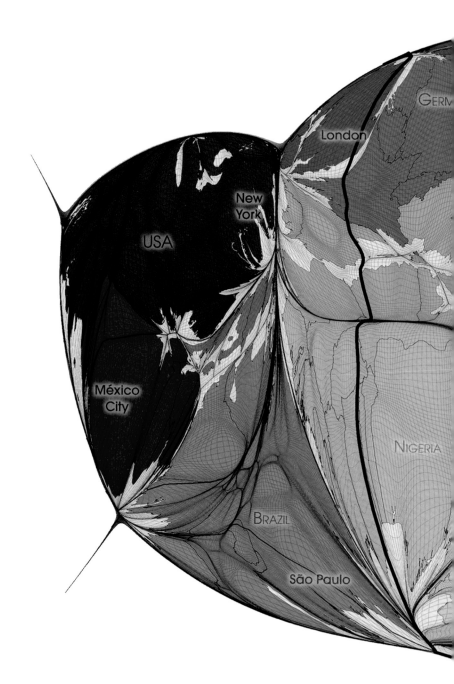

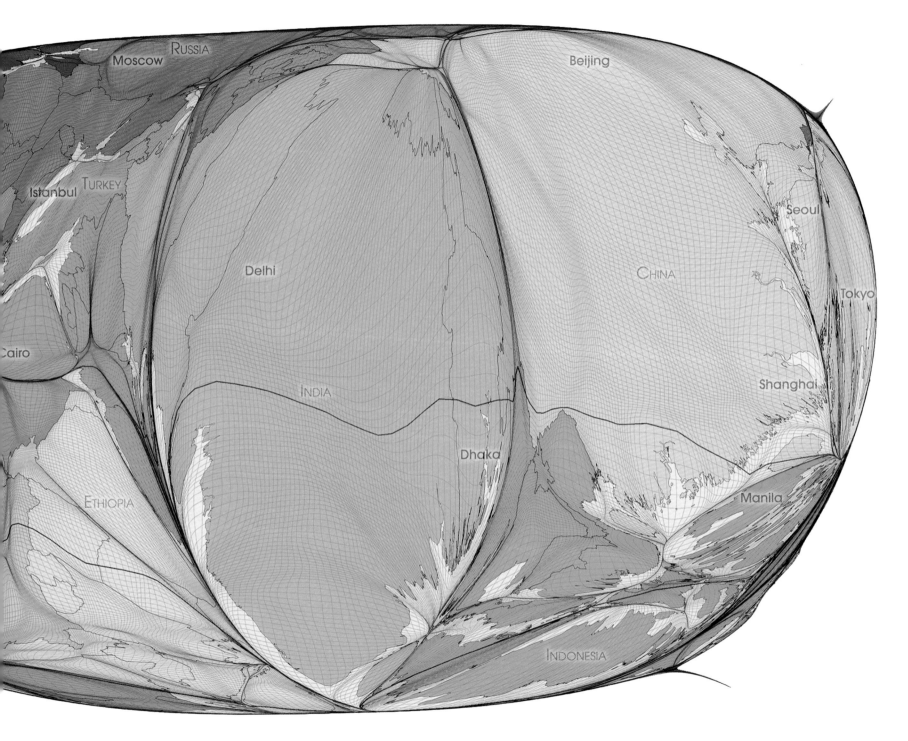

Fig. 92 *Mappa mundi*-style gridded population cartogram of the world which includes the (unpopulated) sea areas in the cartogram transformation. Benjamin Hennig, April 2018.

variations in the population distribution (see gridded population cartogram in fig. 91). This makes cartograms a viable alternative to conventional maps and means that they can help us to understand complex data in novel ways. Used in policy briefs, and also in the popular media, such depictions can help to create different narratives and tell new stories of big data, informing our understanding of the ever-expanding complexity of the world.

An example of how the gridded approach can be used in a more complex way is the transformation of a satellite image of the Earth at night. Lights at night express human activity and the distribution of people across the planet. Seeing an image of the distribution of night light projected onto population space proves that the reality is more complicated (fig. 93). The gridded cartogram, where each area is proportional to the number of people living there, overlaid by the distribution of night lights, highlights those areas that remain darker but that contain a large share of the world's population. Large parts of the African continent remain dark, in direct contrast to the illuminated populations of Europe and North America. Changing the map projection to a cartogram turns the underlying data into a visual illustration of global inequalities that can usually be expressed only in complicated numbers.

Environmental data can equally be mapped with the same level of detail using a gridded cartogram approach. The gridded cartogram of total precipitation (fig. 94) shows the quantitative distribution of rainfall and other forms of precipitation. A conventional map projection would be capable of showing only varying relative amounts of rainfall, while the cartogram gives a much more vivid impression of the absolute quantitative extent across the globe. The example of visualizing precipitation patterns demonstrates how cartograms can provide unique insights into classic geographical topics through more unusual ways of visualizing the underlying data. Neogeography and neocartography help us to gain new insights into the social and physical environments in which we live.

January
February
July
August

pp. 190–91 Fig. 93 Gridded population cartogram visualization of the Earth at night, where each area is proportional to the number of people living there. Benjamin Hennig, March 2018.

March April May June

September October November December

Fig. 94 Gridded cartogram projection of long-term annual global precipitation patterns. The smaller cartogram series below shows monthly variation. Benjamin Hennig, May 2018.

In recent years Worldmapper maps have helped to create such new insights in various ways. For example, climate activists used an inflated globe displaying the distribution of carbon emissions to campaign for their reduction at climate change summits in Copenhagen (2009) and Bonn (2017). The deliberate use of such a thought-provoking image was an important element in helping to engage summit visitors in discussions. The (literal) inflation of the globe gave these dimensions even more impact. Cartograms of global emissions have been extremely popular in similar contexts and have been used widely by campaigners as well as in education in recent years.[4]

Teachers and educational publishers often use cartograms in discussing the theme of global inequalities. Contrasting cartograms of population and wealth provide a classic introduction to understanding the unequal distributions from a geographic perspective. These maps have become increasingly common in textbooks and classrooms. Interestingly, younger people seem to have fewer problems understanding and interpreting cartograms. This demonstrates how world views and certain expectations about how the world *should* look become more ingrained in our brains over time, while in younger minds these perspectives seem more flexible. The use of cartograms by campaigners, NGOs and other similar organizations demonstrates the effectiveness of such striking depictions.

Cartograms are now becoming commonplace in everyday life. British media organizations like the BBC and the *Guardian* newspaper have made cartogram depictions of election results part of their visual toolkit. They are used in the media to create and accompany narratives around themes such as the global economy. Cartograms that come alive as moving and morphing images on television features demonstrate how innovative depictions of the world can help to create new stories about social, political and environmental change.

Using today's computers we are able to analyse millions of data values using the most sophisticated statistical analysis, but in our current digital age, a visual representation is worth so much more than thousands of words. Maps and cartograms help create the stories in our heads and minds by harnessing our visual capabilities to better understand the world around us. Maps have always told stories of the times in which they were made and cartography has a long history of reflecting and shaping the views of our changing planet. Alongside these changes, cartographic practice has also continuously diversified. Cartograms have become a versatile technique for visualizing geographic information about an increasingly complex and interconnected world. Five hundred years after Mercator, is it too much of an aspiration to change our mental map of the world from one that guides ships to one that guides our journey into a more sustainable future for humanity?

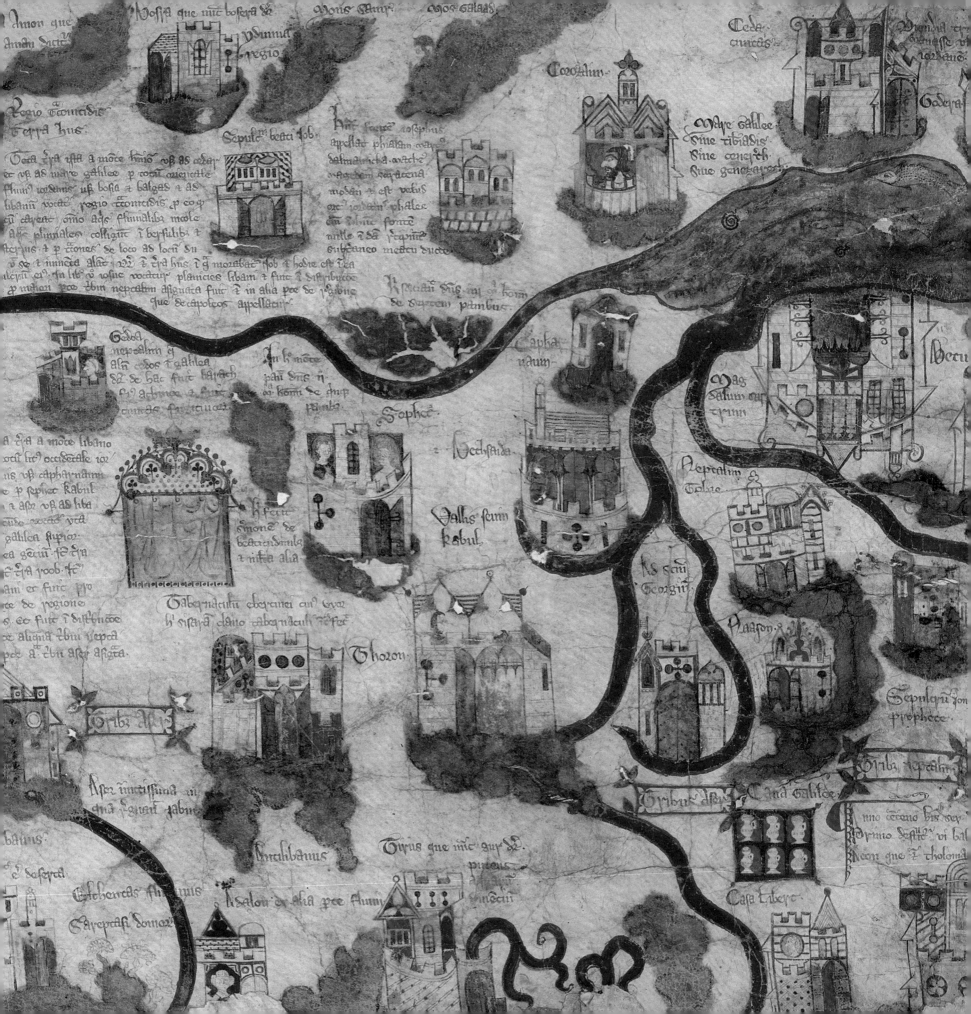

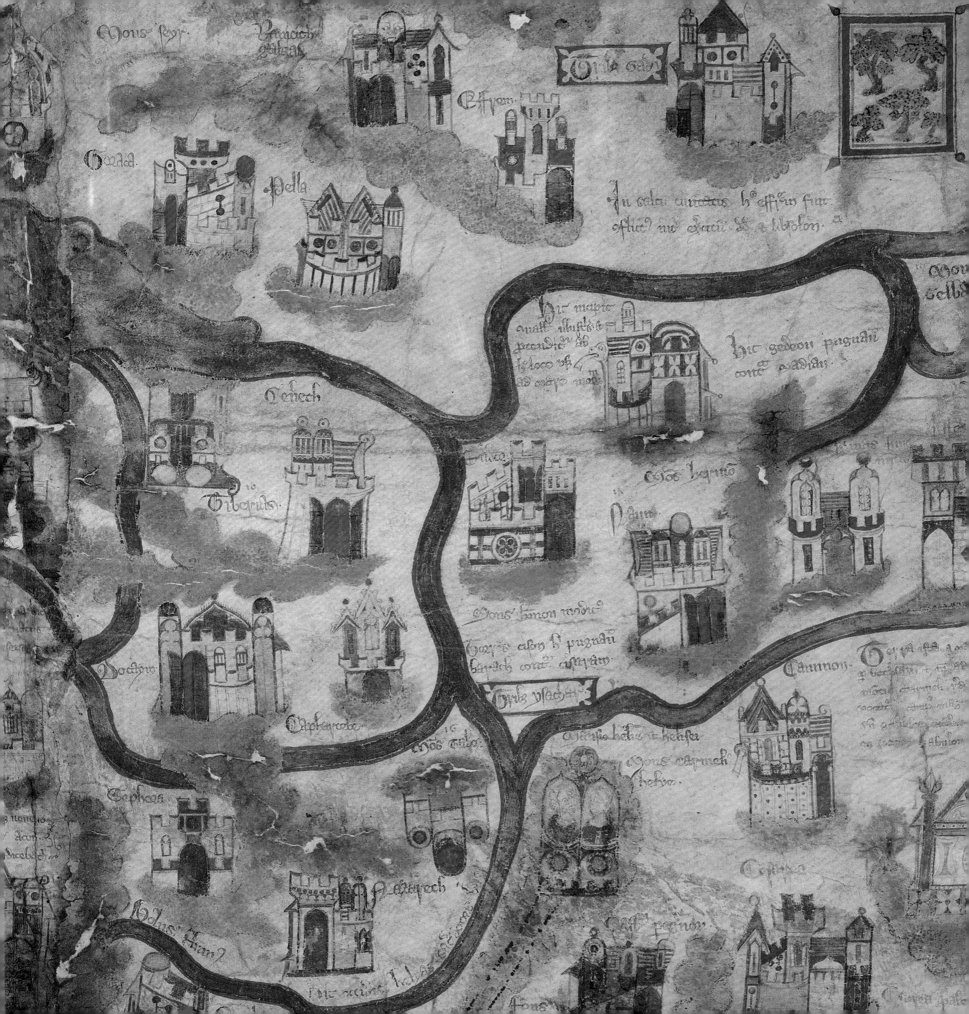

Notes

Introduction

1. Quoted in J. Lennart Berggren and Alexander Jones (eds and trans.), *Ptolemy's Geography: An Annotated Translation of the Theoretical Chapters* (Princeton, 2000), p. 63.
2. J.B. Harley and David Woodward (eds), *The History of Cartography*, vol. 1, *Cartography in Prehistoric, Ancient, and Medieval Europe and the Mediterranean* (Chicago, 1987), p. xvi.
3. Walter James Hoffman, *The Graphic Art of the Eskimos* (Washington, DC, 1897), pp. 938–44.
4. John R. Bockstoce, *Furs and Frontiers in the Far North: The Contest among Native and Foreign Nations for the Bering Strait Fur Trade* (New Haven, CT, 2010), p. 270.

Chapter 1 Orientation

1. See Edward Said, *Orientalism* (London, 1978).
2. For a fine account of how early cultures differed in assuming cardinal directions primarily for religious reasons see B.L. Gordon, 'Sacred Directions, Orientation, and the Top of the Map', *History of Religions*, 10 (3), 1971, pp. 211–27.
3. On Islamic map-making see the essays in J.B. Harley and David Woodward (eds), *The History of Cartography*, vol. 2, book 1, *Cartography in the Traditional Islamic and South Asian societies* (Chicago, 1992). For a more recent survey critical of some aspects of the Harley and Woodward collection see Karen C. Pinto, *Medieval Islamic Maps: An Exploration* (Chicago, 2016).
4. For a superb critical edition and translation of this remarkable manuscript see Yossef Rapoport and Emilie Savage-Smith (eds), *An Eleventh-Century Egyptian Guide to the Universe: The Book of Curiosities* (Leiden, 2014).
5. Quoted in Pierre Jaubert (ed. and trans.), *Geographie d'Edrisi*, 2 vols (Paris, 1836), vol. 1, p. 10. Jaubert's translation is somewhat erratic and has been slightly amended.
6. Ibid.
7. William Shakespeare, *Twelfth Night*, III. ii. 75–7.
8. On the Selden map see Robert Batchelor, 'The Selden Map Rediscovered: A Chinese Map of East Asian Shipping Routes, c. 1619', *Imago Mundi*, 65 (1), 2013, pp. 37–63, and Timothy Brook, *Mr Selden's Map of China: The Spice Trade, a Lost Chart and the South China Sea* (London, 2013).

Chapter 2 Administration

1. Recent research on the map has included hyperspectral imaging to attempt to reveal detail unseen by the naked eye, undertaken by the Bodleian in association with the Rochester Institute of Technology, New York; Raman spectroscopy to examine pigments with the University of Durham; and a 3D scan captured by Factum Arte of Madrid to identify the manuscript's contours.
2. Scan created by Factum Arte, January 2015.
3. We are grateful to Professor Keith D. Lilley of Queen's University Belfast for contributing the section on Coventry to this chapter.

Chapter 3 The Country

1. Raymond Williams, 'Country', in *Keywords: A Vocabulary of Culture and Society* (London, 1976), p. 81.
2. Sarah Tyacke and John Huddy, *Christopher Saxton and Tudor Map-Making* (London, 1980), p. 5.
3. T. Chubb, *A Descriptive Catalogue of the Printed Maps of Gloucestershire 1577–1911* (Bristol, 1913), p. 12.

Chapter 4 The Land

1. As described by Rob Watts, director of DigiData Technologies Ltd, when the terrier was being scanned at the Bodleian Library in 2004.
2. Standing Committee to the Bodleian Curators report, 9 May 1942, Oxford, Bodleian Library, Bodleian Library Records d.1033.

Chapter 5 The Sea

1. William Davenport, 'Marshall Islands Navigational Charts', *Imago Mundi*, 15 (1), 1960, 19–26. Quotation from pp. 21–2.
2. Ben Finney, 'Nautical Cartography and Traditional Navigation in Oceania', in David Woodward and G. Malcolm Lewis (eds), *The History of Cartography*, vol. 2, book 3, *Cartography in the Traditional African, American, Arctic, Australian, and Pacific Societies* (Chicago, 1998), pp. 443–92; see especially pp. 489–92.
3. Kim Tingley, 'The Secrets of the Wave Pilots', *New York Times*, 17 March 2016. https://www.nytimes.com/2016/03/20/magazine/the-secrets-of-the-wave-pilots.html.
4. Yossef Rapoport and Emilie Savage-Smith, *Lost Maps of the Caliphs: Drawing the World in Eleventh-Century Cairo* (Chicago, 2018), chapter 5.
5. Quoted in Tony *Campbell*, 'Portolan Charts from the Late Thirteenth Century to 1500', in J.B. Harley and David Woodward (eds), *The History of Cartography*, vol. 1, *Cartography in Prehistoric, Ancient, and Medieval Europe and the Mediterranean* (Chicago, 1987), pp. 371–463; quotation from p. 371.

6. Quoted in Svat Soucek, 'Islamic Charting in the Mediterranean', in Harley and Woodward (eds), *The History of Cartography*, vol. 2, book 1, *Cartography in the Traditional Islamic and South Asian Societies*, pp. 263–92; quotation from p. 272.

7. On the Selden map and debates surrounding its dating see Brook, *Mr Selden's Map of China*, and Batchelor, 'The Selden Map Rediscovered'.

8. Jon Copley, 'Just How Little Do We Know about the Ocean Floor?', *The Conversation*, 9 October 2014. http://theconversation.com/just-how-little-do-we-know-about-the-ocean-floor-32751.

Chapter 6 Oxford

1. Thomas Sharp, *Oxford Replanned* (Oxford, 1948), p. 20.

2. Ibid., p. 11.

3. Ibid., p. 12.

4. John Davies and Alexander Kent, *The Red Atlas: How the Soviet Union Secretly Mapped the World* (Chicago, 2017), p. 49.

Chapter 7 Sacred Topographies

1. Quoted in Francis Davey (ed.), *The Itineraries of William Wey* (Oxford, 2010), p. 10.

2. For this account of Wey and MS. Douce 389 we are indebted to Pnina Arad's excellent article, 'Pilgrimage, Cartography, and Devotion: William Wey's Map of the Holy Land', *Viator*, 43 (1), 2012, pp. 301–22.

3. John Kleiner, *Mismapping the Underworld: Daring and Error in Dante's 'Comedy'* (Palo Alto, CA, 1994), p. 24.

Chapter 8 Imaginary Plots

1. Alfred Korzybski, 'General Semantics, Psychiatry, Psychotherapy and Prevention' (1941), in *Collected Writings, 1920–1950* (Forth Worth, TX, 1990), p. 205.

2. George M. Logan and Robert M. Adams (eds and trans.), Thomas More, *Utopia* (Cambridge, 1989), p. 111. All references, names and places are taken from this translation.

3. Ibid., p. 5.

4. Malcolm Bishop, 'Ambrosius Holbein's *Memento Mori* Map for Sir Thomas More's *Utopia*: The Meanings of a Masterpiece of Early Sixteenth-Century Graphic Art', *British Dental Journal*, 199 (2), 2005, pp. 107–12.

5. See 'plot, n.', *OED Online*.

6. Peter Turchi, *Maps of the Imagination: The Writer as Cartographer* (San Antonio, TX, 2004). Quotations from pp. 191, 166, 113, 151.

7. The article was first published in *The Idler* magazine in August 1894. All references are to the online version: Robert Louis Stevenson, 'My First Book – Treasure Island', *The Courier*, 21 (2), 1986, 77–88. Quotation from p. 81. See https://surface.syr.edu/cgi/viewcontent.cgi?article=1200&context=libassoc.

8. Ibid., pp. 86, 81.

9. Ibid., p. 87.

10. Ibid.

11. Robert Louis Stevenson, *Treasure Island* (London, 2008), p. 3.

12. J.R.R. Tolkien, informal interview with Denys Gueroult, BBC, 26 November 1964. http://tolkiengateway.net/wiki/1964 _ BBC _ Interview.

13. *The Letters of J.R.R. Tolkien*, ed. Humphrey Carpenter (New York, 1981), p. 168.

14. J.R.R. Tolkien, 'The Ambarkanta', in *The Shaping of Middle Earth*, ed. Christopher Tolkien (London, 1986), pp. 235–61. Quotation from p. 239.

15. Quoted in Wayne G. Hammond and Christina Scull (eds), *The Art of 'The Lord of the Rings'* (London, 2015), p. 99.

16. C.S. Lewis, *Collected Letters*, ed. Walter Hooper (London, 2004–6), vol. 3, pp. 83–4.

17. Perry's comments are at http://paragonpress.co.uk/works/red-carpet.

18. Herman Melville, *Moby-Dick, or, The White Whale* (New York, 1964), p. 65.

Chapter 9 War

1. P. Chasseaud, *Topography of Armageddon: A British Trench Map Atlas of the Western Front 1914–1918* (Lewes, 1991) p. 11.

2. The Bodleian's map collection holds a coloured version of this Jörl sheet, published in 1926, but with a 'Geographical Sec. Gen. Staff. Map Room' accessions stamp dated '4 MAR. 1935'. This represents clear evidence of the value of forward planning.

Chapter 10 Worlds on the Move

1. The 'golden age of statistics' was a phrase coined by M. Friendly, 'A Brief History of Data Visualisation', in C. Chen, W. Härdle and A. Unwin (eds), *Handbook of Data Visualisation* (Berlin, 2008), pp. 15–56.

2. Michael T. Gastner and M.E.J. Newman, 'Diffusion-Based Method for Producing Density-Equalizing Maps', *Proceedings of the National Academy of Sciences of the United States of America*, 101, 2004, pp. 7499–504.

3. The projects mentioned can be found online at https://www.gapminder.org, https://www.ourworldindata.org and https://worldmapper.org. Further background about the aims and history of the Worldmapper project is outlined in Danny Dorling, 'New Maps of the World, Its People, and their Lives', *Society of Cartographers Bulletin*, 39 (1/2), 2006, pp. 35–40; and Benjamin Hennig, 'Worldmapper: Rediscovering the World', *Teaching Geography*, 43 (2), 2018, pp. 66–8.

4. The technique of creating gridded cartograms was developed as part of this author's PhD research. See Benjamin Hennig, *Rediscovering the World: Map Transformations of Human and Physical Space* (Berlin, 2013).

5. Some examples of uses of Worldmapper cartograms are documented in the archive of the Worldmapper website at http://archive.worldmapper.org/news.html.

Further Reading

Barber, P., *The Map Book*, Weidenfeld & Nicolson, London, 2005

Beckett, J.V., *A History of Laxton: England's Last Open-Field Village*, Basil Blackwell, Oxford, 1989

Birkholz, D., *The King's Two Maps: Cartography and Culture in Thirteenth-Century England*, Routledge, London, 2004

Board, C., 'Air Photo Mosaics: A Short-Term Solution to Topographic Map Revision in Great Britain 1944–51', *Sheetlines*, 71, 2004, pp. 24–35

Brotton, J., *A History of the World in Twelve Maps*, Penguin, London, 2012

Chasseaud, P., *Topography of Armageddon: A British Trench Map Atlas of the Western Front 1914–1918*, Mapbooks, Lewes, 1991

Chubb, T., *A Descriptive Catalogue of the Printed Maps of Gloucestershire 1577–1911*, J.W. Arrowsmith, [Bristol], 1913

Crane, N., *Mercator: The Man who Mapped the Planet*, Phoenix, London, 2003

Darkes, G., and M. Spence, *Cartography: An Introduction*, 2nd edn, British Cartographic Society, London, 2017

Davies, J., and A. Kent, *The Red Atlas: How the Soviet Union Secretly Mapped the World*, University of Chicago Press, Chicago and London, 2017

Delano-Smith, C., et al., 'New Light on the Medieval Gough Map of Britain', *Imago Mundi*, 69 (1), 2017, pp. 1–36

Dorling, D., 'New Maps of the World, its People, and their Lives', *Society of Cartographers Bulletin*, 39 (1/2), 2006, pp. 35–40

Gastner, M.T., and M.E.J. Newman, 'Diffusion-Based Method for Producing Density Equalizing Maps', *Proceedings of the National Academy of Sciences USA*, 101, 2004, pp. 7499–504

Hall, D., *Treasures from the Map Room: A Journey through the Bodleian Collections*, Bodleian Library, Oxford, 2016

Harley, J.B., and D. Woodward (eds), *History of Cartography*, University of Chicago Press, Chicago and London, 1987–

Hennig, B.D., 'The Human Planet', *Environment & Planning A*, 45 (3), 2013, pp. 489–91

Hennig, B.D., *Rediscovering the World: Map Transformations of Human and Physical Space*, Springer, Berlin, 2013

Hennig, B.D., 'Worldmapper: Rediscovering the World', *Teaching Geography*, 43 (2), 2018, pp. 66–8

MacCannell, D., *Oxford: Mapping the City*, Birlinn, Edinburgh, 2016

Millea, N., *The Gough Map: The Earliest Road Map of Great Britain?* Bodleian Library, Oxford, 2007

Monmonier, M., *Rhumb Lines and Map Wars: A Social History of the Mercator Projection*, University of Chicago Press, Chicago and London, 2004

Orwin, C.S., and C.S. Orwin, *The Open Fields*, 3rd edn, Oxford University Press, Oxford, 1967

Pepler, J., 'The Unknown A. Bryant and his County Maps', *Imago Mundi*, 67 (1), 2014, pp. 90–103

Rapoport, Y., *Islamic Maps*, Bodleian Library, Oxford, 2020

Rapoport, Y., and E. Savage-Smith (eds), *An Eleventh-Century Egyptian Guide to the Universe: The Book of Curiosities*, Brill, Leiden, 2014

Sharp, T., *Oxford Replanned*, Architectural Press, London, 1948

Sharp, T., *Oxford Replanned: Exhibition of the Planning Proposals made by Thomas Sharp*, Oxford University Press, Oxford, 1948

Tobler, W.R., 'Thirty-Five Years of Computer Cartograms', *Annals of the Association of American Geographers*, 94 (1), 2004, pp. 58–73

Tooley, R.V., *Maps and Map-Makers*, 7th edn, Batsford, London, 1987

Turner, H.L., *No Mean Prospect: Ralph Sheldon's Tapestry Maps*, Plotwood Press, [Derby], 2010

Turner, H.L., 'The Sheldon Tapestry Maps Belonging to the Bodleian', *Bodleian Library Record*, 17 (5), 2002, pp. 293–313

Turner, H.L., 'The Sheldon Tapestry Maps: Their Content and Context', *Cartographic Journal*, 40 (1), 2003, pp. 39–49

Tyacke, S., and J. Huddy, *Christopher Saxton and Tudor Map-Making*, British Library, London, 1980

Wallis, H.M., and A.H. Robinson, *Cartographical Innovations: An International Handbook of Mapping Terms to 1900*, Map Collector Publications/ International Cartographic Association, [Tring], 1987

Wells-Cole, A., 'The Elizabethan Sheldon Tapestry Maps', *Burlington Magazine*, 132 (1047), 1990, pp. 392–401

Worldmapper website at www.worldmapper.org

Picture Credits

Where no name is given, the creator of the map is unknown.

2, 3, 42 Images courtesy of Daniel Crouch Rare Books –
crouchrarebooks.com

4, 35 © Pitt Rivers Museum, University of Oxford

11 © Factum Arte/Teresa Casado, Anna Paola Ferrara, Oak Taylor
Smith, Aliaa Ismail

20 OpenStreetMap

28, 33 Michael Athanson

29 © Ian Bracegirdle

53 © Oxford University Images / Oxfordshire History Centre

55 © Oxford City Council

59 Reproduced courtesy of Historic Towns Trust

66 Ashmolean Museum, University of Oxford

71, 72 © The Tolkien Estate Ltd, 1986

73a, 73b © The Tolkien Estate Ltd

74 Copyright © C.S. Lewis Pte. Ltd. 1950. Reprinted by permission

75 Reproduced courtesy of Layla Curtis

76, 77 © Grayson Perry. Courtesy the artist, Paragon | Contemporary Editions
Ltd and Victoria Miro, London/Venice

90–94 Benjamin Hennig

Acknowledgements

We are very grateful to the following institutions and individuals for permission to loan and/or reproduce materials: the Pitt Rivers Museum, the Ashmolean Museum, Oxford City Council, the History of Science Museum, University of Oxford, and Grayson Perry. Various individuals have generously shared their time and expertise in answering our questions and reading material. We would like to thank Benjamin Hennig for joining the project towards the end and enriching it enormously; Alfred Hiatt for helping with various medieval cartographic queries; Keith Lilley for providing crucial help on the Gough map; Adam Lowe and his team at Factum Arte for their ground-breaking digital work on various maps; Michael Athanson for his cartographic input on the Laxton map; Stuart Ackland, Debbie Hall and Tessa Rose from the Bodleian Maps team for their help in identifying and delivering maps for the volume; Stephen Johnston at the History of Science Museum, University of Oxford, for his expertise on astrolabes and compasses; Charles Manson for crucial assistance on the Tibetan material; Catherine McIlwaine on Tolkien; Pnina Arad on pilgrimage and William Wey; Jack Langton in examining the Laxton map with us; and Yossef Rapoport for sharing his unparalleled knowledge of early Islamic mapping, including unpublished work. The Bodleian Library publishing team have been a model of professionalism and patience, and a joy to work with in producing such a beautiful book: thank you Samuel Fanous, Janet Phillips and Leanda Shrimpton. We have also been indebted to the Bodleian Exhibitions team, especially Madeline Slaven and Sallyanne Gilchrist for their guidance and eye for detail when planning the *Talking Maps* exhibition. Nick would like to dedicate the book to Alice and Evvie; Jerry would like to dedicate it Ruby, Hardie and Honey.

Index

References to illustrations are in *italic* type

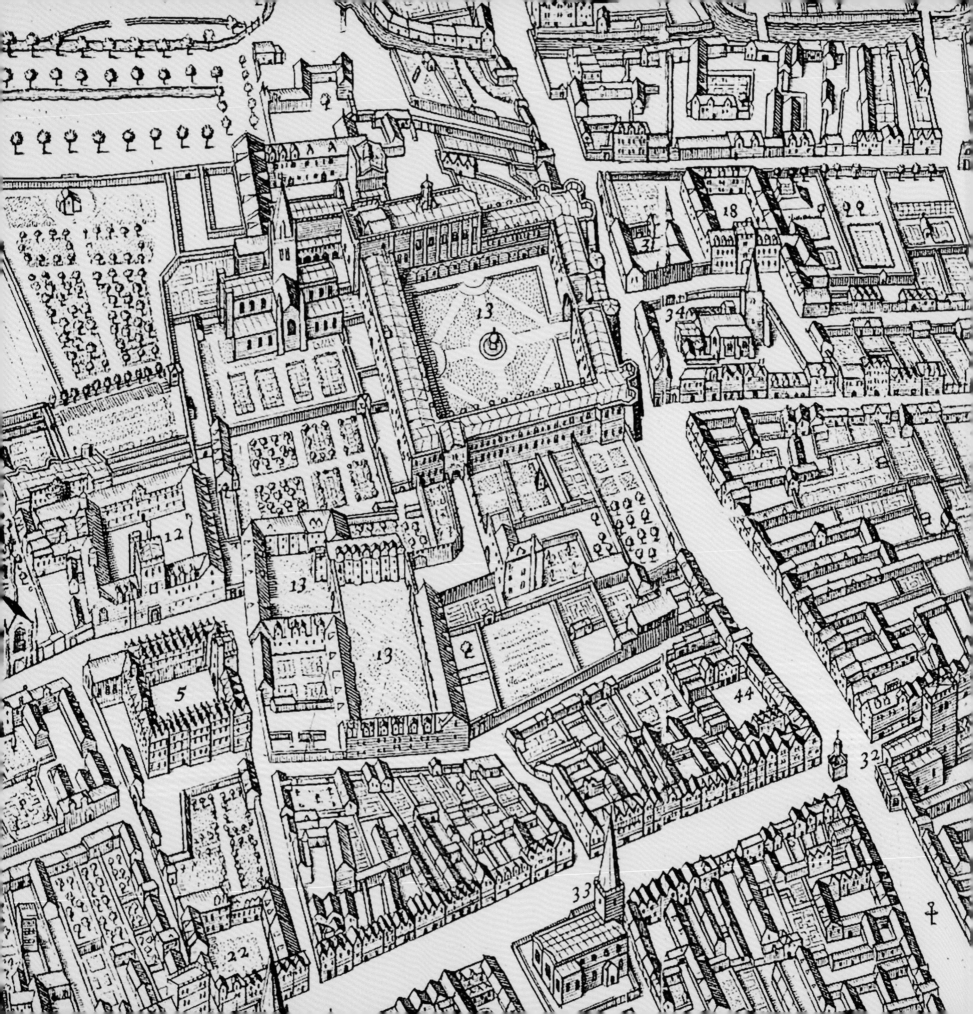